COLLAGE IN TWE
ART, LITERATUR

Emphasizing the diversity of twentieth-century collage practices, Rona Cran's book explores the role that it played in the work of Joseph Cornell, William Burroughs, Frank O'Hara, and Bob Dylan. For all four, collage was an important creative catalyst, employed cathartically, aggressively, and experimentally. Collage's catalytic effect, Cran argues, enabled each to overcome a potentially destabilizing crisis in representation. Cornell, convinced that he was an artist and yet hampered by his inability to draw or paint, used collage to gain access to the art world and to show what he was capable of given the right medium. Burroughs' formal problems with linear composition were turned to his advantage by collage, which enabled him to move beyond narrative and chronological requirement. O'Hara used collage to navigate an effective path between plastic art and literature, and to choose the facets of each which best suited his compositional style. Bob Dylan's self-conscious application of collage techniques elevated his brand of rock-and-roll to a level of heightened aestheticism. Throughout her book, Cran shows that to delineate collage stringently as one thing or another is to severely limit our understanding of the work of the artists and writers who came to use it in non-traditional ways.

For Martin

Collage in Twentieth-Century Art, Literature, and Culture

Joseph Cornell, William Burroughs,
Frank O'Hara, and Bob Dylan

RONA CRAN

Routledge
Taylor & Francis Group

LONDON AND NEW YORK

First published 2014 by Ashgate Publishing

2 Park Square, Milton Park, Abingdon, Oxon OX14 4RN
711 Third Avenue, New York, NY 10017, USA

Routledge is an imprint of the Taylor & Francis Group, an informa business

First issued in paperback 2017

British Library Cataloguing in Publication Data
A catalogue record for this book is available from the British Library

The Library of Congress has cataloged the printed edition as follows:
Cran, Rona.
 Collage in Twentieth-Century Art, Literature, and Culture: Joseph Cornell, William
 Burroughs, Frank O'Hara, and Bob Dylan / by Rona Cran.
 pages cm
 Includes bibliographical references and index.
 ISBN 978-1-4724-3096-0 (hardcover: alk. paper)
 1. American literature—20th century—History and criticism. 2. Collage. 3. Art and
literature. 4. Art, American—20th century—Themes, motives. I. Title.
 PS169.A88C73 2014
 810.9'357—dc23

 2014013561

ISBN 978-1-4724-3096-0 (hbk)
ISBN 978-1-138-74333-5 (pbk)

Contents

List of Figures

Acknowledgements

I am indebted to many wonderful people who have helped this book become a reality, not least Ann Donahue, who agreed to publish it, and Kirsten Giebutowski, for her editorial assistance. I am deeply grateful to Mark Ford, Hugh Stevens, J.D. Rhodes, Pat Palmer, Kasia Boddy, and Robert Hampson for their invaluable academic expertise and support, to Rebecca Robertson and Lucy Griffiths for indulging and cultivating my teenage love of literature, and to John Ashbery for his generosity. For their endless encouragement (and for filling our home with books), I thank my parents, Berna and Hugh Cran. I've been aided inestimably by the support and sense of humour of my sisters, Sophie and Kim, and my friends – particularly Amy Clarke, who nobly volunteered to read my manuscript, and Dolla Hutchinson, who persuaded me to run a marathon and thus ensured my enduring sense of perspective. I would also like to thank the staff at the British Library, the Columbia University Rare Book and Manuscript Library, the Archives of American Art, the Museum of Modern Art, the Tibor de Nagy Gallery, the Berg Collection at the New York Public Library, and the Wylie Agency. This book is dedicated to Martin Spychal and all three Trawler dynasties, without whom it could not have been started, let alone finished.

Quotations from unpublished letters of William Burroughs, courtesy of The Henry W. and Albert A. Berg Collection of English and American Literature, The New York Public Library, Astor, Lenox, and Tilden Foundations. Copyright © The William S. Burroughs Trust.

Quotations from unpublished letters of William Burroughs courtesy of the Rare Book and Manuscript Library at Columbia University. Copyright © The William S. Burroughs Trust.

Excerpts from 'They Dream Only of America' from *The Tennis Court Oath* ©1962 by John Ashbery. Reprinted by permission of Wesleyan University Press.

Six lines excerpted from 'Howl' on p. 213, five from 'Wichita Vortex Sutra' on p. 215, from *Collected Poems 1947–1997* by Allen Ginsberg. Copyright © 2006 by the Allen Ginsberg Trust. Reprinted by permission of HarperCollins Publishers.

Abbreviations

The following short titles and the relevant editions used are:

William Burroughs

DF *Dead Fingers Talk* (1963) (London: Tandem, 1970)

J *Junky* (1953), ed. Oliver Harris (London: Penguin, 2003)

NE *Nova Express* (1964) (London: Granada, 1978)

NL *Naked Lunch: The Restored Text* (1959), ed. James Grauerholz
and Barry Miles (London: Harper Perennial, 2005)

Q *Queer*, ed. Oliver Harris (1985) (London: Penguin, 2010)

SM *The Soft Machine* (1961) (London: Paladin, 1986)

TE *The Ticket That Exploded* (1962) (London: Paladin, 1987)

YL *The Yage Letters Redux* (1963), ed. Oliver Harris
(San Francisco: City Lights, 2006)

Note: I have used the established titles of *Naked Lunch* and *Junky*, as opposed to
the original titles of *The Naked Lunch* and *Junkie*, except in quotations.

Frank O'Hara

CP *The Collected Poems of Frank O'Hara*, ed. Donald Allen,
introduction by John Ashbery (Berkeley: University of California
Press, 1995 [1971])

SS *Standing Still and Walking in New York*, ed. Donald Allen
(Bolinas: Grey Fox Press, 1975)

Spelling and grammatical errors within letters, diary entries, and notes have
broadly been preserved.

Introduction:
Catalysing Encounters

Moreover it called into question personality, talent, artistic property, and all sorts of other ideas that comforted the tranquil sensibility of cretinized brains. I wish to speak of that which one calls collage for purposes of simplicity, even though the use of glue is only one of the characteristics of this operation and not an essential characteristic. Without doubt this subject contains within something that frightens the spirits.

—Louis Aragon[1]

Si ce sont les plumes qui font le plumage, ce n'est pas la colle qui fait le collage.
—Max Ernst[2]

What collage achieves, then, is a metalanguage of the visual. It can talk about space without employing it; it can figure the figure through the constant superimposition of grounds; it can speak in terms of light and shade through the subterfuge of a written text ... As a system, collage inaugurates a play of differences which is both about and sustained by an absent origin.
—Rosalind Krauss[3]

Collage: Approaching a Definition

The invention of collage as we know it today is attributed to Pablo Picasso and Georges Braque, but the poet Guillaume Apollinaire is responsible for its name, which derives from the French word *coller*, meaning *to paste*. From its inception in the twentieth century, then, collage evolved as a plastic process with strong poetic associations, an expansive alliance which, in and of itself, asserts its non-exclusivity. As the diversity of collage works from Picasso's *Still Life with Chair Caning* (Figure I.1) to Ezra Pound's *Cantos* to The Beatles' *Sgt. Pepper's Lonely Hearts Club Band* indicates, collage was embraced, broadened in scope, and adapted by a range of artists, writers, and musicians, whose work helped to dismantle the barriers between their disciplines. In spite of this, dictionary definitions of collage tend to be reductive; invariably they specify the act of

[1] Louis Aragon, 'La peinture au défi' (preface to a catalogue for an exhibition of collages at the Galerie Goemans in Paris, March 1930), in *Les collages* (Paris: Hermann, 1965 [1980]), n.p.

[2] 'If these are the feathers that make the plumage, it is not the glue that makes the collage'. Max Ernst, 'Au-delà de la peinture' (1936), *Écritures* (Paris: Gallimard, 1970), 256.

[3] Rosalind Krauss, 'In the Name of Picasso', *October* 16 (1981): 20.

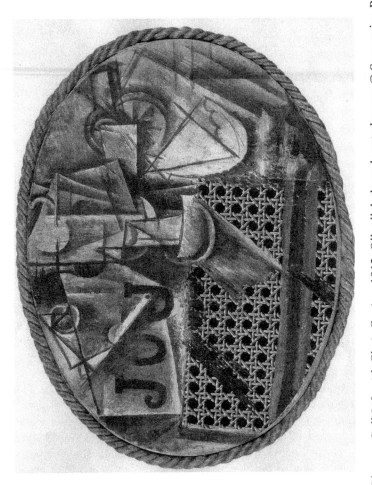

Fig. I.1 Pablo Picasso. *Still Life with Chair Caning*, 1912. Oil, oilcloth, and pasted paper. © Succession Picasso/DACS, London 2013.

gluing or pasting, but allude to little else. *The Oxford English Dictionary*, for example, defines collage as 'an abstract form of art in which photographs, pieces of paper, newspaper cuttings, string, etc., are placed in juxtaposition and glued to the pictorial surface'. *Cambridge Dictionaries Online* classifies it as 'a picture in which various materials or objects, for example paper, cloth or photographs, are stuck onto a larger surface', and *The Chambers Dictionary* terms it 'a picture made up from scraps of paper and other odds and ends pasted up'.[4]

But, as Marjorie Perloff reminds us, 'the process of pasting is only the beginning of collage'.[5] The Surrealist writer Louis Aragon noted in *La peinture au défi*, the preface to a catalogue for an exhibition of collages at the Galerie Goemans in Paris, March 1930 (quoted above), that 'glue is only one of the characteristics' of collage, and indeed, as the great collagist Max Ernst was also at pains to assert, glue alone does not a collage make. Brandon Taylor points out that, idiomatically, just as in English, the word *coller* can refer to students 'absorbed (*collés*) in their books', dogs with 'their noses *collés à la voie* or "stuck to the path"', to a couple living 'in sin' and, when prefixed with the word *papier*, to wallpaper.[6] There is a conspicuous definitive wilderness between the correct but unsophisticated cut-and-paste delineation that the dictionaries provide and, for example, the critic Daniel Belgrad's dense, all-encompassing description of collage as 'the combined intellectual, emotional, and physical engagement of the body-mind with its environment', or the Futurist artist Carlo Carrà's notion of the practice as an 'intuitive self-definition of the artist among objects'.[7] In order to understand the significance of collage in the twentieth century, on both sides of the Atlantic and across the disciplines, and its relevance to the work of Joseph Cornell, William Burroughs, Frank O'Hara, and Bob Dylan, it is necessary to approach this wilderness and comprehensively address the history, theory, and practice of collage. In so doing, a new, broader, and more flexible definition can be reached, encompassing the workings of collage across the disciplines, navigating a path through plastic art, prose, and poetry, and exploring collage's viability as both a physical practice and a theoretical principle. Collage *is* about sticking string and scraps of ephemera to paper. It is also about an intellectual and emotional relationship with a given aesthetic environment. The fundamental difference between these two definitions is that the former limits itself strictly to

[4] http://www.oed.com [Accessed 4 October 2011]; http://dictionary.cambridge.org [Accessed 4 October 2011]; *The Chambers Dictionary* (Edinburgh: Chambers, 1999).

[5] Marjorie Perloff, 'The Invention of Collage', in *Collage*, ed. Jeanine Parisier Plottel (New York: New York Literary Forum, 1983), 6.

[6] Brandon Taylor, *Collage: The Making of Modern Art* (London and New York: Thames & Hudson, 2004), 8.

[7] Daniel Belgrad, *The Culture of Spontaneity: Improvisation and the Arts in Postwar America* (Chicago: University of Chicago Press, 1998), 135. Carlo Carrà quoted in Christine Poggi, *In Defiance of Painting: Cubism, Futurism and the Invention of Collage* (New Haven: Yale University Press, 1992), 185–6.

technique and the practical act of making a collage, whilst the latter is more overtly concerned with the less easily defined concept of collage. In order to understand and evaluate an art form that has 'extended to involve and illumine a large number of seemingly discrete territories'[8] and that has been reliably termed the twentieth century's 'single most revolutionary formal innovation in artistic representation',[9] this book will concern itself with both the technical and the conceptual aspects of collage, arguing that its basic principle (operating with or without glue) is the experimentation with and the linking of disparate phenomena: democratically, arbitrarily, and even unintentionally.

Collage is about encounters. It is about bringing ideas into conversation with one another. Its advent in the twentieth century brought about the deconstruction of old barriers between language and art, with the use of pasted letters in paintings giving rise 'to poetic associations which mere spots of colour [could] not evoke',[10] to quote the French writer and art collector Christian Zervos. This in turn brought about the dissolution of perceived impediments between art and life, demanding that the viewer, reader, or listener increasingly play their own role in the landscape of a work of art or literature, simultaneously experiencing what Daniel Kane calls the 'provocative joys of juxtaposition and mysteriousness', whilst also contemplating what it is that 'constitutes authority, identity, voice, originality, sincerity, and art'.[11] By incorporating into art and literature signs that more closely resembled actual things, collage developed as a sort of intercultural language, offering a range of possible associations between text and image. Its name's origin is deceptively simple, even contentious, given that it so readily spans the disciplines. Collage has been described variously as 'the growth of the surface towards us in real space'; as 'the sensation of physically operating on the world'; and as an 'intuitive self-definition of the artist among objects'.[12] It is multi-dimensional and interdisciplinary: artistic systems of order, upon whose assumed absence the collage aesthetic is founded, are replaced by what Martyn Chalk denotes as 'some intuitive grasp of how the world might be put together'.[13] The act of decoding subsequently required from the viewer or reader constitutes an intellectual and emotional challenge whose rules of engagement necessitate

[8] Bert Leefmans, 'Das Unbild: A Metaphysics of Collage', in *Collage*, ed. Plottel, 196.

[9] Gregory Ulmer, 'The Object of Post-Criticism', in *Collage: Critical Views*, ed. Katherine Hoffman (Michigan: UMI Research Press, 1989), 384.

[10] Quoted in Herta Wescher, *Collage*, trans. Robert E. Wolf (New York: Harry N. Abrams, 1978), 21.

[11] Daniel Kane, *What is Poetry: Conversations with the American Avant-Garde* (New York: Teachers & Writers Collaborative, 2003), 12.

[12] Kazimir Malevich, 'Spatial Cubism', in *Essays on Art 1915–1933* (Vol. 2), ed. Troels Andersen (London: Rapp & Whiting, 1969), 60; Robert Motherwell, 'Beyond the Aesthetic', *Design* 47, no. 8 (April 1946): 3–89; Carrà, in Poggi, 185–6.

[13] Chalk, *Missing, Presumed Destroyed: Seven Reconstructions of Lost Works by V.E. Tatlin* (Kingston upon Hull: Ferens Art Gallery, 1981), 9.

not necessarily the discovery of any specific message, but, rather, the gradual discernment that each artwork, novel, poem, or song is uniquely and subjectively regulated by the viewers or readers themselves. The work of artists like Cornell, Burroughs, O'Hara, and Dylan was based primarily on emotion and intuition rather than didacticism or a desire to represent anything specifically – poetic rather than factual truth – and on the premise that the 'highly personal magic' that emanates from the artist's chosen materials enables them, regardless of their separateness, to 'have their effect on one another'.[14] Collage not only 'declares the continuity of realms' – it also declares the *contiguity* of realms, and carries the 'implications of a life beyond art',[15] without which the art in question could not exist. The context out of which the collage emerges is ultimately that from which it is made – hence the significance of New York City, to which all four were intimately connected – both in terms of being constructed in the reader's or viewer's imagination and, as Thomas Brockelman suggests, in 'embody[ing] a kind of immediate presence beyond the necessity of representation'.[16]

By 1912, when collage began to evolve away from its roots in folk-art, the issue of representation in painting (and, indeed, the necessity of direct representation at all), was growing progressively more problematic. Representative art, by which I mean the figurative painting that had prevailed in Europe since the Renaissance, was proving to be increasingly inadequate for the purposes of a number of young European artists seeking to express the growing sense of unease and displacement that began to pervade Europe in the years prior to the First World War. Figurative painting on its own no longer seemed to have sufficient capacity for true expression, and shortly before the First World War, two young painters working together in France issued the sphere of serious art with a challenge. Their paintings had already started to break away from the strictures of representation that, they felt, had hitherto bound Western art, but in 1912 Pablo Picasso and Georges Braque began to paste objects onto the surfaces of their works, using physical fragments of their quotidian experience, such as newspaper articles and ticket stubs, to dismantle the time-honoured conception that a painting is a mere porthole through reality might be viewed. For Picasso and Braque, and for the collagists who would follow them, the role of art was to embody life, rather than just to document it.

Their endeavours were certainly provocative, but, as Jochen Schulte-Sasse points out, Picasso and Braque did not attempt them in order 'to isolate themselves, but to reintegrate themselves and their art into life'.[17] Clement Greenberg, the art critic who called collage 'the most succinct and direct single clue to the aesthetic

[14] Wescher, 29 and 251.

[15] David Rosand, 'Paint, Paste and Plane', in *Collage*, ed. Plottel, 128.

[16] Brockelman, *The Frame and the Mirror: On Collage and the Post Modern* (Evanston, IL: Northwestern University Press, 2001), 1.

[17] Jochen Schulte-Sasse, foreword to Peter Bürger, *Theory of the Avant-Garde*, trans. Michael Shaw (Manchester: Manchester University Press, 1984), xxxvi.

of genuinely modern art',[18] and whose serious and sustained efforts to theorize collage played a key role in establishing its importance in the development of twentieth-century art, suggests that the problem with painting was that it

> had to spell out, rather than pretend to deny, the physical fact that it was flat, even though at the same time it had to overcome this proclaimed flatness as an aesthetic fact and continue to report nature.[19]

Coy and tentative in some respects, Picasso and Braque's *papiers-collés*, or collages, as the art-form later became known, were less an attack on the institution of art itself than an attempt to show and to see things differently: to make art in a whole new way. Their use of collage, which stemmed from the combination of a desire to explore new methods of representation and a pervasive unease about the growing political instability in Europe, changed the way we view art by giving the individual viewer an essential and unique role as interpreter of the artwork. The subjectivity of the viewer rendered them part of the collage concept, a cornerstone in the operation of this 'new communal art',[20] which offered alternative conditions of ownership and exegesis. Furthermore, because of the detached and non-hierarchical system by which everyday fragments were inserted into their paintings, the experience of looking could be reported democratically by any interpreter, regardless of their artistic background, educational training, or social standing.

This sense of the democracy of collage art was of great importance to Picasso and Braque, and to the movements in art and literature including Dada, Modernism, Surrealism, Futurism, Russian Constructivism, and Abstract Expressionism, which subsequently developed and diversified it. It was also, of course, a key element in the work of the four successors of Picasso's act of provocation, with whom this study is concerned. Picasso, in particular, viewed himself, as Patricia Leighten has shown, very much as 'an artist in society'. Leighten notes that over half of the newspaper clippings used by Picasso in his collages were not, as is frequently suggested,

> arbitrary bits of printed matter, nor mere signs designating themselves, but reports and accounts, meticulously cut and pasted to preserve legibility, of the events that heralded the approach of World War I and the anarchist and socialist response to them.[21]

[18] Clement Greenberg, 'Review of the Exhibition *Collage*', in Greenberg, *The Collected Essays and Criticism, Volume 2: Arrogant Purpose, 1945–1949*, ed. John O'Brian (Chicago: University of Chicago Press, 1986), 259.

[19] Greenberg, 'Collage', in Greenberg, *Art and Culture: Critical Essays* (Boston: Beacon Press, 1961), 71.

[20] Plottel, Preface to *Collage*, x.

[21] Patricia Leighten, 'Picasso's Collages and the Threat of War, 1912–13', in *Collage: Critical Views*, ed. Hoffman, 122.

Collage, a ground-breaking new way of making art, tapped into Picasso's heightening awareness that, as he later explained to Françoise Gilot, the 'world was becoming very strange and not exactly reassuring'. Gilot reports that Picasso felt that by challenging the status quo – the chimera of perspective that hitherto had governed painting – he was provoking people into acknowledging and addressing this strangeness:

> What strikes us most strongly in nature is the difference of textures: the texture of space, the texture of an object in that space – a tobacco wrapper, a porcelain vase – and beyond that the relation of form, colour, and volume to the question of texture. The purpose of the *papier collé* was to give the idea that different textures can enter the composition to become the reality in the painting that competes with the reality in nature. We tried to get rid of *trompe-l'oeil* to find *trompe l'esprit*. We didn't any longer want to fool the eye; we wanted to fool the mind. The sheet of newspaper was never used in order to make a newspaper ... It was never used literally but always as an element displaced from its habitual meaning into another meaning to produce a shock between the usual definition at the point of departure and its new definition at the point of arrival ... This displaced object has entered a universe for which it was not made and where it retains, in a measure, its strangeness.[22]

Gilot's report shows us that for Picasso the role of art was to 'become' reality, rather than merely recording it. Greenberg suggests that Picasso and Braque's collages depict 'a transfigured, almost abstract kind of literalness'.[23] The shocks and the strangeness that the viewer experiences when viewing Picasso's collages come from a sense of displacement or puzzlement engineered through the amputated reality of the ripped letters and incongruous items with which he disrupts his surfaces. It was not enough simply to paint the ripped letters and incongruous elements, as trompe l'oeil painters such as John Haberle had hitherto done, because, as Picasso says, the aim was to fool the mind (trompe l'esprit) instead. The transposed, juxtaposed fragments do more than just *represent* displacement and strangeness: they embody it, emphasising the existence somewhere else of the rest of the fragment, of its original context, either destroyed completely or carrying on, maimed in some way. This would not work with trompe l'oeil painting, in which most of the pleasure for the viewer lies in the understanding that they are being fooled, in knowing that the other half of the ticket stub or fragment of newspaper does not exist at all. By contrast, Picasso's collages are often underpinned by a sort of present absence, with meaning derived from missing letters, from simulacra, and from sections of newspaper, often political responses to the events prefiguring the First World War, deliberately not featured.

The notion of this present absence (or 'absent origin', as suggested by Rosalind Krauss above), of figuring a figure that is never quite there, sustains the practice

[22] Françoise Gilot and Carlton Lake, *Life with Picasso* (London: Nelson, 1964), 70.
[23] Greenberg, 'Collage', 80.

of collage in many ways, as I will show. It is important both in terms of acting as a catalyst for the making of collage art, and in enabling the collage practice to act as a catalyst for other forms of art and literature. The implication of the idea of the absent origin is that whilst the origin may be, or at least seem to be, absent, it nevertheless retains a significant bearing on the product, in the manner that an absent parent may retain unavoidable characteristic influence on their child's personality or appearance. Furthermore, the absence of the origin is necessary, in that it facilitates or enables that from which it is absent, and reinforces the concept that the artist is avoiding direct representation of an object or idea, but that this object or idea exists nonetheless and is important in its unrepresentability. Picasso, Braque, and numerous other collagists insisted on including fragments of the real world within the necessarily artificial structures of their art, and by using collage were able to demonstrate that the real world could exist within their work without being wholly present. In the sense that all art derives from figurative representation, the absence of the figurative in collage is key, and is of course closely related to the subtlety, ellipses, and stories not told, which we associate with modernist art and literature. It was the perceived inadequacy of direct representation that sparked the aesthetic crisis among early twentieth-century European artists, which led to the subsequent questioning of figurative painting. This in turn enabled collage to flourish and to provide the first universal technical means for expressing the formal innovations, critical explorations, and new creative ideologies being investigated by a series of movements beginning with Cubism, and taking in Dada, Surrealism, Modernism, Futurism, and Constructivism, as well as Abstract Expressionism and Pop Art.

At its most basic yet arguably most significant level, the absent origin of collage is the physical act of pasting, which was gradually subordinated to a more conceptual, theoretical approach as the collage practice gained ascendancy during the first half of the twentieth century. In 1912, when collage was first propelled into the sphere of serious art, the use in painting of fragments plucked from the reality of the everyday world succeeded in undermining the power of traditional methods of representation. As the century progressed, however, the physical practices of collage, specifically the use of glue, went into decline, as artists turned increasingly toward photographic painting, printing, and digital media. When, in the late 1950s and 1960s, avant-garde writing and even music began to mimic visual collage in earnest, art seemed to turn away from it, and, to a degree, the practice began to return to its origins in folk-art. But artists such as Lee Krasner, Jess, Romare Bearden, Aleksandr Zossimov, Sarah Lucas, Star Black, Wangechi Mutu, and John Ashbery continued to use collage in their work, and the idea – or principle – of gluing and pasting persisted, regardless of whether the physical substance was present. It remains important because it came to represent the juncture of disparate objects and ideas, democratically, despotically, or by accident, enabling the collage practice to survive and flourish as a theoretical model operating across the disciplines as opposed to a simple practical act confined to the realm of plastic art.

For the four successors of Braque and Picasso's act of provocation, of whom this book is a study – Joseph Cornell, William Burroughs, Frank O'Hara, and Bob Dylan – collage was important both for its practical qualities and its conceptual permissiveness. Each appropriated the techniques of collage for their own creative ends, and while none would claim to be exclusively a collage artist the practice was crucial to the creative development of each, acting as a mechanism or catalyst which enabled their best work to be produced. From our vantage point, decades on, it becomes clear that collage was in many ways the absent origin of their more prominent, non-collage creations, with the medium permeating and inflecting their bodies of work as a whole, whilst also remaining at a distance from them. Furthermore, collage for these four was both formative and cathartic – each used it to dissect their present and to explore the absent origins of their own writing or art. Daniel Kane suggests that 'collage is both the exterior experience one has of the world and an interior choice one makes to determine and shape one's relationship to that world'.[24] This is very much the manner in which Cornell, Burroughs, O'Hara, and Dylan, all narrative archivists of their own lives, put collage to use in their work. Cornell began his artistic career by making collages after visiting a gallery in Manhattan, and although he became famous for his beautiful three-dimensional boxes, the collage practice informed and inspired his oeuvre, and allowed him to delve into and balletically thrash out his remarkable false nostalgia for the Victorian era, his fascination with the majesty of childhood, and his strange and stilted sexuality. Dylan used collage to effectively cast himself in the lead role at the centre of the counterculture whilst simultaneously navigating the pressures of being a valuable product in the new age of mass consumerism, speaking of the need to be 'hip to communication' and of his desire to create a 'collage of experience' for his listeners.[25] The affably iconoclastic Frank O'Hara, writing under the looming shadow of tradition and literary orthodoxy, used collage to explore the intersections between the creative process and the creative product: in his early poems we see him exorcising his poetic predecessors and artistic contemporaries through his employment of collage, before using it to mediate between the disjointed, referential fragments that make up his body of work. In William Burroughs's writing, much of which is extensively cut apart, absent origins are everywhere as he employs collage to enable his novels to repeatedly disintegrate, cave in on themselves, and cease abruptly only to begin again, allowing nothing to resolve. Burroughs's use of collage was both an accident and an expedient. As a writer he found himself beset from the very start by severe organisational and motivational problems, relating both to his general character and to his heavy drug use, as well as by endemic commercial and editorial pressures, which made

[24] Kane, *What is Poetry*, 12.

[25] Dylan, interviewed by Paul J. Robbins, California, 1965. Originally printed in two parts in the *Los Angeles Free Press*, 17 and 24 September 1965 (see Artur, *Every Mind Polluting Word*, 114, http://content.yudu.com/Library/A1plqd/BobDylanEveryMindPol/resources/914.htm [Accessed 29 July 2013]).

him feel, he said, as if he was being 'sawed in half by indecisive fiends'.[26] It is clear from his letters that the organising of manuscripts and the pressure of narrative continuity caused him such intense stress that it almost manifested itself physically. To a degree, he is himself the absent origin of his own work, his true personality concealed within the narrative lacunae of his manuscripts. Furthermore, the bizarre, aleatory, yet almost mathematically structured cut-up novels intimate a sense of antagonism or, at least, unease, toward the spontaneity, emotion, and naivety of other Beat writing, some aspects of which Burroughs could never have achieved, although he might have wanted to (Kerouac's penning of *On the Road* in three weeks, for instance) and some (such as the more overtly spiritual aspects of Ginsberg's writing) which he would not have wanted to, in accord as he was 'with [T.S.] Eliot's notion that the artist's progress is measured by how well he transcends personality and private emotion'.[27]

The work of Cornell, Burroughs, O'Hara, and Dylan is strongly autobiographical but is rarely confessional, and their employment of collage was key in ensuring that this was the case. For these four, as it had been for their collagist predecessors, the use of collage enabled them to find a way of seeing things clearly, of presenting things differently, even deceptively, and of talking about something without having to mention it explicitly. Whether or not this involved psychedelic composite narratives, as in Dylan, literal acts of cut-and-paste, as in Cornell, the random juxtaposition of words and ideas to form a verbal collage, as in O'Hara, or all of the above, as in Burroughs (*Naked Lunch* being an almost accidental collage brought about partly by the writer's inability to organise his narrative), we can see in the work of each a version of Krauss's definition of the function of collage:

> It can talk about space without employing it; it can figure the figure through the constant superimposition of grounds ... As a system, collage inaugurates a play of differences which is both about and sustained by an absent origin.[28]

Working in or intimately connected to New York, a city built on intersections and by immigrants, absent origins were naturally all pervasive. The sense of transience and urban displacement, present in all big cities but particularly in one as densely populous as New York, a city constantly on the move, actively permits this notion of the absent origin in the sense of fleeting, 'now you see it, now you don't' occurrences. For these four artists, Americans with their gazes repeatedly turning toward Europe (yet another present absence), collage itself ultimately functioned as an important absent origin – its disruptive democracy reduced down to its component concepts, it was able to inform and inflect their work without necessarily being continuously present in it.

26 William Burroughs to Allen Ginsberg, 22 April 1952 (Allen Ginsberg Papers, Rare Book and Manuscript Library, Columbia University in the City of New York, Box 1, fol. 22).

27 John Tytell, *Naked Angels: Kerouac, Ginsberg, Burroughs* (Chicago: Ivan R. Dee, 1976), 15.

28 Krauss, 20.

'Understanding collage is the key': Tracing a History

The concept of collage itself is sustained by its own self-perpetuating layers of strata. The dictionary definitions with which this introduction began point out only its absent origin, which is not enough to altogether understand it. If we are to fully comprehend the ways in which, as Aragon asserted, 'collage called into question personality, talent, artistic property, and all sorts of other ideas that comforted the tranquil sensibility of cretinized brains', it is important to trace here in some detail the history, theory, and practice of collage, particularly in the light of two key assertions: one by Jochen Schulte-Sasse, that 'understanding collage is the key to understanding the most important and radical developments of the historical avant-garde of the twentieth century', and the other by Brandon Taylor, that collage 'allows us to see that it is somewhere in the gulf between the bright optimism of the official world and its degraded material residue, that many of the exemplary, central experiences of modernity exist'.[29]

Collage was a key tenet of modernist art, but, although its invention in the modern sense is widely credited to Picasso and Braque in 1912, embryonic collage techniques in fact emerged as early as 200 BC, concurrent with the invention of paper in China. Furthermore, as Eddie Wolfram observes,

> the initial idea of making pictures by sticking together bits and pieces of random and miscellaneous bric-a-brac which might ... stir the imagination to release hidden associations, heighten a written text or illustrate a narrative, is simple, and as shrouded in the genesis of man's creative urge as is his impulse to dance and tell stories.[30]

Collage was used in twelfth-century Japanese calligraphic poems, in which poets began writing on torn and pasted sheets of coloured paper, and in the work of thirteenth-century Persian bookbinders, whose elaborate leatherwork comprised cut images and delicately stitched swathes of goatskin. It can been seen in heraldic coats of arms and sixteenth-century paper-cutting, in Mexican garments decorated in feathers brought back from the New World by explorers, in straw and corn kernel mosaics made by seventeenth-century European prisoners, in religious, butterfly-wing collages made by eighteenth-century European nuns, in early Valentine's cards made at around the same time, and in religious folk-art from central Europe and Russia in which icons of saints were embellished with brocade and gemstones. As the nineteenth century progressed it brought about the first significant shift in collage production: the advent of mass mechanical production and print increasingly commodified newspapers, photographs, advertisements, and postage stamps, enabling scrapbooking to emerge as a popular pastime, and simultaneously rendering this embryonic form of the collage practice

[29] See Bürger, *Theory of the Avant-Garde*, xxxix; Taylor, 9.
[30] Wolfram, *The History of Collage* (London: Studio Vista, 1975), 7.

'a by-product of modernity', rooted in 'disposable culture'.[31] In the nineteenth century collage-making was predominantly a popular, if unremarkable, leisure-time activity for women in upper-middle class European and American families, but it began to take on increasing, and varied, significance in other areas. Friedrich Froebel, the German educationalist and architect of the kindergarten, encouraged visual creativity in his young charges by using collage practices, a method further developed in the twentieth century by Maria Montessori.[32] Victor Hugo, exiled to the island of Jersey, experimented with cut-out shapes which he glued onto sheets of paper and then painted over to create romantic landscapes. The Danish poet and storyteller Hans Christian Andersen made books by hand for his friends' children and grandchildren, which featured collages and paper cuts; in 1874, the year before he died, he also beautifully embellished a folding screen, with what John and Joan Digby describe as a 'vast montage of landscapes, buildings, historical portraits, miniature genre scenes, and imagery borrowed from the history of art'.[33] The American still-life artist John Haberle incorporated trompe l'oeil into his works, with his 1890–1894 painting *A Bachelor's Drawer* (Figure I.2) in particular anticipating the form that much twentieth-century collage art would take. Oscar Gustave Rejlander, a Swedish art photographer working in London, can probably be credited with making the first photomontage. *The Two Ways of Life*, a montaged combination of 32 negatives assembled to form a single image inspired by George Reynolds' penny dreadful *The Mysteries of London* (1844–1848) and staged to look like Raphael's *Scuola di Atene* (1509–1511), caused a stir when it was first exhibited in 1857, partly on account of its featured nudity but also because of its originality and Rejlander's skill in producing it – only five copies were made, one of which was bought by Queen Victoria as a present for Prince Albert. The English photographer Henry Peach Robinson, who founded the Birmingham Photographic Society with Rejlander, also worked using combination printing, and the production of humorous or risqué picture-postcards, created by combining photographic images, was extensive by the start of the twentieth century.

These instances of pre-collage are compelling, and although to date comparatively little is known or has been written about them, many are greatly significant both in their own right and collectively. But collage in the terms that we understand it today, and in the sense that twentieth-century artists, writers, and musicians used it, cannot be said to have really become collage until Picasso and Braque began using it,[34] not just because they heralded it into the sphere of

[31] John and Joan Digby, *The Collage Handbook* (London and New York: Thames & Hudson, 1985), 9.

[32] See Wolfram, 9.

[33] Digby, 9.

[34] Because neither Picasso nor Braque were particularly fastidious about dating their work in the period 1912–1914, neither can definitively claim to have used collage first, though both did. However, Braque's *Still Life with Fruit Bowl and Glass* (1912) is generally thought to have been the first Cubist collage.

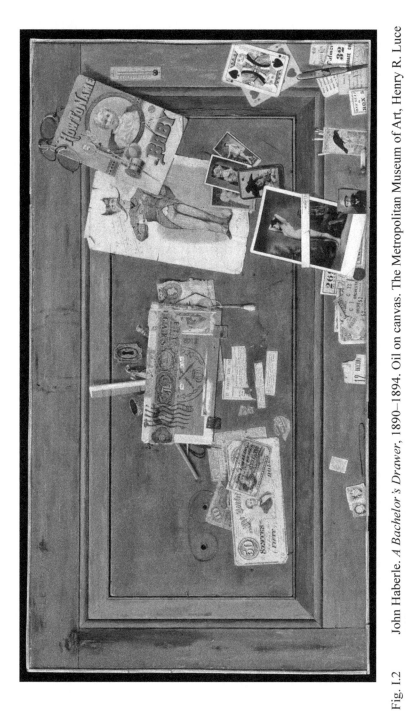

Fig. I.2 John Haberle. *A Bachelor's Drawer*, 1890–1894. Oil on canvas. The Metropolitan Museum of Art, Henry R. Luce Gift, 1970. Image © The Metropolitan Museum of Art.

public art but because they were the first to recognise the conceptual dimensions of collage, as opposed to its purely practical elements. From circa 1912, more was required from the serious collagist than just practical skill and inventive technique: as Taylor notes, 'even in the autumn of 1912 it was clear to some of those who visited Picasso's studio that his goal lay beyond the mere rearrangement of surfaces and texts'.[35] For the Japanese calligraphers, Persian bookbinders, and nineteenth-century educators, collage was predominantly a useful method of making something pretty or interesting or useful to look at or interact with, but for Picasso and Braque, and the artists and writers who subsequently developed and diversified it, it was a means of subverting established ways of making art. Beginning with the appearance of ticket stubs and pieces of rope in the work of established painters, collage expanded to incorporate such diverse work as the avant-garde poet Tristan Tzara publicly writing poetry by pulling words quite literally out of a hat, the Austrian artist Raoul Hausmann's photomontages, the textual interruption of Russian Zaum poetry, the cut-up texts of William Burroughs, and the three-dimensional combines of the American artist Robert Rauschenberg. Collage in its twentieth-century manifestation was about meaningful encounters and juxtapositions, about displacing, disrupting, and deconstructing, whilst simultaneously representing the possibility of dialogue and synthesis between heterogeneous elements. A response, predominantly, to varying representational crises, the technique moved into the sphere of serious art, with the early Cubist collages issuing a challenge to the failing '"illusionism" of perspective'[36] in traditional art. Consciously crafted juxtapositional configurations and an unabashed objection 'to cultural hierarchies, to conventions of representation, to the binary opposites of art and life'[37] are the major conceptual differences between twentieth-century collage and the functionally pasted pictures of the previous centuries. Increasingly, more was required of collage artists than the basic aesthetics of cut-and-paste.

The Cubists' exploration of collage saw it take on an increasingly weighty, wide-reaching, and more complex significance: an entirely new way of making art. Fragments of newspaper and advertisements began to appear in the work of artists who had previously established themselves as painters. This prompted the Cubist advocate Daniel-Henry Kahnweiler to pronounce that

> lyrical painting had discovered a new world of beauty which lay dormant, unremarked, in the wall posters, shop windows, and business signs that play such a great role in our contemporary visual impressions.[38]

[35] Taylor, 25.

[36] Ulmer, 384.

[37] Robin Lydenberg, 'Engendering Collage: Collaboration and Desire in Dada and Surrealism', in *Collage: Critical Views*, ed. Hoffman, 275.

[38] Daniel-Henry Kahnweiler, *The Rise of Cubism (Der Weg zum Kubismus)*, trans. Henry Aronson (New York: Wittenborn, Schulz, 1949 [1920]), 21.

Georges Braque's *Still Life With Fruit Bowl and Glass* (1912) features the use of typography for the first time, whilst Picasso's *Still Life With Chair Caning* (1912) featured a glued-on piece of oilcloth, the word 'JOU', and the use of a piece of rope to suggest the edge of the seat of a chair. The combined painting and collage renders the viewer uncertain as to whether to view the painting vertically, in the traditional manner of looking at art, or to 'read' it horizontally, as if it contained a system of signs and syntactic relationships, not so very far removed from the page of a book. This uncertainty, facilitated by the use of collage, embodies Taylor's delineation of 'Picasso's passion for switching identities, for clever bluff and counterfeit, for expedient and often jocular impersonation of the pictorial by the "real"'.[39] Several early collages of Juan Gris, including *Le lavabo* (1912), *Roses* (1914), and *The Watch* (1912), also demonstrate this shift towards what became known as Synthetic Cubism, marked by the fact that 'the backgrounds are rendered in purely frontal view, whereas the objects on the table are seen as if from above'.[40] This kind of collage germinated in tandem with an incendiary blend of international political and social turmoil and scientific progress that was to simultaneously inform and complicate the practice throughout the first half of the twentieth century – from the military conflict in the Balkans, to the eruption of the First World War, to the reactionary attitudes, virulent anti-Semitism, and homophobia in Europe which drove so many avant-garde writers and artists to America. Picasso's emphasis that the significance of including in a painting 'an element displaced from its habitual meaning into another meaning' lay in his faith in collage to produce 'a shock between the usual definition at the point of departure and its new definition at the point of arrival'.[41] His use of a fragmented newspaper report reading 'LA BATAILLE S'EST ENGAGÉ[E]', in conjunction with the words 'LE JOU', in the collage *Guitar, Sheet Music and Glass* (1912), renders the outbreak of war into some kind of game, and possibly a declaration of artistic, avant-garde battle to his contemporaries. Picasso also gives the example of using a newspaper to represent a bottle, two familiar but unrelated objects that provoke the viewer into exploring links, meanings, and discrepancies in visual representation. In so doing, Cubist collage was key in establishing not just the validity of the linguistic sign within a pictorial medium, but also what would become a longstanding and fertile distrust of 'the representability of the sign'[42] itself. As Braque explained:

> when the object depicted was being broken down, that is, deformed in order to
> be integrated into the pictorial space, the letters signified forms resistant to any

[39] Taylor, 19.

[40] Wescher, 26.

[41] Gilot and Lake, 70.

[42] Perloff, 'The Invention of Collage', 10.

kind of deformation and therefore, by reason of their two-dimensional flatness, outside the spatial construction.[43]

Braque also realised that the use of pasted papers enabled him 'to separate colour from form and to allow both elements to emerge in their own right',[44] a notion that would later have significant implications for literary, or verbal, collage. Collage art, as we can see from the quotation indented above, was explicitly linked with an almost prerequisite questioning of the nature of representation and reality. Whilst it was indeed possible to break down or deform an image – something that Picasso in particular had been doing in his painting and drawing for some time – the letters that now appeared in Cubist art were, as Braque states, resistant to the same manipulation, provoking both the artist and the viewer to contemplate language as an extra dimension in the context of the artwork, an additional facet of the painting's identity as well as an intruder from another realm. This, in particular, is what drew the Dadaists and Surrealists to the collage practice; it is also what subsequently made collage available and appealing to literature, to music, and to film, as well as to plastic art.

Dada, that 'combination of exasperation and carnival',[45] viewed collage as a form of art in keeping with their agenda of broad renunciation, provoked in particular by the horrors of the First World War. The aim of Dada was to renounce all values but the value of life itself, and to express this wholesale renunciation through art. The purpose of art, which, according to Dada principles, made no distinction between literature, drama, dance, music, and painting (much as Frank O'Hara would later view it), was 'not an end in itself ... but ... an opportunity for the true perception and criticism of the times we live in'.[46] Richard Huelsenbeck, the drummer and medical student who helped found the Berlin Dada group, insisted that Dada artists must fully comprehend 'that one is entitled to have ideas only if one can transform them into life', and asserted that the movement should include and be about 'real characters, people of destiny with a capacity for living. People with a honed intellect, who understand they are facing a turning-point in history'.[47] Raoul Hausmann, a photomontagist also from the Berlin Dada group, declared that

[43] Quoted in Wescher, 20.

[44] Wescher, 24.

[45] Leefmans, 214.

[46] Hugo Ball, quoted by the National Gallery of Art, 'Introduction to Dada', http://www.nga.gov/exhibitions/2006/dada/cities/index.shtm [Accessed 13 December 2011].

[47] Huelsenbeck, 'En Avant Dada: a History of Dadaism' (1920), in *Dada Painters and Poets: An Anthology*, ed. Robert Motherwell (Cambridge: Harvard University Press, 1951), 28, and 'First Dada Lecture in Germany' (January 1918), in *The Dada Almanac*, ed. Huelsenbeck; this edition ed. Malcolm Green and Alastair Brotchie (London: Atlas Press, 1998), 113.

the doll a child throws away, a brightly coloured scrap of cloth, are more essential expressions than those of all the jackasses who wish to transplant themselves for all eternity in oil paints into an endless number of front parlours.[48]

He even denounced the Cubists for their 'flat, remembered shape[s]' and their 'incipient hardening of the arteries', arguing that in spite of the advances made in collage art by Cubism and Futurism, these movements were ultimately 'inhibited by their own scientific objectivity'.[49] Dadaism favoured projects featuring collisions and encounters that were overt and ostentatious, smashing images together as a way of accessing truth. They embraced the strong visual impact of protruding mechanistic elements in their work, and, in particular, they experimented with collaging sound, developing Bruitist poetry which focussed on the phonetics of speech, and simultaneous poetry, in which two or more people would read the same poem at the same time, but in a different language and style. Notwithstanding, in their use of interlocked commercial advertising, typography, and the media, Dada artists indicated a similar desire to their French and Italian contemporaries working in other movements, namely to dissect their society using the same method with which it advertised itself, placing an emphasis on shock, distance, and a violent or unsettling sense of departure that was nevertheless rooted in the banal or the everyday. The sensory interconnectedness, as well as the use of diverse and innovative materials promised by collage, was particularly appealing to the Dadaists, both in terms of their fundamental appreciation of the principles of interdisciplinarity, and on account of the 'uproar' collage caused by its 'brilliant wisdom' in being 'neither art nor painting'.[50] Uproar of a more explicitly political, revolutionary nature was also enabled by collage, or, more specifically, photomontage techniques. In particular, Berlin Dadaists Hannah Höch, John Heartfield, George Grosz, and Raoul Hausmann, who continued making art long after the central 'mouvement Dada' had peaked and ended, found that the collage practice both encapsulated their sense of alienation and was an ideal vehicle for dissent. For Höch, this entailed expressing both her commitment to the Dadaist critique of Weimar Germany, as evidenced by her most famous collage, *Cut with the Kitchen Knife through the Beer-Belly of the Weimar Republic* (1919), and her own critique of her fellow (male) Dada artists' ersatz proto-feminism, as seen in her disconcerting combinations of male and female forms, and in collages such as *Dada-Ernst* (1920–1921), in which the main focus is a parted pair of female

[48] Quoted in Wescher, 136.

[49] Anne D'Harnoncourt, 'The Cubist Cockatoo: A Preliminary Exploration of Joseph Cornell's Homages to Juan Gris', *Philadelphia Museum of Art Bulletin* 74, no. 321 (1978), 2–17, 13; Wescher, 122; Hausmann, 'Synthetische Cino der Malerei' ('Synthetic Cinema of Painting') (1918). Republished in Hausmann, *Am Anfang war Dada*, 27–9; quotation from Wescher, *Collage*, 136.

[50] Tristan Tzara remarking on Hans Arp's exhibition at the Galerie Tanner in Zurich, November 1915. 'Zurich Chronicle 1915–1919', in *The Dada Painters and Poets*, ed. Motherwell, 235.

legs at the top of which has been pasted a picture of an eye and some money. John Heartfield would later use collage to satirize Hitler and the rise of Nazism, with his most famous photomontage, *Hurrah, the Butter is Finished!* (1935), mocking Hermann Göring for pronouncing: 'iron has always made a nation strong; butter and lard have only made the people fat'. The collage features an entire family tucking into an array of metal objects in a room wallpapered with swastikas.

The often incendiary tone of Dadaist collage distinguished it from that of the Cubists, but Dada nevertheless took Picasso's theoretical notion of 'shock' and the principle of distance and used them to convey a genuine sense of brutality in the creative process, emblematic of what Robin Lydenberg sees as 'the violent death and resurrection of words, images and objects ... as part of a natural and continuous process'.[51] This is particularly evident in the work of Kurt Schwitters, for whom the only foreseeable solution to the complete breakdown of a culture that was irretrievably consigned to the past by the First World War was quite simply that 'new things had to be made out of the fragments'.[52] Clement Greenberg denounced the move of Dada and Surrealism away from the 'flat and more or less abstract pattern[s]' of Cubism as cheap, unnecessary, emotional, and misguided.[53] This view seems to stem, as Brandon Taylor suggests, from Greenberg's 'obsession with the "flatness" of pictorial art'[54] and also with strict, logical, and inflexible aesthetics. But Greenberg's argument that 'Braque and Picasso had obtained a new, self-transcending kind of decoration by reconstructing the picture surface with what had once been the means of its denial'[55] seems equally applicable to the ways in which Dada artists used collage to attempt to reconstruct their fractured societies, also using as their tools those elements which had once been the means of their denial.

Whilst Schwitters desired that the fragments of his world might somehow be made to synthesize again, however disjunctively, for many Russian artists the brutality and chaos of Russian involvement in the First and Second World Wars utterly refuted the synthesis of discrete elements. For these artists, and indeed for many Russian poets, the 'brute nature'[56] of collage was an intrinsic part of its basic operational framework. Increasingly, there was a corresponding brutality in their demonstration of the creative process, culminating in powerful works such as Aleksandr Zhitomirsky's aggressively macabre anti-Nazi photomontages and the pioneering filmmaker Sergei Eisenstein's cinematic montages, which were, of course, based on the principle of collision. Artists such as Zhitomirsky, the Futurist

[51] Lydenberg, 'Engendering Collage: Collaboration and Desire in Dada and Surrealism', 283.

[52] Schwitters, quoted in John Elderfield, *Kurt Schwitters* (London and New York: Thames & Hudson, 1985), 12.

[53] Greenberg, 'Review of the Exhibition *Collage*', 261.

[54] Taylor, 109.

[55] Greenberg, 'Collage', 80.

[56] Poggi, 185–6.

Kazimir Malevich, Constructivists Aleksandr Rodchenko and Vladimir Tatlin, and certain Futurist poets including Aleksei Kruchenykh, Velimir Khlebnikov, and Vladimir Mayakovsky (who would greatly influence Frank O'Hara) attributed little significance to the attainment of synthesis that their Italian (Futurist) counterparts so greatly esteemed, preferring instead to channel the disruption, deconstruction, and displacement that collage represented into an ongoing and dynamic dialogue between the artist, his materials, and his environment. Kruchenykh's artist's book *Universal War* (1916), featuring Zaum (literally 'transreason') poetry and collages by several artists including himself, used disorder and textual interruption as a direct reaction to the role of Russia in the First World War. Vladimir Tatlin's counter-reliefs abolished not only frames, but also backgrounds: he chose instead to suspend his pieces from the ceiling, in order that the artwork might be spatially limitless and broadly indefinable, blurring the periphery between art and life. Deliberately denying any relation to painting, Tatlin's assemblages consisted of original 'materials whose nature is left entirely intact but whose coordination gives them a new life'.[57] Mayakovsky and Rodchenko collaborated on *Pro eto* (*That's What*) in 1923, with Mayakovksy writing the agonising epic parable of love and ultimate loss ('a squirrel's cage where / I go round and round / feeling more and more alone'[58]), and Rodchenko supplying eleven photomontages designed to interweave with the text, and further highlight the interrupted semantics and disordered grammar of the poem.

Pro eto is related to the collage sound-poem *Zang Tumb Tuuum*, disseminated by Italian Futurist Filippo Marinetti as an artist's book in 1914. Whilst the latter may indeed be, as Perloff suggests, less 'collage than ... catalogue',[59] it is undoubtedly representative of Marinetti's call to abandon punctuation, finite verbs, adverbs, and adjectives as part of his *Technical Manifesto of Futurist Literature* (1912), which fed into his later call for references to the First World War as the Futurists began to use collage in their art. Gino Severini, Umberto Boccioni, Giacomo Balla, and Carlo Carrà, having learned of Picasso and Braque's exploits in collage from Apollinaire, chose to employ the practice as a frenetic, 'violently revolutionary' form of complex propaganda art, in which no transplanted object stood independently, and in which there was 'not merely variety, but chaos and clashing of rhythms, totally opposed to one another', but which could be 'nevertheless assemble[d] into a new harmony'.[60] Vortexes, circles, staccato touches, and expletives in a range of languages were all aspects of Futurist collage employed in an attempt to rid art of the interior representation of the human form. Carlo Carrà described his scrambled, bewildering *Interventionist*

[57] Perloff, 'The Invention of Collage', 39.

[58] Mayakovsky, *Pro Eto – That's What*, trans. Larisa Gureyeva and George Hyde (Todmorden: Arc Publications, 2009 [1923]), 23.

[59] Perloff, 'The Invention of Collage', 28.

[60] Umberto Boccioni et al., 'The Exhibitors to the Public', (1912), in *Futurist Manifestos*, ed. Apollonio Umbro, trans. Robert Brain (London and New York: Thames & Hudson, 1973), 45 and 49.

Manifesto (1914) as a 'painterly abstraction of the uprising of the citizens': it is an attempt to bring in the spectator from the outside, compelling them to forge emotional connections between 'the scattering and fusion of details, freed from accepted logic',[61] without the guidance of the artist. Of all the early twentieth-century artistic movements in Europe, the Futurists were the most exhilarated by technological progress. They viewed the world of mass transport, commodity, and communication 'as a challenge rather than a threat, a new source of imagery and of structuration'.[62] They particularly delighted in movement and what Marinetti called 'the beauty of speed', and incorporated into their verbal and pictorial collages an explicit sense of rhythm and dynamism, following Marinetti's quest for 'an uninterrupted sequence of new images'.[63] They were careful, however, 'not to force human feelings onto matter', instead using the collage practice to attempt to 'divine [matter's] governing impulses'.[64] Futurist influence penetrated American creative frameworks with remarkable longevity: it can be seen in the work of painters such as Joseph Stella, who drew inspiration for his vibrant metropolitan paintings and collages from the 'steel and electricity'[65] of New York; in the calculated whirlpool writing of William Burroughs; in Hart Crane's desire to articulate the Machine Age in *The Bridge*; in the experimental compositions of John Cage, who believed that 'there is no such thing as an empty space or an empty time';[66] and in the work of several Black Mountain, Beat, and New York School poets, whose 'images of "writing a poem"', as David Antin argues, are all ultimately 'a way of being moved and moving, a way of walking, running, dancing, driving'.[67]

It was the Surrealist movement which really established the literary and scientific dimensions of the collage practice, building on the foundations laid by Dada and Cubism, and working to dispel the dictionary definitions I delineated at the start of this chapter (as Max Ernst was at pains to insist: 'I am not responsible for the term "collage"').[68] By the time collage, in its twentieth-century manifestation,

[61] Carlo Carrà to Gino Severini, 11 July 1914, in *Archivi del Futurismo* (Vol. 1), ed. Maria Drudi Gambillo and Teresa Fiori (Roma: de Luca, 1958), 341; Boccioni, 'The Exhibitors to the Public', 47.

[62] Perloff, 'The Invention of Collage', 41.

[63] Filippo Marinetti, 'The Founding and Manifesto of Futurism' (1909), in *Futurist Manifestos*, 21; Marinetti, *Selected Writings*, ed. R.W. Flint (New York: Farrar, Straus & Giroux, 1971), 85.

[64] Marinetti, *Selected Writings*, 87.

[65] Wescher, 177.

[66] John Cage, 'Experimental Music' (1957), in *Silence: Lectures and Writings* (Middletown, CT: Wesleyan University Press, 1961), 8.

[67] David Antin, 'Modernism and Postmodernism: Approaching the Present in American Poetry', in *boundary 2: a journal of postmodern literature* 1, no. 1 (Fall 1972): 131.

[68] Breton emphasised the concurrence of Dada and Surrealism, describing them as 'two waves overtaking one another in turn': 'Dada et le surréalisme ... ne peuvent se

reached America, Surrealism was the art movement with which it was, and has remained, most closely identified, if only because the Surrealists used it more ostentatiously and controversially than other movements. The Surrealists revelled in the juxtaposition of unrelated elements in a manner that chimed with Freudian notions of free association, dreams, visions, and the unconscious, and the rise of psychoanalysis. Named in honour of the poet who had named collage, Guillaume Apollinaire, who used the expression to describe his play *Les mamelles de tirésias* (written in 1903 but not performed until 1917), the Surrealist movement was led by the poets André Breton and Philippe Soupault, who practiced automatic writing and greatly admired the nineteenth-century writings of Baudelaire, Rimbaud, and Isidore Ducasse, otherwise known as the Comte de Lautréamont. The latter's oft-cited phrase – 'beautiful as the chance meeting on a dissecting table of a sewing machine and an umbrella'[69] – taken from the Sixth Canto of *Les Chants de Maldoror* (1868), came to represent what the Surrealists were attempting to realise, namely 'the intoxicating atmosphere of *chance*', as Breton himself wrote. Prefacing the 1920 exhibition of Max Ernst's work, Breton wrote of collage:

> It has the marvellous faculty of attaining two widely separate realities without departing from the realm of our experience, of bringing them together and drawing a spark from their contact; of gathering within reach of our senses abstract figures endowed with the same intensity, the same relief as other figures; and of disorienting us in our own memory by depriving us of a system of reference – it is this faculty which for the present holds us.[70]

Breton had a scientific background, having undertaken some medical training, and for a time he attempted to promote Surrealism as a quasi-scientific form of research activity, presenting findings in the rather solemn publication *La Révolution surréaliste*, talking about the physics of poetry, and portraying artworks as evidence of scientific experimentation.[71] He wished to pioneer a kind of automatic poetry and art that would reveal in practice what Freud described in theory: 'an absolute reality of unconscious mind and uncensored emotions that lay below the threshold of reason'.[72] Alfred Barr argued, in his introduction to the catalogue

concevoir que corrélativement, à la façon de deux vagues dont tour à tour chacune va recouvrir l'autre'. André Breton, *Entretiens 1913–1952* (Paris: Gallimard, 1952), 57. The Ernst quotation is from *Beyond Painting* (New York: Wittenborn, Schultz, 1948), 13. Ernst also asserted that several paintings by both Magritte and Dalí were 'collages painted entirely by hand' (17).

[69] Lautréamont, *Les Chants de Maldoror* (Book 6), trans. Paul Knight (London: Penguin, 1988 [1868]), 217.

[70] Breton, *Mad Love* (*L'Amour fou*), trans. Mary Ann Caws (Lincoln: University of Nebraska Press, 1987), 25, and 'Preface to the Max Ernst Exhibition, May 1920', in Ernst, *Beyond Painting*, 177.

[71] Twelve issues of *La Révolution surréaliste* were published between 1924 and 1929.

[72] Digby, 19.

which accompanied the seminal 1936 exhibition *Fantastic Art Dada Surrealism*, that following the decline of Dada circa 1922, Surrealism had maintained its predecessor's 'anti-rational character ... but developed a far more systematic and serious experimental attitude toward the subconscious as the essential source of art'.[73] The Surrealists' work, unlike that of the Dadaists which tended toward the delirious and the haphazard, adopted a more focussed and directed approach to the subconscious and the irrational, an approach which Max Ernst termed a 'culture of systematic displacement and its effects'.[74]

Initially, the Surrealists did not produce plastic art, for the simple reason that their experiments with automatism were better facilitated with a spontaneous outpouring of words. However automatic writing soon engendered automatic drawing, initiated by André Masson, who upon seeing the shapes of animals and birds materialize in his line-drawn abstractions, began to collage feathers and other materials, plucked directly from the natural world, into his work. Ernst experimented with picture poems, and with *frottage*, where he covered objects with thin paper and rubbed over them with a soft pencil, allowing him 'to be present as a spectator at the birth of his works'.[75] The movement soon invented, capitalised upon, or expanded hybrid genres. These included the act of collaboration, the artist's book, the manifesto, and the visual poem. In spite of Breton's authoritarian attempts at leadership, and as international borders closed with increasing menace around them, the Surrealists insisted upon the transgression and even dissolution of boundaries.

Surrealism on the whole gave precedence to form rather than subject matter, insisting that the disjunctive process of rearranging and interrelating contexts from their psychological germination to their physical manifestation gave meaning to pre-existing fragments or objects. Meret Oppenheim's *Object (Le Déjeuner en fourrure)*, a teacup, saucer, and spoon covered in the fur of a Chinese gazelle, for example, subverted traditional perceptions of feminine domestic etiquette by transforming it visually into a sensuous, subtly sexualized incongruity. Joan Miró and Masson experimented with ways to transmute the poetic experimentation and lyrical expression of their literary counterparts into art, exploiting their dreams and using visual free association. The seamlessness of Max Ernst's collage novels transformed Victorian and Edwardian penny dreadfuls and technical manuals into hallucinatory and disquieting compendiums of his own 'private phantom[s]'[76] in which he 'recovered the past as the psychological locus of dreams',[77] and rendered it tortured. His 1924 painting, *Two Children Are Threatened By A Nightingale*, which I will discuss further in relation to Joseph Cornell, embodies the complete disorientation experienced in a nightmare or hallucination. The irrationality of its subject matter, its manipulation of size and perspective, and its formal mix

[73] Alfred Barr, ed., *Fantastic Art Dada Surrealism* (New York: Museum of Modern Art, 1936), 11.

[74] Ernst, *Beyond Painting*, 13.

[75] Wescher, 186.

[76] Wescher, 203.

[77] Digby, 19.

of three-dimensional wooden add-ons and ostentatious Old Masters influence, instil in the painting a sense of panic spilling over into the waking world. The eponymous children, inexplicably in grave danger from the diminutive bird, are nevertheless within reach of a solid house with a solid wooden gate, as if, as Herta Wescher observes, in so doing the artist 'could guarantee them more security'.[78]

Particularly after 1929 and the arrival in Paris of Salvador Dalí, Albert Giacometti, and René Magritte, irony, violence, eroticism, and zealous atheism operated as colliding components of an increasingly politicized movement which rested upon the opposing yet synthesized tensions of 'life and death, the real and imagined, past and future, the communicable and the incommunicable, high and low',[79] and which used collage as a vehicle for Surrealism's 'interwar project of radical change'.[80] In works such as Magritte's *La lectrice soumise* (1928), *La trahison des images* (*The Treason of Images*) (1928–1929), and *On The Threshold of Liberty* (1937), Luis Buñuel and Dalí's film masterpiece *Un Chien Andalou* (1929), many of Ernst's collages, and Georges Hugnet's 1936 collage novel, *Le septième face du dé* (in which found phrases behave like objects or images whilst found images and photocollages operate as texts), extreme banality was subverted in order to marry the narrative impulse with what Robert Hughes terms the 'tenuousness of signs'.[81] Language and representation were expelled from their traditional purposes, opening the door to an expanding and uncertain realm of perpetual free association fuelled by what Dalí called 'systematize[d] confusion',[82] as Surrealism began to move away from passive automatism towards cultivated paranoia and the deliberate transmutation of reality. Violence towards, and the death and resurrection of, words and images, was seen, as Robin Lydenberg has observed, 'as part of a natural and continuous process',[83] a form of plastic incantation, which was manifested in Surrealist collage. The collages were increasingly subversive in their social critique and barbed in their message, particularly as, in the late 1920s, the movement began simultaneously to splinter and to gain international recognition and notoriety. Artists worked 'to disclose conflicts within the self as well as a subjectivity in conflict with its environment,

[78] Wescher, 120.

[79] Breton, 'Second Manifeste du Surréalisme', in *La Révolution surréaliste* (15 December 1929) 1: 'Tout porte á croire qu'il existe un certain point de l'esprit d'où la vie et la mort, le réel et l'imaginaire, le passé et le futur, le communicable et l'incommunicable, le haut et le bas cessent d'être perçus contradictoirement'.

[80] Stamatina Dimakopolou, 'Nostalgia, Reconciliation and Critique in the Work of Joseph Cornell', in *Opening the Box*, ed. Jason Edwards and Stephanie L. Taylor (Oxford: Peter Lang, 2007), 209.

[81] Robert Hughes, *The Shock of the New: Art and the Century of Change* (London and New York: Thames & Hudson, 2005), 244.

[82] Salvador Dalí, 'L'Âne pourri', in *Le Surréalisme au service de la Révolution* 1 (July 1930): 9.

[83] Lydenberg, 'Engendering Collage: Collaboration and Desire in Dada and Surrealism', 283.

and sought to release the potential of unsuspected and incongruous relations which were open to transformation'.[84] Greenberg described Surrealist collages as 'stunts of illustration',[85] and, although he meant this derogatively, the phrase expressively indicates the theatricality and practical expertise of artists such as Magritte, Ernst, and Dalí, in terms of using collage academically, to illustrate the uncanny, or, indeed, as Stamatina Dimakopolou suggests it might be used: 'to bring back a hidden strangeness within a devalued reality'.[86]

The desire to refresh and more accurately evoke the strangeness of life, and to find new ways to say old things, appealed to writers as well as to artists, and was what drew the Modernist poets William Carlos Williams, Ezra Pound, and T.S. Eliot to the collage practice, as they too attempted to shrug off and destabilize the established structures of Western literature. Williams, seeking to 'integrate unconscious possibility with empirical reality',[87] used fragments cut from historical documents and from his correspondence with Allen Ginsberg and Marcia Nardi to create his vast collage-poem, *Paterson*, asserting that 'a work of art is important only as evidence, in its structure, of a new world which it has been created to affirm'.[88] Pound, too, wove quotations, diary entries, and drawings into the fabric of his *Cantos*, in the manner of the *objets trouvés* pioneered by Dada. Particularly in the work of Pound and Williams, the written character of verbal collage, which puts it at a remove, practically speaking, from its plastic counterpart, is undermined: the external fragments operate within their texts not as crafted expressions of individual poetic consciousness but as external objects within the overall syntactic continuity of the text as a whole. Eliot's *The Waste Land* uses collage in a similar way, but in his earlier work, notably *The Love Song of J. Alfred Prufrock*, he preferred to use techniques of internal fragmentation, 'spatial incoherence', 'semantic overlapping', and 'discontinuous composition',[89] favouring poetic methods that were more often characteristic of collage, rather than being actual collage. In order to 'make it new', and to assert themselves against the preceding generations of writers beside whom they felt judged (not least by themselves), the Modernists, like the Cubists, Dadaists, Surrealists, and Futurists, engaged in these sustained acts of 'discontinuous composition', to borrow from Andrew Clearfield, 'employing the often unheroic images and language of the contemporary age to narrate, comment upon, or interrupt the more high-flying narratives of convention'.[90]

[84] Dimakopolou, 214.

[85] Greenberg, *The Collected Essays and Criticism (Vol. 4): Modernism with a Vengeance, 1957–1969*, ed. John O'Brian (Chicago: University of Chicago Press, 1995), 65.

[86] Dimakopolou, 215.

[87] Belgrad, 31.

[88] William Carlos Williams, 'Against the Weather', in *Selected Essays* (New York: Random House, 1954), 196.

[89] Clearfield, *These Fragments I Have Shored: Collage and Montage in Early Modernist Poetry* (Ann Arbor: UMI Research Press, 1984), 115–26.

[90] Clearfield, 126.

'Feelings must have a medium': Urban Contexts and Collage in New York City

The collage that had germinated in Europe, from the meditative, Cubist *papiers collés* to the whirling Futurist 'manifestos', from the exasperated commitments of Dada to the booby-trapped Surrealist images, was, on the whole, either violent, sexually aggressive, or directly or indirectly politically charged; in many instances it was all of the above. However, upon reaching New York City, much of this charge dissipated due to the absence of its context, and indeed, to the absence of many of its artists. Although their absence had the temporary effect of promoting European artists and writers to the status of 'remote demigods or intellectual father figures',[91] across the Atlantic in New York, the 'new Paris' was evolving, in which the tripartite ideal of 'liberty, progress and modernity'[92] was working to eclipse, or at least to overshadow, the increasingly grim and atavistic spectacle of Europe and its seemingly perpetual embroilment in bloodshed and conflict. Francis Picabia, Man Ray, and Marcel Duchamp had for many years been carrying out a nameless revolution similar to that of Surrealism, but enjoying a sense of humour and detachment from which their European counterparts remained cut off by the threats, realities, and aftershocks of war, as well as their uncertain allegiance to Stalinism. E.B. White, in *Here is New York* (1949), described New York as

> the concentrate of art and commerce and sport and religion and entertainment and finance, bringing to a single compact arena the gladiator, the evangelist, the promoter, the actor, the trader and the merchant. It carries on its lapel the unexpungeable odour of the long past, so that no matter where you sit in New York you feel the vibrations of great times and tall deeds, of queer people and events and undertakings.[93]

By 1945, the great cultural cities of Europe – Paris, Madrid, Rome, London – lay in ruins, while thousands of miles away the bars and lofts of New York were steadily filling up with the artists who had formerly occupied their salons and cafés. At the same time, a new generation of artists and writers, liberated from their confinement in the sterile world of propaganda illustration, murals, and the Works Progress Administration by a growing national (and internationally-minded) interest in home-grown art and literature, found themselves at the heart of the world's new cultural capital. The city was increasingly self-confident and innovative, notwithstanding its anxieties about taking on the mantle worn so long by Paris, while the formerly great city declined in a culturally and politically

[91] Hughes, *The Shock of the New*, 259.

[92] Eric Homberger, 'New York City and the Struggle of the Modern', in *The Cambridge Companion to Modern American Culture*, ed. Christopher Bigsby (Cambridge: Cambridge University Press: 2006), 314.

[93] E.B. White, *Here is New York* (New York: The Little Bookroom, 1999 [1949]), 19–20.

weakened Europe, buoyed primarily by American funds as culture, and modern art in particular, became increasingly and aggressively politicised following Congressional approval of President Truman's Marshall Plan in 1947. The freewheeling self-assurance and willing experimentalism of New York City's artists and writers stood in stark contrast with the 'self-satisfied do-nothingism' of Paris, which, 'due only in part to the extreme political divisions within the art world, hastened Paris's downfall and put the Parisian muse to sleep'.[94]

This self-confidence stemmed partly from an article written in 1937 by Meyer Schapiro, who was a friend of Robert Motherwell, as well as of Breton, Marcel Duchamp, André Masson, and Yves Tanguy. Schapiro validated abstract art by arguing that 'here, finally, was an art of painting in which only aesthetic elements seem to be present', thereby reaching the aesthetic pinnacle of music and architecture, hitherto praised 'as examples of a pure art which did not have to imitate objects but derived its effects from elements peculiar to itself'.[95] Whilst the art movements of Europe – Surrealism in particular – mattered considerably to young American artists, this in no way meant that they merely imitated them. In fact, the tension between the desire not to imitate and a simultaneous respect and admiration for their European predecessors or counterparts produced a current of shifting, creatively uncertain identities in New York, which was partly how American art succeeded not only in finally gaining recognition on the world's cultural stage but in ultimately transfiguring it. It also enabled the enactment, as Max Ernst had stridently worded it (riffing on Breton's notion of convulsive beauty), of the idea (closely related to collage) that 'IDENTITY WILL BE CONVULSIVE OR WILL NOT EXIST'.[96] Concurrently, the particularly urban urge or need to exhibit or express one's individuality was also manifested amongst artists from Cornell to Pollock to Rauschenberg, and writers from Burroughs and Ginsberg to O'Hara and John Ashbery, with each, to quote Georg Simmel, 'summoning the utmost in uniqueness and particularization, in order to preserve his most personal core' against the tide of stimulation found in cities, in which the danger, if one is not careful, is that 'one hardly needs to swim for oneself'.[97] Eric Homberger describes New York as an 'entrepôt of European ideas and a place where symbols of urbanity, pleasure, status, luxury, ethnicity, and moral strenuousness achieved a highly skilled manipulation and projection through both popular culture and elite institutions'.[98] Homberger qualifies this statement with a view of the city as having recently endured and emerged from the dual burden of Prohibition and the Great

[94] Serge Guilbaut, *How New York Stole the Idea of Modern Art: Abstract Expressionism, Freedom and the Cold War* (Chicago: University of Chicago Press, 1985), 5.

[95] Schapiro, 'Nature of Abstract Art', *Marxist Quarterly* 1 (1937): 77.

[96] Ernst, *Beyond Painting*, 19.

[97] Simmel, 'The Metropolis and Mental Life', in *Classic Essays on the Culture of Cities*, ed. Richard Sennett (Englewood Cliffs, NJ: Prentice-Hall, 1969), 59.

[98] Homberger, 314.

Depression, as well as drawing attention to the repressive moral gatekeepers who worked resolutely against the city's burgeoning cultural forces. Nevertheless, New York, from about 1930 onward, had become a place where the European brand of collage could be approached with a degree of detachment, with a kind of unaffiliated enthusiasm and talent for evaluation and differentiation that was so much a part of the tastes of the new generation of American artists and writers, whose style was 'equally aloof from the right and the left'.[99] Hugh Stevens observes that 'Cornell's boxes give lost objects a home and a place to show themselves, just as New York played host to artists fleeing political instability';[100] the act of emigrating to New York had an unavoidable levelling effect on the displaced Europeans, who were simultaneously lost and greatly esteemed in the world's new cultural capital.

Peggy Guggenheim, recently married to Max Ernst, opened her extraordinary Art of This Century gallery on West 57th Street in October 1942. The gallery was designed in such a way as to dispense with traditional methods of displaying and framing pictures, and featured ropes, flashing lights, curved walls, and sound recordings in addition to the work that was displayed there, all with the aim of 'the eradication of the art-life divide'.[101] In 1943 she held the *Exhibition of Collage*, for which the first collages by Robert Motherwell, Jackson Pollock, and William Baziotes were specially commissioned, and which also showed work by Cornell, Picasso, Braque, Schwitters, Ernst, Ad Reinhardt, and David Hare. Pollock's collages, which have since been lost, were, according to Motherwell, made 'in a state of trance'; he recalls Pollock becoming 'more and more tense and vehement, as he tore up papers, pasted them down, even burned their edges, splashed paint over everything'.[102] Motherwell's own collages were swiftly, intuitively produced, prioritising their material qualities but filled nevertheless with a sense of unpredictability and transience, as he worked to manifest the 'sensation of physically operating on the world' that collage production induced in him.

Collage prospered in New York City over the following two and a half decades, with major artists including Motherwell, Pollock, Matisse, and Baziotes all using cut paper in their work. European and American influences tussled productively with one another. In early 1948 Kurt Schwitters exhibited at the Pinacotheca Gallery, whilst later in the year the Museum of Modern Art (MoMA) put on an exhibition simply entitled *Collage*, showing over one hundred works by European and American artists both new and established, dating back to the work of Picasso and Braque. The years 1949–1955 saw Willem de Kooning make his *Woman* series, Jasper Johns his *American Flag* paintings, and Robert Rauschenberg his *Black Paintings*, all of which featured the use of collage. Clement Greenberg,

[99] Guilbaut, 2.

[100] Hugh Stevens, 'Joseph Cornell's Dance to the Music of Time: History and Giving in the Ballet Constructions', in *Joseph Cornell: Opening the Box*, ed. Edwards and Taylor, 92.

[101] Taylor, 104.

[102] Motherwell, quoted in Wescher, 299–300.

Cubism's fiercest supporter, who accused most European and American collage post-1914 of being exploitative of the practice's 'shock value',[103] which he claimed was merely incidental anyway, praised Motherwell and Anne Ryan for their collage work. He also seems to have coached Pollock on 'the uses and abuses of collage'[104] between 1947 and 1949, resulting in a series of flat collage-paintings including *Out of the Web (Number 7)* (1949). Greenberg condemned the notion that 'the need of renewed contact with "reality"' had anything to do with Picasso and Braque's original use of collage. He was particularly scathing of Joan Miró's use of photographs in his collages (despite having previously championed Miró as the only true descendant of Cubism), arguing that they 'they fall down as works of art because they fail to convince one of their inherent necessity, sacrificing as they do the abstract formal order that belongs to pictorial art to the pursuit of emotion that belongs only to raw experience'.[105]

Greenberg asserts that Miró's photographic collages illustrate 'how little he understood the true aesthetic purpose of the new medium'.[106] However, his indictment of an artist's attempt to pursue emotion in his work is an indication of Greenberg's failure to understand, or take pleasure in, the direction that collage, particularly in New York, was increasingly taking. In a city filled with liberal intellectuals, émigré Europeans freshly departed from the horrors of the Second World War and the Spanish Civil War, and black communities progressively and overtly more involved with the Civil Rights Movement, art needed to be able to provide for such a backdrop: as Motherwell concluded, 'feelings must have a medium in order to function at all'.[107] Collage, in spite of what Greenberg drily insisted, was always at least partly about what was going on around the collagist, enabling the autobiographical impulse or the desire to act as the archivist of one's own life. As the twentieth century progressed, artists moved towards an increasingly corporeal involvement in art production. Often, emphasis was placed upon a personal – almost physical – immersion by the artist in the construction of a unique entity, as opposed to the creation of the next in a long academic line of works of art. The importance of collage in fostering this move should not be underestimated. Rauschenberg's polymorphic combine *Bed* (1955), made out of a quilt which was a gift to the artist from the painter Dorothea Rockburne, for instance, simultaneously suggests post-coital sheets and autoerotic yearnings, defying Greenberg's call for flatness in its capacity to initiate three-dimensional looking: *Bed* hangs vertically on the wall in MoMA, but, as with *Still Life with Chair Caning*, the viewer seems to look down at it from above, as well as peering into its three-dimensional space. Joseph Cornell wrote about the pleasure he felt in holding his boxes in his arms, and of the compulsion he felt to climb into them. In

103 Greenberg, 'Collage', 80.
104 Taylor, 109.
105 Greenberg, 'Collage', 70, and *Joan Miró* (New York: Arno, 1969 [1948]), 33.
106 Greenberg, *Joan Miró*, 33.
107 Motherwell, 'Beyond the Aesthetic', 38–9.

a diary entry from October 1950 he expressed the conflicting emotions that such a physical relationship with his artworks engendered, describing the sudden 'sense of completeness, poetry, and connection with life as opposed to the confining, esthetic feeling of limitation experienced too often in working with the boxes'. He also enunciated his 'intense longing to get into the boxes, this overflowing, a richness and poetry felt when working with the boxes but which has often been completely extraneous in the final product'.[108] With collage and related art, this notion extends naturally into the realm of the onlooker, inviting them in from their distanced position as passive viewer of an almost private canvas, to experience the impression of being in a place, of personal involvement in the tensions and conflicts of a creative cycle. It also extends to include the object or artwork itself, acknowledging both original and newfound contexts in order to create a functioning habitat in which mood and emotion may be reciprocally communicated.

New York City, as the setting for this extensive experimentation in collage, acted as a common denominator. The basic constituents of collage, since its inception rooted in the throwaway, in detritus, in scraps of torn paper, in found items, and in subverted advertising, were abundant in the urban mass culture of New York. The city, to quote Harriet Janis and Rudi Blesh, was itself 'pre-existent collage – an expanding image, vast in space and inexhaustible in variety'.[109] Furthermore, the emergence of an urban liberal rebellion which prized the richness to be found in poverty or debris, resisted the rise of cleanly, conservative consumerism, and made art out of whatever objects, views or ideas surrounded it, was a key contributing factor in the permanence of the transfer of collage from Europe to America. The 'hallucinatory power of the shop windows of the Passage de l'Opéra', described by Louis Aragon in *Le paysan de Paris* (1926),[110] transmuted seamlessly to New York. So too the exhilarating air of coincidence and chance that existed wherever there was a bustle of people and objects, where one might observe their flow, 'nourishing the meditation that [such a] place arouses, like no other, concerning the precarious fate of so many little human constructions', observed in Breton's *L'Amour fou*.[111] William C. Seitz, in his introduction to *The Art of Assemblage*, which accompanied the 1961 exhibition of the same name at MoMA in New York, observed that the fundamental premise

[108] 14 October 1950, Joseph Cornell papers, 1804–1986, bulk 1939–1972, Archives of American Art, Smithsonian Institution, Series 3, Box 6, fol. 7.

[109] Rudi Blesh and Harriet Janis, *Collage: Personalities, Concepts, Techniques* (New York: Chilton, 1962), 78.

[110] Martica Sawin, *Surrealism in Exile and the Beginning of the New York School* (Cambridge, MA: The MIT Press, 1997), 11. See Aragon, *Le paysan de Paris* (Paris: Nouvelle Revue Française, 1926), 108: 'Cette marchande de mouchoirs, ce petit sucrier que je vais vous décrire si vous n'êtes pas sages, ce sont des limites intérieures de moi-même, des vues idéales que j'ai de mes lois, de mes façons de penser, et je veux bien être pendu si ce passage est autre chose qu'une méthode pour m'affranchir de certaines contraintes, un moyen d'accéder au-delà de mes forces à un domaine encore interdit.'

[111] Breton, *Mad Love* (*L'Amour fou*), 28.

of collage, namely 'the placement, juxtaposition and removal of objects within the space immediately accessible to exploration by eye and hand is an activity with which every person's life is filled'. His work supports the view that collage is chiefly an urban art form: he argues that 'the cityscape gives striking evidence of the worldwide collision of moralities and panaceas, facts and propagandas, and sets in relief the countless images of contemporary life'. He also emphasises the significance of the 'multifarious fabric of the modern city – its random patchwork of slickness and deterioration, cold planning and liberating confusion, resplendent beauty and noxious squalor'.[112] These qualities, he suggests, are the fundamental components of a collage landscape, and, by their very nature, are available to any artist, regardless of their affiliations, style, or discipline. For Cornell, Burroughs, O'Hara, and Dylan the city existed in precisely this way. New York appealed to Burroughs's 'taste for the rascally and picaresque',[113] and to his desire to be a participant in the half-imagined comic-strip criminal underworld. His vision of New York near the beginning of *Naked Lunch* is typical:

> The Rube flips in the end, running through empty automats and subway stations, screaming: 'Come back, kid!! Come back!!' and follows his boy right into the East River, down through condoms and orange peels, mosaic of floating newspapers, down into the silent black ooze with gangsters in concrete, and pistols pounded flat to avoid the probing finger of prurient ballistics experts. (5)

His writing here epitomises the ostentatious collage that is *Naked Lunch*, and, in its imagery, the cut-up novels. It also signifies the importance for his writing of his simultaneous immersion in the criminal and writerly worlds of New York City as a relatively young man. The narrative action here segues into a fragmented, filmic cultural autopsy, as Burroughs cuts sharply away from the subway train where the protagonist is regaling a 'square' commuter with a lurid tale to the sordid visualisation in mosaic of the contents of the East River. For O'Hara the city was so much a part of his poetry that portrayals of it fragment and filter through his entire oeuvre: sometimes it was a character in its own right, addressed directly as in 'Steps' ('How funny you are today New York' [*CP*, 370]), whilst at other times it provided the flickering backdrop for a meditative afternoon walk as in poems such as 'A Step Away from Them' and 'The Day Lady Died'. Always, though, its solidity and simultaneous potential for refraction and for self-contemplation, manifested in the numerous fountains and glass windows that are the natural companions of twentieth-century skyscrapers, served to remind O'Hara that, as he writes in 'Walking':

[112] Seitz, *The Art of Assemblage* (New York: Museum of Modern Art, 1961), 9 and 73.
[113] James Campbell, 'Scenes from the Early Life of William Burroughs', *The Threepenny Review* 75 (Autumn 1998), 11.

```
          the country is no good for us
     there's nothing
          to bump into
               or fall apart glassily
     there's not enough
          poured concrete
               and brassy
     reflections
          ...
               New York
     greater than the Rocky Mountains. (CP, 476)
```

E.B. White observed that

> in the country there are a few chances of sudden rejuvenation – a shift in weather, perhaps, or something arriving in the mail. But in New York the chances are endless ... many persons are here from some excess of spirit (which caused them to break away from their small town).[114]

This applies equally to Cornell, Burroughs, O'Hara, and Dylan, none of whom were native to Manhattan. Consequently New York was, to quote Cornell, 'a feast of experience' in the flashing glimpses of graffiti, 'omnipresent pigeons',[115] and the inside of strangers' apartments seen from the carriages of the Third Avenue El, in snatches of song heard at the opera reaching out to worthless objects languishing in dime-stores, in scraps of newspaper littering the streets as in so many scenes from so many Hollywood movies, in 'faces bent over cards',[116] in patterns of light, and in the grey of the sky behind the roofs of tall buildings.

The link between collage and the urban is expounded upon by Fredric Jameson in his writing on the collages of Wyndham Lewis, in which he argues that 'the collage composition ... draws heavily and centrally on the warehouse of cultural and mass-cultural cliché – on the junk materials of industrial capitalism'.[117] It was in this kind of 'cultural junk',[118] which by its nature exists only in cities, that Cornell, Burroughs, O'Hara, and Dylan found inspiration. Bert M-P. Leefmans suggests that 'collage ... is an epitome of the preoccupations of its period', positing that it represents 'a way of finding the new – or the news – either in an idea or attitude or vision'.[119] For each, in addition to enabling them to discover the new, the expanding universe of collage provided the means for expressing and preserving

[114] White, 25.

[115] Diary Entry, 24 January 1947, Cornell papers, AAA, Series 3, Box 6, fol. 4.

[116] Charles Simic, *Dime-Store Alchemy: The Art of Joseph Cornell* (New York: New York Review Books, 1992), 26.

[117] Jameson, *Fables of Aggression: Wyndham Lewis, the Modernist as Fascist* (Berkeley: University of California Press, 1981), 73.

[118] Jameson, 80.

[119] Leefmans, 214.

the endlessly revelatory moments of urban juxtaposition which punctuated daily life, as well as an outlet for the urge to self-document. Collage thrived in New York partly because the city itself is a sort of collage, built on intersections and, thanks to its Atlantic-facing port and relative proximity to Europe, by immigrants. Of the eight million people living in New York in 1948, approximately two million were Jews, seven hundred thousand African American, two hundred and thirty thousand Puerto Rican, half a million Irish, half a million German, nine hundred thousand Russian, four hundred thousand Polish, one hundred and fifty thousand English, and twelve thousand Chinese. It was, and indeed still is, as White noted, 'literally a composite of tens of thousands of tiny neighbourhood units',[120] which had been trading on its intersections, juxtapositions, and overlaid edges for over a hundred years.

Furthermore, by its very nature collage represented great artistic possibility: in a sense it is a creative version of the American Dream. For Cornell, Burroughs, O'Hara, and Dylan, collage meant that the perfect combination of words or objects was always just beyond their fingertips – nascent, potentially, in their very next move. The challenge, therefore, which emerges from their work, is not necessarily to uncover the identity of its owner, but to learn to understand the language and the context in which the work in question speaks. The Barthesian notion of 'authorcide' is in operation, but is necessarily tempered. Although a collage is certainly 'a multidimensional space in which a variety of [elements] ... blend and clash ... a tissue of quotations drawn from the innumerable centres of culture'[121] dependent upon the imaginative exegesis of the viewer, it is also heavily dependent on the artist's action of choice, which, in the act of ranging over the collage in question, the viewer cannot afford to ignore. And whilst it is true, as Jean-Jacques Thomas has observed, that with regard to collage production, 'choosing [became] the decisive creative act',[122] it is also important to assert the essentially diacritical nature of collage, as Rosalind Krauss does, whereby 'meaning is never an absolute, but rather a choice from a set of possibilities, with meaning determined by the very terms *not* chosen'.[123] This being the case, the viewer is forced to return to the context from which the elements of the collage have been torn, 'the context that had provided [them] with function and meaning'.[124] In order to understand the language of collage, the viewer must also understand the context in which, and indeed out of which, it has been created. For whilst the collage itself may not be, as Barthes writes, 'tyrannically centred on the author, his person, his life, his tastes,

[120] White, 34.

[121] Roland Barthes, 'The Death of the Author', in *Image, Music, Text*, trans. Stephen Heath (London: Fontana, 1977), 146.

[122] Jean-Jacques Thomas, 'Collage/Space/Montage', in *Collage*, ed. Plottel, 81.

[123] Krauss, 16.

[124] Renée Riese Hubert, 'Pattern and Paradox in Joseph Cornell's Art', in *Collage*, ed. Plottel, 167.

his passions',[125] it has necessarily been literally crafted out of elements that make up his life, his tastes, and his passions, out of what David Antin refers to as 'the chaotic collage landscape of human experience'.[126]

'The catalysing role of the found object'

We can see, then, the resonances that Picasso and Braque's act of provocation had, not just for Cubism, but for art, literature, and music across Europe and America. Several decades after the two artists first began pasting paper onto their canvases, a young poet, a sophomoric novelist, a would-be artist, and a fledgling musician, living in New York City in an overlapping period of four decades, successfully appropriated the techniques of collage for their own creative ends. Although individual studies have noted the significance of collage in the work of each, attention to the subject has largely been cursory or insufficiently inquiring. Furthermore, a conjunctive exploration, as this book will endeavour to carry out, reveals far more not just about the working methods of each, but also about the wider nature of creativity and culture in New York City in the mid-twentieth century.

Starting with Clement Greenberg, the collage practice has, on the whole, received a fair amount of critical attention. The first comprehensive study of collage, W.C. Seitz's excellent companion to the exhibition *The Art of Assemblage* (1961), was also one of the most important. It was followed seven years later by Herta Wescher's sumptuous 1968 volume, *Collage*, containing almost four hundred illustrations and devoting a chapter to each major movement associated with collage art, including Cubism, Futurism, Surrealism, Constructivism, and Dada, in addition to succinctly considering pre-twentieth-century collagists and their importance, or lack thereof. Harriet Janis, Eddie Wolfram, Diane Waldman, Christine Poggi, Brandon Taylor, and John and Joan Digby have also written lively and intelligent comprehensive guides to collage, of which Poggi and Taylor's are of standout value. Poggi's *In Defiance of Painting: Cubism, Futurism and the Invention of Collage* (1992) expertly and refreshingly reconsiders the work of Picasso, Braque, and Gris, exploring the culture of commodities and collage in the public sphere, as well as the interrelationships between poetry and the plastic arts in the context of modernism. Poggi limits her discussion to Cubism and Futurism, however, whereas Brandon Taylor's monograph *Collage: The Making of Modern Art* (2006) covers the subject from Picasso to post-modernist collage with commendable thoroughness, traversing Europe and America, and carrying out his claim to negotiate 'the fine line between understanding collage fragments as "flat, coloured, pictorial shapes" … and taking a more anthropological interest in the category of the discarded, the unwanted, the overlooked, as marks of modernity'.[127]

[125] Barthes, 'The Death of the Author', 143.
[126] Antin, 106.
[127] Taylor, 8.

However, although he mentions the irony 'in the fact that at the very historical moment when avant-garde writing was learning to mimic the collage techniques of the visual arts, the visual arts themselves would now abandon those techniques as no longer up-to-date',[128] he explores collage in literature only very briefly – tantalisingly, in fact. Jeanine Parisier Plottel and Katherine Hoffman have both edited collaborative volumes of essays on the subject of collage, which come closer to approaching the practice from a broader and more interdisciplinary viewpoint. Plottel's *Collage* (1983) features work by Marjorie Perloff, Mary Ann Caws, David Rosand, and Tom Conley, with essay topics including collage in Virginia Woolf's writing; visible language in poetry and painting; music and collage; collage and the dramatization of the problem of selfhood; and even collage aesthetics and the first principles of thermodynamics and molecular biology. Hoffman's *Collage: Critical Views* (1989) comprises essays by well-known contemporary critics of collage (Greenberg, Seitz, Harold Rosenberg, and Meyer Schapiro) as well as work by Robin Lydenberg on collage and desire, Charlotte Stokes on collage and Freud, and Wendy Holmes on signs and surfaces.

These Fragments I Have Shored: Collage and Montage in Early Modernist Poetry (1984), by Andrew Clearfield, is important for my work in the sense that Clearfield sets a convincing precedent for describing poetry with radical narrative and semantic discontinuities, such as that of Eliot and Pound, as collage. The idea of verbal collage, except in its literal, and therefore provable, mode of cut-and-pasted blocks of text, tends to be problematic for some critics, who find the distinction between imagism and collage too ambiguous. However Clearfield's alignment of the Modernist crisis of influence and representation with that experienced concurrently amongst plastic artists, and his recognition of collage's capacity as a conceptual mechanism conceived 'to disorient the beholder and to create new worlds of the artist's own making',[129] goes a long way toward validating the existence of collage methods in literature. Thomas Brockelman's rather theoretical *The Frame and the Mirror: On Collage and the Post Modern* (2001) remains unique in situating collage in the postmodern world, using the medium to reinterpret modernity through a philosophical approach to the problem of representation. Several works provide important insights into collage in the context of larger projects, most notably Daniel Belgrad's *The Culture of Spontaneity: Improvisation and the Arts in Postwar America* (1998), Anne Wagner's *Three Artists (Three Women): Modernism and the Art of Hesse, Krasner and O'Keefe* (1996), and Pierre Joris's *A Nomad Poetics* (2003). Important articles on the subject include David Banash's 'From Advertising to the Avant-Garde: Re-thinking the Invention of Collage' (2004) which makes the important argument that collage was rooted in the advent of mass media, with the result that 'the very genealogy of collage brings with it not only critical possibilities and formal innovations, but also the problems that animate consumer culture as a whole: reification and alienation in the face of the

[128] Taylor, 175.
[129] Clearfield, 11.

commodities and ideologies of consumer capitalism'.[130] Rosalind Krauss's essay, 'In the Name of Picasso' (1981), which I have already discussed, is a key work on the study of collage art, as is David Antin's 'Modernism and Postmodernism: Approaching the Present in American Poetry' (1972), which is relatively rare in its approach to collage as a recognisable characteristic in the work of several poets, including Charles Baudelaire, Robert Lowell, and Frank O'Hara.

Collage in the work of Cornell, Burroughs, O'Hara, and Dylan has been explored to a limited extent. The problem with almost all scholarship in this area is that, whilst it is often illuminating in its own right, it generally fails to establish the intrinsic connection between the work in question and the evolution of collage as a key twentieth-century practice. Considering collage in isolation in this way limits the reader or viewer's ability to understand its relevance, and, instead of illustrating its structural significance, risks side-lining the artist or writer's use of it as an interesting but largely incidental feature of the work of art or text. Usages of collage, as I will show throughout this book, should not be considered in isolation, but, rather, within the wider collage context of twentieth-century art and literature.

Cornell's use of collage, being the most obvious, has received the most critical attention. Lavish, detailed monographs such as Jodi Hauptman's *Joseph Cornell: Stargazing in the Cinema* (1999) and Lynda Roscoe Hartigan's *Joseph Cornell: Navigating the Imagination* (2007) have explored collage in the wider context of his boxed constructions. This approach, which tends to view his collages as interesting but peripheral to his body of work, seems to be a prevailing trend in Cornell scholarship, with Ronald Feigen, Howard Hussey, and Donald Windham's *Joseph Cornell: Collages 1931–1972* (1978) currently the only work to deal exclusively with his collages.

Robin Lydenberg's excellent *Word Cultures: Radical Theory and Practice in William S. Burroughs' Fiction* (1987) remains the standout text regarding Burroughs's cut-up novels. Lydenberg's exhaustive, highly theoretical scholarship successfully exposes the fundamental flaw in denigrating texts as 'lacking in artistic merit because they are lacking in moral purpose'; rejecting the notion of Burroughs as moral arbiter, she instead considers the role of the word as an independent textual object, makes note of the significance of early twentieth-century European art for Burroughs, and explores his use of aggressive mosaic, negative spaces, and textual hiatus in his quest for the 'destruction of the symbolic order'.[131] However, the link between the collage practice and the cut-ups remains implicit rather than explicit in her work – it is certainly noted as significant, but it is rarely elaborated upon directly. Surprisingly, this is the case with much Burroughs scholarship: although almost all critics – most notably Oliver Harris (whose work on Burroughs is second to none), David Banash, and Barry Miles –

[130] Banash, 'From Advertising to the Avant-Garde: Re-thinking the Invention of Collage', *Postmodern Culture* 14, no. 2 (2004): paragraph 5 (electronic journal).

[131] Lydenberg, *Word Cultures: Radical Theory and Practice in William S. Burroughs' Fiction* (Chicago: University of Illinois Press, 1987), 9 and 18.

acknowledge its importance to Burroughs, few have attempted any sustained analysis of collage in relation to his work, or of his work in relation to earlier uses of the practice. This is perhaps because the works to which it most pertains are also his most challenging and least reader-friendly, but it is also because of Burroughs's distracting designation of his own particular collage method as something other than collage, which serves to subordinate the collage practice in the context of his work to the sub-category of his own devising: the cut-ups. Notwithstanding, his cut-ups are clearly a form of collage, as is *Naked Lunch*, and also, as Harris has recently shown, his first three texts – *Junky*, *Queer*, and *The Yage Letters*.

Collage in the work of O'Hara has been noted to a greater or lesser degree by David Lehman, Charles Molesworth, Russell Ferguson, and Mutlu Konuk Blasing, as well as, more recently, by Geoff Ward, Lytle Shaw, Daniel Kane, and Nick Selby in Robert Hampson and Will Montgomery's comprehensive collection of essays, *Frank O'Hara Now: New Essays on the New York Poet* (2010). None, however, have devoted themselves solely to the subject, with the most substantial pieces of work on collage and O'Hara generally tending to discuss his work as a collaborative artist rather than as a poet, or as a poet influenced by art; as with Burroughs, the word 'collage' tends to feature with relative regularity in the study of O'Hara's work but with little exegetical depth to accompany it. Interestingly, the best work on O'Hara, such as Lytle Shaw's *Frank O'Hara: The Poetics of Coterie* (2006), Andrew Epstein's *Beautiful Enemies* (2006), and Hampson and Montgomery's collection, is that which avoids the tendency to hero-worship him,[132] and which figures instead the notion of O'Hara as part of a collective or coterie, 'taking in everything / like boarders',[133] to quote John Ashbery, fitting together numerous fragments of people and ideas, and exploring the openness of his own texts to the presence of others.

Dylan's work is not often considered directly within the context of collage – largely, I would suggest, on account of the wide divergence in views of Dylan's fans, critics, and scholars regarding his influences, style, and methodology, but also because his most overtly collaged work – *Tarantula* – was not a success. Michael Gray, in *Song and Dance Man III* (1999) posits the suggestion that the kind of collage evident in Dylan's lyrics – notably in his subversion of linear time and narrative chronology – is simply characteristic of folk music more generally; he also suggests that the compositional and performative techniques which are often held up as literary are in fact reflections of the folk music traditions in which Dylan developed. But whilst Dylan may have developed in the folk tradition, he is by no means confined to or by it. As Christopher Ricks demonstrates throughout *Bob Dylan's Visions of Sin* (2003) and as Aidan Day shows in *Jokerman* (1989) it can be very rewarding to locate him as a poet working within a highly literary tradition. Stephen Scobie, in *Alias Bob Dylan* (1991), as well as Ricks, has written

[132] Jim Elledge (*Frank O'Hara: To Be True to a City* [1990]) and Marjorie Perloff (*Frank O'Hara: Poet Among Painters* [1977]) are both guilty of this tendency.

[133] John Ashbery, 'Houseboat Days', in *Houseboat Days* (Penguin, 1979), 38.

about Dylan's use of allusion, which is fairly closely related to collage. A good deal has also been said regarding his songs and paintings in relation to the murky but compelling waters of plagiarism, particularly during the last decade, in which he has on several occasions either admitted to, been accused of, or discovered to have been borrowing material from a range of uncredited sources, including the American Confederate poet Henry Timrod, the Japanese writer Junichi Saga, and the photosharing website Flickr. The drama of Dylan's fragmented persona and the past that he collaged for himself out of a range of facts and fantasies is also, to borrow from John Hughes, 'so prevalent as to constitute one of the most dominant clichés around'.[134]

A fairly substantial amount of scholarship, then, has been devoted to the study of collage in the twentieth century. However, whilst the documentation of collage's role in the history of art has been considerable, treatment of it as an interdisciplinary phenomenon has been scant and fragmentary. The role of collage in prose, poetry, and song lyrics remains relatively underexplored, an inconsistency I hope this book will go some way towards ameliorating. Collage revolutionised the way art is made, and as a result had a significant impact on other disciplines. No one, however, has yet attempted a cross-disciplinary study of collage. My study of Cornell, Burroughs, O'Hara, and Dylan offers a cross-section of the workings of collage across the disciplines, showing that an understanding of the medium's history, theory, and practice leads to numerous new analytical possibilities, and is in many instances fundamental to the processes of interpretation. Although, in essence, Cornell, Burroughs, O'Hara, and Dylan meet each other fortuitously in this book, 'like a chance encounter on a dissecting table between a sewing-machine and an umbrella',[135] anecdotal links between all four do exist, moving as they did in similar circles during intersecting periods. Burroughs, O'Hara, and Dylan had mutual friends in Allen Ginsberg and Lawrence Ferlinghetti; Dylan was linked to Burroughs through his friendship with Ginsberg, and met him in 1965; Cornell and Burroughs had mutual friends in Charles Henri Ford and Parker Tyler; and Cornell and O'Hara had mutual associates and acquaintances at the Museum of Modern Art. Burroughs recalled meeting Dylan in Greenwich Village in 1965, following which he wryly observed that Dylan struck him as being someone 'competent in his subject'.[136] Burroughs also noted the death of O'Hara rather misanthropically in a letter to Brion Gysin, in which he wrote:

> News flashes: Conrad Knickerbocker who did the *Paris Review* interview committed suicide two weeks ago. On the credit side of the ledger Frank O'Hara

[134] Hughes, *Invisible Now: Bob Dylan in the 1960s* (Burlington, VT: Ashgate, 2013), 4.

[135] Lautréamont, *Les Chants de Maldoror*, 217.

[136] http://expectingrain.com/dok/who/b/burroughswilliam.html [Accessed 8 May 2013].

was hit and killed by car and Delmore Schwartz (old enemy from *Partisan Review, New Yorker, Encounter*) died of heart attack.[137]

O'Hara wrote a typographically box-shaped poem entitled 'Joseph Cornell', as well as a very favourable review of Cornell's work for *Artnews*, in which he declared Cornell a genius.[138] Cornell subsequently invited O'Hara to meet him at his house in Flushing so that he could give him a box as a present, but on the arranged day, a Saturday in 1955, O'Hara 'didn't feel up to taking a subway to Queens', according to Joe LeSueur, so the two kindred spirits never met.[139] Interesting as they are, however, to labour these connections, or missed connections, too much, would only be distracting. My intention is to emphasise the *different* ways in which collage was used by different artists in overlapping periods and with links to the same geographical location: they are not, on the whole, linked through similarities of technique, as will be made clear, and it is often the differences between them that cast their individual uses of collage in the most revelatory light. Art exists in creating new patterns, and so too, arguably, does criticism. It is on account of their differences that I am considering them in conjunction with one another, in order to clearly illustrate the power and variety of the collage practice, and to explore the suitability of New York City for such a practice to thrive. Where they are similar, however, is in the role collage plays as a crucial catalyst for their work, and as a physical and conceptual response to crisis: none of the four can be considered exclusively collage artists, and yet the practice permeates and inflects their bodies of work, and, I will suggest, actually facilitated some of their most prominent creations. I wish to insert Cornell, Burroughs, O'Hara, and Dylan into the history of collage, and to use the practice as a lens through which to evoke them and appreciate their work in new ways.

Chapter 1 approaches Joseph Cornell's unique and central relationship with his habitat, New York, as well as exploring his problematic dialogue with the Surrealist movement. My focus is largely Cornell's collages, rather than his boxes, not just for the reason that they remain relatively underexplored, but because they can be viewed throughout his career as performing the role of narrator, framing his life's work – introducing, explicating, justifying, supporting, and ultimately concluding it. However I also emphasise that his box constructions are themselves best understood as three-dimensional collages, predicated on a novel approach to the medium's concepts and physical practices. I approach Cornell's work from a critical stance that takes into account the anthropological significance of

 [137] Burroughs to Brion Gysin, 1 August 1966, William S. Burroughs Papers, The Henry W. and Albert A. Berg Collection of English and American Literature, The New York Public Library, Series III, Box 85, fol. 12.

 [138] O'Hara, 'Reviews and Previews: Joseph Cornell and Landes Lewitin', *Artnews* 54, no. 5 (September 1955): 50.

 [139] LeSueur, *Digressions on Some Poems by Frank O'Hara* (New York: Farrar, Straus & Giroux, 2004), 86.

his habitat, tracing the multiple threads of urban, religious, cinematic, familial, Symbolist, and Surrealist influence, and exploring the tensions between them.

My second chapter proposes a new approach to Burroughs's writing (including his correspondence) from *Junky* (1953) to *The Nova Trilogy* (1961–1964), informed by the history, techniques, and principles of collage. I explore the nauseated critical response to the fragmented compositional nightmare of his writing during the 1950s and early 1960s, and suggest that in order to combat the emetic effects of his work, Burroughs's seemingly impenetrable cut-up novels should be understood as a series of artworks in their own right, consisting of found objects, assemblages, and simulated and actual collages, rather than an elusive verbal code which, in spite of the reader's best efforts, remains dauntingly scrambled. In my consideration of collage and the evolution of Burroughs's writing, I examine the role of his letter-writing habits in the formation of the collage structure of *Naked Lunch*, thematic notions of cutting and surgery in his work, and the role of collage architecture in liberating him from the perceived tyranny of the written and spoken word.

Chapter 3 accounts for the ways in which O'Hara's early Surrealist experiments in poetry inflect his later writing and portrayals of New York, tracing his poetic journey from his long poems – 'Second Avenue', 'Easter', and 'Hatred' – to his 'I do this, I do that' poems. I argue that O'Hara's use of collage is part of his larger poetic exploration of the nature of self-definition in his increasingly materialistic environment, and suggest that many of his most-anthologized works would not have been possible without his collage experiments. I also consider the dialogue with materiality, facilitated by collage, that permeates his work and is crucial in shaping the reader's understanding of his shifting personae, his coterie, his relationships with other artists, and his city, showing as I do so that collage for O'Hara was primarily a conceptual method for ensuring that his poetry was experienced, rather than interpreted, by his readers.

My final chapter considers collage techniques in relation to Bob Dylan's songwriting during the 1960s and 1970s. Dylan's formative years as a songwriter were spent in the company of musicians, writers, and artists for whom collage was widely accepted as a key creative process. As a result, he understood it as a practice, and experimented with using it in his lyrics, liner notes, and prose, as well as drawing on it in interviews and performances. I will suggest that although Dylan found that it was not always possible to use collage directly in the construction of the verbal elements of his songs, it is nevertheless important and illuminating to consider his work within the context of collage, taking into consideration its influence on his compositional methods, his desire to create what he called 'a collage of experience'[140] for his listeners, and his attempt to write a collage novel. Dylan's use of collage is also related to that of Cornell, Burroughs, and O'Hara, particularly in terms of corresponding portrayals and explorations of dynamic, shifting, or splintered self-hoods.

[140] Dylan, interviewed by Robbins (see Artur, 114).

My book concludes by reiterating Pierre Joris's key assertion that 'there isn't a 20th century art that was not touched, rethought or merely revamped by the use of [collage]'.[141] I highlight in brief several other figures who also worked in collage or the collage-esque both during and after this period and who had close links with New York City, most notably Allen Ginsberg, John Ashbery, and Joe Brainard, suggesting that their work in particular warrants further study within my framework. In defence of my impressionistic critical style, I invoke the words of Frank O'Hara, who said, in 'Personism': 'you have to take your chances and try to avoid being logical'. My book demands a conceptual attitude toward art and literature that values multiplicity and subjectivity. My linking of Cornell, Burroughs, O'Hara, and Dylan was initially based on fortuity, and the writing of this book was, to a degree, a self-reflexive exercise, embodying the collage form it discusses. By assessing Cornell, Burroughs, O'Hara, and Dylan within the disjunctive context of twentieth-century collage, and considering each as bricoleur of words or objects, my study opens up new avenues of possibility through which their work might be experienced, as well as interpreted, and, regarding our position as reader or viewer in relation to their work, 'yield[s] us a new thought'.[142]

[141] Joris, 'Collage and Post-Collage: In Honour of Eric Mottram', (1997) in *A Nomad Poetics* (Middletown, CT: Wesleyan University Press, 2003), 86.

[142] Ralph Waldo Emerson, 'The Poet', in *Essays and Lectures* (New York: Library of America, 1983), 463.

Chapter 1
Habitat New York:
Joseph Cornell's 'imaginative universe'[1]

'Wonderful, irrational discovery': Cornell, Collage, and the World of Art

Beneath Joseph Cornell's rather staid little Dutch house in Flushing, New York, lay his factory, filled with parts waiting to be assembled – with worlds, unconstructed. Plastic shells, watch parts, springs, white pipes, owl cut-outs, glass cubes, magazine articles, sheet music, ticket stubs, old books, photographs, and coins were amongst the countless articles that lingered, portioned off according to type but nevertheless haphazardly, in the pregnant dark of his basement. In some senses it was a dream factory, not so very far removed from Roald Dahl's BFG's cave, its shelves lined with the captive dreams that he would spend a lifetime bestowing in the form of strange gifts upon children and the childlike. His mother's kitchen, which she shared, rather begrudgingly, with her artist son, doubled as a sort of operating theatre in reverse, on whose dissecting table these sovereign parts – objects, images, films – were not so much cut apart as lovingly cut together, by a nocturnal architect-cum-switchboard-operator speaking 'his *open sesame* ... to a vast and total other dimension'.[2]

This chapter will suggest that the city of New York, in which Cornell lived for his entire life, was the fundamental component of his life's work, and assert that it was the practice of collage that enabled him to carry it out. Broadly, it will consider his relationship with the city in which he lived, examining his dialogue with the European avant-garde within that context, and assessing the problems that occur when his work is too closely associated with the Surrealist movement in particular. Beginning by exploring why Cornell used collage, and considering his discovery of it in the light of the artistic apprenticeship he received from the streets of New York, I will argue for an anthropological as well as a literary and art historical approach to his work. The special reciprocal link that collage provides between habitat, artist, and work of art will be demonstrated by an examination of Cornell's childhood, his aesthetic tastes and his love of the city. Following on from this, the significance of his discovery of Max Ernst's collage novel, *La femme 100 têtes*, at the Julien Levy Gallery in Manhattan, will be posited, as I introduce the problem of comparing Cornell's work too closely with Surrealism. Looking in

[1] Clifford Geertz, *The Interpretation of Cultures* (London: Fontana, 1993), 5.

[2] Howard Hussey, 'Collaging the Moment', in *Joseph Cornell: Collages 1931–1972*, ed. Ronald Feigen, Howard Hussey and Donald Windham (New York: Castelli Feigen Corcoran, 1978), 24.

detail at Cornell's first collages, I will assess his faux-nostalgia for a Europe that existed primarily in his imagination, considering whether his recreation of fleeing images and intersecting glimpses are in fact more Symbolist than Surrealist. Establishing Cornell's eclectic, selective approach to European art and conducting a sustained comparison of his collages with some by Ernst, I will explore Cornell's ability to raise the Surrealist formula above its own standards, enabled by his unique vision of the world. The comparison with Ernst will subsequently lead into an exploration of representations of childhood in Cornell's work. Finally, I will discuss the sense of privacy and shared confidence in Cornell's body of work, compared with the politics and violence of the European avant-garde, taking into consideration his use of dolls and images of women, his physical manifestations of thought, his creation of fragmentary visual narratives, and his lifelong compulsion for sharing, bartering, and passing things on. Whilst my chief focus will be on Cornell's two-dimensional paper collages, it is important to note, as I mentioned in my introduction, that his boxed constructions are also best viewed as three-dimensional collages, which emerged naturally as an extension of his early work in paper. Collage was Cornell's first love and key artistic tool; it enabled him to energetically reframe the frustrations of his working and domestic life in a positive light, and to narrate the story of his life in New York City in unique and uncompromising terms.

Cornell began to make art in 1931, something of an artistic greenhorn at the age of twenty-seven, having spent a decade working in the cloth-cutting industry, peddling fabric samples on the 'the "nightmare alley" of lower Broadway'.[3] He was in some ways like a latter-day version of the woodcutter Ali Baba, transported from the forests of Persia to the concrete jungles of New York City, where he was forced to earn a frustrated, alienated living out of a valuable commodity in order to support his fatherless family. It was here, in Manhattan, that he first made his 'wonderful, irrational discovery'[4] of collage, the *open sesame* exported from Europe in the minds and travelling cases of a throng of artists and writers, which was for him the password to that cave of treasures, the art world, revealing it to him, and granting him access, without ever requiring that he learn how to draw or paint.

Despite his lack of formal training, Cornell was able to accommodate himself very successfully within the context of twentieth-century art by making use of this exported practice; in fact, it was typical of him to use it, it being in a sense the very first scavenged, recycled, or found idea in the long line of many that would make up his career. By the time Cornell happened upon collage, in the backroom of an art gallery on Madison Avenue in 1931, it had become a prevailing artistic

[3] Deborah Solomon, *Utopia Parkway: The Life and Work of Joseph Cornell* (London: Pimlico, 1998), 33. Unlike Man Ray and Sonia Delaunay-Terk, two other successful collage artists who had realised their first abstract compositions 'with the aid of cloth swatches from a tailor's sample book' (Wescher, 124), Cornell appears to have found his initial profession deeply uninspiring and not conducive to creativity.

[4] Julien Levy, *Memoir of an Art Gallery* (New York: G. Putnam's Sons, 1977), 77.

mode, and was continuing to be instrumental in promoting the role of the artist not just as painter but also as storyteller, architect, and thinker, advocating the associative processes of art construction over and above traditional estimations of painterly talent and finished products. From the angled vernacular of Cubist art to the frenetic vortexes of the Futurists and the seductive, sadomasochistic dreamscapes of Surrealism, collage encouraged experimentation and the idea of unlimited possibility. It also emphasised the value of the working process, meaning that Cornell, who had not so much as picked up a paintbrush since high school, was able, with relative ease, to align himself with the European artists in whose company he soon found himself. The only artistic apprenticeship he received took place as he traversed the streets of New York City, delivering cloth samples and simultaneously crafting in his head a 'collage of things seen'.[5] The art of collecting is fundamental to the collage practice. Both mentally and literally, Cornell scrapbooked pieces of the city – 'NY ephemera',[6] as he put it – from Victorian ornaments found in thrift shops to the girls he saw in theatre box offices, finding, as Deborah Solomon notes in her biography, 'connections where others saw only fragments'.[7] For Cornell, as for Frank O'Hara, writing over thirty years later, New York was a 'jungle of impossible eagerness' (*CP*, 326), overflowing with possibilities for collecting and constructing art.

John Ashbery, in 1989, observed that Cornell was 'almost universally recognized by artists and critics of every persuasion – a unique event amid the turmoil and squabbles of the New York art world'.[8] His remark sustains the views of Solomon, who notes that 'artists who agreed on little else agreed on Cornell', and Brian O'Doherty, who reflects that Cornell was 'one of those rare artists whose universe is ... so imaginatively authoritative that it corrects the narrow views we accept without question from the official "art scene" itself'.[9] O'Doherty correctly attributes much of Cornell's ability to appeal to and inspire other artists to his vast aesthetic 'range of territory' and 'the fact that his art includes all the others'. His identification of the lynchpin of Cornell's oeuvre as being 'the most mundane grounding in present experience' highlights the profound and wide-ranging significance of the habitat out of which he worked, both in terms of his own inspiration and, subsequently, in inspiring others. To borrow from Jed Perl, Cornell 'gave esotericism a contemporaneity by suggesting that these were the thoughts that might come to any twentieth-century man as he ambled the streets of a democratic city and gathered curious images and bits of information'.[10]

[5] Cornell, journal, November 1955, Cornell papers, AAA, Series 3, Box 6, fol. 46.

[6] Cornell, journal, February 1949 (scrawled on the back of torn poster for the Egan Gallery), Cornell Papers, AAA, Series 3, Box 6, fol. 6.

[7] Solomon, 91.

[8] John Ashbery, *Reported Sightings*, ed. David Bergman (New York: Knopf, 1989), 14.

[9] Solomon, 373; Brian O'Doherty, *The Voice and the Myth: American Masters* (London and New York: Thames & Hudson, 1988), 257.

[10] Jed Perl, *New Art City* (New York: Alfred A. Knopf, 2005), 304.

Certainly Cornell was particularly influenced by Surrealism, but, over the four decades in which he made art, the 'present experience' through which he lived was necessarily shaped to a great degree by the art world of New York City, which naturally included the Surrealist movement, but also comprised the precedents set by the French Symbolists and American Realists, by the Transcendentalists, by the city's rival affections for Cubism and Futurism, by the not-quite-credible Neo-Romanticists, and by the rising stars of Abstract Expressionism in the late 1940s and 1950s, and Pop Art in the 1960s. It is possible to distinguish traces of all these in Cornell's body of work, without feeling that any ever seek to govern an artwork outright (in the distinctly Cubist collage backdrop to the 1953–1954 piece *A Parrot for Juan Gris*, made up of pasted newsprint, for instance, or in the notably abstract *Blue Sand Box*, from 1950). The links between these movements and Cornell's work is, rather, one that he cultivated himself; one discerns discrete lines of communication with individuals he admired rather than wholesale deference to any particular school or manifesto. Cornell has often been incorrectly labelled a recluse, but in fact he never shut himself off from the world, manifesting a lifelong alertness to the currents and vicissitudes of his habitat and surroundings. The enigmatic qualities of his work, of which he himself is often the deconstructed subject, have resulted in varying critical perceptions of what he was like as a person: was he reclusive, damaged, obsessed with the past, Surrealist, childlike, prematurely aged, or sexually odd? It is interesting that his work generates this kind of response (and certainly all of these traits can be discerned in his work), but too often critics have felt the need to choose between them, or to characterise him according to their own expectations, rather than critiquing him using the collage principles that he himself fostered and disseminated, and allowing him to be represented as a combination of many character traits, influences, and experiences.

A photographic collage portrait, created between 1933 and 1934, is emblematic of Cornell's approach to each of the art movements with which he was surrounded, and with which he has since been associated, to a greater or lesser degree. The collage photograph (Figure 1.1), taken by the young photographer Lee Miller, features Cornell's face as the outsized figurehead of a model sailing boat, with a long skein of blonde hair floating strikingly behind it against a dark background. It is an illustration of the type of artistic synthesis for which Cornell strove, embodying vessel and androgynous voyager as a unified entity in a shadowy setting, and demonstrating, as Dickran Tashjian notes, Cornell's 'affinities with the androgynous imagery that existed on the margins of the Surrealist group among women artists disaffected by its male domination and often violent if not misogynous images of women'.[11] The creative exchanges that Cornell had with women on the fringes of Surrealism, such as Miller, the painter Leonor Fini, and the painter, writer, and set-designer Dorothea Tanning, 'offered lessons of autonomy: Miller, by breaking with Man Ray and forging her own career as a photographer;

[11] Dickran Tashjian, *Joseph Cornell: Gifts of Desire* (Miami Beach: Grassfield Press, 1992), 43–4.

Fig. 1.1 Lee Miller. *Joseph Cornell, New York Studio*, 1933. Black and white photograph. © Lee Miller Archives, England 2013. All rights reserved. www.leemiller.co.uk.

Fini, by refusing to join the Surrealist movement in the first place; and Tanning, perhaps most of all, by striving for her own artistic authenticity'.[12] Cornell learned a great deal from these women and from others, including the ballerina Tamara Toumanova and, later, the writer Susan Sontag, all of whom reinforced his sense of the importance of unfailing artistic experimentation and the need to push or even disregard boundaries, rather than allowing oneself to fall easily within one identity category or another, either socially or creatively. This is also, of course, one of the principle lessons of collage: the continuous cross-pollination of discrete fragments results in striking singularity of product and infinite aesthetic possibilities that simultaneously allow and deny creative autonomy.

It is important, then, to temper a specifically art historical or literary critical approach to Cornell's work with a more anthropological methodology, prioritising the strong attachment that he felt to his life in New York City, and the importance of this in establishing him as a credible artistic figure. The anthropologist Clifford Geertz's discussion, in *The Interpretation of Cultures*, of his method of employing a literary analytical approach when studying the culture of a people, indirectly points to the significance of doing this in reverse. If we are to start with a study of

[12] Tashjian, 61.

the artist in his habitat, and work thereon from the bottom up, rather than zooming slowly in along the lofty but possibly inaccurate trajectory of a given literary or artistic movement, our study of the subject is illuminated by the cultural ephemera which inevitably forms a substantial part of our analysis. Geertz argues that 'man is an animal suspended in webs of significance he himself has spun', and concludes that the study of culture, which he takes to be these webs, is 'therefore not an experimental science in search of law but an interpretive one in search of meaning'. He reasons that as with the study of literature, a greater understanding of the 'imaginative universe' of another can be reached by 'guessing at meanings, assessing the guesses, and drawing explanatory conclusions from the better guess', rather than seeking pedantically to discover 'the Continent of Meaning and mapping out its bodiless landscape'. Geertz contends that 'if you want to understand what a science is, you should look in the first instance not at its theories or its findings, and certainly not at what its apologists say about it; you should look at what the practitioners of it do'.[13]

These arguments are particularly relevant not only in assessing the relationship between Cornell and Surrealism, but in coming to terms with his life and work. If we look for 'laws' in Cornell's work, particularly the laws of the European avant-garde, we should also look for meaning in the wider 'webs of significance' which he himself spun, and, indeed, in which he lived. In entering his 'imaginative universe', we should allow ourselves to construct a shifting collage of guesses, based on the evidence of the primacy – and mystery – he assigned to his habitat. In order to understand the 'science' or 'laws' of Cornell's art, it is necessary to look again at what he actually does: he makes collage, both two-dimensionally and three-dimensionally, out of bric-a-brac found in the environment he inhabits. He defines himself by the objects he chooses. The arrangements he makes distinguish him and enable him not only to assert control over his universe, but to suggest ways of understanding it and narrating its story, and even of aestheticizing it; as Eliot (quoting Mallarmé), wrote, the poet can 'purify the dialect of the tribe'.[14] Cornell attempts, with his unique capacity for imaginative independence enhanced by his use of collage, to crystallise the fleeting instant of visionary creativity or of pure inspiration that he repeatedly found to germinate from a momentary experience, whether in an art gallery, on a street on a rainy day or on a crowded commuter train. Cornell's work may often look Surrealist, but to conclude that that is all it is, is to ignore the significance of his environment, which is, of course, how he came into contact with Surrealism in the first place. Not only was New York crucial in the establishment of Cornell as an artist *alongside* the Surrealists – in other words, as an artist with a biographical rather than an aesthetic connection to them – but it was, furthermore, the very fabric out of which Cornell created his artworks. His habitat was what mattered most to him, being both the source of and material for his expansive imagination, with Surrealism operating simply as a component part

[13] Geertz, 5, 13, 20, 5.

[14] T.S. Eliot, 'Little Gidding' II, *Four Quartets* (London: Faber, 1944).

of this environment. As Perl observes, 'in Cornell's New York, time and place flowed, reversed, overlapped. In his imagination, the city was transformed into an urban pastoral – a city that was both in time and out of time'.[15] This is why his work is so original (and so recognisably his), made up as it is from factors encountered in a way that he alone could encounter them. He used this privately associative 'harvest'[16] according to mood or whim, eclectically, regardless of artistic status: a famous collage by Picasso or Ernst ranked equally in his eyes with an old mustard jar found on the beach or an outdated map or item of jewellery found in a junk shop. All are equally important in the context of his art.

He produced no manifesto, and because he attached himself to no specific movement or school, or to all of them, there can be no exact science to the study of Joseph Cornell. Furthermore, as Robert Hughes observes, 'his work was so idiosyncratic that it made nonsense of its imitators, so that there could be no école de Cornell'.[17] The desire to link him too closely with Surrealism or any other school risks overlooking what he actually does, in favour of what the movement in question, and its proponents, might have to say about him. History may have identified him as an American Surrealist, but this is partly because he emerged into the art world at the same time that Surrealism itself began to be seriously taken note of by American culture. Ultimately, as O'Doherty insists, he is 'a figure large enough that history must inconvenience itself to rearrange its priorities'.[18] Adding an ethnographic angle to a critical approach, whereby Cornell's aesthetic behaviour can be attended to within its own context, 'according to the pattern of life by which it is informed', guards against the temptation to 'arrang[e] … abstracted entities into unified patterns',[19] and reveals his own particular voice within the biographical reality in which he was inevitably contained. Biography may strip the mystery from art,[20] and in the case of Cornell may offer itself up all too often in the form of a seductive psychoanalytic quagmire,[21] but in order that the figure in the carpet may be clearly discerned, and in order that the details of his constructions may be uncovered, it is necessary to situate the artist not within the hyper-real context of a particular art movement, but, instead, within the real spaces of the darkened movie houses, the tide of the New York streets, the crush at

[15] Perl, 290.

[16] Diary Entry, 28 March 1950, Cornell Papers, AAA, Series 3, Box 6, fol. 7.

[17] Hughes, *The Shock of the New*, 255.

[18] O'Doherty, 257.

[19] Geertz, 14, 17.

[20] See Cynthia Houng, 'Art Review: Joseph Cornell: Navigating the Imagination', *KQED Arts*, 5 November 2007, http://www.kqed.org/arts/visualarts/article.jsp?essid=20183 [Accessed 1 December 2009].

[21] For instance, both Jason Edwards ('Coming Out as a Cornellian', in *Joseph Cornell: Opening the Box*, ed. Edwards/Taylor, 25–44) and Wayne Koestenbaum (Review of *Caws, Joseph Cornell: Theater of the Mind*, in *Artforum/Bookforum* [Summer 1994], 2–3) discuss what they view to be Cornell's 'paedophilic' tendencies.

gallery openings, the microcosmic front room, basement and kitchen in Flushing, the backstage spaces at the New York City Ballet, and the carriages of the Third Avenue El as it thundered through unfolding lives in great, inelegant buildings. These places were where Cornell's inspiration originated, as well as providing his artistic apprenticeship. The conceptual articulation and interpretation of Cornell's life within these places enables the viewer of his work to converse directly with him (rather than with the things he looks like), to decipher his collage codes and learn to understand his language, to address the opacity in his art, and to clarify the increasingly ubiquitous role that collage came to play both in his life and in the artistic life of New York City. As far as his relationship with Surrealism is concerned, it can be viewed within the context of the metalanguage of collage. As I noted in my introduction, Rosalind Krauss argues that such a language

> can talk about space without employing it; it can figure the figure through the constant superimposition of grounds; it can speak in terms of light and shade through the subterfuge of a written text.[22]

When this theory is applied to Cornell's work, we can see that in its imagery, form, syntax, and visual rhyme, it evokes a sense of Surrealism which is never fully Surrealist, figuring the figures of artists (Max Ernst in particular), that are, in fact, never quite there. His work, like the aesthetic of collage, 'inaugurates a play of differences which is both about and sustained by an absent origin'.[23] Throughout Cornell's career, then, the Surrealist movement, in its influence, its perceived influence, and its non-influence, and in its aesthetic and its biographical authority, operates as this absent origin.

'The world in which he travelled': Real Worlds, Alternate Universes

Although Cornell made his first collage in 1931, both his upbringing and his own sensibilities had prepared him thoroughly for the practice's potentialities. His mother was a kindergarten teacher, well versed in the German educator Friedrich Froebel's advocacy of collage to inspire creativity and imaginative exploits in children. As was fairly customary for American children raised during the Progressive Era, Cornell would have received basic schooling from his mother in the visual arts and simple manual crafts, and amongst the books he owned as a child was *Warne's Picture Puzzle Album*, a Victorian-era prototypical collage handbook for children, which provided backdrops onto which images could be pasted. Cornell's father was a fabric designer by trade and a talented woodworker and singer in his free time, whose pockets were always filled with small presents for his children. Cornell's childhood, before his father died and he was sent to Phillips Academy in Andover, Massachusetts, was a happy one; born on Christmas

[22] Krauss, 19–20.
[23] Krauss, 20.

Eve, he was himself a sort of gift, and his earliest memories would have been of toys and presents, of the lights and music and magic of a child's favourite time of year. His parents frequently took him and his younger siblings into Manhattan, to watch vaudeville shows or the lights at Times Square, or down to Luna Park at Coney Island in Brooklyn, where he first encountered the penny arcades that would later have such a significant bearing on his work. His parents also acquainted him with children's stories and French literature as he was growing up, to which he remained attached as an adult. Consequently, he sought solace from the boisterous clamour of his reluctant Broadway sales pitches in amassing books and magazines from the second-hand shops on Fourth Avenue below Union Square, in the now vanished Book Row. In his aesthetic preferences he made no particular differentiation between high and popular culture, between Europe and America, or between past and present; although his taste for Victorian nostalgia is well documented, he simultaneously absorbed with equal earnestness the cheap melodrama of the silent film industry, the overblown emotion of the grand opera at the Metropolitan Opera House, and many of the great art exhibitions of the 1920s. He was equally thrilled and moved by catching a glimpse of a famous silent movie star in Flushing as he was by seeing such paintings as Henri Rousseau's *The Sleeping Gypsy* (1897), Georges Seurat's *Le cirque* (1891), and Picasso's *Mother and Child by the Sea* (1902). He also found exciting the technological developments heralded by the twentieth century. In his unqualified approval of the telephone, the aeroplane, the cinema, and the mass media, he anchored himself to and invested himself in, in spite of his strong nostalgic tendencies, a present and indeed a future, in which the inevitable conversation between popular culture and the production of art was beginning to take place, and in which he would play his own small but significant role. His keenness to understand and to engage with the innovative idioms of modernity enabled his relationship with his primarily urban environment to have both physical and intellectual qualities, operating as a functioning economy facilitating daily transactions between past, present, and future moments in the streets, theatres, art galleries, railway stations, and bargain stores of New York City. Cornell was simultaneously a Manhattan scavenger and a nostalgic hoarder of Victorian ephemera, and much of his work embodies the relationship between the two roles, combining elements of the conceptual, discordant collage techniques of the twentieth century with the scrapbooks and picture-puzzle albums of the nineteenth.

Analysts of and apologists for twentieth-century collage generally define it abstractly in terms of space and context, in terms of reciprocity and response, and in terms of its claim to achieve that apotheosis of modern and postmodern aesthetics: the 'new'. Russian Constructivist Kazimir Malevich described collage as 'the growth of the surface towards us in real space'. To Robert Motherwell, it provoked 'the sensation of physically operating on the world', whilst for Carlo Carrà it was fundamentally an 'intuitive self-definition of the artist among objects'. For Daniel Belgrad, collage is defined psychophysiologically, as 'the combined intellectual, emotional, and physical engagement of the body-mind

with its environment'.[24] The general implication, then, is that collage provides a special link between the habitat or context in which the artist is working, the artist themselves (both bodily and psychically), and the piece of art being made, which may or may not also develop its own internal context. We have, by way of example, the *Merzbau* (1923–1947) of Kurt Schwitters – whole rooms in an inhabited house converted into collage sculptures into whose fabric the detritus of the artist's life in Hanover was laced, from ticket stubs, torn letterheads, cigarette wrappers, and presents from friends, to fragments of newsprint, pieces of wire, perambulator wheels, and test prints of his own graphic designs. Schwitters sought 'the combination of all conceivable materials for artistic purposes';[25] his desire, both literally and aesthetically, was to create a new habitat out of the fragments and junk of his old one. A further instance is the work of the German artist John Heartfield (born Helmut Herzfeld), whose dissident photomontages subverted the Nazi advertisements, newspapers, and magazine articles, out of which many of them were made. Heartfield 'used newspapers like voodoo dolls' in order to deny 'both the logic of sentences and the unpleasant reality of news'.[26] On account of having stuck a knife into his society in this way (once again both literally and metaphorically), Heartfield found himself forced into exile for more than twenty years. With both Heartfield and Schwitters, the links between artist, context, and artwork, facilitated by their use of collage, are explicit.

This was also, of course, the spirit in which much of Cornell's work was conceived, as he persistently worked to construct a fictitious alternate or parallel universe for New York, which he could give as a series of gifts. His boxed assemblages and collages show him to be an extraordinary craftsman of the irrational form, whose work, as he himself asserted, was quite literally 'a natural outcome of [his] love for the city'.[27] He realised that the objects with which he worked were, to borrow from Hermann Hesse, 'the plastic material of love, of magic and delight'.[28] His sprawling journals and working dossiers make repeated references to 'wandering NY streets', to 'NY ephemera', and to the 'collage of things seen'.[29] Throughout his career, his artworks were made out of 'the world in which he travelled',[30] from the white clay pipes that he picked up en masse at the 1939 World's Fair that took place practically in his back yard, and the outdated star charts that he found in second-

[24] Kazimir Malevich, 'Spatial Cubism', 60; Motherwell, 'Beyond the Aesthetic', 38–9; Carrà quoted in Poggi, 185–6; Belgrad, 135.

[25] Schwitters, 'Die Merzmalerei', *Der Sturm* (Berlin: July 1919).

[26] Digby, 15.

[27] Quoted in Simic, 16.

[28] Hermann Hesse, *Steppenwolf* (London: Penguin, 1973), 169.

[29] Undated card, 'a Tuesday in 1950', Cornell Papers, AAA, Series 3, Box 6, fol. 7. Journal, February 1949, Cornell Papers, AAA, Series 3, Box 6, fol. 6. Note found on scrap of brown paper in Cornell files, November 1955, Cornell Papers, AAA, Series 3, Box 6, fol. 46.

[30] Hughes, *The Shock of the New*, 255.

hand bookshops, to the fleeting visions, missed opportunities, crossed paths, and naturally-occurring montages so innate to the daily urban experience.

Cornell lived all of his life in Flushing, with his overbearing, overly fond mother, and his disabled younger brother Robert, who had cerebral palsy. Devoted though he was to both of them, Cornell's life in Flushing was unavoidably tainted by a sense of stasis, claustrophobia, fragility, and arrested development, and whilst this casts a revealing light on his preoccupation with childhood and the childlike, and on his decision to work using the closed box form, it was nevertheless his trips into Manhattan which enabled him to perceive the world from a fresh standpoint, and to renew his creativity. The collage *Untitled (Encrusted Clown) (Souvenirs for Singleton)* (1946), for instance, which features a clown made up of a Pierrot engraving head and a colourful body of scraps and small objects found on the city streets, and is named after a character played by the actress Jennifer Jones, subtly commingles Cornell's life looking after the permanently childlike Robert with his adventures in the city. The collage is a toy made out of the detritus of New York, out of the kind of worthless urban oddments that only a person with an extraordinarily childlike sensibility and heightened appreciation of urban culture would find valuable, including a ticket from the New York Zoological Park worth 5¢, a prizewinning coupon, several stickers, a broken watch-face, and numerous small cogs. It also combines an impression of rudimentary craftsmanship and camp homage with the unattainable glamour of the silver screen, emblematic of the average citizen of New York's close proximity to, yet inevitable remove from, the great movie stars of the age.

The state of flux in which Cornell existed is key: the exhilaration of his visits to Manhattan or Brooklyn, where he gathered the material for his collages and boxes, combined with the inertia of his home life, where he found the opportunity to turn this flotsam into art, enabled him to invest with a distinctive, almost enchanted quality the everyday objects, situations, and even individuals which would otherwise be mere quotient parts of the 'serial, reproducible character of urban mass culture'.[31] He was uniquely placed in his emotional, physical and intellectual interaction with New York, experiencing it, as Jodi Hauptman observes, 'as both site (spatiality) and sensation (memory)'. Furthermore, as Hauptman continues, 'by replacing inscription with collection, Cornell composes a picture of the city as it is lived, not an abstraction charted from a safe and sterile distance. Cornell's city is loud, bustling, and dirty, soiled with history'.[32] His collages, and the boxes that make up the bulk of his life's work, both 'salvaged and preserved'[33] the things he collected whilst wandering. They are simultaneously imbued with a biographical quality that retains its referential freshness, whether in the form of

[31] Dimakopoulou, 215.

[32] Jodi Hauptman, *Stargazing in the Cinema* (New Haven: Yale University Press, 1999), 150–51.

[33] Mary Ann Caws, *Joseph Cornell's Theater of the Mind: Selected Diaries, Letters and Files* (London and New York: Thames & Hudson, 1993), 37.

tiny recurring photographs of Manhattan buildings as in *Untitled (Penny Arcade Portrait of Lauren Bacall)* (1945–1946), or in the freely mixed urban ephemera (stamps, coins, cut-outs) of *Untitled (Penny Arcade with Horse)* (c. 1965). Indeed, the very act of wandering, by which Cornell collected the component parts for his work, serves to counterbalance the inevitable sense of claustrophobia that the box form suggests, evoking for the viewer the lived processes by which his uniformly beautiful pieces were constructed, and embodying the fruitful tensions between the productive peace of life on Utopia Parkway in Queens and 'the electric feeling of city life, the contemporaneity, the bustle of crowds'.[34]

'A persuasive, convincing new species, living all on its own': Julien Levy, Max Ernst, and the Problem of Surrealism

In November 1931, Julien Levy, a twenty-five-year-old Harvard dropout who had married Joella Loy, the daughter of the vanguard European poet Mina Loy, opened an art gallery at 602 Madison Avenue. Levy had studied literature and fine art at Harvard, but left before graduating, instead sailing for France in 1927 in the company of Marcel Duchamp. Once in Europe he befriended Man Ray and the sculptor Constantin Brancusi, who would act as witness at his wedding to Joella. Levy's passion was not just for art but for art promotion, and with the help of his mother-in-law, who acted as his Paris art-scout and sometime selector, his gallery was later credited with 'single-handedly import[ing] French Surrealism to New York'.[35] When the gallery's initial retrospective of American photography, including the work of the great Alfred Stieglitz and Clarence White, proved critically and financially unrewarding, the well-connected Levy turned his gaze more emphatically toward the European avant-garde, although he ensured that American photography and experimental film continued to be well-represented, and always kept collectors' bins filled with old photographs in a room at the back of the gallery. The gallery soon evolved into an authentic pocket of Paris, an enclave of dream and imagination, secreted within an outwardly conservative Manhattan. For the next seventeen years the Julien Levy Gallery became a revolving door of European and Surrealist art, boasting works, and in many cases visits, by Max Ernst, Man Ray, Salvador Dalí, Marcel Duchamp, Arshile Gorky, Yves Tanguy, and, of course, Joseph Cornell.

 Although Cornell had had no direct artistic experience or training, it is unlikely that he had not heard of the Surrealist movement prior to visiting Levy's gallery – certainly he had attended the unprecedentedly popular *International Exhibition of Modern Art* at the Brooklyn Museum in late 1926, in the organisation of which Duchamp had been heavily involved.[36] In his literary, musical, and artistic tastes,

[34] Cornell, quoted in Hautpman, 4.

[35] Solomon, 55.

[36] On 27 December 1926, The Brooklyn Museum issued a press release stating: 'Because of the unusual interest in the *International Exhibition of Modern Art* arranged

he was resolutely European, and his penchant for all things French was as fully nourished as his circumstances would allow, meaning that in many ways he was already aligned with many of the same influences as the Surrealists. He read De Nerval, Baudelaire, Rimbaud, and Mallarmé, and listened to Debussy, De Séverac, Dukas, and Satie (who, in 1924, had composed the music for René Clair's short film *Entr'acte*, which featured the bearded Francis Picabia, who wrote the film, dressed as a ballerina and dancing a ballet). Among his favourite films were Carl Theodore Dreyer's *La passion de Jeanne d'Arc* (1928) and Dimitri Kirsanoff's *Ménilmontant* (1926). Lynda Roscoe Hartigan notes an important purchase Cornell made in 1921 from Albert F. Goldsmith's shop, At the Sign of the Sparrow: a 1912 issue of the Paris periodical *Musica*. The issue featured 'an intimate photograph of the late nineteenth-century composer Emmanuel Chabrier playing with his children around an iron sculpture of a bear'.[37] Cornell later used the image in a collage made around 1935 for a series he called *Dedications*. During the 1920s he was impressed by and eager to engage with what was increasingly being called modern art, an eclectic combination of French Impressionism, Post-Impressionism, and the European avant-garde. Hartigan has discovered that he had access to a range of little magazines, and had 'encountered reproductions of works by Georges Braque, Paul Cézanne, André Derain, Juan Gris, Wassily Kandinsky, Paul Klee, Fernand Léger, Pablo Picasso, and Odilon Redon, among others'.[38] But it was not until he ventured into Levy's gallery, that 'trans-Atlantic bridgehead',[39] and came across Max Ernst's collage novel *La femme 100 têtes* (1929) that he was able to encounter in all its nightmarish esotericism the extraordinary nature of Surrealist collage first hand. Although Cornell, by his own confession, was taken aback by Ernst's collages' lewd and often violent subject matter, he was struck by their form and immediately stimulated not only by the recycled Victorian source material, but by the revelation of the possibilities afforded by the practice of collage for an individual artistically-minded but not artistically trained, and, furthermore, by the idea, as Levy later wrote,

> that two entities unutterably dissimilar should in conjunction make … Not a grotesque combination of the parents, not a cumbrous Siamese twin, not a dead stuck-up combine, but a persuasive, convincing new species, living all on its own.[40]

by the Société Anonyme and now current at the Brooklyn Museum (the attendance at the Museum from November 19th through December 26th has reached forty-eight thousand), it has been decided to extend the closing date from January 3rd to January 10th' (Brooklyn Museum Archives, Exhibitions: *International Exhibition of Modern Art* assembled by Société Anonyme, 19 November 1926–10 January 1927).

[37] Lynda Roscoe Hartigan, *Joseph Cornell: Navigating the Imagination* (Salem, MA: Peabody Essex Museum, 2007), 21.

[38] Hartigan, 25.

[39] Sawin, 79.

[40] Levy, 77.

Cornell later confirmed that *La femme 100 têtes* was the definitive stimulus for his entry into the world of art,[41] linking him to the Surrealist movement in ways that, for critics of his work, would prove to be endlessly problematic. The artist David Hare made the important observation that 'Surrealism really had nothing whatsoever to do with painting and not very much to do with literature, it had to do with an attitude of mind'.[42] Whilst the wording of his statement comes across as both hyperbolic and reductive (given that Surrealism really had quite a lot to do with painting and literature), it nevertheless highlights the significant attitudinal nature of the movement, and helps to set out why Cornell is often mistaken for a Surrealist artist, and why he should not be. Although thematically and stylistically aspects of his early work resemble that of Ernst, Cornell's 'attitude of mind' was resolutely not that of the Surrealists. He did not believe in chance as a guiding aesthetic force – he believed in fate and the inescapable. He was also a devout Christian Scientist, firmly believing, amongst other things, in the power of prayer to cure illness (in spite of the evidence of Robert's persisting disability), whilst the Surrealists, on the whole, were delinquent Catholics who, as Hughes suggests, used their art as a series of 'small step[s] in the gradual freeing of man from superstition'.[43] Furthermore, Cornell's art was never purely automatic or mechanical: he shaped, carefully, whatever emerged from his unconscious, tempering and censoring it with his own, very distinct, sense of reason, morality, and aesthetic judgment, a fact which goes some way toward explaining the noticeable absence of any explicit sexual content in his work, despite his attested interests in sex and his attraction to women. As with his fluctuating beguilement with Victorian ephemera, visions of childhood, unattainable women, and caged birds, his relationship with Surrealism was always predicated on 'evocation rather than emulation',[44] homage rather than slavish imitation.

The problem of associating Cornell too closely with Surrealism is that, while it may prove illuminating and of interest to the study of Surrealism itself, it risks both detraction and distraction from Cornell's own work, unless the alleged similarities are rigorously interrogated. Michel Leiris said of Raymond Roussel that he 'never really travelled … in all the countries he visited, he saw only what he had put there in advance, elements which corresponded absolutely with that universe that was peculiar to him'.[45] It is tempting for viewers of Cornell's work to do the same thing, and it is important, therefore, to establish the differences between Cornell and his Surrealist predecessors and contemporaries, particularly Max Ernst, in order to allow the dialogue between them to illuminate *his* work, rather than theirs.

[41] Solomon, 58.

[42] Quoted in Lindsay Blair, *Joseph Cornell's Vision of Spiritual Order* (London: Reaktion Books, 1998), 38.

[43] Hughes, *The Shock of the New*, 249.

[44] Hartigan, 47.

[45] Michel Leiris, 'Le Voyageur et son Ombre', *La Bête noire* 1 (1 April 1935).

'Miracle of beauty in the commonplace': First Collages, Collage Vision

Returning home after having seen *La femme 100 têtes*, Cornell began a reconnaissance of the books, sheet music, cut-out articles, and pieces of Victorian ephemera that he had compulsively hoarded throughout his life, embarking on the collages that would ultimately frame and inspire a unique and successful career by treading gingerly in the footsteps of the Surrealist trickery he had encountered at Julien Levy's gallery. His early work appears to be an attempt to imitate the macabre interventionism of Ernst's collage-novel, and although it is technically and stylistically derivative in many ways, it was clear from the outset that Cornell took a more oblique angle on the collage export than the contrived shock and simulated psychosis that pervaded Surrealism. Finding himself disturbed by Ernst's violent and disconcerting collages, and unable to commit to the black magic of the European art movement which saw itself as 'exempt from any aesthetic or moral concern',[46] he quickly abandoned this artificial form of nightmarish mimicry, transposing it instead into work that increasingly took on the characteristics of lucid dream, as he first adopted and then successfully adapted the collage practice to his own ends.

Although the main body of his work would subsequently take the form of the boxed assemblages for which he is best known, Cornell used collage throughout his career. Having achieved success with paper collage, Cornell subsequently found that he wanted the intricacy, detail, and evocative effects of collage to be magnified, rendered on a larger scale. This, ultimately, is what his box constructions are: more than assemblages, they are three-dimensional collages, fastidiously built according to the principles of the practice. In some senses Cornell can also be seen as writing his own life, and the life of his city, out of his daydreams, and then, as noted previously, giving it as a series of gifts, much as Frank O'Hara's poems were often 'for' someone. The serial approach that Cornell took to his work is reminiscent in some ways of the fiction of the Victorian era to which he felt so drawn (he identified himself closely with Henry James in particular), in the sense of being 'a continuing story over an extended time with enforced interruptions'.[47] His body of work, taken as a whole – an extended personal collage – can be viewed as a cohesive and literary achievement, manifesting the prolonged recompense and 'enlarged sense of time'[48] of the serialized Victorian novel, achieved in Cornell's case through the repeated superimposition of strata using the collage technique.

Cornell returned to Levy's gallery not long after having seen Ernst's work, this time to offer up his own batch of precisely crafted collages. The most striking

[46] Breton, 'First Manifesto of Surrealism', in *Art in Theory 1900–2000: An Anthology of Changing Ideas*, ed. Charles Harrison, James Gaiger, and Paul Wood (Oxford: Blackwell, 2002), 452.

[47] Linda K. Hughes and Michael Lund, eds, *The Victorian Serial* (Charlottesville: University Press of Virginia, 1991), 1.

[48] Hughes and Lund, 5.

of these was *Untitled (Woman and Sewing Machine)* (Figure 1.2), made early in 1932, which riffs gently, even slightly irreverently, on the Comte de Lautréamont's image of the chance encounter between a sewing machine and an umbrella atop an operating table, discussed in my introduction, which the Surrealists prized so highly. In Cornell's collage a paper doll is bisected by a sewing machine on top of a table in what appears to be a Victorian factory filled with seamstresses. An ear of corn rests, almost as an afterthought, on the train of the paper doll's dress, whilst a large flower blossoms with conspicuous luminosity from the wheel of the sewing machine. The well-loved and often studied *Untitled (Schooner)* (Figure 1.3), a tiny artwork measuring less than six inches square, was also among Cornell's first collages, made in 1931. In this piece a clipper ship floats with its sails unfurled on a placid expanse of steel-engraved water. Looming over a diminutive figure positioned in a rowing boat close to the ship's stern is a spider, crouched in a web, which is shrouded by a huge grey rose. In both collages Cornell's necessarily visual approach to art production is imbued with a distinctly narrative quality. The colour of the rose-petals visually rhymes with the colour of the murky water, as do the ropes of the ship and the spider's web, itself a manifestation of the latent webs of significance that ground the collage. In camouflaging the web within the sail, Cornell creates a visual pun on the French translations of 'web' and 'sail' – 'toile' and 'voile'[49] – here so intertwined. In *Untitled (Woman and Sewing Machine)* he plays on the corresponding ideas of sewing with thread and sowing crops, indicated by the burgeoning plant life integrated into the collage. There is a gratifying tension in both as the industrial desire for movement and accomplishment, as illustrated by the clipper and the rowing boat, the sewing machine and the rank of seamstresses, is ironically frustrated by the fecund stasis of natural elements. Once again, this reflects the duality of his life, divided between the strident bustle of Manhattan and the relative tranquillity of his life in Flushing. There are also facets of Perrault's *Sleeping Beauty* (1696) at work in these collages, not least in the sense of anticipatory enchantment experienced at a distance, which also reverberates throughout the rest of Cornell's body of work.

This is all quite alien to the political agenda that was prerequisite to Surrealism, a movement born out of cultural trauma and intended always as a forward-thinking, insurrectionist 'instrument of cultural revolt'.[50] The Surrealist artist Kurt Schwitters, for instance, used collage techniques and sensibilities to rebuild shattered worlds and to come to terms with the brutality of the First World War and, following it, the increasingly ominous political situation in Europe. By contrast, Cornell's artistic sensibilities had developed thousands of miles from the violence and upheaval of early twentieth-century Europe, in isolationist

49 Noted in Julia Kelly, 'Sights Unseen: Raymond Roussel, Michel Leiris, Joseph Cornell and the Art of Travel', in *Joseph Cornell: Opening the Box*, ed. Edwards and Taylor, 77.

50 Werner Spies, *Max Ernst Collages: the Invention of the Surrealist Universe*, trans. John William Gabriel (New York: Harry N. Abrams, 1991), 11.

Fig. 1.2 Joseph Cornell. *Untitled (Woman and Sewing Machine)*, 1931. Collage. © The Joseph and Robert Cornell Memorial Foundation/VAGA, NY/DACS, London 2013.

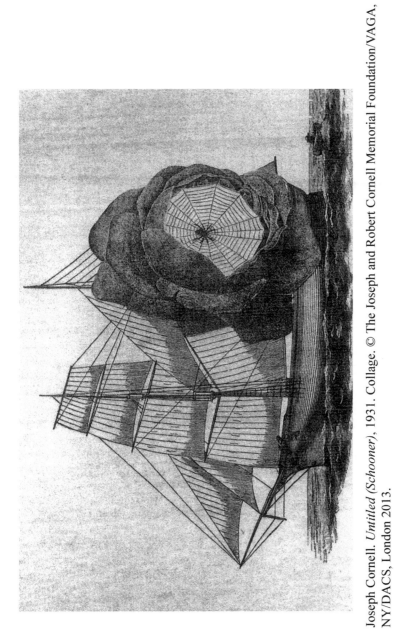

Fig. 1.3 Joseph Cornell. *Untitled (Schooner)*, 1931. Collage. © The Joseph and Robert Cornell Memorial Foundation/VAGA, NY/DACS, London 2013.

America, where he existed in what he later referred to as the 'vanished golden age of gallery trotting'.[51] His introspective art is filled with contemporary American material, but what is particularly American about his work is his demonstrable faux-nostalgia for a version of Europe that did not quite exist; in other words, as Robert Hughes observes, 'the Europe in his boxes lasted from the fifteenth-century to the *Belle Époque*'.[52] Other than in the individual Europeans whom he encountered in New York, Cornell demonstrates little interest in the realities of contemporary Europe, preferring the American present, linked in myriad ways to myriad pasts, but anchored firmly in the burgeoning modernity of the city in which he lived. Cornell's concern appears, in these early collages, to be to construct – or even, at this stage, simply to interpret – a kind of a delicate fiction, in the sense that he is engaged in a skilled 'act of fashioning or imitating'.[53] More Symbolist than Surrealist, he is pursuing fleeting constellations of imagery in the form of intersecting, unexplained, and resolutely mysterious glimpses, both real and fantastical, European and American, in a response to an idealised version of a world which embraces the cultural 'continuity of past and present', and is inspired by 'the community of tradition, the spiritualism ... of culture'.[54]

Levy was impressed by Cornell's 'delicate understanding of what can and cannot be matched',[55] and accepted several of his collages for an exhibition, *Surréalisme*, which would also feature work by Picasso, Pierre Roy, Jean Cocteau, and Duchamp. In the absence of the show's heavyweights, including Man Ray, Dalí, and Ernst, Levy even commissioned Cornell to create the show's publicity (Figure 1.4). Cornell produced a blithe, unpretentious collage featuring a boy trumpeter blowing the word 'Surréalisme' into the air from a cake-icing tube. The piece simultaneously reveals Cornell's enthusiastic adherence to certain tenets of Surrealism whilst manifesting more subtly his somewhat ascetic dissociation from what he viewed as the movement's unhealthier aspects. His choice of the cake-icing tube lends the collage a youthful vitality, and illustrates his inherent aesthetic appreciation for and affinity with what André Breton (Surrealism's dour and formidable captain) described as 'objects that ... go off to dream at the antique fair'.[56] The drifting letters, floating with a gentle, lyrical dynamism above the head of the trumpeter, embody the Surrealist Georges Hugnet's belief that 'with Surrealism all poetic and pictorial manifestations are situated on the level of life and life on the level of dreams'.[57] But whilst Cornell's figuring of a child in the

[51] Quoted in Hauptman, 28.

[52] Hughes, *The Shock of the New*, 257.

[53] http://dictionary.oed.com (*Oxford English Dictionary*): obsolete definition of the word 'fiction' [Accessed 5 May 2010].

[54] O'Doherty, 257–8.

[55] Levy, 77.

[56] Breton, *Mad Love* (*L'Amour fou*), 28.

[57] Georges Hugnet, 'In the Light of Surrealism', in *Fantastic Art Dada Surrealism*, ed. Barr, 52.

Fig. 1.4 Joseph Cornell. Exhibition poster for *Surréalisme*, Julien Levy Gallery, 1932. Collage. © The Joseph and Robert Cornell Memorial Foundation/VAGA, NY/DACS, London 2013.

collage (as well as the deliberate reference to his own considerable fondness for cake) exercises Louis Aragon's notion of the artist's 'individuality of choice',[58] it also marks the absence of the disquieting panoramas, aphrodisiac conspiracies, and argumentative absurdities that are the benchmarks of Surrealist art. The piece is partially an exposition of Hugnet's idea of 'the physics of poetry', but it lacks, deliberately, the 'formidable meaning'[59] that the Surrealists used collage to convey. Cornell chooses instead the frugal, emotive, transfigurative precision of Symbolist writing. As O'Doherty suggests, herein lies the paradox at the heart of Cornell's work: 'Surrealism enabled him to become the last great Symbolist poet'.[60]

Cornell's initial creative dialogue with Surrealism was partly what drove him to his own unique idiom, which remained constant to elements of this preliminary dialogue throughout his career. Like William Burroughs and Bob Dylan, as I will discuss, Cornell took an eclectic approach to European avant-garde art, using some techniques and adopting some attitudes, whilst ignoring or disparaging others, taking what he needed and discarding what he did not. He took from the collages of André Masson and Max Ernst an understanding of the power of the practice for conveying almost inexpressible emotion to the viewer. He garnered partly from Duchamp his lifelong love of boxes and mechanical forms. Increasingly, in his later years, as he returned more directly to the practice of pure collage and began making fewer boxes, he lapsed back toward Surrealism, displaying a stylistic closeness with Magritte from about 1959 onwards. There is a conspicuous similarity between Cornell's *Untitled (First Collage in a Long Time)* (1959) and Magritte's *The Rape* (1934), for example, both in the initial visual impressions of each and in their employment of a Freudian sense of displacement. Both feature a female nude against an indistinct landscape and a blue sky. The colouring of each is similar – both women have auburn hair – and the form of each is incomplete. As ever, the similarities end with form and visual content. Whilst the female in Magritte's image is unsettlingly objectified, both in terms of the title of the piece and by her face having been substituted for her naked torso, Cornell's piece instead displays an underlying sense of Mondrian-esque order, as he bisects his nude, replaces the right side of her body with a vibrantly autumnal tree, and criss-crosses the entire collage with a mathematical grid, creating a tension between the urge to measure and master femininity, as well as the natural and the artistic worlds, and the manifest impossibility of ever being able to do so.[61] Cornell plays on this idea again in a later collage, *Untitled (Ship with Nude)* (1965), in which an image of a young female nude, wearing a pearl necklace and gazing unwaveringly upwards, is pasted over an image of a ship sailing at night, in such a way that

58 Louis Aragon, *La peinture au défi: exposition de collages* (Paris: Galerie Goemans, 1930), quoted in *Fantastic Art Dada Surrealism*, 44.

59 Hugnet, 51.

60 O'Doherty, 274.

61 A further link between Cornell and Magritte is Cornell's 1963 collage *Mica Magritte II*, which uses the image of the train from Magritte's *Time Transfixed* (1938).

the girl is rendered simultaneously the vessel's figurehead and its mast and sail, recalling Lee Miller's portrayal of Cornell in a similar fashion, over thirty years earlier. Pasted over both ship and nude is an astronomical map cut so that it details only the constellation of Hercules, once again alluding to Cornell's desire to map and measure the complex (and, in his eyes, celestial) aesthetics of femininity, as well as to come to terms with the mystery of a wider world which he had never seen, and never would.

Cornell was a consummate archivist, and in possession of a wealth of unrelated objects, many of which held an almost spiritual meaning for him, and which would ultimately feature throughout his work as emblems of his strong autobiographical impulses. Surrealism was, in many ways, merely a stepping stone in the development of the box form, providing the means but not the matter for his move into art. By 1931, as Hauptman notes, he was 'poised for the theoretical framework that would give his archival activities ... form'.[62] There is perhaps a case to be argued that in terms of achieving what their manifestos set out to do, Cornell was actually more Surrealist than the Surrealists. His work is smaller and more fantastic, less wilful, less contrived, less precocious, and less egocentric than many Surrealist pieces, and it possesses an ingenuousness that seems able to tap genuinely into the realm of unconscious desires. Mina Loy observed in 1950 that Cornell, 'while adhering to the Surrealist formula alone has raised it above reality, having achieved an incipience of the sublime solidified'.[63] Much of this is due to the levelling effects of his boxes, in which high art converses with popular culture and city detritus, within the quasi-private confines of a space which by its nature operates variously as a theatre, a treasure chest, a mausoleum and a specimen cabinet. In *Pantry Ballet (for Jacques Offenbach)* (1942), for instance, a group of red plastic toy lobsters wearing tutus dances on an otherworldly stage made up of cut-out paper food, silver cutlery and napkins; in the breath-taking *Taglioni's Jewel Casket* (1940), cubes of artificial ice rest in a treasure case lined with dark blue velvet, whilst behind a rhinestone necklace (which Cornell purchased from a New York dime store), a note in the lid of the box recounts the legend of how the eponymous ballerina once danced for a highwayman on a panther's skin spread over the snowy ground, and subsequently kept an imitation ice cube in her jewellery box, in memory of the evening. These works embody the qualities which John Ashbery believed set Cornell's work above his contemporaries: they 'keep all the stories that art seems to want to cut us off from without giving up the inspiring asceticism of abstraction'.[64]

Cornell's ability to raise the Surrealist formula above its own standards is also due to the startling originality of content and sentiment found upon looking closely at work that at first glance appears derivative. Almost without intending

[62] Hauptman, *Stargazing in the Cinema*, 31.

[63] Mina Loy, 'Phenomenon in American Art' (typescript), Cornell Papers, AAA, Series 9, Box 19, fol. 12.

[64] Ashbery, 'Joseph Cornell', in *Reported Sightings*, 17.

to, he manages to subvert the subversive, turning horror on its head and revealing it to be beautiful. Cornell's idea of the marvellous was quite different to that of the Surrealists: they viewed beauty, horror, and sexual desire quite equally in terms of human experience, whereas for Cornell, the marvellous was usually something simple, ordinary, almost always unexpected, and often transient, an instance or series of instances of fleeting gratification which sustained and inspired him. Waiting in a railway station on a rainy afternoon in January 1949, for instance, he scribbled down a typical encounter on a scrap of Western Union paper (Figure 1.5). Having been 'thinking how uneventful the station is for anecdotes or touches', he suddenly sees a 'jovial man' with a Great Dane on a leash. Cornell overhears the man telling a little girl that the dog is thirty-five years old, to which she responds in amazement, as the man moves toward his train: 'they only have that many birthdays up in <u>heaven!</u>'[65] His diaries include numerous examples of moments like this: on September 10th 1953 he noted down the 'miracle of beauty in the commonplace – house with black tarred roof and chimney purple showing slightly in backyard – completeness of beauty in the unexpected commonplace'.[66] Similarly, he observed on November 13th 1955, whilst shooting a film at Union Square with Rudy Burckhardt, an 'unexpected yield of incidents and enrichment'.[67] It is these unexpected moments of inspiration which Cornell would then painstakingly and in a fervour of premature, or even imagined, nostalgia, attempt to recreate. He spoke of seeing in his surroundings a 'kind of richness in which a revelling in detail becomes such a feast of experience', as on January 24th 1947:

> Shaved and dressed and waved good-bye to Robert on porch (Mother shopping). Waved to Robert from train … went all the way in to Penn Station. Just before going under tunnel looked up at freight cars – the word Jane scrawled on a box-car in large letters, red with a touch of pink, then touches of primary colors mingling with a scene of men working on the tracks with a long crane mounted on a car – all over in a flash but evoking a strong feeling – had not remembered anything just like that at that point – but similar varied combinations many times from the elevated viewpoint of the subway before going under at same point (the puffing locos, omnipresent pigeon, markings on cars in freight yard, etc. Once in a while a touch like the above … Went up in freight elevator and got glimpses into different floors not afforded by passenger elevator (out of order) of workers in grimy industrial plants … Unusual feeling of satisfaction and accomplishment, unexpected and more abiding than usual.[68]

We can learn from such journal entries that Cornell not only saw the world through an artist's eyes, carefully noting the intermingled colours of the places through which he travelled, but through a collagist's eyes, inspired and provoked as he

[65] 5 January 1949, Cornell papers, AAA, Series 3, Box 6, fol. 6.

[66] Diary Entry, Cornell papers, AAA, Series 3, Box 6, fol. 22.

[67] Diary Entry, Cornell papers, AAA, Series 3, Box 6, fol. 46.

[68] Cornell papers, AAA, Series 3, Box 6, fol. 4.

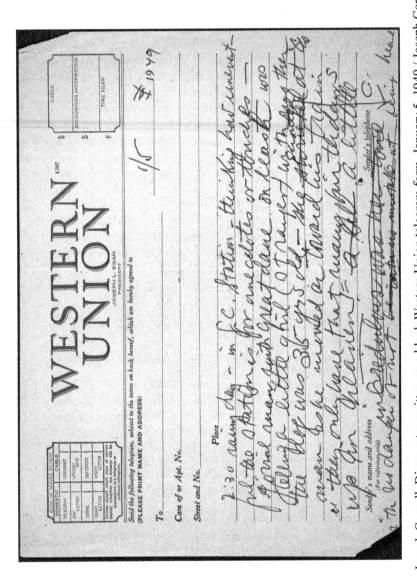

Fig. 1.5 Joseph Cornell. Diary entry written on a blank Western Union telegram form, January 5, 1949 / Joseph Cornell, author. © Joseph Cornell Papers, Archives of American Art, Smithsonian Institution.

was by 'varied combinations' and unexpected juxtapositions, by images seen 'in a flash', and by 'glimpses' into other worlds afforded by novel modes of transport. Like the Surrealists, he believed that art could not make experience, but it could release it 'mediumistically'[69] – though perhaps, as a Christian Scientist, he would have objected to this particular word. There was an ambiguity at the heart of his artistic process, however, whereby he seems to have been alternately motivated by and disconnected from both the creative process and the finished product, which he found paradoxically liberating and confining. In October 1950, for instance, he added the finishing touches to his *Moutarde Dijon* box, and wrote: 'Suddenly the sense of completeness, poetry, and connection with life as opposed to the confining, esthetic feeling of limitation experienced too often in working with the boxes'. A few lines later he seems to contradict this mood, however, describing an 'intense longing to get into the boxes' and of a sense of 'overflowing, a richness and poetry felt when working with the boxes but which has often been completely extraneous in the final product'.[70] Clearly, he experienced both an intense attachment to his artworks and a sense that they failed in some way to fully capture the 'yield of incidents' to which he felt he owed his inspiration.

Much of this inspiration had its roots in the Victorian ephemera with which his house was filled as a child; his early collages were not, like Max Ernst's, a form of raw vengeance unleashed upon the memory of a repressive Victorian childhood, but often an oblique celebration of that era, which he knew only through an imagined nostalgia, partly projected onto him by his parents, and propelled by a narrative impulse that seems more about telling a story than proving a point. His collages are alive not with ever-present threat or the bitter urge to parody, as Ernst's are, but with an inquisitive sense of uncomprehending fascination, 'reflective of a child's worldview and experience',[71] and manifested in images of ants carrying playing cards or children with giant birds. Ernst's collage novels, conversely, are pervaded with menace and mutation. A plate from *Une semaine de bonté* (1934) (Figure 1.6), for instance, features two Victorian ladies seated on an upright sofa in a lounge or parlour. The elder, darker woman seems to be advising the younger blonde; they appear, at any rate, engrossed in conversation. Although light seems to be falling on them, the room itself is dark and richly furnished, its walls papered with a substance which seems to be almost as thick as the carpet, and which, in its swirling design, seems to move and mutate. The two women hold hands and look intently at each other. Above their heads in a heavy frame hangs a painting of two women – again, one dark and one blonde – with their faces pressed together. Without either woman seeming to have noticed it, a gargantuan reptile with huge pointed scales and a tail that indicates brute strength has climbed up the legs and across the back of the elder woman, and has placed its claws with

[69] Hughes, *The Shock of the New*, 225.

[70] Diary Entry, 14 October 1950 (recorded 16th), Cornell papers, AAA, Series 3, Box 6, fol. 7.

[71] Hauptman, 178.

Fig. 1.6 Max Ernst. Untitled plate from *Une semaine de bonté*, 1934.
 © ADAGP, Paris and DACS, London 2013.

a sense of calculated menace on either side of her face. By contrast, an untitled Cornell collage, from circa 1930–1940, features a very similar scenario, with very different connotations (Figure 1.7). A Victorian woman, bathed in light, is seated on an upright chair in a heavily upholstered lounge or parlour, with a large fan in her right hand. In Cornell's collage, the patterns on the wall do not appear to writhe or twist, but the setting is analogous. Leaning against the woman is a huge

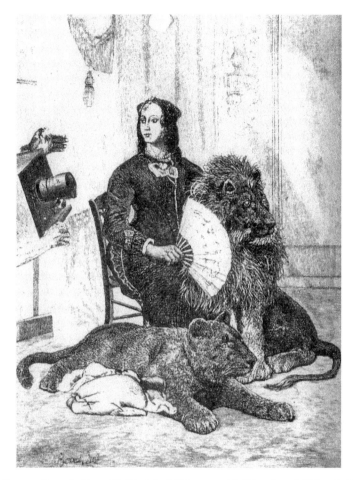

Fig. 1.7 Joseph Cornell. *Untitled (Woman with Lions)*, c. 1930s. Collage.
© The Joseph and Robert Cornell Memorial Foundation/VAGA,
NY/DACS, London 2013.

lion; an equally impressive lioness lounges at her feet on a crumpled rug, her
paws spread languidly in the manner of a contented domestic cat. The woman is
paying no attention to either animal, and yet seems to possess the loving disregard
of a relaxed and experienced cat-owner. A large camera is positioned at the edge
of the collage, held at an odd angle by a disembodied pair of hands. The woman
looks towards it. We can see in the contrast between the collages that whilst Ernst
uses the irrational in order to subvert restrictive domestic order and rationality, in
a manner 'akin to an act of terrorism',[72] Cornell chooses to embrace the irrational
with the enthusiasm of any child who ever wanted a lion for a pet, integrating it

[72] Hughes, *The Shock of the New*, 227.

favourably into the familiarity of a recognisable domestic situation. Whilst Ernst's reptile is determinedly predatory, Cornell's lions have the non-threatening and alluring nonchalance of household cats. Both artists have used exotic creatures that exist partly in myth; but where Cornell's animals are warm-blooded, and embody the gentle, big-hearted ferocity for which their species is fabled, Ernst has chosen a cold-blooded, creeping, half-fantastical fiend that has more in common with the bloodlust and killer stealth of the Komodo Dragon. Ernst has deliberately, with the quasi-misogynistic air of patriarchy associated with Surrealism, depicted the women in his collage as being oblivious and defenceless, whereas Cornell's collage operates on the rationale that the woman is ignoring the lions because she is concentrating on having her picture taken. Furthermore, by putting two people in his collage, and thereby forcing himself to choose which one to subject to his reptile's attentions, Ernst turns the momentum in the artwork upon himself, making it about him, and his choice, rather than about what is happening to the women in the image. Conversely, as Walter Hopps recollects, Cornell's dossiers were often centred 'around a person or the idea of someone'.[73] This is evident in many of his collages, and applies in this instance: the self-referentiality indicated by the woman's disembodied photographer is subordinated to the implied outcome of his efforts – in other words, the photograph of the woman herself.

Both collages function through psychic disproportion and the power of suggestion, but the sense of dread implied by Ernst's lizard, and further evoked by the serpentine carpet and shifting wallpaper, could not be further removed from Cornell's tranquil, yet no less fantastical, collaged living room. Ernst depicts a sort of psychotic vengeance, typical of the Surrealist movement, in his calculated infliction of victimhood upon the women in his collage: it is a manifestation of his belief in wielding a sadistic authority over the past. By contrast, there is a nostalgia in Cornell's collage, a yearning for a past half real and half imagined, where, in a parlour not dissimilar to the one in the house in which he grew up, a lady such as his mother might well have sat straight-backed and noble, with two fully-grown lions at her feet, photographed, perhaps, by her son. Ronald Feigen recalls that Cornell seemed to be 'always struggling to give us a past',[74] while Ernst, on the other hand, seemed always to be struggling to kill it. Although in both collages the context is dreamlike, and the subject enigmatic, Cornell's image is unified by its narrative impulse, and by a sense, also, of being a unique event, rather than part of an image-cycle. It is a simple, self-contained, peculiar little fairy tale that exists independently within the body of Cornell's work. Ernst's collage, however, is very much part of a series – a series which, in its thinly veiled misogyny, suppressed violence, and sheer repetitiveness, borders on the pornographic, a genre that could not have been farther from Cornell's aesthetic psyche.

[73] Walter Hopps, 'Gimme Strength: Joseph Cornell and Marcel Duchamp Remembered', in *Joseph Cornell/Marcel Duchamp ... In Resonance*, ed. Polly Koch (Houston: The Menil Foundation, 1998), 76.

[74] Ronald Feigen, Introduction to *Joseph Cornell: Collages 1931–1972*, 9.

In terms of style, form and visual content, Cornell remained close to Ernst as he continued to make his early collages, depicting, as Ernst had also done, nautical scenes, birds and their relationships to humans, and children, whilst remaining clearly distinct in terms of sentiment and subject. Cornell's collage *Untitled (Man with Portable Motion Picture Camera and Musical Score)* (1932–1938) (Figure 1.8), which he imbues with the emotional luminosity of silent film, corresponds with another plate from Ernst's *Une semaine de bonté*, entitled *Le geste élégant du noyé* (Figure 1.9). In Cornell's collage, a man in a dark suit and a bowler hat stands behind a music stand, upon which sits the eponymous score, as well as a fantastically large bird, which is looking up at him. He points his camera towards a flat and empty expanse of water. In Ernst's collage, a man in evening dress, whose top hat has been blown off, looms disproportionately out of a black and stormy sky, over a shipwreck. Tiny birds swoop and plummet over the mayhem. There are stylistic similarities between the two collages but the correlation here is principally thematic (although once again the differences in tone, mood and imagery are remarkable). Cornell's figure appears to be that of an orchestra conductor doubling as movie director. Parallels emerge with the watery settings, and with Ernst's figure, whose garb, outstretched arms, and position in the collage, elevated as he is above a number of men, also lend him the air of conductor or movie director.

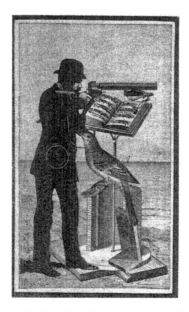

Fig. 1.8 Joseph Cornell. *Untitled (Man with Portable Motion Picture Camera and Musical Score)*, 1932–1938. Collage. © The Joseph and Robert Cornell Memorial Foundation/VAGA, NY/DACS, London 2013.

Fig. 1.9 Max Ernst. 'Le geste élégant du noyé', plate from *Une semaine de bonté*, 1934. © ADAGP, Paris and DACS, London 2013.

However Ernst's figure is portrayed as godlike and terrible, holding sway over a dramatic and brutal scene, and appearing to be whipping it into a frenzy rather than merely recording events. His lost hat suggests a loss of control over the tumult. By contrast the man in Cornell's collage points his camera serenely at a peaceful seascape. Whilst the similarity between the camera and a firearm (point-and-shoot) also render his figure godlike, there appears to be nothing in his sights for the figure to aim at. There is also no orchestra or choir for him to conduct, suggesting that the

musical score is merely a souvenir, serving no practical purpose other than as an agent of nostalgia. This renders the image acutely Cornellian, to the extent of being almost a self-portrait. Cornell was a man who wore dark suits, who loved birds and sheet music and often combined the two in his boxes, and who made movies of tranquil scenes in which nothing very much happened. In spite of the parallel use of birds, men in dark suits, hats, musical imagery and an expanse of water, the difference between the two collages is striking. In Cornell's scenario, nothing is being manipulated, and no one is getting hurt. No violent fantasy is being enacted in order to prove a point about history, or childhood, or the state of modern art, or politics. Instead, a rather private daydream appears to have been collaged together out of Cornell's 'decidedly nonlinear thought process'.[75] It has been created, it would seem, in accordance with Cornell's principle of 'making things without any thought or expectation of exhibiting'.[76] The virulent exhibitionism and desire to shock, which pervades many of Ernst's collages, is noticeably absent. Cornell has not taken Ernst's more prurient ideas and watered them down into self-denying versions of the originals: rather, his own ideas are the originals, pieced together using a combination of established techniques and unique fragments, in order to produce entirely new and unrelated images – which is, of course, precisely the purpose of collage.

'Uniquely qualified': Children in Cornell

Cornell lost his father to cancer when he was just thirteen, an event which effectively ended his childhood. As the eldest child, he was left, in a sense, at the head of a grieving family. Being prematurely catapulted into adulthood in this way seems to have had the effect of enshrining childhood for Cornell, transfixing it in a state of enchantment, which made him view his own childhood as an isolated collection of treasured moments suspended in time, around which he oriented himself, like an object to which he was deeply attached. The fact that his beloved brother Robert, brain-damaged from birth, was trapped in a permanently childlike state of arrested development, further added to the veneration with which Cornell viewed children, as well as objects or images relating to childhood, such as dolls, shells, or penny arcades. Children in his work are consistently treated like young aristocrats (most notably in the *Medici Slot Machine* series of boxes), in such a way that the viewer understands that their nobility is inherently linked to their childishness, to the artless wonder with which they perceive the world, and to the associated democracy and insight of their vision. Cornell chooses to use in

[75] Hartigan, 'Joseph Cornell's Dance with Duality', in *Joseph Cornell: Shadowplay Eterniday*, ed. Hartigan, Richard Vine, and Robert Lehrman (London and New York: Thames & Hudson, 2003), 12.

[76] Cornell, in a telephone conversation with Brian O'Doherty, recorded in *The Voice and the Myth*, 279. O'Doherty notes that the conversation took place at some point between 1965 and 1972.

his work children such as the Medici princes and princesses or the seventeenth-century Spanish princess from Velázquez's *Las Meninas*,[77] in order to highlight the aristocracy of the state of childhood, and the nobility of a childish demeanour. Toward the end of his life, in 1972, Cornell held an exhibition specifically for children, at the Cooper Union in Greenwich Village. Having always felt them to be 'uniquely qualified to understand the spirit of his work', he positioned his by now world-famous artworks low down, at the eye-level of the children, and mingled with his diminutive guests, drinking cherry soda, at the opening of the show.[78] Of course his art itself was not that of a child, but this exhibition, and the one that followed at the Albright-Knox Art Gallery, featuring an exclusive children's preview, vindicated a review by Hilton Kramer:

> his fantasy seems closer to the world of fairy tale and childhood romance than to the scandalous sexual encounters so much prized by the vatic voices of Surrealism ... Not the pathos of experience, but the sentimental revery of an innocent dreaming of experience, has been his particular forte. Psychologically, Mr Cornell's imagery has always been very knowing, but it is knowing in the manner, say, of the children in Henry James's stories – divining things they have never confronted in the flesh.[79]

It is precisely this 'knowingness' which defends Cornell's work from charges of being overly bijou or saccharine; and whilst Kramer is right to assert that Cornell is closer to the realms of childhood fancy than to Surrealism, it is equally possible that it was his initial encounters with the Surrealist idiom that facilitated the otherworldly 'knowingness' of his work. In his receptiveness to the techniques particularly of Max Ernst, Cornell was able to transmute the former's shock effects (often stemming from images of children in danger) into the enigmatic, secretive energy of children with power, more akin to the daring, self-governing children depicted by fellow outsider artist Henry Darger. In Cornell's dossier for the *Crystal Cage (for Berenice)* (1943) series of collages, for instance, photographs of children in wartime scenarios, in front of piles of rubble or bombed-out buildings, are accompanied by light-hearted or positive headlines such as WAR GIVES BREAK TO BOY, and, in one collage, RABBIT JOINS BATTALION. The indication here is that the children are not terrified, helpless victims (as they would be in a more cynical – even realistic – wartime work), but serve in some way to negate the misery created by war, transcending its privations. The positivity that emerges from these references to war, a theme which overall is scantly represented in

[77] Picasso was also fascinated by Velázquez's little Spanish princess, producing, in 1957, fifty-eight of his own variations on the painting.

[78] Solomon, 365.

[79] Hilton Kramer, 'The Enigmatic Collages of Joseph Cornell', Review of *Robert Cornell: Memorial Exhibition* (4–29 January 1966, at Robert Schoelkopf's gallery, Madison Avenue), *New York Times*, 23 January 1966, 107. The exhibition was in memory of Cornell's disabled brother Robert, who had died in 1965.

Cornell's body of work, may also relate to the sense in Manhattan's cultural circles that the systematic dismantling of Europe by outbreaks of war resulted in the reinvigoration and renewal of New York by Europe's displaced artists and writers.

Many of Ernst's shock effects come from two recurring themes in his work: images of women and children, and images of birds, often used in conjunction with one another. His collage painting *Two Children Are Threatened By A Nightingale*, for instance, evokes an irrational hallucinatory sense of dread as two children are menaced by a tiny songbird. In both *Une semaine de bonté* and *La femme 100 têtes*, women and children come repeatedly under threat: some images feature mutilated or metamorphosed female bodies, whilst others depict children fleeing an unseen enemy, their faces contorted with terror. When children appear in Ernst's work they are rarely spared the hallucinogenic torment that afflicts his adult figures. In a collage accompanied by the words 'Ici se préparent les premières touches de la grâce et les jeux sans issue', from *La femme 100 têtes*, for instance, three terrified children are depicted bent almost double as they are guided in their flight from an unknown menace by a solemn, half-naked phantom (Figure 1.10). Cornell's *Untitled (Children with Carnival Carts and Suitcases)*, from 1934, corresponds with this in some ways, also depicting a group of children undertaking a departure, only here they are playing blithely on the chassis of a great, old-fashioned wagon (Figure 1.11). A further image from *La femme 100 têtes* features two children grimacing agonizingly with paralyzing fear before the faceless menace of a figure draped in white (Figure 1.12). The image chimes with Cornell's *Untitled (Seated Figure with Suspended Plates and Bottles)* (1932–1938), again with subtle, attitudinal differences (Figure 1.13). In the Cornell collage, a seated boy appears to have been decapitated by a plate, upon which his head now rests. Nonetheless he sits quite calmly, and appears to be enjoying a good book, whilst the suspended plates and bottles float around him like a scene from *Mary Poppins* or *Alice's Adventures in Wonderland*. Ordinarily, an image of the decapitation of a child would provoke a sense of profound horror in any viewer, but the complete absence of any force for evil within this picture negates this. The steadying presence on a floating plate of a disembodied hand from stage right evokes a sense of dreamlike theatricality or tricksy sleight of hand, which distinguishes this childlike reverie from the gut-wrenching night-terror of Ernst's collage. It is clear that Cornell's boy is not in danger – he is, rather, part of the illusion. For the children in Ernst's collages, there is no such reprieve: whilst the threat may be illusory, originating in a false vision or hallucination, there is no guarantee that it will be over any time soon, or that it will not hurt them.

Ernst's children also face danger from strange winged creatures, including Ernst's sinister shamanistic alter ego Loplop, a collaged man-bird, who came to play a central narrative role in his work. Cornell seems to have taken from this, particularly later on in his career, an invitation to subversion: his own portrayals of children and birds together are, as ever, far more harmonious. An untitled collage created by Cornell at some point between 1930 and 1940 partially subverts the aforementioned Ernst painting, *Two Children Are Threatened By A Nightingale*, in

Fig. 1.10 Max Ernst. 'Ici se préparent les premières touches de la grâce
et les jeux sans issue', plate from *La femme 100 têtes*, 1929.
© ADAGP, Paris and DACS, London 2013.

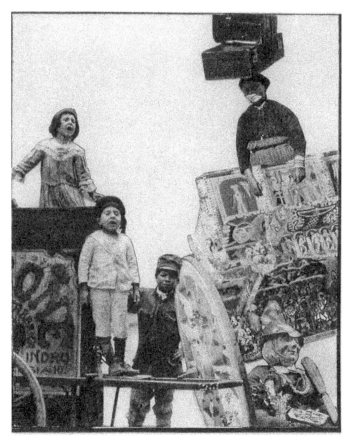

Fig. 1.11 Joseph Cornell. *Untitled (Children with Carnival Carts and Suitcases)*, 1934. Collage. © The Joseph and Robert Cornell Memorial Foundation/VAGA, NY/DACS, London 2013.

its inclusion of two stylized, wooden, yet oddly lifelike birds and one child. It goes further: it distorts the sizes of both the birds and the boy, whilst simultaneously emphasising through the positioning of the figures the total absence of threat. The larger bird is perched near the boy's arm, with its beak near his face in a manner that, like the lions in the collage discussed above, is both nonchalant and captivating. The smaller bird rests coyly on the boy's head, in a manner reminiscent of a story by Hans Christian Andersen or Oscar Wilde. In a similar image, pasted onto the bottom of a letter written to Parker Tyler on October 6th 1940, a boy holds a bird in his hands, whilst a pigeon, again somewhat larger than life, roosts peacefully on a branch to the left of the boy's head. Birds recur throughout Cornell's career, as do children, from the *Medici* boxes to the *Habitat* constructions, but it was not until the 1950s that he began to combine the two in earnest, in boxes such as the *Caravaggio Boy Dovecote* (1953), in which the repeated image of a young

Fig. 1.12 Max Ernst. 'Suite', plate from *La femme 100 têtes*, 1929.
© ADAGP, Paris and DACS, London 2013.

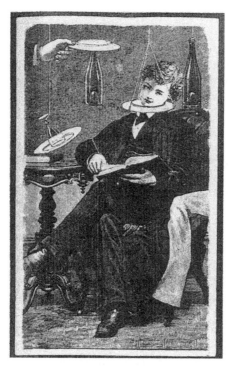

Fig. 1.13 Joseph Cornell. *Untitled (Seated Figure with Suspended Plates and Bottles)*, 1932–1938. Collage. © The Joseph and Robert Cornell Memorial Foundation/VAGA, NY/DACS, London 2013.

boy's face peers out from each of the nesting spaces in the eponymous dovecote, and *Variétés Apollinaris (for Guillaume Apollinaire)* (1953), in which the cut-out image of a young girl holding a basket is pasted onto the back inner wall of the box, whilst three doves flutter around her. In his later work from the 1950s, 1960s, and 1970s, when Cornell found himself returning increasingly to the practice of collage, and by association, to Surrealist techniques and imagery, he revisited and reused these motifs on numerous occasions.

But in spite of continuing to share similar concerns, the manner in which Cornell handled his subject matter remained distinct, as a comparison between the uses of bird imagery in a collage entitled *Allegory of Innocence*, and the Surrealist André Masson's painting *The Blood of Birds*, both made in 1956, illustrates. In Cornell's collage, numerous over-large birds perch almost voyeuristically in the foliage around two identical cut-out images of a woman who is naked from the waist up. In Masson's painting, by contrast, a selection of disembodied feathers is glued to a canvas daubed with sanguinary splashes. In Cornell's *Observations of a Satellite I*, from 1960, a vast hummingbird hovers unthreateningly behind Velázquez's tiny blonde Spanish princess, taken from *Las Meninas* (1656). Again, Cornell seems

to be invoking and subverting *Two Children are Threatened by a Nightingale*. The scenario is once again criss-crossed by a grid, and takes place under a bell jar, in a snowy garden with a tree and a low fence, against a dazzlingly blue sky in which is hung the titular satellite. Whilst the bird, the child, the colour of the backdrop, and the fence all bring Ernst's painting to mind (as well as Velázquez's, and, indeed, Picasso's many variations on it), it appears that what Cornell was really trying to portray when he made the collage was his own garden, and the elusive girls who would sometimes visit him at home, or the songbirds and movie stars about whom he fantasized 'with the sentimental reverie of an innocent dreaming of experience ... divining things they have never confronted in the flesh'.[80] He himself is the satellite, removed both by distance and by an ever-present pane of glass. The child in the image could not be further from danger.

Habitat New York: 'Everything has stopped, everything goes on reproducing itself'

Cornell had little interest in the suspended violence or the cultural, social, and sexual recalcitrance iterated by the European artists who were filling up New York; his artistic intent was relentlessly associative, empathetic, and dialogic, imbued with the 'sense of a ciphered intimacy',[81] as Stamatina Dimakopolou reflects. His work treads the contours of extreme privacy and shared confidence; in a manner reminiscent of Wordsworth's *The Prelude*, one has the sense of reading a diary that the writer both insisted was private and yet always hoped someone would see. However, in even the most eerie of Cornell's works, such as *Bébé Marie* (1940–1942), in which a doll stands in a wooden box behind a barrier of silvery twigs, the viewer is unlikely to discern any of the violent sexual mythology so prevalent in preceding Surrealist objects such as Alberto Giacometti's violent bronze *Woman with Her Throat Cut* (1932), Kurt Seligmann's *Ultra-Furniture* (1938) (a stool consisting of three mannequin legs in stockings and high heels), or Hans Bellmer's *The Doll* (1935), one of many chilling photographs taken by the artist of a naked, dismembered, and grotesquely reassembled mannequin. Unlike any of Surrealism's presiding female images, most notably the faceless and aggressively manipulated mannequin, Cornell's doll is fully clothed in a long, rather dowdy dress, and is wearing an elaborate flowery straw hat. Crucially, she has her own face, with wide, dark eyes, well-defined eyebrows, a neat fringe, a childlike nose, rosy cheeks, and a bright red mouth.

Studying *Bébé Marie* from a book, rather than looking at the original artwork, it is easy to mistake the way in which the box is presented in a gallery. The doll is not, as is often thought, lying in a coffin-like box under a restrictive covering, and cannot be, therefore, a version of Sleeping Beauty or Snow White. She is, rather, standing up, gazing through a beautiful, living fortification – making her more

[80] Kramer, 107.
[81] Dimakopolou, 210.

like a Rapunzel or a Pocahontas, a Daphne or an Alice, perhaps. But there is little sense of victimhood about her; she manifests, as do so many of Cornell's children, or objects associated with childhood, the mysterious potency of the very young. Furthermore, as Solomon observes, in looking in at *Bébé Marie* 'we feel we are also looking in on the troubled inner life of its creator, a grown man who is overly invested emotionally in a doll'.[82] This could certainly be the case, particularly as the doll seems to stay with him throughout his career; a version of *Bébé Marie* reappears in an untitled collage made in 1960, for instance, sitting on the inside ledge of a circular window, high above a city by a river bathed in sunlight. *Bébé Marie*, in her upright box, could be seen to be trapped behind her silver fence, peeking out through the restrictive branches, and trapped equally behind the layer of glass that forms the invisible fourth wall of the box, the captive of a man who loves her too much to let her go. She is perhaps a manifestation of the unattainable dancers and movie actresses to whom Cornell was so attached, for whom he made numerous collages and box constructions,[83] and from whom, ultimately, he found himself kept at a distance by the unassailable silver fence of stardom and showbiz. In a scrawled, half-illegible note written on a scrap of notepaper taken from Madison Avenue's Bodley Gallery by Cornell in 1965, almost twenty-five years after he made the box, it is possible to discern the words 'childhood doll', 'French import', 'kidnapped', and 'this doll encased'.[84] *Bébé Marie* is also, to a degree, on the outside looking in, gazing back at the man so emotionally invested in her and in the trappings of childhood: she is both hostage and hostage-taker, symbolic of Cornell's awareness that he is as much encased as she. She is also, in part, a recreation of one of Cornell's fleeting city apparitions, 'a movie cashier in an Art Deco box',[85] or a girl seen through the window of an inner city train. She is part of the story of Cornell, indicative of Hugh Stevens's observation that his work can 'be thought of both in narrative terms, as offering a fragment of a tale, and in material terms, as the souvenir of an event'.[86] Further, she embodies Hauptman's evocative assertion that Cornell's works 'propose that identity is a doorway, opening onto ever-expanding worlds, that identity is not an end in itself but leads to myriad and multiple explorations: chains of allusions, webs of references, halls of mirrors. A single clue always leads to multiple nexts'.[87]

[82] Solomon, 153.

[83] A series of collages made for the ballerina Tamara Toumanova is particularly striking: in each, Toumanova is portrayed as a fantastical creature of myth or fairy tale, seeming to fly toward a suspended red heart in one, appearing as a beautiful deep-sea witch in another, and as a colourful, carefree mermaid in a third. The implication of all three is that in Cornell's eyes Toumanova was so sublime and so unattainable that she might well have been a latter-day fairy princess.

[84] Cornell, 'Notes on Bébé Marie Doll circa 1965', Cornell papers, AAA, Series 1, Box 1, fol. 1.

[85] O'Doherty, 259.

[86] Stevens, 104.

[87] Hauptman, 4.

In a world of doorways and mirrors, then, it is insufficiently inquiring to assert, as Solomon does, that '*Bébé Marie* is all about sex, even though nothing about it is specifically sexual'.[88] Perhaps the construction is about sex, but in the same way that *Rapunzel* or *Pocahontas* are about sex, rather than in terms of the more Sadeian connotations of Surrealist art. It is important to note, however, following on from Hauptman's observation, that the viewer's interpretation of an artwork such as this is, to a very great degree, informed not just by what we know of the artist, but by the cultural associations that we ourselves bring with us. For example, depending on their tastes, a twenty-first-century viewer may well see not a fairy tale china doll gazing through a hoary fence but, instead, a long-lost sister or bride of the murderous *Chucky* doll, from the *Child's Play* films (1988–2004), waiting to ambush an unsuspecting victim.[89] Harold Rosenberg observed in 1969 that 'Cornell's ties with Surrealism are biographical rather than aesthetic or ideological';[90] similarly, the viewer's ties with Cornell may be little more than autobiographical, rather than necessarily aesthetic or ideological. Just as Cornell may once have seemed to be a Surrealist, by individuals surrounded by Surrealist art and influence, when taken out of that context, his work can in fact appear to be anything the viewer would like it to be, which is, of course, part of its power.

His life's work is, ultimately, as his friend the poet Marianne Moore asserted, an 'initiation in originality'.[91] His hundreds of wooden boxes, collages, and journals constitute a rare act of serial ventriloquism in which Cornell constructed a fragmentary visual narrative already half-imagined, communing simultaneously with the past and with a bittersweet and always retreating future, from the vantage point of a hyper-real present. In collages like *Story without a Name (for Max Ernst)* (1942) and the cut-out *Theatre of Hans Christian Andersen* (1945), we can see him developing ways of telling stories without using words; in other words, inventing a new kind of narrative. His collage letters to Parker Tyler, Pavel Tchelitchew, and Tilly Losch, among others, also demonstrate this, showing that it was never enough for him merely to write down what was on his mind; he wanted his thoughts to be manifested visually as well, and for his correspondents, if they wished, to be able to add their own meaning or interpretation to his missives. Collage enabled Cornell to be both a poet and an artist simultaneously; like a writer, he kept notebooks and journals, forever jotting down his thoughts and ideas on whatever scraps of paper he had to hand. These ideas were then transformed

88 Solomon, 155.

89 Don Mancini's film franchise consists of *Child's Play* (1988) and five other films. The protagonist is a serial killer who uses a voodoo ritual to incarcerate his soul inside a 'Good Guy' doll (Chucky), in order to escape death.

90 Harold Rosenberg, *Artworks and Packages* (Chicago: University of Chicago Press, 1969), 79.

91 Marianne Moore, in a letter of recommendation for the Simon Guggenheim Memorial Fellowship, for which Cornell applied on 19 September 1945, quoted in Tashjian, 72.

and represented visually, rather than in writing, in order to evoke more strongly the sensations that had initially provoked them. 'One can almost feel the chilly breeze of the Channel at Dieppe or some other outmoded, out-of-season French resort', John Ashbery wrote, about the experience of looking at Cornell's *Hotel* boxes from the 1950s. Ashbery identifies 'the secret of [Cornell's] eloquence' in his subtle figuring not of 'the country itself but the impression we have of it before going there, gleaned from Perrault's fairy tales or old copies of *L'Illustration*, or whatever people have told us about it'.[92]

We are not given France in a box, or Italy, or even the stars, but these places as they are imagined by an individual who has never been there, and who knows he will never go, projected into an unattainable future from the crystallized state in which they already exist, and always have, in the form of old maps, sheet music, picture postcards, and books of poetry. The viewer of Cornell's *Hotel* boxes remains, like the implied hotel guest, and like Cornell himself, trapped within the box, and within the dream of travel. Equally, the dream of knowing a woman like Tamara Toumanova or Lauren Bacall, or a poet such as Gérard de Nerval, or of being a significant part of the drifting tide of the New York streets, was always one that partly came true and yet always somehow eluded Cornell, trapping him within the unremitting cycle of his delicate attempts to reincarnate something that had never fully existed. An artistic procedure, modelled on an inherent Symbolist confidence in private visions and contemplated objects,[93] and using the urban treasure-map of the *flâneur*, was carefully developed by Cornell in order to create what Julia Kelly identifies as 'a solitary poetic place of reverie ... permeated with the ambivalence of a nostalgia for places never seen',[94] for women never met, skyscrapers never ascended, centuries never lived in. Ultimately the viewer comes to recognise that this poetic place is Cornell's only destination, that by its very nature it rejects any pretence at external discovery or exploration, and that it is what the collages evoke and the boxed constructions hold. The fragmented hotel advertisements, foreign stamps, and exotic maps have all been found by Cornell in the junkshops of his home city: as opposed to being personal plunder from innumerable trips abroad, they are in fact personal plunder from innumerable trips into Manhattan and its surrounds. Furthermore, if, as Hopps notes, Cornell 'responded to signs in the world – on buildings, shops, stores or theatres', it was not on account of a desire to ape another culture, but rather because 'he liked the language'. Hopps adds that, as in the flyer for Levy's *Surréalisme* exhibition, designed by Cornell, 'the words and phrases in Cornell's work float alone, rather than being built into the composition

[92] Ashbery, *Reported Sightings*, 15.

[93] 'La contemplation des objets, l'image s'envolant des rêveries suscitées par eux, sont le chant' ('the contemplation of objects, the images that soar from the reveries they have induced, constitutes the song'). Stéphane Mallarmé in an interview with Jules Huret, 'Enquête sur l'évolution littéraire' (Paris: Fasquelle, 55–65); originally published in *L'Echo de Paris*, 3 March–5 July 1891.

[94] Kelly, 85.

as they are in the work of Braque or Schwitters'.[95] Unanchored, dislocated, these collage elements operate as a form of misdirection closely related to Hauptman's image of the hall of mirrors. Artistic sleight of hand on Cornell's part initially evokes the expansive illusion of a foreign place or distant universe. However, as in a hall of mirrors, the evocative, mysterious profusion of never-ending images is in fact self-conscious and internal, rooted by necessity in a kernel of reality; in other words, the place in which the reflected object is located, and which the mirrors cannot help but show. In the end, all Cornell's collages and boxes point to the same place – the reflected object is always himself, and his New York.

Similarities have been drawn between Cornell and Raymond Roussel, a writer who, albeit in a manner less ingenuous than Cornell, also chose to present his elaborate imaginative fabrications in the false guise of factual travel narratives. It is therefore interesting to note a quotation copied into Cornell's diary from 1968, from an essay by Alain Robbe-Grillet on Roussel, which Rayner Heppenstall had featured in his 1966 monograph on the writer. The quotation includes the vague, almost contradictory, yet highly telling remark: 'it is a world from which we discover we can never get out. Everything has stopped, everything goes on reproducing itself'.[96] What this enunciates about Cornell's work is the function of his boxes according to the principle of Schrödinger's Cat.[97] At their heart is an undeniable constant, but for as long as the boxes remain closed, both the real and the imaginary may exist simultaneously, fully formed in the mind of the viewer, a quantum structure functioning as a repeated superimposition of states that is neither quite one thing nor another. This effect is one that Cornell seems to have felt could not be achieved solely in the practice of pure, two-dimensional, paper collage: he needed the box constructions, rooted in and continually informed by the principles of collage, in order to express the sense of containment thrown up both by the Manhattan skyscrapers and by his stifling life in the house in Flushing. Travelling, meeting people, or even accepting his fame, necessarily remained an unrealised dream because he felt himself, one way or another, at all times to be trapped within a box construction, within a constructed world, whether by the Iroquois skyscraper builders in New York, or by his overbearing mother and dependent brother on Utopia Parkway. It is a world in which Cornell seems to have existed uncomplainingly, and in which, following his entry into the world of art, his state of confinement was a positive one. Whilst his 'wonderful, irrational discovery' of collage liberated him from his previously mundane and frustrated existence as a cloth salesman, his subsequent move from collage to box construction was almost

95 Hopps, 71.

96 8 April 1968, Cornell Papers, AAA, Series 3, Box 9, fol. 4.

97 Schrödinger's Cat, formulated by the physicist Erwin Schrödinger in 1935, is a thought experiment related to the Copenhagen Interpretation of quantum mechanics. It presents a situation in which a cat may be dead or alive, depending upon an arbitrary sequence of events. However because the sequence of events takes place within a sealed box, the implication is that until the box is opened, the cat is simultaneously alive and dead.

like discovering that the world was round or seeing in colour for the first time. Not only were the boxes more closely representative of the dreamlike affinities which Cornell saw in everyday life, but they also permitted manifestations of sound and movement that were unavailable to pure collage, such as balls that roll around and sands that shift (which, incidentally, was an aspect of Cornell's work by which Frank O'Hara was particularly captivated).[98] Like many of O'Hara's poems, Cornell's box constructions were often 'for' someone – a ballerina, a writer, an artist, a friend – and embody his gift compulsion (a character trait O'Hara also shared), or, as Cornell once jotted down, the 'necessity of approaching own work in a spontaneous spirit of giving first'.[99] They exemplify his appreciation for the passing on of things, for bartering and for sharing, revealing affinities between and giving form and purpose to the otherwise useless, recycled objects with which the boxes are filled. Finally, the boxes, and the items selectively collaged within them, can been seen as acts of reciprocal gift-exchange between Cornell's past, present, and future, charting his life, rarefying and representing in microcosm all that he experienced in New York City. As he said to David Bourdon, 'everything can be used in a lifetime, can't it? ... How does one know what a certain object will tell another?'[100]

[98] 'Reviews and Previews: Joseph Cornell and Landes Lewitin', *Artnews* 54, no. 5 (September 1955), 50.

[99] Diary Entry, 1 September 1953, Cornell Papers, AAA, Series 3, Box 6, fol. 22.

[100] David Bourdon, 'The Boxed Art of Joseph Cornell', *Life*, 15 December 1967, 63–66a.

Chapter 2

'Confusion hath fuck his masterpiece':[1]
Re-reading William Burroughs,
from *Junky* to *Nova Express*

When William Burroughs first emerged on the literary scene in the early 1960s, his published works were subject to numerous emotional, subjective responses, which focussed rather too strongly on the content of his novels and not strongly enough on their compositional style. He was presented by his supporters as a writer in the tradition of Jonathan Swift, Gustave Flaubert, James Joyce, Henry Miller, and Jean Genet, rather than, as would have been more representative of the work he was engaged in, an artist in the tradition of Hieronymus Bosch, Pablo Picasso, Max Ernst, Hannah Höch, and Jackson Pollock. As a result, many readers, both then and since, have come to his work with misleading expectations, and have found themselves at best confused or disappointed, and at worst disgusted and nauseated. This chapter proposes a reassessment of the way readers approach Burroughs's novels of the 1950s and 1960s, from *Junky* to *Nova Express*, arguing that it must be informed by an understanding of his compositional techniques and setbacks: in other words, how and why he came to use collage in his writing. I will chart the development of Burroughs's writing, from the linear narrative of his first novel, *Junky*, through the 'lost' novel, *Queer*, and the epistolary writings which informed much of *Naked Lunch*, to the transformation of his work into the calculated collage style in which he wrote his 'cut-up' novels, also known as *The Nova Trilogy*. I will discuss the reasons for this transformation, and assess the successes and inevitable failures of using the more radical cut-up technique to produce his novels. I have chosen to concentrate chiefly on the novels rather than on the hundreds of shorter cut-up items that Burroughs also produced during the same period, predominantly because of the novels' relative availability and the likelihood of their having a wider readership.

Burroughs took his experiments with collage further, and more seriously, than any other artist working in the twentieth century. He initially developed his cut-up method of composition in Paris, where, as Henry Miller wrote, 'at the very hub of the wheel, one can embrace the most fantastic, the most impossible theories, without finding them in the least strange'.[2] The years he spent living in New York during the 1940s, however, when he dabbled in both petty crime and writing, also had a long-term effect on his career as an experimental writer, informing his views

[1] *NL*, 35.
[2] Henry Miller, *Tropic of Cancer* (London: Calder, 1963 [1934]), 181.

on drug economics, policing, and crime, and engendering in him the paranoia that partly lay behind his later turn to the cut-up technique. During this period he and Jack Kerouac collaborated on a novel based on the murder of one mutual friend by another, entitled *And The Hippos Were Boiled In Their Tanks*.[3] Burroughs and Kerouac wrote and then combined alternate chapters, and in this sense the novel was an inadvertent prototype of his later cut-up and fold-in methods. During this period in New York Burroughs also began to develop, as Francine Prose notes, 'his fascination with transient images – what we see as we walk down a street, the multiple reflections that we catch as we pass a window, the competing columns of text that clamour for our attention each time we leaf through the daily newspaper – and his desire to incorporate that transience, cacophony and multiplicity into his art'.[4]

Whilst many critics and readers remained largely impervious to his cut-up and collaged material, Burroughs's letters throughout the 1960s delineate his passion for collage and the cut-up technique. He enthusiastically extolled the 'spectacular' nature of the photo-collages he was experimenting with, hailing his companion and fellow collagist Brion Gysin as his 'first Master'. He revelled in his belief that the cut-up technique 'place[d] at the disposal of writers the collage used in painting for fifty years', and lamented the failure of the Surrealists to 'develop the formula further'.[5] After nearly a decade of experimentation, in which he applied the cut-up technique to several novels, hundreds of shorter cut-up pieces of writing, film, photography, and audio recordings, Burroughs began to leave the practice of collage behind him, having progressed naturally through it, rather than rejecting it outright. It would, however, inform much of his subsequent work, both conceptually and because it had played such a significant part in establishing his misanthropic, yet somehow alluring (and enduring) persona, as the scourge, iconoclast, and ruthless dismantler of bourgeois ideology – a persona which has since been emulated in the work of writers such as Will Self, J.G. Ballard, Stewart Home, and Bret Easton Ellis.

[3] Written in 1945; published in 2008 by Penguin (UK) and Grove Press (USA).

[4] Francine Prose, 'Magic Moments: Hans Christian Andersen and William Seward Burroughs' in *Cut-Outs and Cut-Ups: Hans Christian Andersen and William Seward Burroughs*, ed. Hendel Teicher (Dublin: Irish Museum of Modern Art, 2008), 62.

[5] Burroughs to Gysin, 16 May 1961 and 14 June 1961 (Burroughs Papers, Berg Collection, Series III, Box 85, fols 4–5). Burroughs to Ginsberg, 2 December 1959, in *Rub Out The Words: The Letters of William S. Burroughs 1959–1974*, ed. Bill Morgan (London: Penguin, 2012), 10. 'The Cut Up Method of Brion Gysin', in *A Casebook on the Beat*, ed. Thomas Parkinson (New York: Crowell, 1961), 105–6. See also Burroughs/ Gysin, *The Third Mind* (London: Calder, 1979), 34: 'Writing is fifty years behind painting. I propose to apply the painters' techniques to writing: things as simple and immediate as collage or montage … The poets are supposed to liberate the words – not to chain them in phrases' ('The Photo Collage', London, 1963. Typescript held in the Burroughs Papers, Berg Collection, Series I, Box 10, fol. 6).

Collage enabled Burroughs to set himself up as an original, to distance himself from the other Beat writers, and to explore the sense he had of himself as being unique, powerful, independent, and revolutionary, which the troubled process of writing his first two novels *Junky* (1953) and *Queer* (written 1952, published 1985) had severely undermined. Collage brought him out from under Allen Ginsberg's protective wing, freed him temporarily from the 'highly irritating'[6] demands of publishers, and simultaneously endeared him to the editors of numerous little magazines. It gave him, for the first time, a sense of control over his writing, and solved the formal, organisational problems that had plagued him since he first began to write *Junky* in the early 1950s. This chapter will chiefly explore the role that collage plays in the often strained relationship between Burroughs's readers and his work. It will suggest that the strong visceral and emotional responses, generated by the subject matter of his writing, distract readers from its formal assault, achieved by his use of collage, which is ultimately more compelling and important in the context of literary and artistic history. His work has an emetic effect that operates on two levels: as revulsion at what he says, and as a kind of motion sickness caused primarily by the form and structure he uses. I want to show that his confusing formal structure – collage – is as much responsible for the nauseating effects of his writing, and, furthermore, to pose the question: hath confusion made or fucked his masterpiece?

Above all, this chapter is an attempt to address and overcome the difficulties of reading William Burroughs's work. Using an understanding of collage as a critical framework, it will assess where readers go wrong and endeavour to navigate a new path through the complexities of Burroughs's writing. Much of the chapter is biographical in emphasis, in keeping with my anthropological approach, drawing extensively on Burroughs's correspondence to demonstrate his growing dissatisfaction with the novel form. I will consider the contemporary responses to Burroughs, and show how he came to be established as a literary figure, credible or otherwise, before illustrating the almost uniformly gastric focus of the reviews of his collaged and cut-up work. My key assertion is that Burroughs's writing is 'sickeningly painful to read'[7] not on account of its content but because of its compositional style. I will briefly consider the role of the publication histories of Burroughs's first trilogy – *Junky, Queer,* and *The Yage Letters* – drawing on the meticulous archival work of Oliver Harris to suggest that the act of cutting up his manuscripts was highly painful for Burroughs if it was not entirely on his own terms; this will set up my later argument that the cut-ups were, in part, an act of revenge on the publishers who had been so highly demanding of him in his early days as a writer. This chapter will also explore the troubled and chaotic genesis of *Naked Lunch* and the beginnings of collage in Burroughs's work, and examine his intensely problematic organisational issues, his apparent inability to

6 Burroughs to Ginsberg, 22 April 1952 (Ginsberg Papers, Columbia, Box 1, fol. 22).
7 Brion Gysin, quoting Burroughs, in Barry Miles, *William Burroughs: El Hombre Invisible* (London: Virgin, 1993), 126.

sustain a narrative thread, and his resulting cannibalisation of his own letters to form a significant part of his most famous work. My discussion of the cut-up novels themselves will assess their relationship to the European avant-garde and the history of collage, to Burroughs's preceding work, and to the establishment of his own mystique, repositioning them less as a sequence of words which must signify meaning, and more as a collection of images, over which our eyes may roam. The lasting value of Burroughs's cut-up works is less as literary texts than as formal collage phenomena, which force a reassessment of the rules of reading and viewing, and which actively dismantle the barriers between scholarly disciplines. In so doing, they align themselves with the great European collage works of the twentieth century, including Picasso's *Still Life With Chair Caning* (1912), Hannah Höch's *Cut with the Kitchen Knife through the Beer-Belly of the Weimar Republic* (1919), and Max Ernst's collage-novel *La femme 100 têtes* (1929).

'Any juryman can vomit': Motion Sickness and Gastric Criticism

Throughout the 1960s, Burroughs fostered a deep, paranoiac mistrust of the written word, which he had come to view as a parasitic entity that was fundamentally unreliable as a means of communication. His cut-up trilogy is an incarnation of his nightmarish vision of the word as parasite, and a sustained experiment in killing the word. In it, Burroughs uses collage to decondition and disorient his readers. The trilogy forces a reassessment of the rules of reading by compelling the reader to confront pages of text and admit that they do not make sense. Burroughs's theme throughout the trilogy, embodied in its seemingly chaotic structure, is the insidious, viral nature of the word, which he came to believe was at the heart of all human transgression, feeding off systems of thought, facilitating systems of control, and transforming 'the life energy of sex and sensory experience into the mindless mechanical responses of pure need'.[8] His aim, in the cut-up trilogy, was to achieve for himself 'even ten seconds of inner silence' (*TE*, 43), or even, somehow, to 'rub out the word forever' (*TE*, 10; *NE*, 10).

When Burroughs's collaged and cut-up writing first emerged on the literary scene in the early 1960s, it was greeted with strong visceral and emotional responses, generated primarily by the explicit subject-matter of his writing, which distracted readers from his work's formal collage assault. *Naked Lunch* and the cut-up trilogy had 'horrified censors, professors and policemen arrayed in mortal combat',[9] with Burroughs's detractors accusing his work of being 'spiritually as well as physically disgusting',[10] and his advocates insisting that he was 'possessed

[8] Robin Lydenberg, 'Notes from the Orifice: Language and the Body in William Burroughs', *Contemporary Literature* 26, no. 1 (Spring 1985): 60.

[9] Herbert Gold, 'Instead of Love, the Fix', *Sunday New York Times Book Review*, 25 November 1962, 4.

[10] Victor Gollancz, *Times Literary Supplement*, 28 November 1963, 993.

by genius'.[11] The unifying trait amongst reactions to his work could perhaps be labelled gastric criticism, pivoting as it did (and still does) around evocations of strong nausea and physical disgust, as well as allegories of consumption, perpetuated to a certain extent by the title of Burroughs's best-known work – *Naked Lunch*. Burroughs himself described his work as 'sickeningly painful to read'.[12] Raymond Walters of the *New York Times* highlighted the book's 'spicy content'[13]. 'Glug, glug', wrote John Willett of the *Times Literary Supplement* (*TLS*), likening Burroughs's writing to 'grey porridge', and envisioning vomiting jurors at the anticipated obscenity trial. Various contributors to the *TLS* continued in this vein, remarking that 'no one has yet claimed one good dinner to be worth half a dozen naked lunches',[14] that Burroughs's writing 'certainly smells very poisonous',[15] and that perhaps 'American stomachs [are] stronger than ours'.[16] Anthony Burgess, writing for the *Guardian*, observed of *Naked Lunch*:

> We are all sitting grinning at a ghastly meat which he suddenly shows us to be cannibalistic. The meat on the end of every fork is revealed as the guts and blood of our fellow-men. It is a revelation which will please nobody and may spoil a few appetites.[17]

In 2009 Kurt Hemmer suggested that Burroughs 'is showing us the naked truth on the end of the fork – and maybe he wants us to be sick',[18] and in early 2012 James Campbell showed that the allegory of ingestion still holds today, endorsing *The Soft Machine* and *The Ticket That Exploded* as 'good reading if taken in small doses'.[19]

Such responses – even the positive ones – clearly indicate the notably anacathartic effect of Burroughs's writing, an effect which has discouraged and distracted many readers from fully understanding Burroughs's decade-long compositional experiment. Whilst *Naked Lunch* ultimately weathered the critical reaction to it, perhaps because the power of the writing transcends its

[11] Norman Mailer, 'William Burroughs' *Naked Lunch*', Grove Press publicity pamphlet, 1962, 4.

[12] Brion Gysin, quoting Burroughs, in Miles, *El Hombre Invisible*, 126.

[13] Raymond Walters, 'In and Out of Books', *New York Times Book Review*, 16 September 1962, 8.

[14] Damian Grant, *TLS*, 23 January 1964, 73.

[15] Dorothy Day, *TLS*, 9 January 1964, 27.

[16] John Carter, *TLS*, 23 January 1964, 73.

[17] Anthony Burgess, 'On the End of Every Fork', *Guardian*, 30 November 1964, 9.

[18] Kurt Hemmer, '"the natives are getting uppity": Tangier and *Naked Lunch*', in *Naked Lunch@50*, ed. Oliver Harris and Ian Macfadyen (Carbondale: Southern Illinois University Press, 2009), 70.

[19] James Campbell, Review of *Letters 1959–1974*, ed. Bill Morgan, *Guardian*, 23 March 2012, http://www.guardian.co.uk/books/2012/mar/23/rub-out-words-william-burroughs-review?newsfeed=true [Accessed 29 March 2012].

alienating form, the cut-up trilogy has, as far as a general public readership is concerned, sunk almost without trace. So what is it about Burroughs's work that makes readers feel sick enough not to want to continue reading it? Certainly the subject matter of these novels is disturbing: hangings, surgical carnage, explicit sex, and graphic depictions of drug-taking are relayed with potentially nauseating frequency. But the subject matter is arguably no more disturbing than that of many other novels: during the same decade Miller's *Tropic of Cancer* was published in America for the first time, whilst Anthony Burgess's *A Clockwork Orange*, Hubert Selby Jr's *Last Exit to Brooklyn*, and Pauline Réage's *The Story of O* were also released, to similar outrage, but have continued to thrive. Similarly, novels written since (by writers who seem to be actively emulating Burroughs's iconoclastic persona), such as Bret Easton Ellis's *American Psycho*, J.G. Ballard's *Cocaine Nights*, Will Self's *My Idea of Fun*, and Stewart Home's *69 Things To Do With A Dead Princess*, have largely met with critical approval and a modicum of success amongst readers. In defence of Burroughs's writing, the publisher John Calder noted that while many novels provoke nausea (for instance, he cites Beckett's *Trilogy* as 'deal[ing] almost entirely in matter that is sordid, unpleasant, nausea-making, and frightening') this fact does not necessarily render them 'without value, beauty, poetry, and truth'.[20] Burgess asserted that 'too many people who should know better protract a squeamishness about subject-matter that sickens their capacity to make purely literary judgments'.[21] Burgess, along with Jack Kerouac and Burroughs himself, attempted to present *Naked Lunch* and the cut-up trilogy as deliberately extreme, hyperbolic satire in the vein of Jonathan Swift's *A Modest Proposal* or *Gulliver's Travels*, but many critics remained unconvinced – as have subsequent generations of readers, who generally eschew the cut-up trilogy in favour of Burroughs's earlier, linear novel *Junky*, and his later, also more linear, *Red Night Trilogy* (1981–1987).

The answer seems to lie in the ways in which the novels were written – and, correspondingly, in the ways in which the novels are read. The *Red Night Trilogy* and Burroughs's early writing, as well as the work of the writers noted above,[22] whilst equally nauseating in terms of content, are formally and stylistically relatively straightforward to read. Conversely, the cut-up trilogy, and *Naked Lunch* to a certain extent, read – if they can be said to read at all – like the uncontrolled spewings of an ailing machine. David Trotter might describe them as 'bad messes', figuring 'the world's opacity in and through the disgust they provoke … [They] do not irritate us, or frighten us; they make us sick'.[23] Due to Burroughs's numerous, simultaneous revisions, the novels cannot be said to begin or end, or even to run in sequence, arguably making the appellation of 'trilogy' something

[20] John Calder, *TLS*, 2 January 1964, 9.

[21] Burgess, *TLS*, 2 January 1964, 9.

[22] Miller, Réage, Burgess, Selby Jr., Easton Ellis, Home, Self, and Ballard.

[23] David Trotter, *Cooking with Mud: The Idea of Mess in Nineteenth-Century Art and Fiction* (Oxford: Oxford University Press, 2000), 16.

of a misnomer. Furthermore, as Alan Ansen argues, 'to sketch a progression is pointless, since the work is conceived as a total presence',[24] or, as Burroughs put it, 'this novel is *happening*'.[25] A kind of twisted anti-logic emerges as the novels progress, as sections of text replicate and permutate from one novel to the next. The texts imply that in some alternate universe the narrative may once have been fully functional, but now it trails only the ghost of familiarity. Robin Lydenberg warns that Burroughs 'deliberately redirects the very process of reading away from any expectation of continued action', subverting the use of sequential refrains and arbitrarily substituting pronouns in a sustained act of wilful 'disorientation which renders everything defamiliarized, shifting and uncertain'.[26] Motifs recur throughout the texts, but are usually unanchored and unexplained. Characters are inserted into the text unannounced and fully formed, akin to Duchamp's readymades, with Burroughs himself asserting that 'you don't know where they came from or how they got to be where they are'.[27] He discards any prescribed transitions or contrived links. Characters vanish inexplicably from the action, 'walk in and out of the screen' (*TE*, 53), and the reader is frequently addressed in a disembodied but oddly intimate voice. 'Remember strange bed?' it asks, in *The Ticket That Exploded* (82), and, sarcastically, in *The Soft Machine*: 'fun and games what?' (17). The elusive, quasi-narrator plays no role in guiding the reader through the linguistic mire in which the action takes place. The reader may gather that there is some kind of a journey taking place, and some kind of a battle, but the whole thing occurs entirely without judgment and, seemingly, without organisation, in locations that are real, imagined, or hallucinatory, primarily in a state of anarchic flux and always on the very brink of catastrophe, both in terms of style, form, and content. The cut-up novels are, in Burroughs's words: 'pure abstract literature'.[28]

These are not novels in the traditional sense, and it is essential, therefore, to reassess the squeamishness they provoke: our nauseated response to them seems to be caused more by textual mess than by textual obscenity. Rather than being straightforward ideological revulsion, it may be a kind of kinetosis, or motion sickness, which obstructs and problematizes the traditional processes of reading and interpretation. Joan Didion, reviewing *The Soft Machine* for *Bookweek* in 1966, argued convincingly that Burroughs's subject matter was 'in no sense the point'. Instead, she suggested, it was the sound of his voice – 'hard, inventive, free, funny, serious, poetic, indelibly American' – that was important:

[24] Alan Ansen, 'Anyone Who Can Pick Up a Frying Pan Owns Death', in *The Burroughs File* (San Francisco: City Lights Books, 1991 [1984]), 22.

[25] Letter to Ginsberg, 28 October 1957 (Ginsberg Papers, Columbia, Box 2, fol. 3).

[26] Lydenberg, *Word Cultures: Radical Theory and Practice in William S. Burroughs' Fiction* (Urbana: University of Illinois Press, 1987), 57–71.

[27] Miles, *El Hombre Invisible*, 157.

[28] Burroughs to Dave Haselwood, 24 June 1960, *Letters 1959–1974*, 33.

> The medium is the message: the point is not what the voice says but the voice
> itself, a voice so direct and original as to disarm close scrutiny of what it is
> saying. Burroughs is less a writer than a sound, and to listen to the lyric may be
> to miss the beat.[29]

Indeed, close scrutiny of *what* Burroughs is saying rarely proves rewarding.
His writing is generally unconvincing in moral terms; satire or not, it fails to argue
for anything that has not been argued for more convincingly elsewhere, but this
is not its point. His work is too fragmented and too frenetic compositionally to be
able to embed within itself a singular message or meaning – there is no victory for
the critic here. Certainly many messages and many meanings can be located within
the tissue of the texts, some originating with the author, some by accident, and the
majority with his readership, the 'one place where this multiplicity is focused',[30]
to quote Barthes, or in Burroughs's own words: 'departed have left spectators
involved' (*TE*, 56). But by listening to his voice, to the sound that it makes rather
than the words it enunciates, the reader is able to focus on the one thing which is
recognisably Burroughs's – namely, his compositional style, comprising his use
of mosaic and of collage, the cannibalisation of his letters, and his cut-ups and his
fold-ins. This legitimises the nature of his subject matter, and is something that
readers can grasp. His methods of composition are significantly more momentous
in relation to both the history and the future of the novel than his subject matter or
any dubious moral message that he may have been attempting to convey. If readers
are to succeed in *not* 'listen[ing] to the lyric', focussing instead on Burroughs's
collaged medium, they will find it possible to think of his writing less as a sequence
of words which must signify meaning (with its attendant feelings of revulsion and
disgust), and re-imagine it instead as a collection of images embodying Burroughs's
larger, central idea – namely, the tyranny of the written word – over which one's
eyes may roam. Burroughs was attempting to show that if readers take words – any
words, including his – at face value, then they are submitting unquestioningly to
their power. But by refusing to allow meaning to take over, readers can negate this
power. Readers who responded to his work on an emotional, visceral level proved
his point: finding themselves nauseated by the subject matter of his work (that is,
by what his words were *saying*) they were looking for meaning in the wrong place.
They were picking through verbal garbage and trying to find a moral message that
would redeem the obscenity, whilst failing to see what was right in front of their
eyes, namely that 'the medium is the message'.

Burroughs's cut-ups are works of literature aspiring to the conditions of the art
world, attempting to posit the linguistic sign as a visual image and to equate the
novels' textual architecture with their grammatical substance and etymological
meaning. His overarching intent was to decondition the kind of automatic,
emotional readerly response that had so characterised the negative reviews of

[29] Joan Didion, 'Wired for Shock Treatments', *Bookweek*, 27 March 1966, 2–3.
[30] Barthes, 'The Death of the Author', 148.

his work. Just as Picasso and Braque's *papiers-collés* were less an attack on the institution of art itself than an attempt to show and to see things differently, so Burroughs's cut-up novels do not attack literature in itself so much as lazy readers and uninventive writers. The ostentatious embedding of the collage practice within his work advocated and, to a certain extent, legitimised the concept that a text is as much a composition of heterogeneous elements, or 'graphical ensemble',[31] as it is a sequence of signs denoting narrative meaning. Thomas Brockelman, who posits collage as a feature of postmodernism imbricated with modernism, advocates a view of 'painting and sculpture as writing'.[32] Equally, then, writing can be viewed as a form of painting. Considered in this way, Burroughs's seemingly impenetrable cut-up novels should be approached not as novels, but as a series of interrelated pieces of art, consisting of found objects, montages, and simulated and actual collages. In the absence of grammatical logic, discernible characters, or plot, the reader is required to participate in the text, moving 'beyond the limits of conventional seeing'.[33] If the reader can disregard their expectations of verbal linearity and plot, they will experience a kind of cinematic weightlessness, in which the words on the page appear as a composition of moving images, a dynamic landscape in which, as Tony Tanner observes, 'images crowd in on all sides and from the past, predetermining the present and pre-empting it of its own reality'.[34]

'A medium suitable for me does not yet exist, unless I invent it'

At the time Burroughs began writing, collage was no longer new to art, and whilst it had engendered in much of modern art a strong inclination to experiment and to collaborate, the act of making collage was no longer the weapon of revolution that it had once been for the plastic arts. However this was not the case for literature and music, where it presented ever-new means for experimentation. Just as the realm of plastic art was beginning to turn away from collage, in the late 1950s and throughout the 1960s, the practice was finally being more fully appropriated by literature and music, being used in various formats by the Beatles, John Cage, Bob Dylan, Adrian Henri, John Ashbery, Frank O'Hara and, of course, Burroughs. Burroughs used it overtly and most consciously in the work that immediately succeeded *Naked Lunch*, not just in the cut-up novels (or *Nova Trilogy*), but also in collaborative works such as *Minutes to Go*, as well as experimenting with collage in photography, film, and sound recordings.

The cut-up novels – *The Soft Machine*, *The Ticket That Exploded*, and *Nova Express* – are generally known as Burroughs's first trilogy, whilst his second

[31] Louis Marin, *Études Sémiologiques: Écritures, peintures* (Paris: Klincksieck, 1972), 19.

[32] Brockelman, 4–6.

[33] Lydenberg, *Word Cultures*, 64.

[34] Tony Tanner, 'Rub Out the Word', in *William S. Burroughs at the Front*, ed. Jennie Skerl and Robin Lydenberg (Carbondale: Southern Illinois University Press, 1991), 109.

trilogy comprises *Cities of the Red Night* (1987), *The Place of Dead Roads* (1983), and *The Western Lands* (1987). However, Oliver Harris's recent work on *Junky* (1953), *Queer* (written in 1952 but not published until 1985), and *The Yage Letters* (written in 1953 but not published until 1963), however, has shown that these three volumes were also very closely related, in spite of the considerable time lapses between the publication of each, which was due to endemic commercial and editorial pressures, and to Burroughs's reluctance to publish *Queer*. In fact, Harris's expert re-editing of all three has brought to light numerous unpublished manuscript fragments and exposed their rich and tangled textual histories, revealing each text to be a collage of the others. *Queer*'s epilogue, 'Mexico City Return', for instance, was originally intended to conclude *The Yage Letters*, but was temporarily lost; the 'letters' which comprise *The Yage Letters* are in fact mostly deliberate composites, made up of notes, diary entries, and material clearly not intended to be epistolary; and roughly an eighth of *Junky* is actually made up of excised parts of *Queer*, added because the publisher, Ace Books, demanded a longer novel and an introductory preface. This evidence repudiates the view that Burroughs's earliest novels are straightforward, realist texts from which he veered wildly with *Naked Lunch*. The complex and concealed chronicle of the production of these texts is very much a part of the experience of reading them, as with all Burroughs's work. Unfortunately, and to the detriment particularly of the cut-up novels, this is not always apparent at the time of reading. In order to begin to understand the labyrinthine structure and seemingly undisciplined form of the cut-up novels, and to understand their importance in relation to Burroughs's career, it is necessary to trace their thematic and stylistic origins back to *Naked Lunch*, to the tentative, paranoid, and unschooled pages of *Queer*, and to the vivid but deadpan, semi-autobiographical *Junky*.

The cut-up novels evolved out of *Naked Lunch* in much the same way that *Naked Lunch* evolved out of Burroughs's first two novels, *Junky*, published under the pseudonym William Lee in 1953, and *Queer*, which was written shortly after *Junky* but was not published until 1985. *Junky* is an ethnographic depiction of post-war heroin subcultures in New York, New Orleans, and Mexico City, related in measured prose by a curiously un-literary version of Burroughs himself. Whilst it is autobiographical, Will Self is correct to posit it less as a memoir about heroin addiction than an 'insistent monologue' in the vein of Camus's *The Fall* (1956) or Sartre's *Nausea* (1938), 'in which an alienated protagonist grapples with a world perceived as irretrievably external and irredeemably meaningless'.[35] Although *Junky* is a written using a straightforward narrative, thematically it is typical of much of Burroughs's work, which has its roots in his period as a small-time criminal in New York and which depicts crime, criminality, and systems of control, and is populated with stool pigeons, narcotics dicks, marks, the FBI, and private detectives, all mechanisms of a perceived authoritative conspiracy which he saw as a 'cancer on the political body of this country which no longer belongs to its

[35] Will Self, Preface to *Junky* (London: Penguin, 2002), xi.

citizens'.[36] Burroughs, who studied anthropology as a graduate student at Harvard, was fascinated by an underworld of which he was simultaneously a part and not a part. Harris has illustrated this key duality in Burroughs's persona by exploring his famous proclivity for hats, suggesting that Burroughs's hat of choice (typically a fedora or trilby) nodded simultaneously to criminal underworlds and conservative professions, evoking both gangsters and bankers, mean streets and manners.[37] His texts often reveal him to be surveilling himself, 'the Ugly American' (*NE*, 16), a voyeur on a criminal underclass, for which he is only too eager to throw away his life of privilege. Trapped in 'a loveless and parasitic system',[38] relationships between the watchers and the watched in his work are deeply ambiguous. His eloquent, liberal, and often far-fetched solutions to the pyramidal systems of drug abuse are underpinned by an assertion that no politician or policeman would really want to eliminate such problems. Finally, however, the gulf between the remarkable crimes in which he himself was involved during his life, and the lurid depiction of criminality in his novels, indicates that for him the gesture of egress, of closing one's eyes, was the ultimate act of subversion, and the only way to draw a line between painful self-surveillance and gratuitous voyeurism.

Eric Mottram, in his seminal work on Burroughs, *The Algebra of Need*, described *Junky* as the 'documentary from which the action novel of *The Naked Lunch*' was made, observing that, among other things, it 'contains ways in which junk experience releases typical twentieth-century urban horror, the staple of the later works'.[39] The linear narrative style of *Junky* often conceals its similarity to the more notorious, stylistically radical *Naked Lunch*, as well as to aspects of *The Nova Trilogy*, but it is populated by the same liars, manipulators, criminals, parasites, and atrophied personalities, informed by the same sense of purposelessness, paranoia, and wry despair, and permeated with the same vicious burlesquing of international corruption and the hideous economics of want and need, all of which Burroughs had experienced during his time as a petty criminal and burgeoning drug addict in New York City. What appears to be an ingenuous first novel re-emerges six years later in the form of *Naked Lunch*, a masterpiece of artifice, but, as Harris has shown, the transformation is 'not just *from* one text *to* another but *of* one text *into* another'.[40] The effect on *Junky*, unfortunately, has been to push it into the shade in terms of literary merit, rather like the character of Bubu in *Naked Lunch*,

[36] Burroughs to Kerouac, 24 June 1949, in *The Letters of William S. Burroughs, 1945–1959*, ed. Oliver Harris (New York: Viking, 1993), 52.

[37] See http://ebsn.eu/ebsn-reviews/taking-shots-the-photography-of-william-s-burroughs-exhibition-and-beyond-the-cut-up-william-s-burroughs-and-the-image-conference-reviewed-by-rona-cran [Accessed 28 April 2014].

[38] Eric Mottram, in *Conversations with William Burroughs*, ed. Allen Hibbard (University Press of Mississippi, 1999), 12.

[39] Eric Mottram, *William Burroughs: The Algebra of Need* (New York: Intrepid, 1971), 19.

[40] Harris, *William Burroughs and the Secret of Fascination* (Carbondale: Southern Illinois University Press, 2003), 49.

whose Latah[41] 'sucks all the persona right out of him like a sinister ventriloquist's dummy … "You've taught me everything you are …"' (*NL*, 118).

Junky provides a foretaste of the grim surrealism and violent derangement which is developed in *Naked Lunch* and taken to questionable extremes in *The Nova Trilogy*. Throughout his work of the 1950s and 1960s episodes reappear verbatim, cut from one novel and collaged into another, and descriptions of drug-taking, dependence, paranoia, sex, and corruption expand up and out, becoming endless lucid nightmares, vast hierarchical versions of the microcosmic delinquencies of *Junky*. Similarities are evident in numerous characters, particularly the atrophied personalities of terminal drug addiction, whom Burroughs merges into one another. The 'narcotics dick … trying to pass as a fag' in a white trench coat, who appears on the first page of *Naked Lunch*, chasing the protagonist into a subway station, has already harassed William Lee in *Junky*.[42] Gene Doolie, 'informer to the bone' (*J*, 39), whose 'envelope of personality was gone, dissolved by his junk-hungry cells', his face 'blurred, unrecognizable, at the same time shrunken and tumescent' is a version of *Naked Lunch's* 'blind pigeon known as Willy the Disk' (7). Doolie has been reduced to 'viscera and cells, galvanised into a loathsome, insect-like activity' (*J*, 48), and Willie to a 'round, disk mouth lined with sensitive, erectile black hairs … you can hear him always out there in the darkness (he only functions at night) whimpering, and feel the terribly urgency of that blind, seeking mouth' (*NL*, 7–8). Doolie also prefigures or is absorbed by the 'anonymous, grey and spectral' undercover narcotics agent Bradley the Buyer, whose cells become so junk-hungry that his body turns into an auto-immune, parasitic effluvium which begins making its own narcotics (*NL*, 14–17). Lee, in *Junky*, describes meeting Mary, the girlfriend of a 42nd Street hustler, in terms which are loudly echoed throughout Burroughs's later novels, as he grows increasingly obsessed with the image and metaphysical implications of skeletal absence:

> There was something boneless about her, like a deep-sea creature. Her eyes were cold fish eyes that looked at you through a viscous medium she carried about with her. I could see those eyes in a shapeless, protoplasmic mass undulating over the dark sea floor. (*J*, 11)

Mary's characteristics become standard fare in the later novels, as transparent jellies, metamorphosing protoplasm, and noxious fluids ooze through the texts, emblematic of helpless revulsion and insidious control, but also indicative of Burroughs's growing preoccupation with notions of the mercurial, and of shifting,

[41] 'Latah is a condition occurring in Southeast Asia. Otherwise sane, Latahs compulsively imitate every motion once their attention is attracted by snapping the fingers or calling sharply. A form of compulsive involuntary hypnosis' (*NL*, 25).

[42] 'Sure enough, there was a burly young man in a white trenchcoat standing in a doorway. When he saw me he started sauntering up the street ahead of me. Then he turned a corner, waiting for me to walk past so he could fall in behind. I turned and ran back in the opposite direction. When I reached Sixth Avenue, he was about fifty feet behind me' (*J*, 45).

deceptive, unrestricted ideas which resist organisation and which seem to have a will of their own.

The reader also glimpses visions in *Junky* of the apocalyptic worlds Burroughs will go on to create: depressed and in withdrawal, the protagonist closes his eyes to see

> New York in ruins. Huge centipedes and scorpions crawled in and out of empty bars and cafeterias and drugstores on Forty-second street [sic]. Weeds were growing up through cracks and holes in the pavement. There was no one in sight. (23)

He later muses, 'if junk were gone from the earth, there might still be junkies standing around in junk neighbourhoods feeling the lack, vague and persistent, a pale ghost of junk sickness' (93). Variations of this drug-fuelled, paranoiac, 'urban horror',[43] first glimpsed by Burroughs in New York, recur throughout his later work. The 'Composite City' section of *The Yage Letters*, for instance, depicts an imagined place where 'vast crustaceans hatch inside and break the shell of the body ... where all human potentials are spread out in a vast silent market' (50). *Nova Express*'s Agent K9 has an erotic encounter which ends 'with a smell of burning metal in empty intersections where boys on roller skates turn slow circles and weeds grow through cracked pavement' (138),[44] whilst in *The Soft Machine* the reader learns that 'crystal tubes click on the message of retreat from the human hill and giant centipedes crawl in the ruined cities of our long home' (119). Similarly, in *The Ticket That Exploded*, Ali, one of the protagonists, finds himself in the 'dark street life of a place forgotten – The city was swept by waves of giant land crabs and Ali learned to hide himself when he heard their snapping claws like radio static' (35–6). Cities in *Naked Lunch* and *The Soft Machine* are portrayed as Bosch-esque tableaux of apocalyptic chaos and iniquity, in which 'religious fanatics harangue the crowd from helicopters and rain stone tablets on their heads, inscribed with meaningless messages ... Leopard Men tear people to pieces with iron claws, coughing and grunting ...' (*NL*, 33) and 'workers attack the passerby [sic] with torches and air hammers – They reach up out of manholes and drag the walkers down with iron claws ... Sentries posted everywhere in towers open fire on the crowds at arbitrary intervals ... The city pulses with slotless purpose lunatics killing from behind the wall of glass' (*SM*, 111).

These scenarios are dormant in Burroughs's descriptions, in his first novel, of the grim junky streets of New York, New Orleans, and Mexico City, but the collage incisions which will release 'the deeper meaning hidden inside'[45] have yet to be performed. These premonitions, which will appear in his later texts having grown out of his hallucinatory perceptions and radical redefinition of reality, occur

[43] Mottram, 19.

[44] See also *TE*, 30, where this scene appears almost verbatim.

[45] Miles, *The Beat Hotel: Ginsberg, Burroughs and Corso in Paris 1957–1963* (London: Atlantic, 2003), 240.

in this text as literal premonitions of impending doom, usually, as with the vision of New York in ruins, when Lee is in withdrawal from heroin. The most telling example is towards the end of *Junky*, when, drunk and unable to sleep, William Lee once again closes his eyes, this time to see

> an Oriental face, the lips and nose eaten away by disease. The disease spread, melting the face into an amoeboid mass in which the eyes floated, dull crustacean eyes. Slowly, a new face formed around the eyes. A series of faces, hieroglyphs, distorted and leading to the final place where the human road ends, where the human form can no longer contain the crustacean horror that has grown inside it. (*J*, 111)

He concludes: '"I got the horrors", I thought matter of factly'. This short hallucination operates almost as an abstract for the writing to come, featuring not only the ghastly crustacean metamorphoses,[46] the fixation with disease and with protoplasmic masses, the recurring 'Orientals', the nightmarish exploration of the human condition, and the bleak, sardonic humour with which it is all related, but also a preoccupation with the corruption of the organic whole and the replacement of it by hieroglyphic series: what happens to the Oriental face in Lee's hallucination is closely mirrored by what happens to Burroughs's writing in the 1960s.

Whilst these indicators of what is to come are present within the text of *Junky*, what conceals them is not so much the disinterested factual narrative, as the narrator's relationship with the reader. The narrator in *Junky* is didactic, honest, and almost kind, and though the narrative voice is also largely ambivalent, it manifests little of the psychopathic mockery of *Naked Lunch* or the conspiratorial insanity of the cut-ups. As Harris asserts, in writing so candidly but so flatly about the experience of drug addiction, 'Burroughs intended neither to justify nor to deter but, disinterestedly, to document'.[47] Harris posits a 'new sense of readership' in *Naked Lunch*, which is marked by a 'nakedly motivated performance' on the part of the narrator, in order to establish a new reader-relationship based on 'hostile terms of seduction and exploitation'.[48]

Burroughs acquired this new motivation for textual performance via *Queer*, the writing of which provided the conduit between the deadpan, realist *Junky*, and the experimental study-in-grotesque that is *Naked Lunch*. *Queer*'s protagonist, yet another version of William Lee, is this time a 'frantic, inept Lazarus' (129), in withdrawal from heroin addiction and 'subject to the emotional excesses of a child' (127). The setting is relentlessly cold, dirty, and windy, imbuing the novel with a chill, nightmarish despair manifested in a narrative made up of increasingly

[46] Burroughs's fascination with crustaceans seems to have begun when he moved to Texas in 1947: a letter from Joan Vollmer to Allen Ginsberg notes that they were 'being attacked by hordes of all sorts of dreadful bugs, including scorpions, to which William has taken quite a fancy' (23 March 1947). Ginsberg Papers, Columbia, Box 1, fol. 15.

[47] Harris, *Letters 1945–1959* (New York: Viking, 1993), xxi.

[48] Harris, *The Secret of Fascination*, 50–51.

unsettling routines and tortured meanderings around the bars of Mexico City and the jungles of Panama and Ecuador. The novel ultimately disintegrates, caving in on itself, the action ceasing abruptly only to begin again, in an anguished, dreamlike epilogue told in the first person, in which nothing is allowed to resolve. In some ways *Queer* is not very far removed from the riotous, accomplished, comic armageddon of *Naked Lunch*. Ribald humour, comic routines, and deeply disturbing imagery abound, whilst certain motifs, particularly that of the metamorphosing centipede, and ideas of paranoia and control 'gone cancerous and berserk' (*Q*, 81), reappear almost verbatim in *Naked Lunch*. There is, however, a sense of vulnerability and emotional hyperbole in *Queer*, which provides a rare glimpse into the concealed territory of Burroughs's psyche, increasingly veiled after the shooting of his wife Joan and following the international success of *Naked Lunch*. Lee, the protagonist, ponders: 'Perhaps I can discover a way to change fact' (55). Burroughs echoed this in the introduction to the novel which he wrote in 1985, professing: 'My past was a poisoned river' (*Q*, 131). His famous assertion that he 'would never have become a writer but for Joan's death' (*Q*, 135) is manifested in the necessarily imperfect pages of *Queer*, with the novel's free indirect discourse confusing the intersection between Burroughs the author and Lee the protagonist.

Burroughs at the time of writing *Queer* was on junk, had recently killed his wife and was awaiting trial in Mexico, was in exile from the US, and had a young son, who had witnessed the death of his mother. Lee is none of these things, and yet reflections or shadows from the events in Burroughs's life appear in distorted manifestations throughout the novel. Early on, for example, Lee reads aloud from a newspaper 'about a man who murdered his wife and children' (19). A later scene also has dark parallels with the circumstances of Joan's death, in which Burroughs had attempted to shoot a highball glass off the top of his wife's head from a distance of about nine feet, and missed:

> The busboy had caught a mouse and was holding it up by the tail. Lee pulled out an old-fashioned .22 revolver he sometimes carried. 'Hold the son of a bitch out and I'll blast it', he said, striking a Napoleonic pose. The boy tied a string to the mouse's tail and held it out at arm's length. Lee fired from a distance of three feet. His bullet tore the mouse's head off.

> 'If you'd got any closer, the mouse would have clogged the muzzle', said Richard. (63)

Perhaps most chillingly, Lee dreams, deep in the jungles of Puyo in Ecuador, that he is standing in front of a Mexican bar called the Ship Ahoy, a thinly veiled version of the Bounty Bar and Grill, above which was the apartment where Joan was killed:

> The place looked deserted. He could hear someone crying. He saw his little son, and knelt down and took the child in his arms. The sound of crying came closer, a wave of sadness, and now Lee was crying, his body shaking with sobs.

> He held little Willy close against his chest. A group of people were standing there in convict suits. Lee wondered what they were doing there and why he was crying.
>
> When Lee woke up, he still felt the deep sadness of his dream. He stretched a hand out toward Allerton, then pulled it back. He turned around to face the wall. (104)

In the telling of this dream, with the repetition of the word 'crying' and the ill-omened crowd in their convict suits, followed by his doubtful withdrawal from Allerton, his disinterested lover, the lives of Burroughs and his protagonist painfully intersect. Burroughs seems to be putting into practice his idea of 'writing as inoculation', whereby he hoped to achieve 'some immunity from further perilous adventures ... by writing [his] experience down' (*Q*, 128). The description of the people as *wearing* convict suits, rather than actually *being* convicts, coupled with Lee's uncertainty as to the reason for his tears, suggests that Burroughs was unsure of the extent to which he should feel guilty about the killing. It also indicates a turn toward his belief that he had been possessed by the 'Ugly Spirit' (*Q*, 135) on the day he shot Joan – a belief that he felt was validated many years later when he made a cut-up in Paris which read 'raw peeled winds of hate and mischance blew the shot' (*Q*, 133).

Lee is oddly self-aware, detachedly witnessing himself provoking paranoia and suspicion in others. He recognises that Allerton is 'dubious of [his] sanity', and that he 'put [him] on guard' (*Q*, 20–21). In Ecuador he feels that 'there was something going on ... some undercurrent of life that was hidden from him' (*Q*, 84), and that the doctor he meets in the jungle 'was clearly suspicious, but why or of what, [he] could not decide' (*Q*, 102–3). His attempt to address Allerton with a 'dignified old-world greeting', instead becomes

> a leer of naked lust, wrenched in the pain and hate of his deprived body and, in simultaneous double-exposure, a sweet child's smile of liking and trust, shockingly out of time and place, mutilated and hopeless. (*Q*, 15)

The repeated shocks of rejection throughout the novel seem to manifest themselves physically on Lee. This mirrors the excruciating reckoning of Burroughs's manuscripts with his own body, whereby his publisher's demands that he excise parts of his writing left him feeling that he was 'being sawed in half by indecisive fiends who periodically attempted to shove [him] back together'.[49] Misery is described as 'spread[ing] through [Lee's] body', tears as 'hit[ting] his eyes', whilst rejection causes 'a physical pain, as though a part of himself tentatively stretched out toward the other had been severed, and he was looking at the bleeding stump in shock and disbelief' (*Q*, 50–52). Late in the novel, after Allerton has rejected him again, 'his whole body contracted with shock [...] He felt a deep hurt, as though he

49 Burroughs to Ginsberg, 22 April 1952 (Ginsberg Papers, Columbia, Box 1, fol. 22).

were bleeding inside' (*Q*, 104), and finally, when Allerton can no longer be found, the internal pain is described as being as 'sharp and definite as a physical wound' (*Q*, 115–16).

Lee eventually returns alone to Mexico City, and the narrative shifts into the first person – a telling gesture that simultaneously recalls the self-composure of *Junky* and anticipates the disorderly chutzpah of *Naked Lunch*, as well as indicating the fragmented nature of the novel's composition. *Queer* is an embryonic, uncontrolled, uneven attempt at the written sorcery of *Naked Lunch*, in which Burroughs finally succeeded in harnessing the sinister effluvium which threatened to pollute his life, and for which the only solution, he felt, was 'to write [his] way out' (*Q*, 135). It is, of course, the unevenness and hysteria of *Queer* which make it so unique amongst Burroughs's works, because whilst its comic routines and pervasive paranoia will go on to become a staple of Burroughs's writing, the naked pain manifested in its pages will not, rendering the novel a rare glimpse of the man behind the curtain. Burroughs seemed embarrassed by it, refusing to allow Ginsberg to try to publish it, and denying its existence in 1964 in a letter to the publisher Gus Blaisdell: 'There is no manuscript of *Queer*, in fact never was, this being a suggested title that never accreted any text to speak of'.[50] It is in this novel, which bridges the gap between the dry, documentary prose of *Junky* and the rambunctious, masterly style of *Naked Lunch*, that the writer is clearly revealed to be tussling with his demons, forcing himself to the realisation that, as he acknowledged to Ginsberg, 'a medium suitable for me does not yet exist, unless I invent it'.[51]

Although *Junky*, *Queer*, and *The Yage Letters* have been proved by Harris to be closely interrelated, they are nevertheless very different texts, clearly illustrating the level of the varied intervention in his work by both his friends and his publishers, and the fact that at this time Burroughs really had no distinct literary intentions, nor sufficient authority to refuse his publishers' demands. *Junky* was too impersonal, *Queer* too personal, and *Yage* too long, fragmented, messy, and duplicitous in the making. In his early years as a writer Burroughs was concerned about (and ultimately disappointed by) the commercial worth of his work and the financial dividends he hoped it would reap, advising Ginsberg 'I am about ready to hack it up and peddle it to magazines', and 'if you all can peddle it anywhere I can use the $', and 'sell me to a newspaper, Al. You're my agent'.[52] However, the editorial demands placed on him by the publishers whom he hoped would earn him money made him deeply uncomfortable, particularly with *Junky* and *Queer*. He resented cutting up his own manuscripts at the behest of strangers, deriding their

[50] 3 May 1964, *Letters 1959–1974*, 154.

[51] 23 May 1952 (Ginsberg Papers, Columbia, Box 1, fol. 22).

[52] 5 November 1951 (Ginsberg Papers, Columbia, Box 1, fol. 21); 20 December 1951 (Ginsberg Papers, Columbia, Box 1, fol. 21); Burroughs to Ginsberg and Kerouac, 23 October 1955, *Letters 1945–1959*, 299.

ideas as 'appalling', and as 'not only highly irritating but contradictory as well'.[53] But whilst he lamented that his publishers were trying to cut him in half, his being 'completely unknown'[54] left him powerless to prevent it from happening. His zest for editing his own work was erratic: he veered between a pedantic insistence that changes he had made were 'very important' to begging Ginsberg, 'please, Sweetheart, write the fucking thing, will you?'[55] Tellingly, given Burroughs's later turn to collage, he advised that Ginsberg, rather than the publisher, was permitted to cut up his work on his behalf, and that he was 'free to choose, add, subtract, rearrange'.[56] But the role of his friends and publishers in the production of *Junky* and *Queer* was ultimately too great for Burroughs to be able to feel that they were truly his. These texts began the process of realization for him that if he was to make his own mark on the canon, he would himself have to cut up the work that had already been done, partly by him, but partly only in his name.

It is for this reason that the cut-ups present both his writing and his own established mystique in parts, rather than as an organic whole, subverting preconceptions about himself whilst simultaneously enabling him to relinquish control over his manuscripts, the organisation of which had always caused him extreme pain, as I will discuss. But as early as 1955 he was coming to terms with the idea that his 'chapters form a sort of mosaic', a notion he was gradually able to acknowledge, having accepted that 'the fragmentary quality of my work is *inherent* in the method and will resolve itself so far as necessary'.[57] This first 'trilogy', then, was not only his first, albeit inadvertent, collage, it was also the crucial step toward Burroughs's invention of his own medium: the cut-ups. After all, lauded as *Naked Lunch* would be, it was the cut-up technique that truly caught the attention of both the press and the literary world.

Collage as Deliverance: Naked Lunch, the Epistolary, and the Turn to Cut-ups

Naked Lunch – that 'collage of extraordinary fragments'[58] – came even closer to the invention of Burroughs's own medium. Although ultimately a success, the novel had proved almost impossible to write, with the requirement that he impose some kind of order on his manuscript causing him such distress that it almost manifested

[53] Burroughs to Ginsberg, 23 December 1952 (Ginsberg Papers, Columbia, Box 1, fol. 23); Burroughs to Ginsberg, 22 April 1952 (Ginsberg Papers, Columbia, Box 1, fol. 22).

[54] Burroughs to Kerouac, April 1952 (Kerouac Papers, Columbia, Box 1, fol. 4).

[55] 5 November 1951 (Ginsberg Papers, Columbia, Box 1, fol. 21); 23 May 1952 (Ginsberg Papers, Columbia; Box 1, fol. 22).

[56] Burroughs to Ginsberg and Kerouac, 23 October 1955, *Letters 1945–1959*, 295.

[57] Burroughs to Ginsberg, 21 October 1955, *Letters 1945–1959*, 289; Burroughs to Ginsberg, 6 January 1955 (Burroughs Papers, Columbia, Box 1, fol. 4).

[58] Mailer, 'Evaluations – Quick and Expensive Comments on the Talent in the Room', in *Advertisements for Myself* (London: HarperCollins, 1994 [1961]), 417. Originally published in *Big Table* 3 (1959): 88–100.

itself physically. Once again, he had to have significant help with finalising the manuscript. Burroughs, Sinclair Beiles, and Brion Gysin typed up, re-edited, and delivered the first edition by hand to the printers in haphazard sections over a period of less than two weeks, so its juxtapositional form came about partly by accident. But Burroughs had been considering 'the cryptic significance of juxtaposition, like objects abandoned in a hotel drawer'[59] for some time, and, therefore, it is more accurate to posit the structure and style of *Naked Lunch* as partly deliberate and partly naturally-occurring collage (as opposed to the highly calculated make-up of the cut-up trilogy, which was designed with the intention of alienating readers and diverting their attention from the author).

Harris, as noted above, posits a 'new sense of readership' in *Naked Lunch*, which is marked by a 'nakedly motivated performance' on the part of the narrator, in order to establish a new reader-relationship based on 'hostile terms of seduction and exploitation'.[60] Burroughs's narrator no longer panders to his audience. Instead he is psychopathic and mocking, forcing the narrator-reader relationship to pivot on a knife-edge, and appending his depictions of unconscionable acts with the malevolent, nonchalant challenge to the reader: 'Wouldn't you?' (*NL*, 207). The narrator has the rabid enthusiasm of a demented scientist, a lunatic genius rampaging through his underground laboratory, exposing 'controlled chaos, confusion close-hauled into art, arbitrary order and manic manipulation ... through careful composition'.[61] Gone are the linguistic signposts, the brightly lit stylistic paths and the formal map of *Junky* – instead the reader must follow a dangerously deceptive trail of breadcrumbs through a murky, protean jungle, at the heart of which lies the sinister gingerbread cottage, or our 'feast of a novel'. The narrative has moved into an unnerving present tense – it 'not only coexists but coincides with the reader',[62] attempting to collage us into the text. The reader is implicated in the textual action from the very first paragraph of the novel, in a direct, confidential address. '[Y]ou know the type' (*NL*, 3), the narrator drawls, launching into his tale in enthusiastic, demonstrative New York-ese that belies the subsequent unfolding of events, if this is what the body of *Naked Lunch* is. Crucially, our new narrator intersects with that of *Junky* and *Queer* in order to bolster the nightmare with objectivity. Chaotic as the reading of *Naked Lunch* may be, it never trails into total abstraction, as the cut-up novels do, and the reading experience is rendered all the more visceral for its anchoring in an identifiable version of reality. *Naked Lunch* is a collage of Burroughs's surroundings and experiences at the time of writing, his narcotised sensations, letters from his friends, and encounters in Tangier with 'that

[59] Burroughs to Ginsberg, 21 October 1955, in *Letters 1945–1959*, 289; see also *NL*, 97.

[60] Harris, *The Secret of Fascination*, 50–51.

[61] Mottram, 31.

[62] Harris, *The Secret of Fascination*, 50.

pure, uncut boy stuff'.[63] The unsentimental reportage of *Junky*, which only ever subsides in order to depict hallucinatory moments of agony or ecstasy, features in the narrative of *Naked Lunch*, but is juxtaposed with gruesome, mercurial episodes in which, as Robin Lydenberg suggests, 'we cannot locate the author or the "truth"'.[64] She proposes that in order to locate the author, the truth, or even just a deeper understanding of the novel

> we must look to the negative space ... to the space cleared by the antithetical clash of these two ways of seeing. It is here, in the 'hiatus between thoughts', that Burroughs' new poetry will show itself.[65]

This idea of negative space was closely related to Burroughs's increasing awareness and acceptance of the collage form, which was, in his words, 'defined by negatives and absence' (*NL*, 97). Burroughs's life in Tangier, during the period in which he was writing *Naked Lunch*, could also be said to have been defined by negatives and absence, most notably that of Allen Ginsberg, his hitherto tireless editor and agent, and object of his largely unrequited affection. The negative space created by Ginsberg's absence bestowed on Burroughs the role of devoted correspondent, forcing him to write regularly and at length, in a way that he had never had to do whilst living in the US – a factor that may be related to his relatively late development as a writer. He admitted to Ginsberg that 'a letter is a major operation', writing that he 'like[d] to keep a letter to you on the stove and put in miscellaneous ideas, a sort of running diary', and revealingly suggesting that 'maybe the real novel is letters to you'.[66] With Ginsberg increasingly distant – busy with his own life and attempting to dispel Burroughs's romantic notions about the nature of their relationship, and at one point disappearing off the radar completely for several months – Burroughs's letters to him were transfigured from being a means to an end, to being an end in themselves. As Harris suggests, they became 'lifelines, cast across continents and oceans, converting the isolation of addiction and exile into the workshop of creativity'.[67] Much of *Naked Lunch* was written in epistolary fragments, with many of the routines in the novel occurring first in his letters, in the form of excerpts included verbatim for critiquing, but also, more interestingly, as half-formed ideas, snippets of news, or transient remarks that Burroughs shared with his correspondent almost in passing, resulting in 'the fusions and reversals of past and future, fact and fantasy that came about from

63 Tangier, as Harris notes, was itself a 'strange collage of histories and cultures', *Letters 1945–1959*, xxxiv–xxxv. Quotation is from Burroughs to Ginsberg, 13 October 1956, *Letters 1945–1959*, 329.

64 Lydenberg, *Word Cultures*, 12.

65 Lydenberg, *Word Cultures* 12–13.

66 13 December 1954, *Letters 1945–1959*, 243; 24 June 1954, *Letters 1945–1959*, 217.

67 Harris, *Letters 1945–1959*, xvi.

transcribing, cutting, and selecting from a mass of fragmentary material drawn from his letters'.[68]

Burroughs's letters indicate that despite the fortuitous publication of *Junky*, it was only by engaging in extensive correspondence that he came to the realization that he could actually write, and furthermore, although this took longer, that he could write without the help of others. Indeed, Burroughs later gave his reasons for starting to write both *Junky* and *Queer* as being because he 'had nothing else to do' (by contrast, he notes to Ginsberg whilst writing *Naked Lunch*: 'I have a great deal to do').[69] Furthermore, he recalled that whilst writing *Junky* in particular he felt confined to linear narrative, 'like a soldier to the boredom of the barracks', and had limited his style to one that vigorously eschewed 'all theory and domestic relations'.[70] In his letters, by contrast, his writing style is erratic and playful, creative and vitriolic, demonstrating his gift for the vernacular and the parodic, as well as for relaying in clinical detail the idiosyncrasies of the people and places around him, in terms at once comic and alarmingly sinister, and illustrating the plain fact that this is the kind of writing he enjoys. To Ginsberg from Tangier, for example, he writes, in a vignette that could easily be a scene from *Naked Lunch*:

> They got vicious, purple-assed baboons in the mountains a few miles out of town. (Paul Bowles was set upon by enraged baboons and forced to flee for his life.) I intend to organize baboon sticks from motorcycles. A sport geared to modern times.[71]

Increasingly, many of his letters are largely constituted of sections of text that do eventually form a part of his published work, including, from *Naked Lunch*, fragments of varying sizes from the chapters 'Benway', 'The Black Meat', 'The Market', 'Interzone', 'Hauser and O'Brien', and 'Atrophied Preface'.

His letters also make clear, however, that the organising of his manuscript and the obligation to construct some kind of narrative continuity was causing him such intense stress that it was having a physical effect. In a letter written in April 1954, Burroughs laments that his most recent 'attempt to organize is more painful than anything I ever experienced'.[72] He frequently refers to his formal mess as hopeless and horrible, and although Harris equates this with 'the pains of addiction',[73] it really has more in common with the pains of withdrawal, as evidenced by the example of the shattered Lee in *Queer*. Later in 1954, in a letter to Kerouac, Burroughs writes that 'the novel form is completely inadequate for

[68] Harris, *Letters 1945–1959*, xxxiv–xxxv.

[69] Quoted in *Letters 1945–1959*, xxii and in a letter to Kerouac, 26 March 1952 (Kerouac Papers, Columbia, Box 1, fol. 4); Burroughs to Ginsberg, 11 September 1957 (Ginsberg Papers, Columbia, Box 2, fol. 3).

[70] Harris, *Letters 1945–1959*, xxi.

[71] 1 March 1954, *Letters 1945–1959*, 199.

[72] Burroughs to Ginsberg, 7 April 1954, *Letters 1945–1959*, 201.

[73] Harris, *The Secret of Fascination*, 211.

what I have to say. I don't know if I can find a form. I am very gloomy as to prospects of publication'.[74] By February 1955, Burroughs confessed that the pressure of attempting to 'impose some form on material, or even to follow a line (like continuation of novel) ... catapults me into a sort of madness where only the most extreme material is available to me'.[75] In October of the same year he decided to use his letters as part of the novel, planning an epistolary second chapter which would enable him to evade the narrative responsibility which had so clearly troubled him during the writing of *Junky*, and, indeed, had continued to do so ever since. His suggested title for the chapter was 'Selections from Lee's Letters and Journals'. 'With this gimmick', he wrote,

> I can use all letters including love letters, fragmentary material, anything ...
> Funny how the letters hang together. I figure to use one sentence and it pulls
> a whole page along with it. The selection is difficult, of course, and tentative.[76]

Crucially, although this section of the novel never materialised, Burroughs had begun to capitalise on the idea of collage. He increasingly advocated a stylistic formlessness, revisiting the theme of 'objects abandoned in a hotel drawer' when discussing his compositional style and technique in the 'Atrophied Preface' of *Naked Lunch*, in which he abdicated his responsibility as writer 'to impose "story", "plot" "continuity"' (*NL*, 184). Whilst simply inserting pre-written letters into an ongoing piece of writing may seem to be taking the easy way out, what Burroughs was realising was that the epistolary form facilitates narrative ellipsis, which is what he had wanted all along. Collage also permits ellipses in narrative, allowing it to be both indulged and subordinated at the will of the artist. Memories can exist within memories, or outside of them, hanging together like a collection of paintings; Burroughs envisaged such a method enabling him to create simultaneously the straightforward chronologies that some readers craved, and the more abstract stories, with their infinitely elusive chronologies, which his nature dictated.

A letter dated October 21st 1955 is the first instance in which Burroughs begins to develop his extensive later use of the collage technique. He mentions the artists Hieronymus Bosch and Paul Klee in the letter, suggesting a shift in his influences, not just toward the art world, but also toward collage, identifying the work of Klee with 'what I saw high on Yage in Pucallpa when I closed my eyes'. His description of his methodology ('Of course I am not using anywhere near all the letters. I will often sort through 100 pages to concoct 1 page') is indicative of the mechanical manner in which he later described selecting his cut-ups, when he asserted: 'someone has to programme the machine. Remember that I first made selections.

[74] 18 August 1954, *Letters 1945–1959*, 227.

[75] Burroughs to Ginsberg, 7 February 1955, *Letters 1945–1959*, 262.

[76] Burroughs to Ginsberg, 21 October 1955, *Letters 1945–1959*, 288.

Out of hundreds of possible sentences that I might have used, I chose one'.[77] It is also a key indication that he was actively attempting to resolve his deep frustration with the written word, which seemed to have been developing into a pathological fear of textual organisation, rather than succumbing miserably and unprofitably to it. His idea of using letters as part of the make-up of what would become *Naked Lunch* enabled him to create an overarching schema operating on the principles of collage, which in turn ameliorated his dread of organisation. In the long term, having written and published *Naked Lunch*, Burroughs would be shown by Brion Gysin that the collage practice could be very deliberately manipulated, a move which would result in the cut-up trilogy and an ironic return to this obsessive preoccupation with organisation.

From late 1955 onwards, Burroughs wrote more and more fluidly, as he began to harness the pain caused by his formal problem and channel it into his creativity. It was this pain that caused him to seek out, and ultimately welcome almost too keenly, a new form. Burroughs gradually realised, particularly following his move in 1959 to the Beat Hotel in Paris and the subsequent blossoming of his friendship with Gysin, to which I will return in due course, that this pain was an important writerly device. By turning his inward, he was able to anchor the acute awareness that heroin withdrawal bestowed upon his sensibilities. In his 'Letter from a Master Addict to Dangerous Drugs', written in August 1956 and published in the *British Journal of Addiction*, Burroughs likened the reactions of early withdrawal to certain states of drug intoxication, citing 'mild paranoia' and 'sense impressions ... heightened to the point of hallucination', adding that 'the addict is subject to a barrage of sensations external and visceral. He may experience flashes of beauty and nostalgia, but the overall impression is extremely painful'. The reader can see this experience being put to use in *Naked Lunch*. In the novel's torrent of vivid, sensuous, cloacal routines there is a grotesque hallucinatory quality that is rooted in reality, as if mundane, everyday detail has been magnified a thousand fold and revealed to be endowed with a hideous 'writhing fertile life'.[78] What makes this worse, and more brilliant, is the knowledge that these visions have arisen out of some terrible, unquenchable need – a knowledge which also validates the writer's claim that he saw himself merely as 'a recording instrument', noting down '*what is in front of his senses at the moment of writing*' (*NL*, 184) without consideration for the imposition of order or narrative or added authorial guidance.

Having abandoned the need for order, then, Burroughs began to develop a methodology that encouraged disorder to emerge organically, romantically, almost, in a manner true to life, informed by many possible orders, from which the writer, and indeed the reader, may choose. The editorial task he had once referred

[77] Burroughs to Ginsberg, 21 October 1955, *Letters 1945–1959*, 288. 'The Art of Fiction No. 36', *Paris Review* 35 (Fall 1965): 30.

[78] Burroughs, 'Letter from a Master Addict to Dangerous Drugs', *British Journal of Addiction* 53, no. 2 (1957): 119–32.

to as 'a labor of Hercules',[79] became, as he wrote more and more of *Naked Lunch*, increasingly insignificant. The tone of his letters becomes less overwrought. He accepts in February 1957 that he remains 'badly in need of advice, editing, collaboration' from Ginsberg and Kerouac, but almost brushes this concern aside, continuing:

> it is hard for me to evaluate this material. Some of it should obviously be omitted and the whole put in some sort of order, but I keep writing more and no time to revise ... As you see I am running more and more to prose poems and no straight narrative in over a month. I must take it as it comes.[80]

By the autumn of that year he had left his early writings behind completely, writing confidently to Ginsberg:

> as regards MS., I think any attempt at chronological arrangement extremely ill-advised ... It is not at all important how anybody gets from one place to another ... I do not see organization as a *problem*. The gap between present work, that is last year or so, and work before that is such that I cannot consider the previous material as really pertinent, and trying to fit it in according to any schema could only result in vitiating the work.[81]

The following month he asserted: 'I have given up all attempts to impose any arbitrary form on my novel and it seems to be taking that is to already have a form of its own ... All I have to do is transcribe'. He qualified his bid for freedom from the controlling forces of narrative and his own past output by arguing:

> if anyone finds this form confusing, it is because they are accustomed to the historical novel form, which is a three-dimensional chronology of events happening to someone already, for the purposes of the novel, dead. That is the usual novel *has happened*. This novel *is happening*. The only way I can write narrative is to get right outside my body and experience it.[82]

Having experienced 'narrative' both internally and externally, then, Burroughs was able to collage his alter egos, his inner struggles, his daily encounters and unique perceptions, his psychological ramblings, and his numerous physical menaces into the structure of a text that logically makes no sense at all, but that psychically is as powerful as Hieronymus Bosch's *The Garden of Earthly Delights*. The awkward, revealing juncture between author and text, so embarrassingly evident in *Queer*, is erased, and as John Tytell remarks, 'the author's eye moves

[79] Burroughs to Ginsberg and Kerouac, 23 October 1955, *Letters 1945–1959*, 299.

[80] Burroughs to Ginsberg, 14 February 1957, *Letters 1945–1959*, 356–7.

[81] 20 September 1957 (Ginsberg Papers, Columbia, Box 2, fol. 3).

[82] Burroughs to Ginsberg, 14 and 28 October 1957 (Ginsberg Papers, Columbia, Box 2, fol. 3).

swiftly, cinematically, uninterested in formal transitions or artificial connections, concerned primarily with capturing the sense of chaotic flux'.[83]

There is a destructive joy in *Naked Lunch* – the raucous, spontaneous, transitory delight of a gleeful schoolboy defacing tradition. Burroughs grew up in the same city as T.S. Eliot: in St. Louis, Missouri. When asked about his childhood Eliot loftily recalled something 'incommunicable'[84] in the corrupted splendour of the Mississippi, but Burroughs, typically, recollected another river: a thirty-foot wide open sewer called the Rivière des Pères which oozed sluggishly through the city's neighbourhoods, before enfolding itself in the mud of the Mississippi. It is possible to discern a corresponding perversity in the pages of *Naked Lunch*, as Burroughs's feelings of iconoclasm relating to literary tradition manifest themselves in a form of collage which rebels against Eliot's, subverting it, chastening it, ridiculing it – mocking its perceived stringency, literariness, and elitism. *The Waste Land* appears cut up in *Nova Express*, but the poem is given no privilege in the text, its already collaged phrases separated by dashes to prevent them coming together. Burroughs celebrates his liberation from regulatory principles, from tradition, from talent. But this comes at a price: as Jennie Skerl observes, 'the individual, anarchic freedom that lies behind the destructive satire exists in a vacuum, with no moral or social structure to support it or to give [it] any function but destruction'.[85]

Burroughs himself seemed to realise this, and eventually lost sight of the success of his riotous mayhem when he attempted to give back some form to his stylistic revolt against structure while writing the cut-up novels. He became increasingly scientific, serious, and humourless as his literary anarchism developed, sacrificing his audience in an act of self-sabotage that whilst cementing his status as an experimental artist simultaneously undermined him as a credible author. Having finished *Naked Lunch*, and whilst experimenting extensively with his newfound cut-up technique as he worked on the manuscript of *The Soft Machine*, Burroughs began to attempt to sculpt what he felt to be his deeper awareness of the processes of physical and mental life, revisiting his efforts at puritanical self-discipline, this time with greater success. He anchored them to the searing, hallucinatory pain of heroin addiction and withdrawal, and, in an almost sadomasochistic venture, aimed at achieving a simultaneously punctilious and universal understanding of both psychic and writing processes. In 1960 he wrote to Ginsberg:

> The 'pain' referred to is pain of total awareness. I'm not talking mystical 'greater awareness'. I mean complete awareness at all times of what is in front of you. LOOK OUT NOT IN ... This means kicking ALL HABITS. Word HABIT.

[83] Tytell, 112.

[84] Quoted in Ted Morgan, *Literary Outlaw: The Life and Times of William S. Burroughs* (New York: Henry Holt, 1988), 29.

[85] Jennie Skerl, *William S. Burroughs* (Boston: Twayne, 1985), 46.

SELF HABIT. BODY HABIT. Kicking junk [a] breeze in comparison. Total awareness = Total pain = CUT.[86]

As Brion Gysin replaced Ginsberg in Burroughs's affections, Burroughs became more preoccupied with his cut-ups, announcing to Ginsberg, 'I have met my first Master in Brion'.[87] He began to 'detach himself from his old friendships and dissect them with a cold, unsentimental methodology, which horrified Ginsberg'.[88] He became obsessed with compiling a sort of experiential inventory of himself and his friends, dabbling in Scientology and growing coldly scientific, relinquishing the disorderly but high-spirited voice of *Naked Lunch* and the letters of the late 1950s. Many of his letters, particularly of the early 1960s, are garbled and uninformative, often heavily cut up.

Paradoxically, Burroughs was ultimately gripped by conflicting compulsions for control and chaos, for order and experimentation, and his cut-ups, in their intricate combination of disorder and extreme organisation, were an attempt to do resolve these internal and aesthetic conflicts. As Neal Oxenhandler suggests:

> Burroughs is a poet who knows something about language he can never forget, something about form that he can never eradicate … He tries to wipe out order which appears within the chaos, tries to strangle his own voice.[89]

The cut-up technique, in combining mathematical grids with intuitive choices, was an appropriate vehicle for such a problematic dichotomy because, from the reader's point of view, as Ihab Hassan has noted, 'chance denies the order we have brought ourselves to accept'.[90] Equally, from Burroughs's perspective, order can be imposed arbitrarily on the chaotic manuscripts which so nearly proved to be his undoing, enacting a refrain from *Naked Lunch*: 'as one judge said to another: "Be just and if you can't be just, be arbitrary"' (5). The cut-up technique was a logical continuation of the turbulent style of *Naked Lunch*, informed by Burroughs's desire for calculated chaos, which, for the rest of his career, provided him with a way in which to generate ideas for his writing. The 1960s was a decade of intense literary experimentation for Burroughs; it may have culminated in what Theodore

[86] 5 September 1960 (Ginsberg Papers, Columbia, Box 2, fol. 6). This sentiment anticipates Burroughs's coming involvement with Scientology and its key principle of 'clearing', whereby an individual would be 'audited' using a device known as an E-meter, in order to allow them to respond independently to life events rather than reacting to them under the direction of stored 'engrams'.

[87] 2 December 1959, *Letters 1959–1974*, 10.

[88] Miles, *The Beat Hotel*, 240.

[89] Neal Oxenhandler, 'Listening to Burroughs' Voice', *Surfiction: Fiction Now … and Tomorrow*, ed. Raymond Federman (Chicago: Swallow Press, 1975), 182.

[90] Ihab Hassan, 'The Subtracting Machine: The Work of William Burroughs', *Critique* 6 (1963): 12.

Solataroff accurately describes as 'a brilliantly lit dead end',[91] but the work produced is nonetheless both significant and fascinating. By the end of the 1960s, the increasing alienation of Burroughs's readership 'pointed up his overwhelming need as a writer to resume contact with the reader',[92] who had effectively been abandoned after *Naked Lunch*. Burroughs himself admitted that in his enthusiasm he may have taken the ideological lure of the cut-up technique too far, defending himself with the assertion that 'writers get carried away by a technique and what they can do with it and carry it so far that they lose their readers'.[93]

Part of the reason for this may have been a wilful perversity on Burroughs's part to avenge himself against the treatment he had received at the hands of publishers during his early forays into writing. The act of cutting is also a form of decision-making. Harris notes that 'to *decide* is to *cut off*', with the word 'decision' deriving 'from the Latin *decidere*, combining the prefix *de* with the verb *caedere*, meaning 'to "cut"'. In relation to this, Harris also explores the idea that, with regard to the processes of publishing *Junky* and *Queer*, Burroughs seemed 'to identify with both the *cutter* – the psycho serial killer who wants to hack off limbs – *and* with the one being cut, the body sawed in half'.[94] Once he became an international literary celebrity, however, Burroughs recognised that the power balance had shifted, and that he was no longer constrained to play the role of the bisected victim, 'sawed in half by fiends'. Any cutting to be carried out on his manuscripts would now be strictly on his terms: no longer would an anonymous publisher instruct him what to cut and where. The fact that he carried on with the cut-ups for so long, can, in this respect, be seen as a form of vengeance, not just against literary traditions but also against the commercial world of publishing, which had once been so reluctant to take him in but which was able, following the success of *Naked Lunch*, to reap the fruits of his labour. The problem was, of course, that, in Burroughs's own words, many of the cut-ups were 'interesting experimentally, but simply not readable',[95] with the aesthetics of the finished product often subordinated to the processes of creation.

Whilst the cut-up trilogy does often lose contact with the reader, it remains important to explore, for reasons other than the comparative lack of critical attention it has hitherto received. It provides a fascinating insight into Burroughs's writing technique: with its revisions, repetitions, hallucinations, and inserted commentaries, it shows the writer's mind at work, and is a variation on John Ashbery's notion of the poem, or in this case the novel, remaining 'the chronicle

[91] Theodore Solataroff, 'The Algebra of Need', *New Republic*, 5 August 1967, 34.

[92] Harris, 'Cut-Up Closure: The Return to Narrative', *William S. Burroughs at the Front*, ed. Skerl/Lydenberg, 256.

[93] Miles, *El Hombre Invisible*, 126.

[94] Harris, 'Confusion's Masterpiece: Re-Editing William S. Burroughs' First Trilogy', http://realitystudio.org/scholarship/confusions-masterpiece [Accessed 1 April 2012].

[95] Burroughs/Daniel Odier, *The Job: Interviews with William Burroughs* (London: Cape, 1970), 56.

of the creative act that produces it' (introduction to *CP*, viii–ix). The unique form of the cut-ups also forces a reassessment of the rules of reading, which reaches beyond the boundaries of these particular texts, facilitating not just an appreciation of Burroughs's other novels (and providing a means by which to overcome their emetic effect), but also a re-evaluation of the ways in which we as readers approach any text. Burroughs's use of collage as a key component of the trilogy's compositional style was a significant development of one of the most ubiquitous artistic practices of the twentieth century. His radical, experimental use of collage, which he 'extended to involve and illumine a large number of seemingly discrete territories',[96] just as the art world began to abandon it, played a fundamental role in propelling the collage practice forward, making it, as well as himself, an enduring creative force in popular culture, perhaps best exemplified by the inclusion of Burroughs on the collage cover of The Beatles' seminal 1967 album, *Sgt. Pepper's Lonely Hearts Club Band.*

Cut-up Autopsy

As noted earlier in this chapter, an artistic, rather than a literary approach, may hold the key to tidying up the chaotic, problematic, and alienating reading experience presented by the cut-up trilogy. It was through his close friend and mentor, the artist Brion Gysin, that Burroughs first discovered the cut-up technique, whereby pages of text, his own and that of other writers including Shakespeare, Rimbaud, and Eliot, as well as scientific articles and certain of the negative reviews that his work received, were cut apart or folded up, and then rearranged in a random order, in a quest 'to form new combinations of word and image'.[97] It is no coincidence that it was Gysin, rather than any other of Burroughs's artist friends such as Francis Bacon or Robert Rauschenberg, who introduced him to this form of literary collage. Gysin was a multimedia artist who held direct links to the radical art movements of early twentieth-century Europe and America. He had shared an apartment with Roberto Matta in New York, and had associated with Pollock and Arshile Gorky. More significantly, he had spent his formative years in Paris, as a member of the Surrealist group, and in 1935, at the age of nineteen, he had exhibited his work at the Galerie Quatre Chemins alongside such renowned artists and collagists as Picasso, Max Ernst, Salvador Dalí, Man Ray, René Magritte, and Marcel Duchamp. Gysin was expelled from the group in the same year, allegedly for insubordination to André Breton, but he retained his allegiance, if only stylistically, to the international 'crisis of representation',[98] provocatively promoting Tristan Tzara, rather than Breton, as a key influence when he began using cut-ups.

[96] Leefmans, 196.

[97] Burroughs, quoted in Miles, *El Hombre Invisible*, 119.

[98] Perloff, 'The Invention of Collage', 32.

Gysin discovered or invented the cut-up method by accident in September 1959, after slicing through a pile of newspapers with a Stanley knife whilst cutting a mount for a drawing. Readymade phrases dropped onto the table imbued with a weird logic that seemed to come from the rearrangement of stale or formulaic words and phrases into fresh patterns. This, of course, immediately recalls the practices of Dada, both in terms of the movement's aspiration to dissect contemporary society using the print media with which it advertised itself, and the implied combination of mechanical rationality with the irrationality of chance. It further recalls, as Burroughs also did when writing about the cut-up method, Tristan Tzara's 1920 stunt of 'writing' a poem in front of an audience by pulling words out of a hat.[99] Surrealist principles of chance meetings on dissection tables are also in evidence, as are the deconstructed newspapers and flat, unemotional qualities of Cubism; indeed, Barry Miles asserts that from the beginning of the experiment Burroughs used the cut-up method as a way of composing images and sequences 'in a Cubist manner'.[100] Harris simultaneously invokes and dismisses Tzara and the Surrealist Max Ernst as influential predecessors of the technique, working to establish, in his essay on the collaborative *Minutes to Go*, how different Burroughs's cut-ups were from anything that had preceded them.[101]

It would be inaccurate to suggest that Burroughs was *directly* influenced by all of these artists and art movements. However, whilst he rarely displays a specific awareness of the collagists who preceded him, his work certainly owes them a debt, not least for enabling a culture in which the cut-ups could be produced and published. And yet whilst it is not possible to assert that he was a Cubist working in the Cubist tradition, or a Surrealist working in the Surrealist tradition, it was through his eclectic employment of assorted techniques inspired by the practices of numerous different artists and art movements that he was able to place at his disposal 'the collage used in painting for fifty years'. Furthermore, the radical work undertaken by Europe's avant-garde artists during the first half of the twentieth century prepared the ground for the cut-ups not just by providing the inspiration and, to a degree, the techniques, but by pre-conditioning a generation of readers who were prepared to engage with discontinuous narrative, anarchic nonsense, and aesthetic fragmentation. The collages made by Cubist, Dadaist, Futurist, and Surrealist artists advanced the notions of fragmentation and discontinuity in art in a way that the work of T.S. Eliot, Ezra Pound, or James Joyce could not, the anarchy of whose work was necessarily tempered (or redeemed) by their overt academicism. Like Tristan Tzara, Hugo Ball (creator of the 1916 Dada Manifesto), André Breton, and others, Burroughs was relatively untroubled by the academic

[99] Burroughs, 'The Cut Up Method of Brion Gysin', 105–6; in a letter to Paul Bowles whilst writing *The Soft Machine*, Burroughs also noted that 'the book writes itself out of a hat' (25 January, 1961, *Letters 1959–1974*, 65).

[100] Miles, *El Hombre Invisible*, 126.

[101] Harris, '"Burroughs Is a Poet Too, Really": The Poetics of Minutes to Go', *The Edinburgh Review* 114 (2005): 24–36.

or artistic acceptability of his final product. The purpose of art, he believed, was 'to make people aware of what they know and don't know'.[102] What mattered was the process of creation, the final outcome being, as Ball asserted, 'not an end in itself ... but ... an opportunity for the true perception and criticism of the times we live in'.[103]

Cut-ups and collage became an infatuation for Burroughs, occupying his time and his thinking for long periods during the 1960s. In addition to the cut-ups, which proved to have the greatest longevity of all his work in the collage practice from this time, he also experimented extensively with photo-collages, or 'collage concentrates'. These, in his view, were the logical extension of the Surrealist collages of the 1920s, which, he wrote, were 'simply an arrangement of objects and pictures presented as art object [sic]', and which 'did not develop the formula further to take photos of the collage and use these pictures in arrangements of abstracted collages ... They did not make collage concentrates'. Burroughs's photo-collages are energetic, sometimes sinister, and on occasion effective, but across the board they are fairly unremarkable, in spite of his repeated insistence to Gysin that an exhibition of them would be 'spectacular'. He did, however, 'apply what I have learned from the photo collages back in writing', particularly in terms of notions of time travel, and what he called 'mood concentrates', which are clearly evident in certain of the more ethereal passages in *The Soft Machine* and *The Ticket That Exploded*.[104]

Collage and cut-ups were also something of a passing interest for poets such as Gregory Corso and Sinclair Beiles, who were living at the Beat Hotel with Burroughs and Gysin at the time.[105] In 1960, Burroughs, Gysin, Corso, and Beiles published *Minutes to Go*, a limited edition collaborative collection of cut-

[102] Interview with Jennie Skerl, 4 April 1980, New York City. *Modern Language Studies* 12, no. 3 (Summer 1982): 12.

[103] Hugo Ball, quoted by the National Gallery of Art, 'Introduction to Dada', http://www.nga.gov/exhibitions/2006/dada/cities/index.shtm [Accessed 13 December 2011].

[104] 'The Photo Collage'. (Undated typescript found in the Burroughs Papers, Berg Collection, Series I, Box 10, fol. 6); in one photo-collage by Burroughs, Ginsberg, bald and bearded, looms large on the left hand side of the image, whilst Burroughs, languid, bespectacled, and smoking a cigarette, is in the bottom right. An image of a desert city has been superimposed onto his shirtfront. Behind both of them is a seemingly endless sea of parked cars. (Burroughs Papers, Berg Collection, Series II, Box 90). Letter to Gysin, 16 May 1961 and 14 June 1961 (Burroughs Papers, Berg Collection, Series III, Box 85, fols 4–5).

[105] Corso soon grew disillusioned with cut-ups, calling them 'uninspired machine-poetry' in his Postscript to *Minutes to Go*, adding: 'Tzara did it all before' (61). He was enraged when Burroughs cut up one of his own poems, at which Burroughs justified his actions by arguing: 'writers don't own their words. Since when do words belong to anybody. "Your very own words", indeed! And who are you?' (*The Third Mind*, 34.) Corso later came back around to Burroughs's cut-ups, acknowledging in an undated letter to Gysin that '*The Soft Machine* shows and proves the soul cuttable, no destruction here, nay, but creation

ups which can, in some ways, be viewed as an early manual for the technique, exemplified by cryptic passages which defy close reading but which seem to be invoking some kind of hidden message or alchemical prophecy, beginning with the words 'the hallucinated have come to tell you'.[106] It was the first of Burroughs's hundreds of cut-up texts and experiments in collage. Although, unlike Gysin, he was unable to paint, he felt that his literary style and motivations were much akin to Gysin's paintings, viewing their work equally as a form of 'straight exploration' and asserting that, even before the cut-ups, what they were doing was 'precisely the same thing in different mediums'.[107] He was delighted, therefore, to have discovered what he saw as a valid alternative to paint, and so set about using scissors to launch his extraordinary 'physical assault on the very medium of written communication'.[108]

Burroughs had for some time, as both his personal life and the text of *Naked Lunch* demonstrate, been fascinated by the thematic notions of cutting and surgery, another factor which informed the zeal with which he embraced collage, a practice whose key tenet is an initial cut. His interest in notions of cutting evolved from the visceral violence manifested in the pages of *Naked Lunch*, particularly relating to the character of Dr Benway, to the literal, physical cutting of his novels typified by the cut-up trilogy. The word 'cut' itself appears thirty-three times in *Naked Lunch* alone – forty-eight times if the subsidiary additions of the Miles/Grauerholz edition are included. In 1940 Burroughs had cut off the last joint of his left little finger in a skewed romantic gesture. In 1947 Ginsberg, aged just twenty-one, had authorized the performance of a lobotomy on his mother Naomi, an action which resonated with many of the Beat writers for years to come. The character of Dr Benway appears to be based, to a certain extent, on the real-life 'lobotomy king', Dr Walter Freeman, who may or may not have carried out the lobotomy on Ginsberg's mother, but who had certainly operated on many occasions at the Pilgrim State Hospital in New York, where Naomi resided. Famous for his strong advocacy of lobotomy as a means of control for psychiatric patients (particularly homosexuals), Freeman had developed a technique known as the transorbital, or 'icepick', lobotomy, designed to enable psychiatrists untrained in surgical procedures to perform lobotomies in overcrowded institutions, by inserting a metal pick into the corner of a patient's eye in order to sever nerve connections to and from the frontal cortex. The transorbital lobotomy could be performed without the need for an operating theatre, using electroconvulsive therapy instead of anaesthesia. Freeman himself, in spite of having no surgical training and in the face of extensive criticism, toured the U.S. in order to train other non-medical staff in the procedure, performing

of the highest order, the soul made new, better, wisdom reversed ...' (Undated typescript found in the Burroughs Papers, Berg Collection, Series I, Box 5, fol. 39).

[106] Burroughs, Sinclair Beiles, Gregory Corso, and Brion Gysin, *Minutes to Go* (Paris: Two Cities, 1960), 3.

[107] Burroughs to Ginsberg, July 1959 (Ginsberg Papers, Columbia, Box 2, fol. 5).

[108] Harris, *Letters 1945–1959*, xl.

over 3,400 lobotomies (at just $25 each) during the four decades of his career. Many of these were performed on homosexual men, in an attempt to 'cure' them. It seems likely that Burroughs had Freeman in mind when he wrote the routine in *Naked Lunch* featuring the Salesman with the 'M.D.'s Can Do Kit for busy practitioners' (104). Certainly his crafting of Dr Benway's casual refusal to allow his own demonstrable incompetence, not to mention brutal insanity, to stand in the way of his medical experiments, seems to be the direct satirical response of a gay man to the quasi-surgical outrages perpetuated by Freeman.

Benway is introduced to the reader as 'a manipulator and coordinator of symbol systems, an expert on all phases of interrogation, brainwashing and control'. His assignment is 'T.D. – Total Demoralization', which he brings about by applying his Freeman-esque philosophy that

> the subject must not realize that the mistreatment is a deliberate attack of an anti-human enemy on his personal identity. He must be made to feel that he deserves *any* treatment he receives because there is something (never specified) horribly wrong with him. (19)

Benway wields his unsterilized scalpel with a terrifying degree of imprecision. Regardless of appalled onlookers, he treats operations, as Freeman also seems to have done, as medical circus acts or public spectacles. He brags about performing 'an appendectomy with a rusty sardine can' (51), and recounts tales involving 'scalpel fight[s] with a colleague in the operating room' (26) in which the patient, being the 'weakest party', always comes off worst. He performs operations, which, he boasts, have 'absolutely no medical value', in front of packed auditoriums, describing them as 'pure artistic creation ... the surgeon deliberately endangers his patient, and then, with incredible speed and celerity, rescues him from death at the last possible split second' (52). Benway also makes note of a colleague, Dr Tetrazzini, who

> would start by throwing a scalpel across the room into the patient and then make his entrance like a ballet dancer. His speed was incredible: 'I don't give them time to die', he would say. Tumors put him in a frenzy of rage. 'Fucking undisciplined cells!' he would snarl, advancing on the tumor like a knife-fighter. (52)

Although Benway's lack of self-discipline is at once hilarious and grotesque, his purpose in Burroughs's writing is to represent the ghoulish 'impulse of the scientific mind to improve or correct human nature',[109] stemming from a basic contempt inherent in Burroughs's own mind for the body's weaknesses and the mind's tyranny. Burroughs enacts this contempt through language, directing his disgust toward words. His notion that the human creature is essentially a binary structure, bound in conflict with itself, is depicted and ridiculed in the novel, as

[109] Lydenberg, 'Notes from the Orifice', 57.

verbal function is disabled and the body (or 'the soft machine') debilitated. His obsession with the anatomy of the body, with medical attempts to control it, and with its helpless role as the focus of widespread societal urges to judge and punish,[110] is explored in his tendency to depict humans as truncated body parts (as seen in the emotional dismemberments of *Queer*), and, as Lydenberg has further noted,[111] defined by their mouths (Willie the Disk), their asses (the carnival worker), their ectoplasms (Mary, Bradley the Buyer), and castigated for being 'scandalously inefficient' (*NL*, 110).

The word 'anatomy' derives from the Greek for 'cut up': it is, as Jonathan Sawday observes in *Emblazoned on the Body*, 'an act of partition or reduction ... associated primarily with medicine', in which, nevertheless, 'there lurks ... a constant potential for violence'.[112] In *Naked Lunch*, Burroughs deliberately uses language to perform a metonymical autopsy on the idea of the body, cutting it up with all the flair of a surgeon performing a public dissection in the style of Rembrandt's *The Anatomy Lesson of Dr Nicolaes Tulp* (1632). The self-reflexivity inherent in this act of literary self-harm, as Burroughs performatively carves into the body of his own text, exposes 'the violence and domination inherent in the dualism of body/mind; the use of language as a basic weapon in that struggle for supremacy; and the inevitable outcome of the struggle in silence and death'.[113]

The cut-up trilogy is also a performance of this kind, but of a more complex nature. Where *Naked Lunch* chiefly used language to cut up the body, the cut-ups instead use the body (hands holding scissors) to cut up language. In this sense, regarding his earlier work, they enact both of the Oxford English Dictionary's definitions of the word 'autopsy':

> 1. Seeing with one's own eyes, eye-witnessing; personal observation or inspection.

> 2. Inspection of a dead body, so as to ascertain by actual inspection its internal structure, and as to find out the cause or seat of disease.

In creating the cut-ups Burroughs transformed himself into a Benway figure. In front of the audience attracted by *Naked Lunch*, Burroughs turned to cut-ups to enable himself to cross the cultural divide between the subjectivity of art (as characterized by *Naked Lunch*) and the objectivity of science (as seen in the cut-ups), with which to diagnose, improve on, and ultimately correct the more resolutely 'human' internal structures of his earlier work, by which, during the 1960s, he

[110] For an extended treatise on the surveillance of the body and questions of control and power, see Michel Foucault's *Surveiller et Punir: Naissance de la Prison* (Paris: Gallimard, 1975).

[111] Lydenberg, 'Notes from the Orifice', 64.

[112] Jonathan Sawday, *Emblazoned on the Body: Dissection and the Human Body in Renaissance Culture* (London and New York: Routledge, 1996), 1.

[113] Lydenberg, 'Notes from the Orifice', 59.

seemed somewhat embarrassed. In early 1960, for example, Burroughs began to insist that *Naked Lunch* was also a cut-up text. He wrote to Irving Rosenthal that '*Naked Lunch* is all cut up, though I was not then fully realising the method and the need for a pair of actual scissors', and to Paul Bowles that it 'was indeed cut up but I did not realize at the time of publication to what extent'.[114] These 'realizations' seem to be a retrospective attempt to impose order and structure on *Naked Lunch*, to suppress its self-evident chaos in the same way that he had attempted to suppress the mawkishness of *Queer*.

Elizabeth Klaver's *Sites of Autopsy in Contemporary Culture* establishes that

> performing an autopsy in the West has meant surgical mutilation, penetration to the interior's most private parts by cleaving phallic instruments, combining ana-tomē (to cut up) and auto-opsis (to see with one's own eyes) to produce a 'piercing gaze'.[115]

The cut-up novels are precisely this: a public act of mutilation dependent on a pair of scissors or a knife for both the destruction of one accepted body of meaning and the creation of another. But within the internal dynamics of the cut-up trilogy, the incision is rendered harmless, and is transformed instead into an attempt to facilitate a new way of reading. In *Naked Lunch*, negative instances of cutting up and cutting off – basic, conceptual dissection – would have resulted in wilful truncation and amputation. In the cut-up trilogy such instances extend into the positive ideals of cutting loose, cutting free, and cutting out, as in this example of verbal collage from *The Ticket That Exploded*:

> Film flakes drift adiós – Showed you your air – the Doctor on stage – the pipes are calling – September left no address – For i have known last air – The days grow short – ... A street boy's courage exploded the word – last round into air – like good bye then – story of absent dreamer – Last September fades streaked with violence – surges of silence ebbing, stranded, and we haven't got courage to let go. (103)

Readers are encouraged to see with their own eyes, not with the author's, as Burroughs attempts to reduce himself to the purity and abstraction of the disembodied hand: 'Not political propaganda or if so entirely by accident. I do not subscribe to any of the sentiments expressed necessarily. Are not personal opinions. Only a transcription of voices'.[116]

Dismemberment in the cut-up novels is rendered as a form of escape, as a reaffirmation that, to paraphrase Klaver's assessment of the emotional difficulties of dissection, the corpse occupies space/time but does not suffer in it. The severed

[114] 24 January 1960, *Letters 1959–1974*, 19; 30 January 1960, *Letters 1959–1974*, 20.

[115] Elizabeth Klaver, *Sites of Autopsy in Contemporary Culture* (Albany: State University of New York Press, 2005), 19.

[116] Burroughs to Dave Haselwood, 24 June 1960, *Letters 1959–1974*, 33.

limbs and physical lacerations of *Queer*, and the *Macbeth*-inflected hacking and gouging of *Naked Lunch*, are tempered and ultimately replaced by a more deliberate, constructive sort of violence, more akin to a dream experienced by the character of Orvil Pym, in Denton Welch's *In Youth is Pleasure*, in which he is lying 'full-length in an enormous open wound'.[117] Burroughs's encounter, through Gysin, with the more artistically-minded, positivistic cuts associated with collage, facilitated a new way of approaching his expressive dilemmas, allowing him to cut them up whilst preventing them from breaking him down. Burroughs performs a quasi-medical act of anatomization, 'whereby something can ... be constructed ... In lieu of a formerly complete 'body', a new 'body of knowledge and understanding can be created'.[118] Dissection, in the cut-up novels, is rendered a means of encounter rather than a means of separation; or, at least, the separations necessitated by the cut-up method release powerful messages, according to Burroughs, decipherable only by those versed in the technique. Emphasising that the cut-ups were blueprints not for analysis but for action, he wrote:

> Cut the words and see how they fall. Shakespeare Rimbaud live in their words. Cut the word lines and you will hear their voices. Cut ups often come through as code messages with special meaning for the cutter. Table tapping? Perhaps.[119]

Writing to Ginsberg in mid-1960, he advised, 'Don't theorize. Try it', explaining:

> Take the enclosed copy of this letter. Cut along the lines. Rearrange by putting section one by section three and section two by section four. Now read aloud and you will hear My Voice. Whose voice?[120]

The following month he advised the publisher Dave Haselwood:

> I find that people read *Minutes to Go* without ever using the cut up method for themselves. But when once they do it themselves they see. Any missionary work you do among your acquaintances in showing people how the cut up system works will pay off in sales.[121]

This urge to engage others with the physical processes of the cut-up technique, ostensibly to help them reach an understanding of the texts, indicates a desire on Burroughs's part to present his methods as a form of co-operative public spectacle. Much as Dr Freeman had attempted to do with his lobotomies, Burroughs's

[117] Denton Welch, *In Youth is Pleasure* (Oxford: Oxford University Press, 1982), 9. Burroughs cited the minor English novelist as one of his major influences, and based the character of Kim Carsons in *The Red Night Trilogy* on him.

[118] Sawday, 2.

[119] Burroughs, 'The Cut Up Method', in *The Moderns: An Anthology of New Writing in America*, ed. Leroi Jones (London: MacGibbon & Kee, 1965), 347.

[120] 21 June 1960, *Letters 1959–1974*, 31.

[121] 26 July 1960, *Letters 1959–1974*, 39.

simultaneously affects his cuts upon his readers and endeavours to force them into complicity with his systematic violations of narrative, in order to 'cut the word lines. And step out into silence'.[122]

'Pure abstract literature': Reassessing the Rules of Reading

Burroughs's theme throughout the trilogy is the apocalyptic, parasitic, viral nature of the word, which he came to believe was at the heart of all human transgression and would ultimately destroy humanity. Because constructive violence is inherent to his subject matter, violent collage is an appropriate vehicle through which to convey it. Collage begins with a cut, after all, with an act of arbitrary dismemberment: as David Rosand observes, 'the process of construction begins ... in a destructive act of rendering and uprooting'.[123] Burroughs's decisive, clean cuts imply a gesture of transplantation rather than mere aggressive tearing or uprooting. As a result, the dislocated sections of text can be reintegrated, creating fresh tensions and compelling the reader to respond with an increased dynamism and flexibility. A distorted dialogue subsequently emerges within the texts, as sections permutate and correspond, suggesting that in the destruction of one artwork lies the creation of another.

Burroughs rewrote the majority of *The Soft Machine* in the five years between its first and second publications, citing 'bad cut-ups'. Certainly there are instances in all three novels in which the technique fails, where the juxtapositions are too swift or too sluggish, too conclusive or too obscure, despite the fact that, as Barry Miles emphasises, 'every word in the finished manuscript would have gone through a lengthy process of selection'.[124] But where the juxtaposition does work, the reader witnesses a darkly brilliant kind of prose-poetry, in which the bleak underbelly of human existence and experience is upturned, exposing the devastating physics of malevolence which Burroughs saw in everything from the writing process to the media to human relationships. In *The Ticket That Exploded*, for example, we have this cut-up:

> You can say could give no information – dominion dwindling – We intersect on empty kingdom read to by a boy – Five times i made this dream – Consumed brandy neat, muttering in the last terrace of the garden – Light and shade departed have left no address – For i have known the body of a God bending his knees – Isn't time is there left? – The bitter foliage my friend to give you? – an odor of deluge and courage to let go – In the open air a boy waiting – Smiles overtake someone walking – The questions drift down slowly out of an old dream – mountain wind caught in the door. (54)

[122] Burroughs to Gysin, November 1960 (Burroughs Papers, Berg Collection, Series III, Box 85, fol. 2).

[123] Rosand, 132.

[124] Miles, *El Hombre Invisible*, 130.

This excerpt is a scrambled section of text that denies attempts at close reading or New Critical-style 'symbol-hunting',[125] and yet it boasts a certain inexplicable effect. It is enigmatic, meditative, and self-assured, and, in the absence of grammatical logic, discernible character, or plot, the reader is able to participate in the text, moving 'beyond the limits of conventional seeing',[126] as the arrangement of the words takes cumulative effect.

This passage, typical of many in Burroughs's work, subverts the traditional mode of reading, and promotes a view of the word as image. The page of text here can function as a circular field of reference operating on a system of juxtaposition, fracture, and fusion. Throughout the first half of the twentieth century, this was an idea that collage had helped to develop, pioneering new possibilities in signification and attempting in part to 'reassert ... control over a pictorial world',[127] as I established in my introduction. Picasso's 1912 *Still Life With Chair Caning* had permitted painting to be read horizontally as a kind of writing, or 'a system structured by arbitrary signs',[128] as well as seen vertically. Similarly, the ostentatious embedding of the collage practice within Burroughs's work advocated the concept that a text is as much a 'graphical ensemble'[129] or composition of heterogeneous elements as it is a sequence of signs denoting narrative meaning. Much of Burroughs's cut-up work, which, like Picasso and Braque's collages, is also an attempt to reassert control over the world, subverts the traditional mode of reading, and promotes a view of the word as image, adding an extra dimension to the written text. In an excerpt from *The Electronic Revolution* (1970), Burroughs elucidates:

> The written word is of course a symbol for something and in the case of a hieroglyphic language like Egyptian it may be a symbol for itself that is a picture of what it represents. This is not true in an alphabetic language like English. The word leg has no pictorial resemblance to a leg. It refers to the SPOKEN word leg. So we may forget that a written word IS AN IMAGE and that written words are images in sequence that is to say MOVING PICTURES.[130]

If Max Ernst 'liberated collage from art, from its concerns with plastic and visual planes, and turned it into a theatre of the irrational',[131] then Burroughs took it both one step forward and one step back, developing a view of art and writing as originally mutually exclusive, whilst incorporating into his use of collage as many of the theories and tenets developed by the artists of the preceding fifty years

[125] Lehman, *The Last Avant-Garde*, 157.

[126] Lydenberg, *Word Cultures*, 64.

[127] Rosand, 122.

[128] Yve-Alain Bois and Rosemary Krauss, *Formless* (New York: Zone Books, 1997), 28.

[129] Marin, 19.

[130] Burroughs, *The Electronic Revolution* (Bonn: Expanded Media Editions, 1970), 5.

[131] Digby, 19.

as he possibly could. He turned collage into a war machine, using it as his chief weapon with which to attempt to '*rub out the word forever*' (*NE*, 10). He collaged 'science and science fiction, nightmare and comic strip, carnival, satire, and sexual aberration'[132] in order to replicate his apocalyptic vision of the word as a form of consciousness-devouring parasite, and he exploited the interdisciplinary nature of collage in order to de-condition and disorient his readers. Burroughs used collage methods to manifest physically the ubiquitous coupling of violence and sexuality in his texts, cutting up his manuscripts in the 'destructive act of rendering and uprooting'[133] that is fundamental to the process of collage, and that is so prevalent in the cut-up novels, but in such a way that the dismembered pieces might be neatly reintegrated into the body of the text in illogical but revealing combinations.

Much of the disorder in the cut-up novels bears the imprint of Dada and Surrealism. At least in theory, the concepts, premises, and processes of collage and the cut-ups are given precedence over outcome and technique. Burroughs himself repeatedly emphasised the experimental nature of his work, affirming that 'any cut-up technique presupposes a great deal of experimentation',[134] and positing the origins of the method as being 'experimental in the sense of being *something to do*';[135] it also embodied his belief that 'writing must always remain an *attempt*'.[136] John Calder also reiterated the image of Burroughs as a 'scientist in literature' who 'must be allowed to experiment freely even if his experiments eventually lead nowhere'.[137] It is important to note the multi-faceted nature of his experiments: just as he had no single technique, so he had no singular purpose for using the cut-up method. He claimed it was not for propaganda purposes, and yet he also wrote that it could be used very effectively to make statements. It was both polemical and 'purely abstract'. In this sense, then, he is not a scientist, or a theorist, but some kind of illusionist, concerned less about the legitimacy of his act than about its diverse effects.

Subversively anti-humanistic, bleakly humorous, and characterised by an aspiration to dissever civilization using its own knife, *Naked Lunch* and the cut-up novels wield collage as a form of burlesque, operating along the Dadaist lines of 'exasperation and carnival'.[138] In *The Soft Machine* a Rindpest outbreak in Guayaquil has bizarre but devastating consequences: 'no calcium in the area you understand. One blighter lost his entire skeleton and we had to carry him about in a canvas bathtub. A jaguar lapped him up in the end, largely for the salt I think' (61).

[132] Tanner, 105.

[133] Rosand, 128.

[134] Burroughs, 'Interview with Felix Scorpio, London 1969', in *Burroughs Live: The Collected Interviews of William S. Burroughs 1960–1997*, ed. Sylvère Lotringer, (Los Angeles: Semiotext(e), 2001), 118.

[135] Burroughs, *The Third Mind*, 31.

[136] Burroughs to Ginsberg, 23 May 1952 (Ginsberg Papers, Columbia, Box 1, fol. 22).

[137] Calder, *TLS*, 21 November 1963, 947.

[138] Leefmans, 214.

This is clearly related to Dr Benway's famous sequence, in *Naked Lunch*, in which a carnival worker teaches his asshole to talk:

> After a while the ass started talking on its own ... Then it developed sort of teeth-like little raspy incurving hooks and started eating ... the asshole would eat its way through his pants and start talking on the street, shouting out it wanted equal rights. It would get drunk, too, and have crying jags nobody loved it and it wanted to be kissed same as any other mouth. (111)

Eventually the ass takes over the carnival worker completely: 'for a while you could see the silent, helpless suffering of the brain behind the eyes, then finally the brain must have died, because the eyes *went out*' (112). There is both hilarity and horror at work in these episodes, recalling the work of Ernst and Dalí, who combined in their artwork a realistic depiction of basic representative elements with the hallucinatory qualities associated with collage by Dada and Surrealism. Ernst's particularly Burroughs-esque example of 'the coupling of two realities, irreconcilable in appearance, upon a plane which apparently does not suit them', was of a canoe making love to a vacuum cleaner in a forest.[139]

In a style reminiscent of Dada artist Hannah Höch, whose visual paradoxes were often based upon disconcerting combinations of the male and female form, and Man Ray's photographs of Marcel Duchamp's alter ego Rrose Sélavy, Burroughs creates characters whose sexes are not only ambiguous but are actually shifting. In *The Soft Machine*, for instance, the narrator describes how 'from a remote Polar distance I could see the doctor separate the two halves of our bodies and fitting together a composite being' (53). Early on in *The Ticket That Exploded*, 'a cold glamorous agent from the Green Galaxy' (12), presumably one of the 'Green Boy-Girls from the terminal sewers of Venus' (46), repeatedly changes sex over the course of several pages, morphing from female agent into 'the green boy', 'the green boy-girl', and finally into 'the Green Octopus who was there to block any composite being' (12–14). The sequence begins with the semblance of a functional narrative – 'The room was on the roof of a ruined warehouse' – which provides the reader with a fleeting illusion of lucidity and straightforward narrative. The ensuing metamorphoses and textual permutations, however, obliterate this illusory fragment of reality. Phrases migrate within the action, blending into one another, with the effect that words seem animated, moving with the green boy-girl and his/her blue lover as they writhe surrounded by swirling mists and poisonous vapours. The word 'twisted' appears five times in different contexts, implying a profound fusion not only of the characters and their surrounds, but of the text itself, which ties itself in vicious knots as it loops tauntingly out of the conventional reader's grasp. The episode ends tellingly with the disembodied voice of Lee's 'old CO' barking 'You see this noose, Lee? This is a *weapon* ... an enemy *weapon*' (14).

Burroughs uses this weapon to parody the dynamics of need that he felt were intrinsic to the imposition of both institutional and interpersonal control, and

[139] Ernst, *Beyond Painting*, 13.

in which he saw language as the principle agent. A section of *The Ticket That Exploded*, for instance, wryly entitled 'do you love me?', cuts apart the lyrics of popular love songs and reintegrates them into a mosaic of bizarre invective, a caricature of courting rituals which grows increasingly savage throughout the passage. The songs – *I've Got You Under My Skin* and *Tell Laura I Love Her*, among others – are fused with profanity:

> i've got you deep in the guides body enclosed darling in *my* fashion – yes cool
> hands on his naked flesh my way – evening intestines of the other – Tell Laura
> i love her sucked through pearly genital woman off your big fat shower of
> sperm –. (40)

Burroughs uses collage in this way to mock traditional notions of love, particularly sentimental, heterosexual love, which, he felt, was 'largely a fraud – a mixture of sentimentality and sex that has been systematically degraded and vulgarized by the virus power'.[140] The virus here is language. By merging the language of the everyday, which we hear and hum without even thinking about it, with a crass and largely unspoken vernacular, Burroughs subverts the control of the former and undermines the power of the latter. His intention, however, as Lydenberg observes, 'is not to measure inappropriate action against a set of empirical norms, but simply to reveal a more naked truth' about the condition of human experience.[141] In order to explode the conditioning myth of sentimentality manifested in the love songs, Burroughs must root the cut-ups in negative difference, bringing about a latter-day version of the total annihilation of everything but life itself, as advocated four decades earlier by the Dada movement.

Burroughs augmented his Surrealist/Dadaist imagery with compositional methods forged by the Cubists, refuting traditional modes of representational construction, and sacrificing raw emotion to 'abstract formal order'[142]. The 'emotional excesses' (*Q*, 127) to which Burroughs recalls being subjected as a recovering heroin addict, the sorrow and guilt that he suffered as a result of Joan's horrific death, and the loneliness, rejection, and self-pity that pervades many of his unanswered letters to Allen Ginsberg, are transcended, having been surrendered to 'the Rewrite Department' (*SM*, 22), from which they emerge objectified beyond recognition. Lyrical images or popular songs – 'paper moon and muslin trees' (*TE*, 30)[143] – are detached from their humanist associations, which traditionally lend them their lyricism. Body and spirit are repeatedly distorted in 'a spectacle of suffering'[144] that is both nightmarish and carnivalesque: 'Two Lesbian Agents with

[140] 'Interview with Eric Mottram, London 1964', in *Burroughs Live*, ed. Lotringer, 55.

[141] Lydenberg, *Word Cultures*, 9.

[142] Greenberg, *Joan Miró*, 33.

[143] The line riffs on Harold Arlen's 1933 song 'It's Only a Paper Moon', made popular in the mid-1940s by Ella Fitzgerald and the Nat King Cole Trio, and which also featured in Tennessee Williams's *A Streetcar Named Desire*, which opened in 1947.

[144] Tytell, 120.

glazed faces of grafted penis flesh sat sipping spinal fluid through alabaster straws' (*NE*, 56). Even the depiction of the intergalactic 'WAR TO EXTERMINATION' (*NE*, 55) is devastatingly flat, couched 'in the impersonal and condensed economy of the telegram'[145] – as the tenebrous narrator interjects, 'they do not have what they call emotion's oxygen in the atmosphere' (*NE*, 63). An initially strict, mathematical structuring process undermines, at the most basic level, the illusion of chaos in Burroughs's novels, as evidenced by the geometric grids he habitually drew over writing that he intended to cut up (Figures 2.1 and 2.2).

Following this initial process, however, came one of intuition rather than arbitrariness. Burroughs emphasised: '[s]omeone has to program the machine. Remember that I first made selections. Out of hundreds of possible sentences that I might have used, I chose one'.[146] As Jean-Jacques Thomas argues, with this type of collage – in which 'choosing has become the decisive creative act'[147] – in order to grasp the text's significance 'the reader has to pass through the incongruity and apparent disorder of the constituents in order to enter the labyrinth of exegesis and … uncover the *hidden* regulating system'[148] behind the mess. This is, of course, partly why Burroughs was so keen that readers practice their own cut-ups, rather than just reading the theory behind them.

'Rub out the word forever': Collage Architecture, Liberation, and Silence

The regulating system behind the cut-ups is Burroughs's ambition to free himself and his readers 'from conditioning forces'[149] – from the tyranny of language. Burroughs pursues this desire in part by drawing on a style of collage which often resembles that used by the Futurists, employing the frenzied, 'violently revolutionary' aspects of collage in which there is 'not merely variety, but chaos and clashing of rhythms',[150] (as seen in, for example, Carlo Carrà's whirling collage-painting *Interventionist Manifesto* [1914][151]). Burroughs's use of vortex, staccato, and technological imagery, combined with the dizzying speed of his juxtapositions also recalls Futurist collage aesthetics. Like Marinetti, Carrà, and Boccioni, Burroughs employs traits of collage including 'dislocation and dismemberment … the scattering and fusion of details, freed from accepted logic',[152] as a form of propaganda which belies his insistence that his work was purely abstract. Throughout the cut-up novels, and, to an extent, *Naked Lunch*,

[145] Lydenberg, *Word Cultures*, 65.

[146] Burroughs, 'The Art of Fiction', 30.

[147] Thomas, 81.

[148] Thomas, 101.

[149] Tanner, 112.

[150] Umberto Boccioni, 'The Exhibitors to the Public' (1912), 45–50.

[151] In Tangier in 1964 Burroughs and Ian Sommerville made a photocollage entitled 'Infinity' which (possibly coincidentally) intriguingly resembles Carrà's collage-painting.

[152] Boccioni, 'The Exhibitors to the Public', 47.

transplanted objects and cut-up fragments rarely stand independently. Unlike many of Burroughs's characters, who often arrive unannounced, the majority of truncated, reintegrated, textual fragments are weighted with a biographical quality which tugs the reader away from any inherent expectations of propulsive continuity, shifting them backwards and forwards in time, and forcing the reader's memory to bridge the gaps. The result, when reading, is a 'more detached and alert consciousness',[153] which allows the reader to put into practice one of collage's key principles: instead of questing ineffectually after reassurance from the author or narrator, the reader can begin to consider that understanding may in fact lie in the processes of connection and in the gaps between elements. For example, a phrase from *Naked Lunch*: 'all kinds masturbation and self abuse ... young boys need it special' (193) reappears first in *The Soft Machine*: 'we sniff the losers and cut their balls off chewing all kinds masturbation and self abuse like a cow with the aftosa' (16), and then in *The Ticket That Exploded*: 'his plan called for cinerama film sequences featuring the Garden of Delights shows all kinds masturbation and self abuse' (10). In *The Soft Machine* the phrase appears in the context of a dense cut-up of the preceding narrative, in which the Chimu people's so-called 'fun fests' (14) have been described. In the second, the phrase has not only migrated into a new text, it has now become part of a description of a film, which in turn recalls the screenplay sequence of *Naked Lunch* which takes place at 'A.J's Annual Party' (74–87). This repetition compels the reader to an increased cognitive flexibility, 'proceed[ing]', as Lydenberg suggests, 'by a kind of looping process in which he skids, recovers and reorients his reading to the context of the new fragment'.[154] The avant-garde composer John Cage argued that such methods of disorientation, 'where each small part is a sample of what you find elsewhere', facilitate 'at least the possibility of looking anywhere, not just where someone arranged you should', concluding that 'you are then free to deal with your freedom just as the artist dealt with his, not in the same way but, nevertheless, originally'.[155] The cut-ups require a willingness on the part of the reader to collaborate in the process, reflecting Burroughs's desire to incorporate multiplicity and a cultivated nebulousness within his work, and also explaining the difficulties that some readers will inevitably encounter. Despite his rigorously structured writing process, a true appreciation of his work can only come from an acceptance on the part of the reader that the text is governed chiefly by their own imagination. That this was possible is due in part to the developments in European art that had dissolved the strictures of traditional representation. The 'silence',[156] which Burroughs saw as the ultimate objective of the cut-ups, enables the reader, finally, to hear; or, as Bert Leefmans argued in his

153 Lydenberg, *Word Cultures*, 64.
154 Lydenberg, *Word Cultures*, 68.
155 Cage, *Silence: Lectures and Writings*, 100.
156 Burroughs to Gysin, November 1960, *Letters 1959–1974*, 55.

Fig. 2.1 Photograph of archival cut-up material by William S. Burroughs held at the Columbia Rare Book and Manuscript Library. Draft cut-up from the Burroughs Papers, Series II (experimental prose), Box 1, Fols 11–16. Copyright © The Estate of William S. Burroughs, used by permission of The Wylie Agency LLC.

'Metaphysics of Collage', it is 'the "content" of the gap that becomes the source and power of the new'.[157]

Inherent to the collage practice is a defence against singularity and wholeness. Marjorie Perloff argues that 'each element in the collage has a dual function: it refers to an external reality even as its compositional thrust is to undercut the very referentiality it seems to assert'.[158] This opposition to cohesion can be attributed to its context – not only did collage emerge concurrently to an international 'sensibility

[157] Leefmans, 'Das Unbild: A Metaphysics of Collage', 193.
[158] Perloff, 'The Invention of Collage', 10.

Fig. 2.2 Photograph of archival cut-up material by William S. Burroughs held at the Columbia Rare Book and Manuscript Library. Selection of cut-up fragments from the Allen Ginsberg Papers, Series II, Box 16, Fols 7–8. Copyright © The Estate of William S. Burroughs, used by permission of The Wylie Agency LLC.

in transition',[159] but intrinsic to its evolution were two world wars, a civil war, and a series of violent revolutions. John and Joan Digby observe that after the First World War, Dada and Surrealist 'image-making, only a few decades later than the Victorian montages of passive memorabilia, illustrated the degree to which the war had obliterated the past, and made nostalgia impossible'.[160] David Antin suggests that Europe after the Second World War had been reduced to 'a ready-made rubble heap (a collage)',[161] echoing the great collagist Kurt Schwitters's conviction, following the First World War, that 'new things had to be made out of the fragments'.[162] The rationalization through collage of such a ubiquitous fragmentation of the known world lay predominantly in works of art and literature that attempted 'not to reflect but to change reality'.[163] The Russian Constructivists in particular were opposed to any kind of concord in their work, operating instead upon principles of collision and brutal creativity. They understood that the capacity to disturb, frighten, or stimulate lies in creating a relational structure around familiar but displaced words and images 'whose nature is left entirely intact but whose coordination gives them a new life'.[164] Whilst the effect of this can be the manifestation of mere chaos or absurdity, this is ultimately overridden by a more meaningful 'global statement built up like a riddle'[165] to produce a distorted, and yet eerily familiar, vision of disorder and madness. Numerous collaged sequences within Burroughs's cut-up novels resemble in their bitter humour and almost incredible incongruity the disorder and textual interruption of Kruchenykh's Zaum poem *Universal War* (1916), and Aleksandr Zhitomirsky's grim anti-Nazi photomontages, bleak satires of the horrors of the Second World War, featuring skeletons posed as soldiers with comedy-sized images of Hitler dancing parasitically at their feet. In *The Soft Machine* – and in a scene repeated in *Dead Fingers Talk* – the 'public agent' murders a homosexual in a 'subway pissoir' in front of three witnesses whose only response is to 'arrange themselves on the floor like the three monkeys: See No Evil, Hear No Evil, and Speak No Evil' (*SM*, 18; *DF*, 78). In *Naked Lunch*, also in a scene revisited in *Dead Fingers Talk*, in a chillingly Auschwitz-esque laboratory, junior physician Schafer voices his concerns that what he and Dr Benway are doing feels '*evil*'; Benway responds in German – 'Jeder macht eine klein Dummheit' – before misquoting Macbeth's final words (V, vii): 'damned be him who cries 'Hold, *too much*!', qualifying them with his view that 'such people are no better than party poops' (*NL*, 110; *DF*, 88–9). William Lee, in 'The Mayan Caper' section of *The Soft Machine*, experiences

[159] Digby, 12.

[160] Digby, 18.

[161] Antin, 'Modernism and Post-Modernism: Approaching the Present in American Poetry', 108.

[162] Schwitters, quoted in Elderfield, *Kurt Schwitters*, 12.

[163] Ulmer, 'The Object of Post-Criticism', 386.

[164] Perloff, 'The Invention of Collage', 39.

[165] Thomas, 52.

'the crushing weight of evil insect control forcing my thoughts and feelings into prearranged moulds', and learns of 'the horrible punishments meted out to any one who dared challenge or even think of challenging the controllers: *Death in the Ovens*' (55). Ultimately, escape from these kinds of control mechanisms lies in the fragmentary counter-tactic of Burroughs's pervasive refrain: 'Cut the word lines – Cut music lines – Smash control images – Smash the control machine – Burn the books ...' (*SM*, 57). As the novels continue, the Nova Police (the force attacking the parasitical word virus) increases in strength, and the setting becomes increasingly galactic. The noisy features of an earthbound existence fade out of the texts, suggesting to Allen Ginsberg that the cut-up trilogy was 'a work of art fitting to the mutant movement of the human race as it prepares to leave the earth'.[166] The reader drifts further and further into the fissures between the cut-ups, increasingly unanchored by the weighty progression of text, until they are released, finally, into space and silence, articulated in the final line of *Nova Express* as 'fresh southerly winds a long time ago' (157).

This internal liberation, or freeing of the mind and the imagination (and silencing of 'sub-vocal speech' [*TE*, 43]), is, as Tanner suggests, a 'two-way movement – out into reality, up or back into space'.[167] It resembles, in its idealism, Vladimir Tatlin's spatially limitless suspended counter-reliefs, which, like Burroughs's writing, are 'both deeply immersed in the lowest forms of materiality and serenely withdrawn from them'.[168] This kind of work has been referred to as a form of skywriting, in which a message diminishes even as it is given. Regarding Burroughs's skywriting in particular, Joan Didion perhaps puts it best:

> To anyone who finds Burroughs readable at all, he is remarkably rereadable, if only because he is remarkably unmemorable. There are no 'stories' to wear thin, no 'characters' of whom one might tire. We are presented only with the fragmented record of certain fantasies, and our response to that record depends a good deal upon our own fantasies at the moment; in itself, a book by William Burroughs has about as much intrinsic 'meaning' as the actual inkblot in a Rorschach test.[169]

Burroughs's writing is most significant at the moment in which it disappears, melting into the seams of the collage that has delivered it. Recurrent images of windows and sky permeate the cut-up trilogy, whilst words such as 'fading', 'melting', 'dwindling', and 'falling', are used repeatedly; *The Soft Machine* ends with 'dead fingers in smoke' (129), *The Ticket That Exploded* with a modified quotation from *The Tempest* (IV.1.150): 'cut the prerecordings into air into thin air' (159) – and *Nova Express* concludes as noted above, with 'fresh southerly

[166] Undated manuscript fragment found in the Burroughs Papers, Berg Collection, Series I, Box 5, fol. 37b.

[167] Tanner, 112.

[168] Tanner, 112.

[169] Didion, 2–3.

winds', following the repetition of the phrase 'melted into air' (157). Burroughs's work has the potential for longevity not because, as he had hoped, it is either 'spectacular' to look at or to read, but because it is mutable, subjective, and elusive, with the source of its power located, to quote Barthes, 'not in its origin but in its destination', ultimately governed by no law other than that of the reader's imagination.[170]

For Burroughs, the act of withdrawal, of egress, was 'the most subversive move to any establishment',[171] because it rendered the imposition of law by any control mechanism obsolete. He proved this, not only by exiling himself in Europe and Africa following his various transgressions in the US and Mexico, but also by embodying it in his writing. Collage, which involves 'both placing and ellipsis',[172] is simultaneously the brazen avatar of vociferous protest and the apostle of silent resistance. Burroughs uses the collage practice to this end, to create a sort of absent presence, 'a speech beyond silence',[173] a latticework through which glimpses of vision might penetrate. In this sense they carry more weight as biographical texts than the documentary novels *Junky* and *Queer*, as they allowed Burroughs to engage intellectually, emotionally, and physically with his environment, and expose him doing so, revealing 'those gaps, interstices, holes that are compulsively filled in and covered over by the conventional metaphoric text'.[174] Furthermore, his struggle to achieve silence using language can be understood as a writer's quest for liberation from himself in an experiment he had begun, but failed to complete, in the purgative writing of *Queer*, before his discovery that collage's 'silent language of juxtaposition ... can be learned and used to ~~mask~~ make statements'.[175]

Burroughs, ultimately, defined himself intuitively by the cut-ups. He resides, if the reader cares to look for him, in the fissures between the fragments, as much a part of the collage architecture as the cut-ups themselves. Barry Miles demonstrates the confessional nature of the cut-ups, which 'make explicit the actual phenomenon of writing and show it to the reader, revealing the psychological process of what was going on – literally a map of the writer's consciousness'.[176] Whilst the cut-up trilogy does often lose contact with the reader, it provides a fascinating insight into Burroughs's writing technique, whereby the aesthetics of the finished product are subordinated to the processes of creation. Like Cornell's boxes and much of

[170] Barthes, 'The Death of the Author', 148.

[171] Burroughs, 'Interview with Felix Scorpio, London 1969', in *Burroughs Live*, ed. Sylvère Lotringer, 117.

[172] Motherwell, quoted in Taylor, 105.

[173] Susan Sontag, *Styles of Radical Will* (London: Secker and Warburg, 1969), 18.

[174] Lydenberg, 'Notes from the Orifice', 70.

[175] Burroughs, 'The Photo Collage'. On the original typescript the word 'mask' is crossed out and followed by the word 'make' – I have retained the error here because it seems revealing, reiterating Burroughs's awareness of the multi-faceted nature of collage, which can simultaneously mask and make statements.

[176] Miles, *El Hombre Invisible*, 131.

Frank O'Hara's poetry, the cut-up trilogy is a narrative of its own conception, or, as noted earlier, 'the chronicle of the creative act that produces it' (*CP*, viii–ix). With its revisions, repetitions, hallucinations, and inserted commentaries, the cut-ups literally show the writer's mind at work. The unique form of the cut-ups also forces a reassessment of the rules of reading which reaches beyond the boundaries of these particular texts, facilitating not just an appreciation of Burroughs's work (and providing a means by which to overcome its emetic effect), but also a re-evaluation of the ways in which we approach any text.

Burroughs claimed that he saw 'no point in exploring areas that have already been thoroughly surveyed',[177] and certainly his cut-up novels took the collage technique into uncharted waters, like the 'early navigators when the vast frontier of unknown seas opened their sails in the fifteenth century'.[178] The cut-up technique embodied his conviction that 'writing must always remain an *attempt*'.[179] Burroughs's journey into collage actually leads back into the rich, experimental half-century of European art that had gone before him, and into which his resulting cut-up work must be incorporated if it is to be fully understood. Burroughs certainly was not an imitator, and although he lived and worked in Paris, and had travelled extensively throughout Europe during the 1930s, it is difficult to say whether or not he actually ever went to look at a collage by Picasso or Ernst. But the groundwork was done for him, and by the time that he came to write the cut-up novels, collage was one of the most ubiquitous creative techniques of the era: as Pierre Joris asserts, 'there isn't a 20th century art that was not touched, rethought or merely revamped by the use of [collage]'.[180] Unwittingly or otherwise, Burroughs took an enormous amount from the European art movements which preceded his cut-ups, and it is therefore essential and rewarding to consider them within the context of twentieth-century European art, as well as American literature, not just because they have a place there, but because such consideration will render them more comprehensible to readers in doubt of their literary merit.

The key problem with Burroughs's writing remains, however: his subject-matter *does* get in the way of his form. In spite of Burroughs's attempts 'to strangle his own voice,'[181] the scenes he conjures up are too visceral, and the expurgatory reflex too strong. As Brion Gysin joked, Burroughs's texts would need to be 'wrapped in sheets of lead and sunk in the sea, disposed of like atomic waste'[182] before we can forget them. Ultimately Burroughs cannot adopt silence and continue to write He is unable, finally, to make that 'artist's ultimate

[177] Edinburgh Writers' Conference, 24 August 1962: 'The Future of the Novel'.

[178] Quoted in *The Job*, 21.

[179] Burroughs to Ginsberg, 23 May 1952 (Ginsberg Papers, Columbia, Box 1, fol. 22).

[180] Joris, 86.

[181] Oxenhandler, 182.

[182] Gysin, in Brion Gysin and Terry Wilson, *Here To Go: Planet R-101* (San Francisco: RE/Search Publications, 1982), 191.

other-worldly gesture'[183] – that is, to grow quiet and disappear. The hysterical, emotional response to his collaged work simultaneously proved and disproved his theories, showing words to be precisely the controlling force he so feared, but also that regardless of the order in which they were placed they somehow retained their power. However, although he was unable to 'rub out the word' or even to achieve 'ten seconds of inner silence', the cut-ups remain significant experimental works, whose lasting value is as formal collage phenomena rather than literary texts. In order to refute the quotation from *Naked Lunch* with which this chapter began ('confusion hath fuck his masterpiece'), the reader might return to its origin, *Macbeth*, II.3.70, and consider the possibility that perhaps, after all, 'confusion now hath made his masterpiece'.

[183] Sontag, 6.

Chapter 3
'Donc le poète est vraiment voleur du feu':[1] Frank O'Hara and the Poetics of Love and Theft

The title of this chapter is a form of collage, an appropriation and an assimilation, intended to reflect both 'the stolen hearts and emotional misdemeanours',[2] and the heisting of cultural and contextual materials, which permeate O'Hara's compositional process. O'Hara steals what he loves, and loves what he steals, and the result is usually a remarkable collage of ideas, moments, quotations, emotions, thoughts, and situations, both his own and those originating in other people, enacting Gregory Ulmer's notion of collage as 'a kind of theft which violates "property" in every sense'.[3] This chapter's title is itself, of course, the latest in a genealogy of violated property: for the most part it is borrowed from Bob Dylan's 2001 album, *Love and Theft*, the title of which was in turn taken from Eric Lott's 1993 publication, *Love & Theft: Blackface Minstrelsy and the American Working Class*, which was itself a riff on Leslie Fiedler's *Love and Death in the American Novel*, published in 1960. The quotation – 'thus the poet is truly the thief of fire' – comes from a letter written by Arthur Rimbaud to George Izambard in 1871, which is often used as a preface to *Illuminations*. The letter, with its evocatively primal image of the poet as a thief of fire – as a kind of Prometheus figure – resounds with the passion and unpredictability of O'Hara's poetry, with its lived qualities, with

[1] 'Donc le poète est vraiment voleur de feu. Il est chargé de l'humanité, des animaux même; il devra faire sentir, palper, écouter ses inventions; si ce qu'il rapporte de là-bas a forme, il donne forme; si c'est informe, il donne de l'informe. Trouver une langue ... cette langue sera de l'âme pour l'âme, résumant tout, parfums, sons, couleurs, de la pensée accrochant la pensée et tirant ... Cette avenir sera matérialiste, vous le voyez ... La Poésie ne rhythmera plus l'action; elle sera en avant'.

'Thus the poet is truly the thief of fire. He is responsible for humanity, even for the animals; he will have to have his inventions smelt, felt, and heard; if what he brings back from down there has form, he gives form; if it is formless, he gives formlessness. A language must be found ... This language will be of the soul for the soul, containing everything, smells, sounds, colours, thought holding onto thought and pulling. This future will be materialistic, as you see; ... Poetry will not lend its rhythm to action, it will be in advance'. (*Rimbaud: Complete Works, Selected Letters*, ed. Wallace Fowlie [Chicago: University of Chicago Press, 2005 (1966)], 376–9.)

[2] Eric Lott, interview with David McNair and Jayson Whitehead, *Gadfly Online* (December 2001), http://www.gadflyonline.com/12-10-01/book-ericlott.html [Accessed 9 October 2010].

[3] Ulmer, 391.

the sense that in his writing he was stealing something back from the literary gods, and also with the impression that his writing is unequivocally enmeshed with the authority of witness.

Collage, as I have noted, has been described as both 'an intuitive self-definition of the artist among objects'[4] and as 'the growth of the surface towards us in real space'.[5] In the light of both statements, this chapter will account for the effects of collage on O'Hara's work, and use the practice as a lens through which it can be appreciated. I will explore the role collage played in the dialogue between materiality and self-definition enacted in O'Hara's poetry, and consider the ways in which his early Surrealistic experiments in collage were crucial to the definition of his poetic. I will also examine his use of the collage practice in relation to his interactions with the European avant-garde, with his readers, with his coterie, with painters, with other poets, and with New York City, positing the argument that collage, for O'Hara, was ultimately both a state of mind and a means of enabling readers to experience rather than merely to interpret his work.

Materiality and Self-Definition: Why Collage?

Collage was a crucial part of O'Hara's exploration into the nature of his self-definition as a poet in his increasingly materialistic environment. In addition to the escalating commodity culture of the 1940s and 1950s (which O'Hara embraced aesthetically and made use of), he also found himself inevitably immersed in what fellow poet James Schuyler called 'the floods of paint in whose crashing surf we all scramble'.[6] The prevailing (and, to O'Hara, most appealing) mode of creativity at the time he began to write seriously, was in physical materials – paint – rather than in words. New York, the newly-crowned capital of the art world, was a realm of paint and materiality in which, as Saul Bellow's protagonist notes in *Seize the Day*, 'there were fifty thousand people ... with paints and brushes, each practically a law unto himself. It was the Tower of Babel in paint'.[7] Writers in New York City soon realised that this world of art and painting could exist quite successfully outside the domain of language and literature. John Ashbery spoke of the coveted freedom of creativity enjoyed by the Abstract Expressionist painters, for instance, which remained, initially, off limits for the poets:

> Artists like de Kooning, Franz Kline, Motherwell, Pollock – were free to be free in their painting in a way that most people felt was impossible for poetry. So I think we learned a lot from them at that time, and also from composers like John Cage and Morton Feldman, but the lessons were merely an abstract truth – something like Be yourself – rather than a practical one – in other words,

4 Carrà, quoted in Poggi, 185–6.

5 Malevich, 'Spatial Cubism', 60.

6 Schuyler, quoted in David Lehman, *The Last Avant-Garde: The Making of the New York School of Poets* (New York: Doubleday, 1998), 2.

7 Saul Bellow, *Seize the Day* (London: Penguin, 2006 [1956]), 35.

nobody ever thought of scattering words over a page the way Pollock scattered his drips.[8]

During the early 1950s – the period in which O'Hara produced long, fraught, collage-heavy poems such as 'Second Avenue' (1953), 'Easter' (1952), and 'Hatred' (1952), as he was making the transition from Harvard to New York – he had not yet come to terms with the notion of artistic freedom discussed by Ashbery above. Writing at a junction in literary history when tradition and literary orthodoxy loomed particularly oppressively over creativity, he seems also, judging by such poems, to have been experiencing a more personal kind of writerly crisis of influence and a struggle to find his own poetic voice. His decisive use of collage during this period represents a form of 'askesis', or purgation, to borrow from Harold Bloom's set of terms deployed to define the anxiety of influence. The poems manifest an iconoclastic, self-purgative instinct. They appear to be deliberately *artistic* acts of aggression against the poetic tradition, as O'Hara struggles to be what Bloom calls 'the truly strong poet' who is 'both Prometheus and Narcissus ... making his culture and raptly contemplating his own central place in it'.[9] The freedom of experimentation enjoyed by the artists, and their attendant success in the wider circles of culture, represented an ideal for O'Hara: artists like Willem de Kooning and Jackson Pollock, in particular, succeeded at arresting the gaze of the cultural world whilst simultaneously remaining true to themselves and to their ideals. They also seemed to be having more fun than their literary counterparts; as Ashbery noted, 'no one with a sense of adventure was going to be drawn to the academic poetry that flourished at the time'. It therefore seemed both rational and exciting to O'Hara to use art in order to try to liberate himself from the restrictive bonds of literary influence and the tedious 'politics of getting into never-to-be-heard-of anthologies'.[10]

The influence of art on O'Hara is evident in poems from across the spectrum of his work, from titles that sound like paintings ('Study For Women On A Beach', 'Image of the Buddha Preaching'), to poems dedicated to painters ('For Bob Rauschenberg', 'For Grace, After A Party', 'Ode to Willem de Kooning', 'Hieronymus Bosch'), to poems that deliberately employ the stylistic techniques of collage, Surrealism or Abstract Expressionism. 'In Memory of My Feelings', as Anthony Libby has suggested, is reminiscent of a Pollock drip-painting, such as *Summertime 9A*, in its looping ubiquity, its underpinning by an even but dynamic tension, and its absence of linear stimulus.[11] 'To The Film Industry In Crisis' is a classic example of self-reflexive verbal montage which cleverly

[8] Ashbery, 'The New York School of Poets' (1968), in *Selected Prose* (Manchester: Carcanet, 2004), 115.

[9] Harold Bloom, *The Anxiety of Influence: A Theory of Poetry* (Oxford: Oxford University Press, 1997 [2nd edn]), 119.

[10] Ashbery, 'Frank O'Hara, 1926–1966' (1966), *Selected Prose*, 78–80.

[11] Anthony Libby, 'O'Hara On The Silver Range', *Contemporary Literature* 17, no. 2 (Spring 1976): 249.

mimics cinematic narrative techniques: it is, to borrow from Andrew Clearfield, 'marked by a succession of visually disconnected images which, cut together ... tell a coherent story or furnish some sort of ironic commentary upon that story'.[12] 'Chez Jane' is punctuated by visually juxtaposed objects – 'the white chocolate jar', 'petals', 'the terrible puss' (*CP*, 102) – which, in themselves, connote little beyond the simple fact of their representation of themselves, but as a collective serve as a constituents of a vivid, Surrealist still life, brimming with pleasurable contradictions. 'Easter' recalls the improvisatory, disorienting elements of Dadaist collage, whilst 'Biotherm' is an orchestral collage sequence featuring divergent yet interrelated 'puns, in-jokes, phonetic games, allusions, cataloguing, journalistic parodies, and irrelevant anecdotes',[13] in an accomplished mélange of the fantastic and the real. Collage in O'Hara's work is difficult to define precisely because it operates conceptually – it is rarely possible to say that this or that fragment of text has *actually* been cut and pasted in from elsewhere. It is important to bear in mind, then, the opening arguments of this book, in which I established that 'the process of pasting is only the beginning of collage',[14] and that its long-term impact was as much as a conceptual phenomenon or attitude of mind as it was a physical practice.

Collage, as the European avant-garde had shown (and as Ashbery would also find, particularly when writing *The Tennis Court Oath* [1962], which I will discuss in my conclusion), was the ideal method with which to indulge the creative impulse to take the world apart in the name of aesthetic liberty, originality, and self-excavation. Although he was growing increasingly involved with Abstract Expressionism, in the early 1950s O'Hara remained somewhat mired in Surrealism: his poems from this time are often violent and extreme, abstract and self-annihilating, an aggressive torrent of collage frequently inundating the reader with wilfully disjunctive imagery. There is also, however, a distinctly un-Surrealistic emotional quality to the poems, which bubbles through and threatens to disrupt his otherwise deliberately flat poetic surfaces, indicative of his later, more profound and long-lasting involvement with the non-figurative emotional intensity of Abstract Expressionism.

In particular, O'Hara's experimental employment of collage in three poems from the early 1950s – 'Second Avenue', 'Easter', and 'Hatred' – paves the way for his better-known poetry, which, made up as it is of simple, everyday fragments collaged together, is related to the collages of Picasso in the period 1912–1914. We see in the later poems the same benign 'element of provocation' that Peter Bürger, in his *Theory of the Avant-Garde*, saw in Cubist collage: 'the reality fragments remain largely subordinate to the aesthetic composition ... although there is a destruction of the organic work that portrays reality, art itself is not being called into question'.[15] O'Hara's later poetry, particularly the 'I do this, I do that'

[12] Clearfield, 9–10.

[13] Perloff, *Poet Among Painters*, 174.

[14] Perloff, 'The Invention of Collage', 6.

[15] Bürger, 74.

poems, are weighted far more in a material, fragmented reality out of which the poetic psyche may be mined. Although the solipsistic antagonism has dissipated, the roots of this poetic stance are nevertheless particularly visible in 'Second Avenue', a poem O'Hara described as itself *being* the subject, rather than being *about* a subject ('Notes on "Second Avenue"', *CP*, 497). In order to understand the route by which O'Hara travelled from 'Second Avenue', 'Easter', and 'Hatred' to the 'I do this, I do that' poems and beyond, this chapter will conduct a broadly chronological assessment, first exploring his earlier writing before moving on to discuss his later poetry in the second half of the chapter.

'Speaking with things': Poetic Bricolage, Surrealist Experiments, and the Lure of Europe

Ideas and instances of love and theft in O'Hara's work operate most significantly in relation to the role he carves for himself both as the kind of *flâneur* for whom the joys of the city lie in fragmentary surface images which can be looked at and heard without necessarily requiring interpretation; and as a poetic *bricoleur*, of the kind discussed by Claude Lévi-Strauss in *The Savage Mind*:

> The 'bricoleur' … derives his poetry from the fact that he does not confine himself to accomplishment and execution: he 'speaks' not only with things … but also through the medium of things: giving an account of his personality and life by the choices he makes … The 'bricoleur' may not ever complete his purpose but he always puts something of himself into it.[16]

We see this in much of O'Hara's poetry, from his early attempts, in poems such as 'Second Avenue' and 'In Memory of My Feelings' (1956), to try on the Surrealist voice, to his 'I do this, I do that' poems, in which the buildings and people of New York are interlinked to give an account of his personality and life. Furthermore, because O'Hara worked so fast, because he didn't 'believe in reworking – much' (*SS*, 21), and because he died unexpectedly at a relatively young age, he did not, in a sense, ever complete his purpose. And yet, he himself was so much a part of his poems that his body of work flourished following his death, as his devotees sought to use it to reconstruct him, both in terms of keeping his work current, and attempting, with varying degrees of success, to adopt his poetic style and techniques. Emerson wrote that 'every master has found his materials collected, and his power lay in his sympathy with his people, and in his love of the materials he wrought in'.[17] O'Hara built his poetry out of the things he loved, the things he hated, and the experiences he had in New York City, depicting them within his work in such a way that they operate as far as possible as found objects, or as pasted-in fragments,

[16] Lévi-Strauss, *The Savage Mind* (London: Weidenfeld & Nicolson, 1966), 21.

[17] Ralph Waldo Emerson, 'Shakespeare, or the Poet', in *The Collected Works of Ralph Waldo Emerson Vol IV: Representative Men: Seven Lectures*, ed. Wallace E. Williams (Cambridge: Harvard University Press, 1987), 110.

in spite of the fact that the work, of course, is made of words (O'Hara accepted that as a poet he could not, ultimately, move outside of language, an acceptance which William Burroughs found far more difficult to reach). O'Hara's satisfaction with collage relates partly to its potential for expressing 'the relationship between the surface and the meaning' (*CP*, 497), a particular facet of his early poetry which he felt was important, writing in his 'Notes on "Second Avenue"' that 'the one is the other (you have to use words) and I hope the poem to be the subject, not just about it' (*CP*, 497). O'Hara's use of collage delineates the intersections between words and images and ideas, compelling the reader to take note of the referential quality of transposed fragments of experience, however large or small, abstract or specific they may be, before considering them in the role they have assumed, situated within the context of the poem. The speaker in the seventh section of 'Second Avenue', for example, declares 'I want listeners to be distracted' (*CP*, 145). Picasso, similarly, talking about his own pioneering use of collage, asserted that

> It was never used literally but always as an element displaced from its habitual meaning into another meaning to produce a shock between the usual definition at the point of departure and its new definition at the point of arrival … This displaced object has entered a universe for which it was not made and where it retains, in a measure, its strangeness.[18]

It is this jolting sense of departure and arrival that O'Hara puts to work across the surfaces of poems such as 'Second Avenue'. Tom Conley, discussing 'the literatures of collage' explores a similar idea, proposing that the 'reader's memory of the source and citation provides an imaginary break of continuity and a glimpse of the work of writing'.[19] This fits with the deliberate obscurity cultivated by O'Hara in many of his poems, as well as with his statement that his 'Notes on "Second Avenue"' 'were explanatory of what I now feel my *attitude* was toward the material, not explanatory of the meaning which I don't think can be paraphrased (or at least I hope it can't)' (*CP*, 495). The poem resists meaning, its 'diced excesses' (*CP*, 139) moving too fast to sustain much reflection on the part of the reader. What it explores instead is the key notion of 'enlacement' or 'contamination' (*CP*, 141), whereby words or images are replaced or cross-pollinated with others, creating within the text false memories for the reader, who is then accused of 'the deviousness of following' (*CP*, 143). In the line 'cerise cumulus cries' (*CP*, 145), for instance, readers often hear 'skies'; in 'alternate sexual systems' (*CP*, 140), readers will half-hear 'solar', and so on. This is a form of audio collage, which complements O'Hara's free-spirited compositional self-contradiction, which he describes in the 'Notes'. He initially recalls the lines 'and your wife, Trina, how like a yellow pillow on a sill / in the many-windowed dusk where the air is compartmented!' as being about 'a de Kooning WOMAN which I'd seen recently at his studio'. He then reconsiders, however, writing 'actually,

18 Picasso, quoted in Gilot and Lake, 70.
19 Conley, 153.

I am rather inaccurate about the above, since it is a woman I saw leaning out of a window on Second Avenue with her arms on a pillow, but the way it's done is influenced by de K's woman' (*CP*, 497). In collaging the two separate memories, splicing them together and proceeding to move back and forth between them in order to create the instance depicted in the poem, O'Hara makes clear that in addition to the heaped and strange disjunctive imagery which marks the surface of his work, biographical fissures run deep beneath it.

Brockelman, in *The Frame and the Mirror*, describes collage as being representative of 'the intersection of multiple discourses'.[20] O'Hara himself was the embodiment of the idea of an intersection of multiple discourses. At the time of his death, he was the centre of an eclectic, even collaged, social circle: as an art critic, curator at the Museum of Modern Art, talented pianist, poet, and playwright, he moved with ease between disciplines, taking people on their individual merit rather than choosing sides between the numerous different groups or schools of artists or writers with whom he came into contact. His views on the inspiration he drew from art had become confidently equivocal, and he asserted: 'I don't find that one year I'm excited by Abstract Expressionism, the next year by Pop Art, the next year by Op Art, and this coming year by spatial sculpture or something. It is all in the same environment which I live in' (*SS*, 6). Regarding the world of poetry, Anne Waldman (paraphrasing Edwin Denby) recalled that 'it was through Frank O'Hara that the uptown poets and the downtown poets got together and eventually the West Coast too, plus the painters and Frank was at the centre and joined them all together. After his death there was no centre for that group'.[21] In his writing, his aesthetic appropriation and interweaving of a vast range of material, makes clear, as Ginsberg observed of him, that O'Hara 'felt that any gesture he made was poetry, and poetry in that sense was totally democratic. So that there were no kings and queens of poetry'.[22]

His lifelong receptivity to other art forms, and his sustained use of collage concepts, came partly, as fellow New York poet Barbara Guest explains, from growing up 'under the shadow of Surrealism':

> In that creative atmosphere of magical rites there was no recognized separation between the arts ... all the arts evolved around one another, a central plaza with roads which led from palette to quill to clef. One could never again look at poetry as a locked kingdom. Poetry extended vertically, as well as horizontally. Never was it motionless within a linear structure.[23]

[20] Brockelman, 2.

[21] Anne Waldman, 'Paraphrase of Edwin Denby speaking on the New York School', in *Homage to Frank O'Hara*, ed. Berkson and LeSueur (Bolinas: Big Sky, 1978), 32.

[22] Ginsberg, 'Early Poetic Community' (discussion with Robert Duncan at Honors College, Kent State, 7 April 1971), in *Allen Verbatim: Lectures on Poetry, Politics, Consciousness*, ed. Gordon Ball (New York: McGraw-Hill, 1974), 149.

[23] Barbara Guest, *Forces of Imagination: Writing on Writing* (Berkeley: Kelsey Street Press, 2003), 51–2.

Much of O'Hara's earlier poetry is Surrealist in tone and diction, and it differs significantly from the city poems which he wrote later, for the most part because the later proliferation of contextual information is either jumbled or absent altogether. The Surrealist stimulus is more immediately apparent in certain shorter early poems, which are more obviously related to the plastic rather than the poetic arts. 'Homage to Rrose Sélavy', written in 1949, for instance, refers directly to Marcel Duchamp's alter ego, and recalls his two most famous works. In the lines 'When I see you in a drugstore or bar I / gape as if you were a champagne fountain' (*CP*, 10), we are reminded of Duchamp's most famous readymade, the porcelain urinal entitled *Fountain* (1917). Later in the poem the lines 'clattering down a flight of stairs like a / ferris wheel jingling your earrings and feathers' simultaneously evoke the artist's *Nude Descending a Staircase, No. 2* (1912), his readymade *Bicycle Wheel* (1913), and the photographs, taken by Man Ray, of Duchamp dressed in drag as the eponymous Rrose. It is interesting to compare this poem with the later love poem, 'Having a Coke With You' (1960), in which O'Hara blithely relegates the *Nude Descending a Staircase* to the position of just another piece of art he 'never think[s] of', grouping Duchamp together with several other celebrated artists, including Da Vinci and Michelangelo, who 'used to wow me', but whom he now deems to have been 'cheated of some marvellous experience' (*CP*, 360). There is a marked distinction between the tone of almost slavish adulation in 'Homage to Rrose Sélavy' and his casual dismissiveness of art in general in favour of the experience of being with, and simultaneously writing a poem for a loved one in 'Having a Coke With You'.

The coolly sinister 'Female Torso', written in 1952, relates in its imagery and motifs to the subversive doll photography of the German Surrealist Hans Bellmer, who had also been included in the 1948 *Collage* exhibition at the Museum of Modern Art. Bellmer's work features life-sized female mannequins, often lacking heads and arms, and, in an image that particularly chimes with O'Hara's poem, photographed in a woodland setting. The correlation is clear:

Each night plows instead of no head
nowhere. The gully sounds out
the moonlight, a fresh stream
licks away blood ties they'd touched
my trail by. Clouds pour over engines
and the children log down this chute
who is the vernal rattletrap. See,
much am I missed among the ancients.
Here jerk the cord around my neck
to heel. I'm the path so cut and red.
She shall have her arms again. (*CP*, 78)

Longer poems such as 'Oranges: 12 Pastorals' (1949), 'Second Avenue', 'Memorial Day 1950', 'Hatred', and 'Easter' reveal O'Hara's Surrealist influences by encompassing collage, obscene juxtapositions, hallucinatory transformations,

distraction techniques, and irrational, varied syntax. James Breslin suggests that these early poems are often 'more contrived than revelatory, as if bombastic French language games were a sufficient substitute for the current "academic parlor game"'.[24] To a degree he is correct: too often these poems do fall foul of O'Hara's self-confessed 'passion for poetry and his own ideas ... [which] tend to run away with the poem ... until the poet feels that his emotions are more important than any poem, that indeed they, not words, *are* the poem' (*SS*, 35). This failing notwithstanding, O'Hara nevertheless succeeds in using the language and collage constructs of Surrealism to great effect in order to render intricate emotional dynamics out of the detritus of his linguistic and spiritual world; or, to borrow from Herbert Leibowitz (who identified O'Hara as 'a distant cousin of the Dadaists'), 'the brittle, decorated surfaces of his poems, the droll humour, cloak a Pierrot who is easily wounded'.[25]

'Memorial Day 1950' (*CP*, 17), for example, is part memoir, part manifesto, part memorial to the artists, particularly the European ones, who inspired O'Hara as a young man. The poem is one of O'Hara's first to use collage as a means to attempt to appropriate the techniques of film: less those of classic narrative cinema (which splices together sequential shots which are demonstrably related to one another), than those of Sergei Eisenstein, who used the principle of collision to evoke emotion in his audiences, and the avant-garde films of Dalí and Buñuel, or Francis Picabia and René Clair. O'Hara dissolves and cuts away throughout stanzas that accumulate almost as separate entities, held together by abstract, even polarized, emblems which logically are not connected, but which operate on emotional links instead, such as 'surgery', the 'guitar', 'fathers', and the colour blue, which run through the poem. In contrast to Joseph Cornell, O'Hara uses collage to downplay the role of symbolism in the poem, to emphasise the physicality of the objects he refers to, and to ensure that the fragments of autobiography he chooses to reveal neither drift meaninglessly apart nor subsume the abstract and experiential details of the rest of the poem. The result is a shifting, nonorganic canvas in which meaning is derived from old contexts and new arrangements. It is Surrealistic and self-reflexive in its open referencing of Picasso, Gertrude Stein, Apollinaire, Max Ernst, collage, and the 'Fathers of Dada!' It also establishes a precedent for O'Hara's later poetry, in which the varied styles of William Carlos Williams, Walt Whitman, and Ezra Pound complement the synaesthesia characteristic of Dada, and in which the 'wasted child' who 'tried / to play with collages' at the start of the poem is, by the closing stanza, a poet in his own right, 'dress[ed] in oil cloth and read[ing] music / by Guillaume Apollinaire's clay candelabra'. Phrases such as 'all of us began to think / with our bare hands' and 'we never smeared anything except

[24] James Breslin, *From Modern to Contemporary: American Poetry from 1945–1965* (Chicago: University of Chicago Press, 1984), 242.

[25] Herbert Leibowitz, 'A Pan Piping on the City Streets', review of *The Collected Poems of Frank O'Hara*, *New York Times Book Review*, 28 November 1971 (reprinted in Elledge, *Frank O'Hara: To Be True To A City* [Ann Arbor: University of Michigan Press, 1990, 26]).

to find out how it lived', also indicate the beginning of O'Hara's move away from the political, psychically-driven cynicism of Surrealism and toward the warmer, more positivistic physical processes and ideas of Action Painting.

This poem is typical of the ways in which O'Hara, particularly at this relatively early stage in his career, often seemed to be viewing American culture through the lens of French art and poetry, turning his gaze toward Europe in much the same way as Joseph Cornell. Rod Mengham notes the striking frequency, throughout the *Collected Poems*, with which O'Hara manifests this tendency: 'New York references are supplanted by French references, ... the space that these poems explore seems to be simultaneously French and American, ... meditations on New York end up being displaced by reveries about Paris'.[26] In 'Oranges: 12 Pastorals', for instance, the speaker cries revealingly: 'I hear you! You speak French!' (*CP*, 5). In 'Naphtha' (1959), O'Hara explores and expresses his anxiety at what he perceives to be his creative inertia, questioning the validity of the place he occupies within his context – physically, creatively, and temporally. He achieves this through his subtle depiction of the corresponding skylines of Paris and New York, as the poem veers sharply from an image of the French artist Jean Dubuffet 'doing his military service in the Eiffel Tower / as a meteorologist' to an image of 'the gaited Iroquois on the girders', building the skyscrapers of an ever upwardly-expanding New York, before returning to Paris, to 'the haunting Métro / and the one who didn't show up there / while we were waiting to become part of our century' (*CP*, 337). In the final stanza O'Hara pastes in a statement by Dubuffet, taken from the 1947 invitation to his *Portraits* exhibition: '"with a likeness burst in the memory"'.[27] O'Hara uses quotation marks to clearly demarcate the fragment from the rest of the poem, drawing attention to its alienness in order to highlight what he perceives to be the cultural divide between his world and Dubuffet's. It is clear too, however, that he selected this quotation for its proximity to his own mind-set regarding

[26] Rod Mengham, 'French Frank', in *Frank O'Hara Now: New Essays on the New York Poet*, ed. Robert Hampson and Will Montgomery (Liverpool: Liverpool University Press, 2010), 49.

[27] According to Michel Ragon's *Dubuffet* ([New York: Grove Press, 1959], 23), the quotation in line 38 of O'Hara's poem is probably taken from a statement by Dubuffet in the catalogue for his 1959 show at the Museum of Modern Art – however this is likely to be a reprint of a 1947 invitation to an exhibition of Dubuffet's Portraits, which read:

People are much better looking than they believe
Long live their true faces
At the Galerie Drouin
17, Place Vendôme
PORTRAITS
with a likeness extracted,
with a likeness cooked and preserved in the memory,
with a likeness burst in the memory of
MR JEAN DUBUFFET
Painter

his relationship with European culture, and his own creative ideology, in that he almost perceives his European influences as memory, as something which is a part of his own history, and which he can therefore recall and legitimately draw upon. This act of trans-Atlantic collage, and O'Hara's linking of the Dubuffet exhibition with the occasion of his poem, further enforces the doubling of Paris and New York, France, and the US, emphasising the complex anxieties and responsibilities felt by many New York artists about living and working in the new capital of the art world, while the former capital deteriorated within the wider context of a politically and culturally weakened Europe.

O'Hara explored this anxiety more explicitly in his introduction to the exhibition catalogue which accompanied Robert Motherwell's 1965 show at the Museum of Modern Art. O'Hara discusses the 'intense Francophilism among all liberal intellectuals' caused by the fall of France during the Second World War, and describes the European émigré artists and writers as

> emblems of art and also as emblems of experience – an experience which no American artist save Gertrude Stein suffered as the French themselves did. Their insouciant survival in the face of disaster, partly through character, partly through belief in art, is one of the great legends ... In the artistic imagination these refugees represented everything valuable in modern civilisation that was being threatened by physical extermination.[28]

O'Hara's stance toward France was by no means one of untempered adulation, however, although it is interesting to note how little acknowledgment he gives to the imperialism and patriarchy of France, particularly under the rather chauvinistic Charles de Gaulle. Mengham draws attention to a recollection by Barbara Guest, when, during a trip to Paris, O'Hara allegedly commented somewhat trenchantly: 'their history ... doesn't interest me. What does interest me is ours, and we're making it now'.[29] This highlights the fact that O'Hara was actively trying to be a poet of America, even if he sometimes had to remind himself of it. Notwithstanding his admiration for the French, he was keenly aware of and attuned to the rising star of his Americanness, and he maintained his commitment to resisting the notion 'that *avant-garde* was not only a French word but an École de Paris monopoly'.[30] Whilst his admiration for French poets such as Apollinaire, Rimbaud, and Reverdy was profound (and not, of course, terribly unusual), he was very much at a remove from the strand of Anglo-American modernism which disparaged the creative legacy of Walt Whitman, or the currency of developments in poetry from other cultures, and for whom literature was almost exclusively equated with the European past (T.S. Eliot, in 'Tradition and the Individual Talent', for instance, views 'tradition'

[28] O'Hara, introduction to *Robert Motherwell* (New York: Museum of Modern Art, 1965), 10.

[29] Quoted in Mengham, 'French Frank', 50–51.

[30] O'Hara, *Robert Motherwell*, 8.

as equating exclusively to 'the whole of the literature of Europe',[31] seemingly disregarding the traditions in literature of the rest of the world). O'Hara displayed a Franco-American esteem for the brazen romanticism of Whitman's poetry, and, to quote David Antin, for 'the anti-literary impulses embodied in the great catalogues and the home-made tradition of free verse'.[32] Ultimately, of course, as he declared in his riotous mock-manifesto, 'Personism' (1959), 'only Whitman and Crane and Williams, of the American poets, are better than the movies' (*CP*, 498).

'Physically operating on the world': 'Second Avenue', 'Hatred', and 'Easter'

Poetic bricolage, anti-literary impulses, the aesthetic intersections between surface and meaning, and the relation of America to the rest of the world are all in evidence in the cathartic verse expanses of 'Second Avenue', 'Hatred', and 'Easter'. In their speed, imagination, and brazen aggression, these collage poems of the early 1950s provide a distorted impression of a multitude of voices and attitudes, techniques and imagery, and events both real and psychological. They are underpinned by a use of collage which is at once despotic and totally democratic, in which the reader is seemingly invited to engage and to explore, but is then surreptitiously unmanned by the extreme levelling of the poems' misleading component parts. Written in March and April of 1953, 'Second Avenue' is O'Hara's best-known poem from this period. It consists of eleven unequal, unrhymed sections that trace, upon close inspection, O'Hara's concerns, aesthetic concepts, and preoccupations at the time of writing, including, as Lytle Shaw notes, 'not merely the familiar existential struggles, but also the "inadmissible" contexts of American cars, Hollywood violence, and Cold War ideology'.[33] The reader must navigate the poet's verbal junkyard, encountering some concepts naturally associated with O'Hara, in lines such as 'it's very exciting to be an old friend / of Verlaine' (*CP*, 145), or 'At / lunch in the park the pigeons are like tulips on the trees' (*CP*, 147), but having to reconcile them with stranger ones, some of which seem incongruous or unlikely, but not impossible – 'Bill was married secretly by a Negro justice / over the Savoy on Massachusetts Avenue' (*CP*, 148) – and others manifestly acts of old-fashioned cut-and-paste collage:

> And then staggering forward into the astounding capaciousness
> of his own rumor he became violent as an auction,
> rubbed the hairs on his chest with bottles of snarling
> and deared the frying pan that curtained the windows
> with his tears. (*CP*, 144)

[31] Eliot, 'Tradition and the Individual Talent', in *The Sacred Wood* (London: Faber, 1997 [1920]), 41.

[32] Antin, 127.

[33] Shaw, 'Gesture in 1960: Toward Literal Situations', in *Frank O'Hara Now*, 37.

O'Hara uses collage in this way to evade and subvert the views of readers and critics, continually redeploying himself in varying guises throughout the text. In the third section alone he himself appears to manifest as 'the animal', 'the paralytic', 'the dancer', 'the condemned man', and 'the judge' (*CP*, 142). This is deliberate misdirection on the part of the poet, and the reader, in coming to critical terms with the poem, as Andrea Brady argues, 'is expected to have already failed'.[34] O'Hara's attitude toward the figure of the critic is distinct from his attitude toward the reader, but this is something which we learn in hindsight, not just from reading O'Hara's notes on the poem, but from studying his body of work as a whole. Take this anachronistic understanding away, and the poet's attitude toward his readers seems petulant and schizophrenic; in terms of tone, the dryness, irony, and, at times, concerted disregard for his readership, is undermined by a distinct but subtly revealed vulnerability on O'Hara's part. The text veers between quasi-confessional outpourings such as admitting to 'the longing to be modern and sheltered and different / and insane and decorative as a Mayan idol too well understood / to be beautiful' (*CP*, 141), and accusations that the analytical (and perhaps inadvertently New Critical) reader is a 'grinning Simian fart, poseur among idiots / and dilettantes and pederasts' (*CP*, 148). O'Hara brazenly pulls the reader's attention swiftly to and fro across the text, attempting to prevent them from delving beneath the surface, or from embarking on any processes of psychoanalysis or interpretation; instead, with a defiant insolence, he poses the question to the reader: 'Is your throat dry with the deviousness of following?' (*CP*, 142) This question is also, of course, directed at himself, problematizing his own role as a reader of other people's poetry and his struggle, as a young poet, with the anxieties of influence.

The longer view of 'Second Avenue' reveals a poem that, like 'Oranges' (as I will discuss), is attempting to be painterly, and is thwarted in its attempts on account of the length of time it takes for a reader simply to read it, let alone come to an understanding of it. Unlike a painting, which the gaze can take in in a matter of seconds, a poem – particularly one of this length – takes much longer. Alan Ansen wrote of William Burroughs's *Interzone* that 'to sketch a progression is pointless, since the work is conceived as a total presence'.[35] This caveat applies equally to 'Second Avenue', suggesting that painterliness is what unites all literary collage (Burroughs and O'Hara tend toward visual stasis in their work, whilst Cornell began in visual stasis but tended always toward narrative). In many ways the poem feels like a unique amalgamation of Surrealist technique and Abstract Expressionist intent, in that its sly and oblique rendering undercuts its grand, non-figurative, emotional qualities, in a manner which signposts the presence of the poet's unconscious self. A strong impression throughout, and one that impacts greatly on the reading experience, is that the poem is, as its speaker himself suggests, 'a performance / like a plate of ham and eggs eaten with a fur collar on' (*CP*, 143).

[34] Brady, 'Distraction and Absorption on Second Avenue', in *Frank O'Hara Now*, 63.
[35] Ansen, 22.

'Second Avenue' embodies O'Hara's general poetic stance, whereby he treats his subject matter as the material substance of his work: he wanted the poem to be the subject, not just *about* a subject. The reader may be at a loss as to how to approach it: as Brady suggests, O'Hara's 'anxiety to avoid interpretation and to create an anti-absorptive poem makes it very difficult to read "Second Avenue" without becoming distracted by its distractions'.[36] But these distractions are partially the point: the speaker in the poem wants his 'listeners to be distracted' (*CP*, 145). The speed of movement throughout the poem, the heaping up of unrelated images, the shifting personae, the hybridism, and the revealing concentration of words such as 'diced', 'disorder', 'splintering', 'enlacement', 'spiritual contamination', 'deviousness', and 'remake', result in 'Second Avenue' resembling an avant-garde cinematic montage, in which the reality with which we are presented is, by necessity, fragmented, but in which the cumulative effect is lost if the reader or viewer takes too much time to deliberate on each image or concept individually.

It is in this respect that 'Second Avenue' is most provocative to the institutions and traditions of poetry at the time in which O'Hara was writing. In 'Second Avenue' he defies the New Criticism's injunction to leave himself, the poet, out of his own poetry. He demonstrates that the fragments of the poem are subordinate to the whole – they are opaque and almost meaningless in their own right. This is his attack on the institution of poetry, facilitated by the use of collage and montage. 'Second Avenue' is made up of fragments which cannot be broken down and closely analysed on their own, because the more the reader tries to do so, the less sense the poem makes. To a certain extent, O'Hara takes this technique to extreme lengths in 'Second Avenue', alienating the reader, and undermining or even overwhelming his own purpose, as Burroughs would later do with the cut-ups. On account of his insistence on the flatness and one-dimensionality of his poem, as Brady suggests, 'the reader is restrained by the tyranny of superficiality into respecting the poet's autonomy, without enjoying any of her own'.[37] The reader is almost entirely at O'Hara's mercy. The danger with 'Second Avenue' is that it can seem inaccessible, and that the sum of its component parts is ultimately available only to its author. However, as with much of O'Hara's work, the reader is required to be quick, and if one can be quick enough, and intuitive enough about the poem's collage processes, its elusive or seemingly inaccessible qualities will prove rewarding rather than merely frustrating.

Brady suggests that there is 'a tension in the poem between a deliberately fashioned structure and an associative drive which must work fast to avoid being set in the concrete of analysis'.[38] However, the structure of the poem is not, in fact, as strong or as linear as Brady indicates, or, indeed, as perhaps it would have been had O'Hara not been so strongly influenced by the combined forces of Surrealism and Abstract Expressionism at the time of writing. On account of

[36] Brady, 59.
[37] Brady, 69.
[38] Brady, 64.

his use of collage, the reader's own associative drive is able to play a greater role in reaching an understanding of the poem. 'Second Avenue', as a whole, operates on an underlying principle of fluid dynamism and free association, and, therefore, provides the reader with more opportunities to make associations of their own than if the structure had been more concrete and more directed, as in, for example, a collage poem such as Eliot's *The Waste Land*. O'Hara's reader is able to move swiftly over the surface of 'Second Avenue', without being hindered or impeded particularly by its overall structure, which feels somewhat arbitrary, a token gesture to the more rigid aesthetics of an earlier generation of poets. Reading 'Second Avenue', in spite of the time it takes to do so, is an experience more akin to looking at a great Action Painting or an arresting Surrealist collage than reading a long, intricately-crafted, Modernist poem. The 'associative drive', which is the poem's key operational principle, is, by its very nature, quick and shallow, impossible to outpace or outwit – it is not an investigative or exegetical impulse, but rather one which triggers multiple associations which then enable the reader to rove mercurially over the surface of the text. The problem with 'Second Avenue', however, is that O'Hara requires too much from his readers: the demand to be quick is often too great. O'Hara soon realised this, and slowed down the internal dynamics of his later work, modifying his technique so that the collaged quotidian fragments which make up his poems continue to carry weight in their own right, but also allow the poems to be more mobile, more plastic, more malleable, more three-dimensional, and less egotistical, with the reader permitted to have a significantly greater input into their own reading experience.

'Hatred' (*CP*, 117), composed on a long roll of paper[39] in the summer of 1952, is a violent, disjunctive, unruly act of verbal negotiation, in which the murkiness of a barely focused hatred is addressed via notably Surrealist imagery and a deeply fragmented syntax. It reads almost as an anti-collage – a tearing apart which is simultaneously a pasting together. The poem resounds with separations, seams, rendings, and motifs of theft, stitched together to form a devastating tapestry. 'I part / my name at the seams of the beast / in a country of robbers', the speaker announces, before, significantly, making reference to the cuckoo, a bird notorious for stealing the nests of other birds in which to hide its eggs – an odd, profound kind of theft. Strange images combine to suggest a simultaneous fracturing and dissipation, both violent and intimate in its nature. 'The sea's split resistance', for instance, is a dexterous aquatic metaphor that neatly sets up the speaker's ensuing declaration: 'I'd retch up all men'. The speaker goes on to elucidate an apparent division within himself: 'I have hounded myself out of the coral mountains … I have hounded and hounded into being born my own death … clutching my wounds …'. America, in the poem, is ripped 'sideways into pieces and shreds of blood'. Images such as the 'cleft palate' and 'my brittle bones' reinforce the sense of skeletal fragility and deformity, which underpins the poem as a whole. (Notably, the one aspect of the poem that appears fixed and incontrovertible is

[39] This artefact is privately owned and I have been unable to locate any images of it.

the speaker's conviction about slavery: the reader is reminded, in bitter, ironic terms, that 'slavery will not just burst like a volcano'.) Such large-scale fracture has the effect, as Richard Deming suggests, of illustrating 'that hatred is not a solitary condition, though it is an alienating one'.[40] It is arguable too that it is a negotiable one, albeit, in this poem at least, in an overwhelmingly negative bent. The closing line of the poem – 'So easily conquered by the black torrent of this knife' – invokes one of the key principles of collage, namely cutting. This opens up a whole new world of possibility in the form of redemption through art. The Surrealist mantra, Lautréamont's nineteenth-century evocation of a 'chance encounter on a dissecting table of a sewing machine and an umbrella',[41] has cutting at its cornerstone, whilst the liberating and democratic, albeit inherently violent, nature of collage – cutting loose, cutting free, cutting up, cutting off, cutting out – is dependent upon the instrument which can perform the cuts; in other words, a knife. As I have already discussed in relation to the work of William Burroughs, a collage originates in a cut, in a process of dismemberment, arbitrary or otherwise. As O'Hara furiously cuts together a mass of textual abstractions, impossible images, and wild syntactical hybrids in this poem, a nebulous dialogue occurs as dislocated fragments begin to correspond with each other across the text. This is not to suggest that the poet retreats into the Symbolic mode, as well he might, for whilst the disjunctive components of the text may converse with one another, they do not necessarily unify, in part because in its shifts and ruptures the poem also encourages the reader to interact with the pieces, with the fallout, therefore, from the speaker's hatred, playing their own role in constructing, deconstructing, and ultimately reconstructing the poem. In this sense, O'Hara engages in a process of dissection in 'Hatred', specifically enabled by his use of collage, in which his readers must participate. Furthermore, the poem fully embodies the duality of the act of dissection, as delineated by Jonathan Sawday, which is both a 'methodical division ... for the purposes of "critical examination"' and a 'violent "reduction" into parts: a brutal dismemberment of people, things, or ideas'. Of course, as Sawday continues (and as is in evidence in this poem), dissection is also 'an act whereby something can be constructed ... In lieu of a formerly complete "body", a new "body" of knowledge and understanding can be created'.[42]

'Hatred' collages numerous constructs in a style that combines Dada and Surrealism – violent fantasies designed to reflect off each other, providing an ironically disharmonious synthesis. Whilst the poem as a whole operates as a form of polemic, it is possible, and indeed profitable, to cut it apart. It is, as Deming observes, a poem which encourages the reader 'to begin to think about the broader chiastic relationship between language and one's being in a world of possible

40 Richard Deming, 'Naming the Seam: On Frank O'Hara's "Hatred"', in *Frank O'Hara Now*, 137.

41 Lautréamont, 217.

42 Sawday, 1–2.

worlds'.[43] Lines such as 'the morasses of ritual archers milking', 'a prison of bread and mortar', 'the savage foam of spears not polished to celebrate marriages', 'like a palace in a nightmare about anarchists', 'a cleft palate in a bus of silver', and 'the world's years / of war turn like walls of bottles' hint at the possibilities of other worlds, and are also typical of the absurd hallucinogenic torment of many of the collages of Max Ernst. The recurring bird imagery throughout the poem – 'cuckoos, cormorants and cranes', 'my wings', 'prophetic ravens', 'herons and priests', 'pyramids and swallows' – also relates to Max Ernst, for whom, as I noted in my discussion of Cornell, strange, winged creatures, including his sinister alter-ego the man-bird Loplop, came to play a central narrative role in his work and in his quest to avenge and destroy his memories of a tyrannical late-Victorian childhood. O'Hara responds to, and adapts, these types of images in pursuit of his own desire for self-purgation. His phrasing, in its strategic disorienting of familiar images, also embodies aspects of the subversive political photomontages of Dadaists Hannah Höch, Raoul Hausmann, John Heartfield, and Aleksander Zhitomirsky, in which an emphasis on unexpected divergence from the banal enables the portrayal of inexpressible emotion. Further, O'Hara's use of startling juxtapositions (archers milking, bread/mortar, foam/spears, etc.), and arresting imagery recalls Hans Arp's image of 'sofas made of bread' in 'The Domestic Stones',[44] or Breton's images in 'The Spectral Attitudes', in which the speaker describes 'branches of salt', 'a musician … caught up in the strings of his instrument', and being 'dragged along by an ice-pack with teeth of flame'.[45]

Surrealist collage is the ideal vehicle for O'Hara's complicated rage and self-abnegation in 'Hatred'. Fundamentally aggressive, Surrealism was a movement born out of darkness and violence, and many of its principal actors had themselves come to America under similar circumstances. Collage, too, as I have discussed, began in a time of political uncertainty and representational crisis. In 'Hatred', O'Hara explores his perception of the animosity and arrogance directed by America both at the wider world and at itself, a hatred not ultimately constricted by time or circumstance, and a hatred in which he, as an American, feels reluctantly complicit. The poem is both a warped portrait of the time and place in which he finds himself living – a kind of anti-propaganda – and an intuitive response to that situation. In its vitriol, the poem also seems, perversely, to be attempting to redress an imbalance of experience. In relation to O'Hara's established but problematic veneration of the Europeans as emblems, and indeed survivors, of a lived experience which American artists could barely even imagine, this poem suggests that O'Hara felt a degree of irrational guilt and envy that he had not suffered, and therefore had not experienced as much as his European counterparts.

[43] Deming, 133.

[44] Hans Arp, 'The Domestic Stones', in *Collected Verse Translations of David Gascoyne*, ed. Robin Skelton and Alan Clodd (Oxford: Oxford University Press, 1970), 1.

[45] Breton, 'The Spectral Attitudes', in *Collected Verse Translations of David Gascoyne*, 2.

The extent to which this sentiment can be extended to include other American artists and writers in O'Hara's circle is not made explicit in the poem, but certainly the anxiety felt by many about being the new tenants of culture's zenith has been well documented.

The opening line of the poem – 'I have a terrible age' – evokes O'Hara's apprehensions, rooting the speaker's hatred in the present and looking ahead to the misgivings of 'Naphtha', in which the speaker will ponder the shadow of Europe over America, and brood upon the uncertainties and complexities of 'waiting to become part of our century'. In place of the voice of experience, which the speaker covets, he has instead a voice of hatred, a voice that is also, increasingly, one of self-hatred. As the poem progresses, the reviled self divides, and one part of the self addresses another, as the poem builds toward its sinister final stanza:

> ... I shall forget forever America,
> which was like a memory of an island massacre
> in the black robes of my youthful fear of shadows.
> So easily conquered by the black torrent of this knife. (*CP*, 117)

This chilling ending, taken in the context of allusions in the poem to the Apache tribe, who suffered greatly at the hands of the US government, and to the observation that 'slavery will not just burst like a volcano', enunciates the speaker's concern that perhaps the American experience is closer, after all, to that of the hated oppressors of the European refugees.

'Easter' (*CP*, 96), also written in the summer of 1952, is less vitriolic than 'Hatred', more abstract and open to the possibilities of irony. Dense and undisciplined, it is easy to see why Ashbery felt that such a style might need some sort of new vernacular to 'ventilate' it (*CP*, x). It gushes off the page, a carnivalesque torrent of camp ('the razzle dazzle maggots'), Burroughsian brutality ('all the powdered and pomaded balloon passengers / voluntarily burning their orifices to a cinder'), wit ('a marvellous heart tiresomely got up in brisk bold stares'), and obscenity ('when the world booms its seven cunts'). Overall, the poem emphasises physicality, both in its assault on the reader (reading it straight through will leave one gasping for breath), and in its accumulation of body parts, which anticipates O'Hara's later idea that we are 'mired' in flesh ('To the Movies', [*CP*, 208]). Hazel Smith observes that as this is, ostensibly at least, a poem about Easter, this physical quality 'suggests the resurrections of the spirit through the body'.[46] Ultimately, however, the cumulative effect of the barrage of juxtapositions, repeatedly refocused imagery, and roguish experimentation with language, is rather that of a great, disembodied voice, through which the speaker may channel, to its outermost reaches, the possibilities offered by Surrealist collage. As with 'Oranges' and, to an extent, 'Second Avenue', O'Hara is attempting an immediacy of delivery which, given the poem's length, is impossible to fully achieve. His

[46] Smith, *Hyperscapes in the Poetry of Frank O'Hara: Difference/Homosexuality/ Topography* (Liverpool: Liverpool University Press, 2000), 98.

later, more accessible poetic style, in evidence in immediately authentic poems such as 'Poem (Lana Turner has collapsed!)' and 'Poem (Today the mail didn't come)', is arguably informed particularly by this prior experimentation, because in pushing the experiment so far, he is able, as Smith suggests, to 'expose … its limits' – although not quite in the way she means.

Smith continues: 'despite the heterogeneity of the images they nearly all contain bodily parts or functions'.[47] This, surely, is a choice that O'Hara made, and one that is key to understanding the poem in question, rather than being a natural limit of Surrealist collage. The limit that O'Hara exposes in his unregulated, Surrealist flow is that Surrealist collage cannot successfully represent the unconscious without a degree of discipline and internal logic. This is why, ultimately, O'Hara moved beyond it, taking from it only what he needed: he wanted his poetry to do more than just pretend to represent the unconscious mind. For him, the element of surgical precision needed to achieve the kind of dramatic combinations apparent in the work of Ernst, or Schwitters, or Breton, subordinated the equally vibrant yield of the conscious mind. After all, to quote Ashbery, 'why should our unconscious thoughts be more meaningful than our conscious ones, since both are a part of poetry?'[48] O'Hara's overall poetic approach is less than surgical; instead of cutting into the world, he wished to present it as it is, as he experienced it, in a casually disjunctive outpouring of oblique, democratic chatter, which is where the differences between his work and Surrealism are thrown into relief.

'A new and intuitive definition': Beyond Experimentation

Apollinaire, writing in 1913 when the practices of collage were relatively new, sought to legitimise the use of the random elements of everyday life in art and poetry, on the basis that although they are 'new in art, they are already soaked in humanity'.[49] This humanity is what is at risk, however, in poems such as 'Second Avenue', 'Easter', and 'Hatred', where too much is dependent upon chance, automatism, free association, and the unconscious. Certainly, some significant artworks are produced entirely by chance, but artists working in this mode are demonstrably not in a position to publish or exhibit every piece in the raw state in which it emerges. Even if the artist vetoes all elements of choice when creating the artworks themselves, they will be forced, ultimately, to choose between those that are good enough and those that are not; and if they cannot do so, their editors, publishers, or curators, will do so for them. Tristan Tzara, for instance, would not always be able to pull a poem out of his hat, and, as I have discussed with regard to Burroughs, the act of arranging texts in random order does not automatically equate to literary or artistic merit, however interesting the results may be. This is

[47] Smith, 97.

[48] Ashbery, 'Writers and Issues: Frank O'Hara's Question', in *Selected Prose*, 80–83. Originally published in *Bookweek*, 25 September 1966, 3.

[49] Apollinaire, quoted in Rosand, 126.

something which O'Hara seemed to learn, in that as his career developed, many of his poems became shorter and were executed with a lighter touch, rendering them less manic, less contrived and serious; ultimately he 'grabs for the end product – the delight – and hands it over, raw and palpitating, to the reader, without excuses',[50] to borrow once again from Ashbery. Nevertheless, in many of his poems, O'Hara punctuates the flow of autobiographical and observational fragments with interjections whose role is to mediate between or evaluate them. He concludes the love poem 'Having a Coke With You', for instance, with the lines:

> it seems they were all cheated of some marvellous experience
> which is not going to go wasted on me which is why I'm telling you about it.
> (*CP*, 360)

This determining evaluation not only justifies the beautiful detailing in the preceding list-like twenty-two lines of the places, experiences, and artworks which cannot compare to the simple event of having a Coke with Vincent Warren, O'Hara's boyfriend and a dancer with the New York City Ballet, but it also validates and explains why O'Hara writes the kind of poetry he does – because the 'marvellous experience' of being alive and being in love is poetry. The final line of the poem 'Early on Sunday' has a similar effect, subtly altering the reader's understanding of the poem they have just finished reading. The poem itself is a non-evaluative, autobiographical stream of thought, taking in the time of day ('It's eight in the morning'), O'Hara's physical state ('I feel pale'), the weather ('it's raining'), as well as some early-morning musings, both poetic and nonsensical, typical of O'Hara ('with hot dogs peanuts and pigeons where's the clavichord' and 'how sad the lower East side is on Sunday morning in May'). The closing lines, however, detail the return to the apartment of Joe LeSueur, who lived with O'Hara for many years:

> Joe stumbles home
> Pots and pans crash to the floor
> Everyone's happy again. (*CP*, 405)

The point of the poem, of the hesitancy in its short lines, of its uncertain flitting between thoughts, of the abstract sadness of the lower East side, suddenly becomes clear: Joe makes Frank happy, and as this is the motivation for writing down the poem, no further justification is required.

These simple acts of poetic mediation indicate a level of self-knowledge and assurance that has yet to develop in the long, densely-collaged poems discussed above, in which the poet's motile and metamorphic self has more in common with Burroughs's contemptuous self-portrayal than Cornell's reverential self-archiving. O'Hara believed that identity was constantly shifting, but around the ideal of some

[50] Ashbery, 'Writers and Issues: Frank O'Hara's Question', 80–83.

kind of constant centre. The collage-poem 'In Memory of My Feelings', written in 1956, is O'Hara's most fully-realised exploration of the self in the context of poetry and art. It represents his decisive leaving behind of Surrealist imitation, and the liberation of the independent self-hood from which his best poetry stems. In the poem, O'Hara explores the concept of a collaged ego, or the notion that a person has not just one face but many, 'several likenesses', representative of 'a number of naked selves' (*CP*, 252). This concept demands a new reckoning of poetry that goes beyond traditional criticism of the lyric. The poem articulates an almost palpable tension between control and chaos, depicting the self as walking a fine line between what Andrew Epstein calls 'variousness and incoherence'; it is simultaneously bleak yet fertile, with each uneasily equivocal scenario suggesting 'signs of a restless desire to move onward'.[51] The 'likenesses' depicted are referred to only in similes: they are 'like stars and years, like numerals … like vipers in a pail'. They resist unification or stasis, pulling apart from each other throughout the poem, subverting the conventions and expectations of memoir set up by the poem's title. Grace Hartigan, to whom O'Hara dedicated the poem, explained that she felt that the poet was attempting to delineate 'inner containment', arguing that the strongly pragmatic approach to ideas of the self within the poem was aiming at a definition of 'how not to panic'.[52]

O'Hara begins the poem contemplatively, in 'quietness', before releasing into the text 'a number of naked selves', which repeatedly metamorphose in order to recreate within the poem 'the light mist in which a face appears'. Experiences and identities circle around each other, hallucinations are mingled with reality, and the indeterminacy of the poet's 'self' suggest that not only is it in fragments but that it may actually be on the verge of total dissolution. The shifts in experience are unsynthesized, and cannot be reconciled with the excess of feeling which this generates – the only consolation that the speaker can find is the rhythmic equivalent to the relentless pacing of a caged animal. Enclosed within an endlessly shifting disposition which, nevertheless, struggles to move in any significant direction, O'Hara uses collage in order that the form of the poem fully embodies its sentiment; in other words, to quote Breslin, to try to 'find any vantage point from which to construct a sequential narrative or stable identity out of his experience'.[53]

He realises that in order to be able to construct a stable identity out of the dislocated shards of experience, he must first deconstruct his existing identity, in the hope that fragmentation will lead, ultimately, to unification, and through this to illumination. Mutlu Konuk Blasing observes that, by the end of the poem, 'it makes sense that O'Hara's series of selves, ranging geographically from Africa to China, historically from Hittites to Indians, and psychologically from women to

[51] Epstein, *Beautiful Enemies: Friendship and Postwar American Poetry* (Oxford: Oxford University Press, 2006), 96 and 93.

[52] Hartigan, quoted in Perloff, *Poet Among Painters*, 141.

[53] Breslin, 248.

children, add up to an imperial self, consuming all and being consumed by all'.[54] O'Hara recognises that he 'singly must now kill' the multitude of his selves – 'the scene of my selves' – which has whirled so violently and ecstatically through the poem, as part of the compositional process and in order to 'save the serpent in their midst', liberating a more unified version of himself as poet. His use of the word 'must' implies an unwillingness married with a determination that what he is doing is for his own greater good, a sentiment reinforced by the embodiment of self as serpent, with its connotations of slipperiness and evasiveness.

O'Hara's body of work displays a sustained commitment to the possibility of change. Such metamorphosis is redeemable chiefly through the all-embracing principles of the collage practice, in which fragments can legitimately co-exist both autonomously and as part of a collective, mirroring the ideal role of the artist within society and within history. Collage also staves off the threat of creative stasis, enabling O'Hara to define himself in relation to his environment, and 'to fashion comparisons, resemblances, rather than identities',[55] the collation of which produces a real yet endlessly protean identity, wherein lies artistic freedom. Blasing's observation that 'the "several likenesses" of [O'Hara's] transparent self are presumably designed to protect it from the fixity of a singular identity',[56] operates anagrammatically, in that the fixity of a singular identity is equally designed to protect the self from fragmentation beyond function, which is the evident problem with poems like 'Second Avenue', 'Easter', and 'Hatred'. In this way, the self can remain free, but rooted nonetheless, choosing where and when to manifest itself, invisible but present, the elusive but endlessly enticing centre of O'Hara's entire poetic.

Emerson wrote that 'power ceases in the instant of repose; it resides in the moment of transition from a past to a new state'.[57] O'Hara, having used the space of his long, heavily collaged, early poems in which to explore and work out his relation to his poetic predecessors and contemporaries, to the European avant-garde and home-grown American artists by whom he was increasingly surrounded, to the growing commodity culture of 1950s New York, and to the uneasy post-war politics of his country as a whole, was able to move successfully from the limitations of the past to a powerful new present, reaching a new and intuitive definition of himself as a poet. Ashbery, although he refutes the unified existence of a New York School of Poetry, concedes that if as a group of poets they could be said to have any kind of 'program', it was that their poetry was 'descended from Surrealism in the sense that it is open', and 'that it amounts to not planning the poem in advance but letting it take its own way; of living in a state of alertness

[54] Multu Konuk Blasing, *Politics and Form in Postmodern Poetry: O'Hara, Bishop, Ashbery, and Merrill* (Cambridge: Cambridge University Press, 1995), 61.

[55] Epstein, 96.

[56] Blasing, 57.

[57] Emerson, 'Self Reliance' (1841), in *Essays and Lectures* (New York: Library of America, 1983), 271.

and being ready to change your mind if the occasion seems to require it'.[58] These are the principles with which O'Hara's collage experimentation enabled him to come to terms, and to embrace. His appropriation of the techniques of collage, and the principles behind the use in art of found objects, enabled his poetics to progress beyond the mere imitation of Surrealist and Abstract Expressionist art, which was always doomed to fail, whilst retaining those qualities that had proved transferable from plastic art to poetry. In this sense, at the level of composition and craftsmanship, Rimbaud's evocation of the poet as Prometheus figure, as 'thief of fire', resounds particularly with O'Hara's poetics, at whose fiery heart lies the guiding principle of creative appropriation from sources as varied as Surrealist techniques, cinematic methods, musical practices, the everyday words and phrases of friends and contemporaries, and the daily experiences of life in New York.

'One's own measure and breath': New York, O'Hara, and the Creative Act

The essential poetic aim, according to O'Hara, as he explained in an interview with Edward Lucie-Smith, was 'to establish one's own measure and breath in poetry … rather than fitting your ideas into an established order' (*SS*, 17). Establishing his own unique 'measure and breath' required some poetic trial and error on O'Hara's part, however, and this is what he seems to have been doing in his long poems of the early 1950s: experimenting with the collage practice and trying on the Surrealist voice. In this sense, he was confronting his relationship to the literary establishment, and problematizing his own position in relation to poetic tradition. The end results undoubtedly bear what Russell Ferguson calls 'the traces of a somewhat overheated and ill-digested Surrealism',[59] but, as with Burroughs's rather uneven cut-ups, the insight they provide into the creative process is fascinating. 'Oranges: 12 Pastorals', for example, is indelibly marked by painterly influences that translate into words unevenly at best. Although O'Hara himself could not paint or sculpt,[60] from a young age he understood that the processes involved in doing so were deeply relevant to the type of poetry he was trying to write. Whilst he had few doubts about his ability as a poet, his writing often shows that he viewed his artist friends as somehow superior to him. In a short poem addressed to the painter Larry Rivers, for instance, he reassures the artist: 'You're worried that you don't write? … You do what I can only name' (*CP*, 128). Ironically, it was his status as a non-painter and his attendant feelings of inadequacy, as well as his incisiveness as an art critic, which made the processes

[58] Ashbery, 'The New York School of Poets' (1968), in *Selected Prose*, 113–16.

[59] Ferguson, *In Memory of My Feelings: Frank O'Hara and American Art* (Berkeley: University of California Press, 1999), 46.

[60] Significantly, O'Hara's 'solo art effort', according to Joe LeSueur (*Digressions on Some Poems by Frank O'Hara* [New York: Farrar, Strauss & Giroux, 2004], xix), was a collage, now lost, featuring a photograph of Arthur Rimbaud, which he gave to Edwin Denby.

of plastic art so invaluable to the way he put his poems together. Five years after writing 'Oranges: 12 Pastorals', O'Hara wrote 'Why I Am Not a Painter' (1956), in which he looks back on the process of writing 'Oranges', and examines the parallel unfolding of this difficult and irregular twelve-poem sequence with the artist Mike Goldberg's painting *Sardines*:

> One day I am thinking of
> a color: orange. I write a line
> about orange. Pretty soon it is a
> whole page of words, not lines.
> Then another page. There should be
> so much more, not of orange, of
> words, of how terrible orange is
> and life. Days go by ... (*CP*, 261)

Deliberately eschewing imagery in favour of a heavy, looping repetition – 'I drop in ... I drop in again ... I drop in' – O'Hara uses the space of 'Why I Am Not a Painter' to evaluate the creative impasse he came up against during the drawn-out process of writing 'Oranges', in a manner related to Jackson Pollock's use of the space of his horizontal canvasses when he first began his experiments in drip painting. Both O'Hara and Pollock use the page or canvas as 'an arena in which to act'.[61] O'Hara merges the poetic process and the poetic product. The poem simultaneously is the subject and is about the subject – in other words, to return to John Ashbery, the poem becomes 'the chronicle of the creative act that produces it' (*CP*, viii–ix). When a viewer encounters a drip painting by Pollock on a gallery wall (aside from the fact that it will usually be hung vertically, rather than laid horizontally, as it would have been when the artist painted it), the painting almost succeeds in taking the viewer back into the studio with the artist, to watch the work unfold as it is being painted. This effect, and O'Hara's initial inability to achieve something comparable in his poetics, is what the difficulties encountered when writing 'Oranges', and other poems of the same period, seem to have revealed to him. In many of his subsequent 'I do this, I do that' poems, the reader, rather than being cajoled into thinking that the poem they are reading is really a painting, is instead encouraged to feel that they are present during the moments of composition, witnessing both the chronicle of the composition and the composition itself, simultaneously. This is where the collage technique proved invaluable for O'Hara: his readers cannot literally see every detail of the street or the bar or the party being portrayed in the poem in question, and yet by carefully selecting representative fragments of his reality and collaging them together in such a way that the reader will notice only what he deems important, O'Hara invites the reader to share his world of *flânerie*, to see the surfaces as he sees them, and to hear the same city sounds. Collage enabled him to recreate on the page a vivid impression of New York as he experienced it on a day-to-day basis.

[61] Rosenberg, *The Tradition of the New* (New York: McGraw-Hill, 1965), 25.

O'Hara's poetic technique proceeds not – as in some of the more serious, academic poetry of the time – by elimination, but by inclusion; as one detail greets the next, the reader is confronted by a language with its own laws of movement and flow, a language which moves mercurially and in multiple directions. 'What is happening to me', O'Hara wrote in his 'Statement for the New American Poetry', 'allowing for lies and exaggerations which I try to avoid, goes into my poems. I don't think my experiences are clarified or made beautiful for myself or anyone else; they are just there in whatever form I can find them' (*SS*, 112).

The title of O'Hara's third collection of poems, *Meditations in an Emergency*, is relevant to much of his work, because, as fellow New York poet and close friend, Kenneth Koch, remarked, with O'Hara everything was 'an emergency because one's life had to be experienced and reflected on at the same time'.[62] His enduring subjects were himself, his friends, and his New York City, and his notably unprogrammatic poetry is a succession of related but disjunctive images, which often do not mean anything beyond themselves and instead serve the purpose of grounding a mood within the poem or anchoring a particular moment, which frequently occurs in the final lines of the poem. Consider these end lines, taken from four separate poems:

> 'my heart is in my pocket / it is *Poems* by Pierre Reverdy' ('A Step Away From Them' [*CP*, 257])

> 'I wonder if one person out of the 8,000,000 is / thinking of me as I shake hands with Leroi / and buy a strap for my wristwatch and go / back to work happy at the thought possibly so' ('Personal Poem' [*CP*, 335])

> 'and everyone and I stopped breathing' ('The Day Lady Died' [*CP*, 325])

> 'happiness / the least and best of human attainments' ('Poem Read at Joan Mitchell's' [*CP*, 265])

Each – so tender, so moving and serious – follows an immersion in casual, urban experience: 'I walk around at lunchtime' (*CP*, 335); 'I go get a shoeshine' (*CP*, 325); 'The sun is hot, but the / cabs stir up the air. I look / at bargains in wristwatches. There / are cats playing in sawdust' (*CP*, 257); 'Tonight you probably walked over here from Bethune Street / down Greenwich Avenue with its sneaky little bars' (*CP*, 265); 'Neon in daylight is a / great pleasure' (*CP*, 257); 'I walk up the muggy street beginning to sun' (*CP*, 325). The 'I do this, I do that' style of composition populates his poems with a catalogue of 'happenings', in which nothing fixed is allowed to build, until the moment of climax, which consequently resonates with the reader long after the poem has ended. O'Hara lifts these scraps of experience and unconnected images directly from his everyday life, cutting them together in a form of vibrant, fluctuating, temporal collage. Discordant elements are linked

62 Kenneth Koch, *in Homage to Frank O'Hara*, 206–7.

imaginatively, as in a train of thought, and grow vivid as their functional but initially hidden relationships emerge.

O'Hara spent fifteen years living in New York, and the city permeates his work, moving through his poems, balancing them, providing texture and tone, as he actively negotiates the variousness of the city. The patterns and sounds of many of his poems originate in the New York skyline, as well as in the city's harbour and streets, bars and cafes, traffic and train-lines: Ashbery called this O'Hara's 'urban world of fantasy where the poems came from' (*CP*, vii). In poems such as 'A Step Away from Them' (1956) and 'The Day Lady Died' (1959), New York plays the supporting role, with descriptions and collaged vignettes of the city making up the majority of the lines, driving movement and meaning through the poem in meandering, suspenseful digressions before the final emotive climax. New York in other poems is a personality – a leading lady – in a manner resonating with the closing phrases of Pasternak's *Doctor Zhivago*, a work of some significance to O'Hara:

> Moscow below them and reaching into the distance – Moscow, the author's native town and the half of all that had befallen him – now appeared to them, not as the place where all these things had happened, but as the heroine of a long tale[63]

In the poem 'Steps' (1960), O'Hara addresses the city affectionately in the second person: 'how funny you are tonight New York' (*CP*, 370) he declares, likening the city to 'Ginger Rogers in *Swingtime*' and in so doing evoking both the physicality and vivacity of the twentieth-century's 'second metropolis',[64] as well as highlighting, to quote Jed Perl, 'how hopelessly mixed up nature and culture had become'.[65] In other poems the city takes on a different character – sinister, more powerful, more intense; the poems are akin in the deadpan irrationality of their diction and imaginative texture to the seamless Surrealist collages of Max Ernst discussed in my chapter on Cornell. In the poem 'To the Mountains in New York' (1954), for instance, the city is

> Hairy ... wrinkled like a detective story
> and noisy and getting fat and smudged
> lids hood the sharp hard black eyes ...
> [its] alleys
> open and fall around me like footsteps
> of a newly shod horse treading the
> marble staircases of the palace (*CP*, 198)

[63] Boris Pasternak, *Doctor Zhivago*, trans. Max Hayward and Manya Harari (London: HarperCollins, 1995 [1957]), 574.

[64] John Dos Passos, *Manhattan Transfer* (London: Penguin Classics, 2000 [1925]), 23.

[65] 'The idea that the slant of the light on a church steeple on a particular day might kick off thoughts of old Hollywood musicals told you how hopelessly mixed up nature and culture had become'. Perl, 282.

In other poems O'Hara uses the city as a vessel through which to filter his feelings, memories and fits of disquiet: everything he 'felt happening (saw, imagined)' (*CP*, 497). In 'Berdie' (1958), for example, which was part of a collaboration of lithographs with the artist Larry Rivers, the angle of the poem shifts from the sudden rain on Second Avenue, a key location within O'Hara's oeuvre, to the absent 'Berdie', Rivers' mother, who had died the previous year:

> It has suddenly rained
> on Second Avenue and
> we are thinking of you
> as the small thoughts of
> the rain drum on tin
> and soot runs down the
> windows we always do
> in the rain it's no more
> different than the rain
> you went there honorably as
> stone becomes sand and
> the sad shore falls
> into the unwilling sea (*CP*, 312)

The movement of the rain traces a line through the poem, from the concrete physicality of the city ('drum on tin', 'soot runs down the windows') to the elusive abstraction of 'there', mirroring in its passage the mutual sorrow of O'Hara and Rivers.

'Naphtha' (1959–1960) illustrates O'Hara's subtle use of the city to explore his anxiety and unease with relation to his time, his legacy, and his creative pressures and precedents. It recalls Ginsberg's 'A Supermarket in California' (1955), in which the poet, in his 'hungry fatigue and shopping for images', roams a 'neon, fruit supermarket' in whose aisles Walt Whitman and Garcia Lorca are lurking.[66] 'Naphtha' is a precariously balanced poem – there is a tension running through it, holding it in place, like a steel girder in a skyscraper. It reads like a balancing act; footage of Philippe Petit's high-wire walk between the Twin Towers in 1974 chimes with the poem, in the sense that both are acts of extreme beauty, daring, and nostalgia, fitting tributes to the buildings which will resonate both into the past and into the future. 'Naphtha' is a poem about construction – about the architecture not just of a city, but of its culture. It is also a meditation on a poet's creative anxiety about his role within this city and this culture. The poem moves in and out of buildings, and up and down them, the bipolarity of the skyscrapers implying the vicissitudes of O'Hara's frame of mind. References in the first stanza to the artist Jean Dubuffet up in the Eiffel Tower, and to the Iroquois Indians (who helped to build many of New York's most famous landmarks) up on the girders building the tallest skyscrapers in the world, lead into a contrast in the second

[66] Ginsberg, *Collected Poems 1947–1997* (New York: HarperCollins, 2006), 144.

stanza with the poet (or poets), who is revealed to be down on the ground, or even under it, in the Paris Métro, not 'do[ing] much but fuck[ing] and think[ing]' and waiting for someone who ultimately doesn't even 'show up' (*CP*, 337). The speaker clearly wants to become 'part of [his] century', a word which appears on four occasions in a poem fixated by the movement of time. Much of the poem's diction consists of temporal words: 'when', '1922', 'the 20th century', 'while we were waiting', 'ancient September', 'burst in the memory', 'my century'. O'Hara seems to want to be a Dubuffet, an Ellington, or a builder of a wonderful city (we have seen the steel hats of the construction workers before, in 'Personal Poem' (1959), which was written shortly before 'Naphtha', in which O'Hara campily says: 'If I ever get to be a construction worker / I'd like to have a silver hat please', and, later on, 'we just want to be rich / and walk on girders in our silver hats' [*CP*, 335–6]). Instead he appears to view himself as being limited to the position of merely being entertained by his century, or, at best, chronicling it. The line 'just as you can't make a hat out of steel and still wear it' illustrates his understanding of the futility of pretending to be something you're not, whilst not denying the fun in it, a sentiment which is echoed, once again, in the final line of the poem: 'but I have to smile'. O'Hara compares himself to Ellington, and to the Iroquois, but whilst they are 'made in the image of god' he is 'made in the image of a sissy truck driver'. Does he feel he could do more, perhaps by heeding the 'parable of speed' of the Indian tribe, rather than, in the custom of his own 'tribe', simply 'beguil[ing]' his audience? Whilst he seems to be uneasy about his own creative value, it is also possible that he sees himself as just another figure in the haphazard collage of a modern city – the Iroquois build, Dubuffet paints his cows, Ellington plays his music, and O'Hara writes his poems. 'Naphtha' is written (and O'Hara performed it) with enough buoyancy and pace and humour to mute any sense of stoicism or tendency toward the confessional; and yet there is an immediacy and a rawness apparent in the poem, manifested particularly in the syntactic confusion that runs throughout the poem. Whose are the 'fragile backs'? Were 'you' also 'made in the image of … Jean Dubuffet'? To whom does the 'likeness' refer? and so on. This belies the blithe up-beat tone and reveals a characteristically muted but very genuine anxiety about the poet's place in his city.

'The instrument on which the poet sings': Autonomy, Subjectivity, and 'The Day Lady Died'

Nevertheless, poetry for O'Hara was about his participation in, and enthusiasm for, life in New York, in the twentieth century: as he wrote in his 'Statement for the New American Poetry', 'I am mainly preoccupied with the world as I experience it, and at times when I would rather be dead the thought that I could never write another poem has so far stopped me' (*SS*, 112). Life, therefore, was equally about poetry. His poetic ambition was to encompass life in his poetry as it was happening, and his actions, as David Herd explains, were logically 'a continuation of his

aesthetic', operating 'as a formal principle in and for his writing'.[67] One of the best examples of this is the poem 'Sleeping on the Wing' (*CP*, 235). Allegedly written as a result of a challenge by friends to produce a poem in a matter of minutes, the poem is an embodiment of the self's intimate (to the point of claustrophobia) relationship with its own 'aesthetic'. It explores the desire to escape, depicting a vast imagined patchwork of what the world looks like from a distanced yet still connected perspective. The poem reads rapidly, permeated with an impression of movement, of *going*, suggesting, as Breslin argues, 'an uneasiness with reality'.[68] The reader witnesses the poet's self ascend, violently, 'as a pigeon does when a car honks or a door slams', to find itself 'soaring above the shoreless city'. The word 'shoreless' implies an oppressive infinity, or inescapability, avoidable only by the imagined flight into the 'impersonal vastness' in which the poem so wistfully delights. As the poem exults in a newfound freedom, greater ideological concerns, such as slavery and the American Civil War, dissipate with the breeze, and the self can forget the burden of its 'position in respect to human love'. The poet, 'a sculptor dreaming of space and speed' (note the Futurist, and, indeed, futuristic, connotations), is suddenly master of his own destiny, free from the constraints of friendship and love, from 'the sad struggle of a face'. But as the poem draws to a close, the speaker begins to doubt his flight, questioning (as we imagine him falling, like Icarus): 'is there speed enough?' Even as the words are uttered, the reader, and the newly elated poetic self, knows that the answer is no, that the self 'must awake', and return to its earthly chains, to the bonds of O'Hara's always intense relationships, in which, he feels, 'space is disappearing and your singularity'. This is one of the clearest articulations O'Hara gives of his fear of the encroachment of his friends upon his individuality and artistic autonomy. The poem's concluding lines feel weighted and solemn: jolted back to earth, the self finds itself apprehended once more within the boundless collage realm of human existence and the urban experience.

This lived, and living, collage of friends, associates, and places, however, was also, for all its problems, something O'Hara treasured, and from which he appropriated many of the words and phrases which make up his body of work, the 'pale fire' which poems like 'Sleeping on the Wing' enabled him to 'snatch ... from the sun'.[69] He often appropriated them directly from the mouths of others, stealing out of love: as Merle Brown has written, 'he valued certain persons more than most people think any person should be valued'.[70] Kenneth Koch recalled, in an interview with Daniel Kane: 'What a gift for the immediate! Frank could write fast – he could sit down in the middle of a party and write a poem, and if you went

[67] David Herd, *Enthusiast! Essays on Modern American Literature* (Manchester: Manchester University Press, 2007), 149.

[68] Breslin, 225.

[69] *Timon of Athens*, IV.3.423.

[70] Brown, 'Poetic Listening', *New Literary History* 10, no. 1 (1978): 135.

over and talked to him he'd put what you just said into the poem'.[71] Joe LeSueur also recollects specific instances of this poetic technique in action, particularly with regard to several of his plays:

> One Saturday afternoon … Bill Weaver and I were sitting around with Frank, who was busy at his typewriter and talking to us at the same time. Bill had brought Frank a half-pint of brandy; he asked me if I wanted some, and I said I'd rather have a cognac. 'Didn't you know cognac was brandy, queenie?' Bill shot back. Frank laughed and promptly put what Bill had said into the play. A little later, he happened to remember a line from an anecdote Bill de Kooning had recently told him over drinks at the Cedar Bar. 'It's terrible under Kay Francis's armpits', de Kooning quoted Arshile Gorky as saying to him as they were leaving one of her movies. That, too, went into the play he would call *Awake in Spain.* (Gorky's weird observation was a source of continued amusement to Frank; ten years later, the line popped up again in a poem called 'On Rachmaninoff's Birthday & About Arshile Gorky'.)[72]

A video recording of O'Hara with the filmmaker Alfred Leslie, made by Richard Moore as part of a series of interviews and readings for KQED-TV in 1966, perfectly encapsulates the seamlessness with which O'Hara's daily life merges with his identity as a writer. The film shows O'Hara in compositional mode at his typewriter, while Leslie sits just off camera on the floor. They are collaborating on a film script, which O'Hara is exuberantly improvising and typing out: 'She thinks she's some sort of cornball Salome … I think she'd like to have my head'. The phone rings. O'Hara lifts the receiver with a fluidity that makes the telephone seem like an extension of his own arm, all the while continuing to type. 'Jim'[73] is on the other end. ''lo?' O'Hara drawls pleasantly down the line, explaining: 'This is a very peculiar situation because while I'm talking to you I am typing and also being filmed for educational TV – can you imagine that? Yeah! Alfred Leslie is holding my hand'. He listens, before continuing: 'It's known as *performance.* What? Yeah? Oh right, flash and bolt? What does that mean? *Flashing* bolt, you mean? Oh good … Flash-ing bolt (typing) … A flashing bolt – is that art, or what is it?' He then types what has just been said into the film scripts, and tells him: 'I've just laid it onto the paper'.[74]

It is instances such as these that clearly evoke Rimbaud's image of a poet stealing fire from life. Figuratively, O'Hara cuts out and pastes into his writing words or phrases from his daily conversations, collaging them exactly as they occurred into whatever poem he happens to be working on at the time, and, in

[71] Koch, in Kane, *What is Poetry*, 99.

[72] LeSueur, introduction to *Amorous Nightmares of Delay: Selected Plays* (Baltimore: John Hopkins University Press, 1997), xviii.

[73] It is unclear which of O'Hara's friends called Jim is calling.

[74] *USA Poetry: Frank O'Hara*, dir. Richard O. Moore (WNET, 1966). Emphasis mine.

this way, keeping them alive on paper. In a manner that relates to his often overly sentimental feelings toward his friends, O'Hara's attitude toward such moments, or fragments of conversation, or snatches of music heard on the radio, is one of instant nostalgia: no sooner is the moment upon him than he is devising a way to somehow keep it alive forever, much as Cornell would attempt to capture fleeting experiences within his collages and box constructions. Koch explains that 'the speed and accidental aspect of his writing are not carelessness but are essential to what the poems are about: the will to catch what is there while it is really there and still taking place'.[75] O'Hara's work operates in a constant state of flux, often moving with a dreamlike absurdity in which an awareness of self amounts only to an acknowledgment and acceptance of its unremitting and disorderly metamorphosis. In a poem such as 'To the Mountains in New York', he embraces this abdication of authorial responsibility, announcing 'Yes! yes! yes! I've decided, / I'm letting my flock run around' (CP, 198). This style leaves his poetry deliberately open to the subjectivity of his readers, or, as he writes in 'Poem (Instant coffee with slightly sour cream)', 'my life held precariously in the seeing / hands of others' (CP, 245). In taking fragments of whatever it was that happened to be happening to him, and filtering them through his own imaginative interpretation of them, O'Hara constructed a fluctuating selfhood which remains fiery and alive today, dependent as much upon what readers bring to his poetry as on what he himself put in it. It is possible to view the Collected Poems as a vast improvisational collage: without doubt the O'Hara that we 'know' now is the O'Hara of his poems, rather than, say, the O'Hara of anecdote or biography (although he, of course, is famous too).

As a poet O'Hara worked as a receptive, improvisational, two-way canvas upon which he may draw, and, more significantly, upon which he encourages others to draw. As Charles Molesworth observes, 'unlike Whitman, O'Hara never sings of himself; rather, his self is the instrument on which the poet sings'.[76] Molesworth, remarking that O'Hara's poetry 'startles as does any utterance clearly self-begot', likens his poetry to Saul Steinberg's self-portraits, in which the hand holding the pen is simultaneously sketching both the artist's line and a drawing of the artist himself. And indeed, in spite of his frequent collaging of appropriated material, O'Hara's work is both self-begot and self-begetting: Elaine de Kooning's 1962 portrait of O'Hara, in which the figure of the poet is faceless and yet is unmistakeably O'Hara, reveals this further. De Kooning recalled her decision to smudge out the face in the painting, saying that in doing so it was rendered far more like O'Hara than when the portrait contained his distinctive and carefully delineated facial features. A similar principle operates in O'Hara's poetry – although it is full of the names of people and places we cannot possibly know, and

[75] Kenneth Koch, 'All the Imagination Can Hold', *The New Republic*, 1 and 8 January 1972, 23–5.

[76] Molesworth, '"The Clear Architecture of the Nerves": The Poetry of Frank O'Hara', *Iowa Review* 6 (Summer/Fall 1975): 62.

of snippets of unmediated conversation we may not be able to understand, our lack of knowledge is irrelevant because he is not trying to draw a diagram. The purpose of his poetry is to evoke a mood or a feeling, which is as much dependent on the subjective response of the reader – the receiver of fire – as it is on O'Hara himself. As I established in my introduction, the collage aesthetic requires from the reader or viewer not necessarily the discovery of any particular message but the intuitive discernment of the emotional regulating system upon which the poem or artwork in question operates – a system which normally carries the 'implications of a life beyond art',[77] without which the work in question could not exist. In O'Hara's case this regulating system is of course that which Ashbery called his '*culte du moi …* the poems are all about him and the people and images who wheel through his consciousness, and they seek no further justification'.[78]

'The Day Lady Died' (1959), for instance, is an elegy to Billie Holiday and one of O'Hara's most accomplished poems, in which an assortment of collaged details focuses our attention on the evocation of O'Hara's mood upon learning of the singer's death, rather than any specific visualisation of her. Charles Simic, writing about Joseph Cornell in *Dime-Store Alchemy*, imagined that 'somewhere in the city of New York there are four or five still-unknown objects that belong together. Once together they'll make a work of art'.[79] Brought together, five objects more or less make up the work of art that is 'The Day Lady Died': a hamburger, an ugly NEW WORLD WRITING, a little Verlaine, a bottle of Strega, and a carton of Gauloises. The poem uses a collage style to interweave and juxtapose the everyday objects, with which it is broadly composed, in order to formulate unexpected layers of meaning and a tone of intimacy that is autobiographical without being confessional.

O'Hara's choice of title sets the reader up for a mournful homage which is never realised in the traditional sense. Instead of the standard direct address to or lament about the departed artist, O'Hara only mentions Holiday twice, and then not even by name. The meandering nature of the poem's collated detail even implies that Holiday might not have been mentioned at all, had the wandering figure of the poet not happened to catch sight of the 'NEW YORK POST with her face on it' (*CP*, 325), a newspaper cutting which O'Hara almost literally pastes into the poem. The poem abounds in times, dates, and proper nouns, from which the reader is naturally but only gently alienated, the effect of which is to furnish the poem with a state of abstraction against which the subtle, breathless poignancy of the final stanza might be juxtaposed.

Abandoning elegiac emotion, O'Hara begins by inundating the reader with a detailed pageant of illustrative facts, all of which took place on 'The Day Lady Died'. We learn that

[77] Rosand, 128.

[78] Ashbery, 'Writers and Issues: Frank O'Hara's Question', *Selected Prose*, 82.

[79] Simic, 14.

It is 12:20 in New York a Friday
three days after Bastille day, yes
it is 1959 and I go get a shoeshine
because I will get off the 4:19 in Easthampton
at 7:15 and then go straight to dinner (*CP*, 325)

This stanza sets the tone for the majority of the rest of the poem and establishes
O'Hara's intention to accumulate fragmentary, quotidian occurrences, and set them
in apposition to each other for aesthetic effect. Marjorie Perloff argues that the
fragments of detail accumulated in the poem, particularly the items he purchases,
are deliberately selected in order to embody Billie Holiday as 'both the foreign-
exotic and the native American'.[80] However this seems to rather miss the point of
the poem, which is less about creating a portrait of Billie Holiday for readers to
admire than it is about expressing how O'Hara felt on the day she died. The poem
is a collage of fragments that relate to him, rather than to her, leaving behind an
accurate impression of O'Hara of the kind that can be gleaned by sifting through
the receipts and ticket stubs in a person's wallet. We learn that he is a poet, that
he has friends in the affluent Hamptons, that he is a perennially overdrawn neo-
Bohemian who is financially secure 'for once', and that he has a taste for European
cigarettes and foreign literature. In placing himself so unequivocally within the
context of the poem, and representing himself as an active, middle-class, male
poet buying gifts for his friends prior to a weekend in Easthampton, he provides
a stunning juxtaposition with the understated image of the black, female, drug-
addicted, dead singer, whose death, after all, is the occasion for the poem. Across
the surface of the poem O'Hara combines the seamlessness of a Max Ernst collage
and the heterogeneity of a collage by Picabia, to give Holiday a place in his poem,
whilst simultaneously ensuring that she remains separate enough for the feelings
provoked by her loss to be remarkable.

O'Hara's exploitation of the natural fragmentation in the day's experience is
the key factor in the poem's success. Anthony Libby notes that although 'O'Hara's
lines are unusually rich in detail, he tends to force the details to replace rather
than amplify each other'.[81] In this way, although the reader is presented with a
catalogue of 'happenings', nothing fixed is allowed to build, and the day continues
through the poem as it would have done in real life, and indeed, if Holiday had
not died. Bill Berkson elaborates on this distancing technique, explaining that
'by the cancellation of one detail by another ... the reader is confronted by a
language with its own laws of continuity, not necessarily those to which he has
been accustomed'.[82] The result of this is that the mood of the poem is appropriately
one of transience, volatility, and fleeting moments, aided by the impression we
have of O'Hara walking around Manhattan gathering gifts with the intention of
going elsewhere. In some ways, the poem is a motile collage – fragments are

[80] Perloff, *Poet Among Painters*, 182.
[81] Libby, 244.
[82] Berkson, in *Homage to Frank O'Hara*, 164.

incorporated sequentially, and then moved swiftly on, as time passes and O'Hara continues on his journey. But the journey through the day, and through New York, is also a journey shared with the reader, toward, inevitably, the irrevocable 'NEW YORK POST with her face on it', and consequently the memory of Holiday's secret performance at the 5 Spot.[83] The journey contains also the strange moments of clarity associated with grief or shock, in which insignificant details take on greater poignancy or significance in hindsight. Furthermore, the process has repeatedly laid emphasis on disconnections and on anomalies: O'Hara does not know who will feed him, nor 'what the poets / in Ghana are doing these days'; 'for once in her life' the cashier does not look up O'Hara's balance, and, spoilt for choice, he almost, contradictorily, falls asleep. All this incongruity, when juxtaposed, finally, with the one moment of stasis and finality in the poem – O'Hara's memory of Holiday singing at the 5 Spot – helps to stabilise the glaring sense of discontinuity provoked by her death.

O'Hara moves the action of the poem into the past tense in the final stanza to heighten its quelling effect. Until the penultimate line, the poem is almost entirely in the present tense, occasionally dipping into the future, in a manner typical of O'Hara's 'I do this, I do that' style. If the poem's title were different, one might believe that he actually *is* doing all that he says he is – getting his shoeshine, going to the bank, eating a hamburger. However because the title informs us that we are in fact hearing about a memory, we are disoriented as the poem progresses in its terribly chipper, forward-looking mood, being drawn nonetheless into the poet's present time. Paul Carroll's remark that O'Hara represents 'the poet as mirror ... He reflects the surface of what that particular July afternoon in 1959 looked like to him',[84] echoes the disjunctive temporality of the poem, implying that O'Hara is a mirror capable of reflecting the past. The poem is just long enough to allow the significance of the title to fade, and then to recur to the reader, who will suddenly recall it as they reach the closing lines. It is then that O'Hara switches achingly to the past tense, to the memory of a memory which brutally juxtaposes death with life, and which almost succeeds in causing time to stand still:

> ... she whispered a song along the keyboard
> To Mal Waldron and everyone and I stopped breathing (*CP*, 325)

This powerful use of language to represent a shifting of time illustrates how far O'Hara has come since abandoning his efforts to replicate painting in poetry: this is a technique which an ordinary painting, with its inability to manipulate verb tenses, cannot achieve. A collage, however, occupies a unique place, part way between painting and text, and, as Andrew Clearfield observes, a collage

[83] Holiday was temporarily banned from performing by the FBI, on account of her drug use. Although O'Hara is probably referring to the ravaged qualities of her voice in this poem, the notion that she 'whispered' because she was performing in secret is an appealing one.

[84] Paul Carroll, *The Poem In Its Skin* (Chicago: Follet Publishing Co., 1968), 163.

may incorporate within its structure 'the temporality that has generally been an essential aspect of literature. It will, however, always obscure, and frequently deny, chronology'.[85] We can see, then, in 'The Day Lady Died', that the power of the final two lines is very much dependent upon the progression of the preceding twenty-seven lines, just as in a collage the overall effect is dependent upon the accumulative process, upon juxtapositioning and sequentiality, and upon the artist's ability to show that mood and meaning reside in the bonds of experience rather than, necessarily, experience itself. Furthermore, without the collaged surface of this poem – the tapestry of mundane memories, deliberately placed in apposition to the extraordinary one at the end – O'Hara's recollection of the night at the 5 Spot would be rendered far less significant. As it is, the memory is startling and memorable, and in its evocation of tragedy succeeds in transcending time for the reader, just as it did for him. Clark Coolidge encapsulated this achievement in his own drifting, syntactically confused tribute to O'Hara:

> The way things go by within his lines, to the side and away, just catching the edges ... The small things tangential and instantly deflected in the going forward but not before they register. The mind is moving, passing, and (even absently) collecting the while. However minute, the bright included. A master of peripheral vision.[86]

'Familiar bits of the world': Commodification, Democratization, and Proper Nouns in O'Hara

The living quality of O'Hara's poetry is sustained by his efforts not to recreate or re-imagine 'in tranquillity'[87] events such as this one, but, instead, to attempt to reconfigure the act of writing itself so that it might encompass life, or seem to, as it was happening; in other words, so that he might write his poems at parties, or on ferry journeys, or on display typewriters in the Olivetti showroom during his lunch hour, or, if he could not, to at least give the impression to his readers that he had done so, keeping the surface of his work alive. Joe LeSueur recalled:

> we lived ... in a second-floor apartment so close to the street that it seemed an extension of it, a cacophonous symphony of ugly urban sounds played fortissimo outside our window, punctuated regularly by the sound of the Ninth Street crosstown bus making its stop next to the downstairs doorway – incredibly, these distractions not only failed to impede but seemed to spur the steady stream of words rushing from his teeming brain to his two nimble index fingers.[88]

[85] Clearfield, 10.
[86] Coolidge, in *Homage to Frank O'Hara*, 184.
[87] William Wordsworth, 'Preface' to *Lyrical Ballads* (London: Longman, 1805), 1.
[88] LeSueur, 276.

The velocity of life in a chaotic urban environment inspired O'Hara to attempt to outpace thought in his writing, propelling him to carry out with such success the kind of 'theft of fire' to which Rimbaud refers in his letter. This urban drive was not, however, as Susan Rosenbaum suggests, O'Hara deriding 'an older pastoral ideal, aligning it with nostalgia for a past-that-never-was, with the "naive" romantic values of innocence, sincerity, and depth'.[89] O'Hara may mock the pastoral ideal, but it is inaccurate to suggest that his poems lack innocence, sincerity or depth, or, indeed, that these things cannot be found within an urban setting. O'Hara does not mock romantic values – he rather mocks the confinement of these ideals to a pastoral setting. He asserts in the prose poem 'Meditations in an Emergency':

> I have never clogged myself with the praises of pastoral life, nor with nostalgia
> for an innocent past of perverted acts in pastures. No. One need never leave the
> confines of New York to get all the greenery one wishes – I can't even enjoy a
> blade of grass unless I know there's a subway handy, or a record store or some
> other sign that people do not totally *regret* life. It is more important to affirm the
> least sincere; the clouds get enough attention as it is and even they continue to
> pass. (*CP*, 197)

The problem with Rosenbaum's argument is that whilst she is correct in her observation that O'Hara 'celebrates a present of irony, surface, and the "least sincere", rejecting the desire to define a space distinct from the landscape of consumption', she misleadingly presents her interpretation as a dichotomy, implying that a poem is either all innocence and sincerity, or all irony and surface, which is to disregard the fact that O'Hara's poetry is often both, and that beneath surface, inevitably, is depth.

It is of course true that O'Hara was never one to take an oppositional stance toward commodity culture. It was very much a part of his poetry, and also of his critical writing and role as curator, in which he had to promote art in such a way that it could withstand the complexities of commodification and politicization, enabling it to remain fresh and original, even revolutionary, whilst simultaneously adorning the walls of government buildings or being co-opted into representing US interests abroad. He achieved this by refusing to present avant-garde art as antagonistic or 'oppositional', to quote Blasing, instead writing about it in a manner that 'locates [art's] impulse to technical innovation within the cultural and economic mainstream', and showing it as reacting creatively to 'the stresses and strains of a specific historical moment'.[90] O'Hara succeeded in avoiding what Ashbery would later denounce as 'the loyalty-oath mentality ... where Grove Press subway posters invite the lumpenproletariat to "join the Underground Generation", as though this were as simple a matter as joining the Pepsi Generation, which it

[89] Rosenbaum, *Professing Sincerity: Modern Lyric Poetry, Commercial Culture and the Crisis in Reading* (Charlottesville: University of Virginia Press, 2007), 60.

[90] Blasing, 30.

probably is'.[91] O'Hara resisted this kind of attitude in his body of work in a manner similar to his practice of name-dropping within the context of his poems, namely by employing a levelling effect and insisting upon the total democracy of the appreciation of art. Just as 'Janice', 'Bill', and 'Maxine' could appear alongside Rimbaud and Prokofieff, and 'the soot … of New York' (*CP*, 361) alongside 'the Travesera de Gracia in Barcelona' (*CP*, 360), so he insisted that a piece of art is what it is, regardless of where it ends up or who looks at it, drawing for this on the democratizing principles of collage.

The illusion of flatness or one-dimensionality in O'Hara's poetry stems partly from the disproportionate critical attention paid to his shorter, more mercurial and immediately accessible poems – it is interesting to wonder whether, had he lived as long as, say, John Ashbery or Kenneth Koch, he would have been known instead for poems more in the vein of the forceful and lengthy 'Biotherm', to which he seemed to be moving at the time of his death. It also lies, however, in O'Hara's view that writing poetry and living life must go hand in hand, unimpeded by overly rigorous academicism, and that, as Rimbaud asserted, the poet

> must see to it that his inventions can be smelled, felt, heard … summing up everything, perfumes, sounds, colours, thought grappling thought, and pulling … This future, as you will see, will be materialistic … Poetry will no longer accompany action, but will lead it.[92]

O'Hara manifests this notion in many of his poems, which are anti-elitist in the sense of being, as Ashbery notes, 'part of a modern tradition which is anti-literary and anti-artistic' (*CP*, vii). It is evident in poems such as 'Having a Coke With You' (1960), in which, in a poetic tradition dating back to Petrarch, the works of Michelangelo, Duchamp, da Vinci, and Marino Marini are weighed up next to the attributes of O'Hara's lover, Vincent Warren, and found wanting ('I look / at you and I would rather look at you than all the portraits in the world', 'the fact that you move so beautifully more or less takes care of Futurism', etc.). The featherweight, breathless 'Poem (Lana Turner Has Collapsed!)' was dashed off on the Staten Island ferry, in 1962, on the way to a public reading. The poem has the effect of making the reader or listener feel outpaced, much as a newcomer to a big city may feel. This effect is even greater if the poem is read aloud, forcing the reader to experience its breathlessness physically.

> Lana Turner has collapsed!
> I was trotting along and suddenly
> it started raining and snowing
> and you said it was hailing
> but hailing hits you on the head

[91] Ashbery, 'Writers and Issues: Frank O'Hara's Question', 81.

[92] Rimbaud to George Izambard, 3 May 1871, in *Complete Works, Selected Letters*, 376–9.

hard so it was really snowing and
raining and I was in such a hurry
to meet you but the traffic
was acting exactly like the sky
and suddenly I see a headline
LANA TURNER HAS COLLAPSED!
there is no snow in Hollywood
there is no rain in California
I have been to lots of parties
and acted perfectly disgraceful
but I never actually collapsed
oh Lana Turner we love you get up (*CP*, 449)

In seventeen short lines, unpunctuated except for two exclamation marks, O'Hara once again manipulates tenses and constructs as sensually as possible the velocity, the turbulent rhythms, and the captivating absurdities of a modern city. Verbs are piled absurdly on top of one another as the speaker hurries across town, depicting 'the moment-to-moment reality of the individual',[93] to quote Fred Moramarco. The incongruous, disorienting descriptions of the weather subtly link O'Hara's frothy, filmic New World caricature with Surrealist Europe, whilst the speed of the transitions in the poem, which drag the reader into the meteorological vortex being described, carries distinct Futurist connotations, whirling like a collage by Carlo Carrà, as well as manifesting O'Hara's interest in the nature of time by revealing the endless tiny, entropic changes that are, in the words of Geoff Ward, 'the ways life makes itself felt'.[94] Like many of O'Hara's most famous poems, this is an occasional poem, and as such it exists completely in the moment of perception, its details and appropriations resisting interpretation, hierarchy, and longevity, so that instead of organising experience, the imagination simply records it, and in so doing shrugs off what Charles Altieri has called 'its noble form-creating role'.[95]

'Poem Read At Joan Mitchell's' (*CP*, 265), another occasional poem, further refutes Rosenbaum's suggestion that O'Hara's poetry is inherently unromantic and insincere. Although, as an epithalamion, its poetic surface suggests a celebration of the marriage of O'Hara's friend Jane Freilicher to Joe Hazan, in the fissures between each collaged fragment O'Hara reveals an internal resistance to the notion of complete, permanent unity between two people. The poem is informed by collage principles and is inherently fragmented and deliberately stylistically uneven, ranging in style from campy, Mayakovsky-esque word-drunkenness ('It's

[93] Moramarco, 'John Ashbery and Frank O'Hara: The Painterly Poets', *Journal of Modern Literature* 5, no. 3 (September 1976): 444.

[94] Geoff Ward, '"Housing the Deliberations": New York, War, and Frank O'Hara', in *Frank O'Hara Now*, 20.

[95] Charles Altieri, *Enlarging the Temple: New Directions in American Poetry During the Sixties* (Lewisburg: Bucknell University Press, 1979), 110–11.

so / original, hydrogenic, anthropomorphic, fiscal, post-anti-esthetic, / bland, unpicturesque and WilliamCarlosWilliamsian!) to poignant sentimentality ('This poem goes on too long because our friendship has been long, long / for this life and these times'). Moments of sincerity concerning the couple's relationship are also subtly ironic:

> city noises are louder because you are together
> being together you are louder than calling separately across a tele-
> phone one to the other
> and there is no noise like the rare silence when you both sleep (*CP*, 265)

They are further destabilised by a sequence of double-edged, lightly mocking observations, which hint at the changes marriage brings: 'it is most modern to affirm someone', 'no one will be bored tonight by me because you're here', ' your peculiar desire to get married', 'did you spit on your index fingers and rub the CEDAR'S neon circle for luck?' The poem's progression indicates that this hesitancy regarding marriage stems from and is counterbalanced by O'Hara's own fear of being alone. The poem grows increasingly nostalgic – the speaker hopes for 'more drives to Bear Mountain ... more evenings avoiding the latest Japanese movie ... more sunburns and more half-mile swims', implying, simply by mentioning them, his fears there will not be. O'Hara imbues the concluding lines of the poem with resignation – that the couple in question will probably be happy, and that he, the poet, probably will not – but, unable to concede this completely, the poem ends on a note that is uplifting in a rather knowing way: 'something to cling to, happiness / the least and best of human attainments'. Despite being a poem about an engagement, read to a group of close friends, it remains fragmented, emphasising its fissures in its arbitrary incorporation of place names and memories, and its halting, inconsistent style and heavy enjambment. O'Hara dances around 'the paradoxes of self and union inherent in marriage and friendship'[96] without ever confronting them directly, choosing instead to duck through the ellipses permitted by his employment of collage, which enable him to enunciate his feelings, as in 'The Day Lady Died', without ever denoting them specifically; in other words, he indulges his desire to self-document without being directly confessional.

The heightened subjectivity of the collage practice and of modern art in general, and the increasing acknowledgment of the quotidian fragment as an important aesthetic constituent, enabled O'Hara to use in his poetry an expansive gallery of characters, both real and fictitious, around whom associations, recollections, ideas, or emotions may cluster. O'Hara was strongly influenced in this respect by the writer and activist Paul Goodman's essay, published in the summer of 1951, entitled 'Advance-Guard Writing, 1900–1950'.[97] Goodman depicts society

[96] Epstein, 109.

[97] Goodman, 'Advance-Guard Writing, 1900–1950', *Kenyon Review* 8, no. 3 (Summer 1951): 359–80. Quotations from pages 361, 369–70, 375–6, and 178. Andrew

as being alienated 'from its own creative development', writing: 'its persons are estranged from one another; but most of the members of society do not feel their estrangement; ... the artists, however, feel it, regard themselves as estranged'. Specifically referring to the post-Second World War era, he writes that

> the norms that a young person perforce introjected were now extraordinarily senseless and unnatural – a routine technology geared to war, a muffled and guilty science, a standard of living measured by commodities, a commercial art, a moral freedom without personal contact.

Under such circumstances, he argues, 'we can expect little creativity, advance-guard or otherwise'. His proposed remedy to this alienation and 'shell shock', which is what O'Hara took to heart, was 'the physical reestablishment of community', whereby the avant-garde writer would 'take the initiative precisely by putting his arms around [people] and drawing them together. In literary terms this means: to write for them about them personally'. Goodman continues:

> But such personal writing about the audience itself can occur only in a small community of acquaintances, where everybody knows everybody and understands what is at stake; in our estranged society, it is objected, just such intimate community is lacking. Of course it is lacking! The point is that the advance-guard action helps create such community, starting with the artist's primary friends. The community comes to exist by having its culture; the artist makes this culture.

These ideas come across very clearly in O'Hara's intensely social poetry: he writes for and about not just his friends but also his idols and even people he disliked altogether, bearing out Goodman's view that a writer's 'audience and his relation to his audience are his essential plastic medium'. O'Hara furthers this notion by allowing the processes of poetry to be reciprocal – he, as author, is just as much the plastic medium of his audience as they are his. Goodman's essay was a 'validation'[98] of his developing poetic ideology. In an effusive letter to Jane Freilicher, O'Hara called Goodman's manifesto 'delicious', writing that 'it is really lucid about what's bothering us' and that 'it is so heartening to know that someone understands these things'.[99] Heartening indeed, for an increasingly collaboratively-minded poet whose aim was to remove the 'versus' in poetry, and to narrow the gap between art and community through the integration and subjectification of his work.

The collaged proliferation of proper nouns within many of O'Hara's poems has the dual effect of simultaneously seducing and disorienting the reader by

Epstein has written more extensively on the influence of this essay on O'Hara's entire body of work, in *Beautiful Enemies*, 29–32.

[98] Epstein, 31.

[99] O'Hara to Jane Freilicher, quoted in Brad Gooch, *City Poet: The Life and Times of Frank O'Hara* (New York: Knopf, 1993), 187.

incorporating within their plane the 'familiar bits of the world without regard for their iconic value'.[100] The familiar tone with which O'Hara drops names onto the surfaces of his texts heightens the reader's consciousness of their unfamiliarity with them. Because of this, many of O'Hara's poems might be regarded as what Roland Barthes denotes as being 'text[s] of bliss', in the sense that the bewilderment they inspire 'imposes a state of loss … that discomforts [and] unsettles the reader's historical, cultural, psychological assumptions, the consistency of his tastes, values, memories, bring[ing] to a crisis his relation with language'.[101] This is also, of course, part of the main purpose of collage; it is, as Max Ernst asserted, a conquest of the irrational through the coupling of two or more irreconcilable realities upon an unsuitable plane, thus pioneering a fresh approach to the work of art in question. One only remains mystified by O'Hara's intimate web of interpersonal affiliations if one is intent when reading his poetry on pinning down exact meanings, analysing images, and dragging the riverbed of opacity for symbolic corpses. Proper nouns within O'Hara's poetry, if treated instead as fragments of an extended collage, enable the reader to understand their function within the context of the poem in question, rather than as 'real' individuals from whom we are obstructed by our lack of knowledge of them. Charles Altieri highlights the importance of not worrying about who 'Joe' or 'Jane' might be, within the context of O'Hara's poetry, by emphasising that such characters 'continually insist that they are not representations of reality but the enactment by the artist of certain attitudes and choices within that reality'.[102] What matters is how the poetry operates around such characters, and what poetic role they have to play in terms of informing the 'attitudes and choices' of the poet.

The collaged cast of characters appearing in O'Hara's poetry often evokes, ironically, a sense of isolation, with the poem becoming, as Terence Diggory observes, 'the space in which persons are mutually exposed in their separateness'.[103] O'Hara's poem 'Joe's Jacket' (*CP*, 329), for instance, which Epstein describes as 'an experience of disorienting emotional enjambment',[104] features an extended collage of names and individuals which ultimately conveys a sense of poignant hollowness. The poem centres around 'an enormous party mesmerizing comers in the disgathering light', at which the poet is one of many guests, of whom 'Jap', 'Vincent', and 'Kenneth' are named, whilst 'Ashes' and 'Janice' also feature as

[100] Clearfield, 15.

[101] Barthes, *The Pleasure of the Text*, trans. Richard Miller (London: Jonathan Cape, 1976), 14.

[102] Altieri, 119.

[103] Diggory, 'Community "Intimate" or "Inoperative": New York School Poets and Politics from Paul Goodman to Jean-Luc Nancy', introductory essay to *The Scene of My Selves: New Work on the New York School Poets*, ed. Diggory and Stephen Miller (Orono, ME: National Poetry Foundation, 2001), 25.

[104] Epstein, *Beautiful Enemies*, 118.

absent friends.[105] 'D.H. Lawrence' is also mentioned by name. The poem begins with O'Hara, 'Jap', and 'Vincent' in the 'parlor car' of a train on the way to a party, with O'Hara musing on his notion of 'life as a penetrable landscape lit from above', an image whose painterly connotations are clear. The role of 'Jap' and 'Vincent' in the text is not dependent on the reader's knowledge of who they are; their role is to root O'Hara in the present, protecting him from the menacing nostalgia of the subsequent lines:

> ... I
> pretending to be adult felt the blue within me and light up there
> no central figure me, I was some sort of cloud or a gust of wind (*CP*, 329)

As soon as the party to which the three travellers are 'entraining' begins, proper nouns vanish from the stanza. The word 'disgathering' carries the implication that despite the large numbers of people being drawn to the party, they are psychically at a remove from one another, and that rather than gathering together, they are actually drifting, or even being forced apart. O'Hara's reactions to the large, faceless group – 'boredom', 'mounting panic', 'anxiety and self-distrust' – build into a terrible despair by the third stanza, ominously demarcated by 'the D.H. Lawrence on the floor and ... "The Ship of Death"'. Unusually for O'Hara, he also uses a metaphor for his depression here: 'the beautiful desperation of a tree / fighting off strangulation'. This continues until, looking out of the window the following morning, he sees 'Kenneth' appear, whose evidently familiar face instantaneously transforms his mood, diverting his thoughts toward 'beauty, art and progress' until 'musical and strange the sun comes out'.

The poem continues to relate the poet's borrowing of 'Joe's seersucker jacket', a temporary act of larceny which prompts a fragmented blend of beautiful, protective memories of travelling in Europe and feelings of warm nostalgia: 'it is all enormity and life it has protected me and kept me here'. Once again, the reader does not require prior awareness of who 'Joe' is: what matters is O'Hara's employment of him, in order to convey a mood. As his mood shifts, and proper nouns make their way back into the poem ('Paris', 'Haussmann and the rue de Rivoli', 'my Spanish plaza', 'San Marco's pigeons', 'the Kurfurstendamm', 'Ashes in an enormous leather chair in the Continental'), it becomes clear that they mark the seams of the collage. O'Hara collates emotions, and indicates their shifts by the entrance and exits of the names of friends, people, and places, as the poem progresses. Our attention is naturally drawn to the names through curiosity and because they stand out on the page. Proper nouns echo throughout O'Hara's oeuvre, corresponding with each other like refrains across the surfaces

[105] The poem refers to the artist Jasper Johns ('Jap'), the dancer Vincent Warren, with whom O'Hara had fallen in love the summer the poem was written, O'Hara's friends the poets Kenneth Koch and John Ashbery ('Ashes'), and Koch's wife, Janice. The eponymous 'Joe' is O'Hara's close friend and flatmate Joe LeSueur. Their relationship had recently been complicated by the arrival into it of Vincent Warren.

of his texts, and embodying 'the multiple facets of experience'.[106] This is their role within O'Hara's poetic – whatever he experiences, he usually experiences with, or because of them; and if he is alone, their absence is notable enough to bestow it with the weight of presence. In this way O'Hara's characters operate as emotive signals, acting as both seams and fissures in the collage as he portrays the fluctuations of friendship and his relationship to place and space. Their most significant collective collage function, however, is as a simultaneous distraction from and indicator of the motivation behind O'Hara's poetic; in other words, himself – 'mobile, shifting, multiple ... contradictory, elusive and incomplete'.[107]

'We just liked the splash of it': Confessionalism, New Criticism, and Collage as Modus Operandi

John Ashbery noted that although O'Hara's poetry is 'almost exclusively autobiographical, there is little that is confessional about it – he does not linger over aspects of himself hoping that his self-absorption will make them seem exemplary' (*CP*, x). Ashbery draws a line here between the autobiographical and the confessional modes, highlighting the subjective nature by which a poetic style may acquire a label. So whilst O'Hara's poems are quite clearly confessional in the literal (and expansive) sense of the word, it is the connotations of the form which he, and critics of his work, take issue with. He possessed a particularly lingering distaste for the work of Robert Lowell, seen as the father of the confessional mode. In 1965, in an unusually acerbic outburst, he savaged one of Lowell's most famous poems, 'Skunk Hour', saying:

> I think Lowell has ... a confessional manner which [lets him] get away with things that are really just plain bad but you're supposed to be interested because he's supposed to be so upset ... And I don't think that anyone has to get themselves to go and watch lovers in a parking lot necking in order to write a poem, and I don't see why it's admirable if they feel guilty about it. They should feel guilty. Why are they snooping? What's so wonderful about a Peeping Tom? And then if you liken them to skunks putting their noses into garbage pails, you've just done something perfectly revolting. No matter what the metrics are. And the metrics aren't all that unusual. Every other person in any university in the United States could put that thing into metrics. So I don't really associate very much with it. (*SS*, 13)

Lowell's confessionalism can certainly seem tactical and consciously introspective when compared with O'Hara's infinitely more grubby, casual, and conversational aesthetic, which was engineered not around an audience of one, but between a shifting, undefined community of people. Lowell's brand of confession comes as a result of a day of languishing in bed looking out at 'the abstract

[106] Altieri, 119.
[107] Breslin, 223.

imperial sky' and lamenting: 'Everyone's tired of my turmoil'.[108] O'Hara on the other hand writes a 'Song' in the back of a taxicab having just been diagnosed with a venereal infection: 'how I hate disease, it's like worrying / that comes true' (*CP*, 361). Anne Hartman suggests that O'Hara's objection to Lowell stems from the latter's 'spurious claims to sincerity and cathartic release from a guilt that is in fact its precondition', arguing that Lowell's poems are 'characterized by controlled spontaneity or feigned carelessness ... a self-conscious, composed style of self-narration we have come to expect from models of confession descending from Augustine and Rousseau'.[109] But Lowell appears to have touched a raw nerve in O'Hara, whose atypical outburst seems to be about more than mere temperamental aversion, and perhaps, rather, exposes the similarities in their creative processes, uncovering in O'Hara the poetic devices he conceals not just from his audience, but also, as far as possible, from himself. Since the days of his early experimentation with collage in poems like 'Second Avenue', he had been practicing the art of concealing his poetic devices, so as to make his poetry seem as spontaneous and as improvisational as possible. Whilst Lowell articulates grandiose confessions with a poised theatricality ('everyone's tired of my turmoil'), O'Hara roves frenetically into and over the surfaces of his own psyche, tempering his strong performative tendencies with intimate ruses designed with the pleasure of an audience in mind: the lines 'in a world where you are possible / my love / nothing can go wrong for us, tell me' (*CP*, 361) sounds initially blithe and confident, but the final two words reveal the devastating uncertainty which is the motivation behind this short poem. It is interesting to situate Lowell's genuine psychic anguish alongside O'Hara's bitterness toward him: Lowell represents an immersion in a therapeutic culture which O'Hara, for all his own psychological troubles, seems to resist, dedicated as he is to pitting his anti-elitist impulses against Lowell's self-conscious introspection. He is appalled by Lowell's claim to exemplary status purely on account of his dissemination of his own psychological troubles. As an artist, O'Hara's spontaneity and literary dirtiness are arguably just as much a subterfuge as Lowell's decontaminated metrics. The stylistic purity of 'Skunk Hour' juxtaposed with its images of skunks and garbage pails forces O'Hara to confront his own artifice, unsettling the view he espouses in 'Song (is it dirty)', in which he justifies his lover's bad character by comparing it with the dirty city air, which 'you don't refuse to breathe do you' (*CP*, 327). The spontaneous impurity of O'Hara's work is a natural impulse first, and a poetic tactic second, whereas in Lowell the reverse seems true, and recognition of this may have rather unnerved O'Hara.

Allen Ginsberg perhaps articulated these differences best when in an interview in 1966 he posed the question: 'what happens if you make a distinction between

[108] Robert Lowell, 'Eye and Tooth', in *For the Union Dead* (New York: Farrar, Straus & Giroux, 1964), 19.

[109] Anne Hartman, 'Confessional Counterpublics in Frank O'Hara and Allen Ginsberg', *Journal of Modern Literature* 28, no. 4 (Summer 2005): 41.

what you tell your friends and what you tell your Muse? The problem is to break down that distinction: when you approach the Muse to talk as frankly as you would talk with yourself or with your friends'.[110] Indeed, as Russell Ferguson notes, it was never O'Hara's aim 'to flaunt his erudition, but rather to submerge its deeper content in the embrace of the quotidian; to write always in the now of a particular time and place'.[111] O'Hara was a judicious listener, and seems to have been able, critically and with remarkable self-confidence, to siphon off the more perceptive and charismatic elements from his inner verbal flow which he genuinely wanted, and, indeed, needed, to share with others: as he says in his 1961 poem 'For the Chinese New Year & For Bill Berkson', 'what do you do with a kid / like me if you don't eat me I'll have to eat myself' (*CP*, 389).

O'Hara was therefore troubled by, but largely ignored, the dry, self-conscious, poetic template drawn up by the New Criticism, particularly by academics such as W.K. Wimsatt and Monroe Beardsley, which seemed to go against everything he stood for, both as a poet and an art critic, as well as a reader of poetry. When asked by Edward Lucie-Smith to weigh in on the aesthetic debate over 'the raw and the cooked' in poetry, and to give an idea of where he stood in relation to the poets and the poetry involved (predominantly Lowell versus Ginsberg), his response was fairly equivocal: 'Actually I don't really see what my relation is to them one way or the other except that we all live at the same time' (*SS*, 12–13). But the isolationist readings championed by the newly elevated advocates of the New Critical movement, whose enduring achievement was to professionalize criticism as a serious academic discipline, created a self-enclosed literary elite that seemed restrictive and authoritarian, particularly for a writer whose immediate audience was always his own, intimate community, or coterie, and much of whose poetry, particularly in the long-term, served to articulate the juncture between text and experience, something the New Critics largely rejected. Detractors of O'Hara's writing could argue that it is just as self-enclosed as the elites he criticises, and in fact merely perpetuates a different kind of elite, punctuated as it is by the names of his friends and by lowbrow allusions to diners, bars, parties, streets and other city-places that the majority of readers would never even have heard of, let alone visited. He also makes frequent references to obscure or high cultural sources – Rachmaninoff, Macbeth, *Fantômas*, the Kikuyu, Saint Adalgisa's day – ostensibly in the vein of the Modernist collage style of Eliot, Pound, or Lowell. And yet *The Waste Land*, the *Pisan Cantos*, and Lowell poems such as 'Mr Edwards and the Spider' and 'Skunk Hour' were being absorbed into the literary professoriate by the New Critics, whilst O'Hara's work, in spite of its irony, complexity, and self-reference, all attributes championed by New Criticism, was not.

The difference between O'Hara's poetic style, and Eliot's, Lowell's, or Pound's, is that his often equally obscure references do not detract from the overall meaning of any given poem; they operate instead as something akin to the found

[110] Ginsberg, 'The Art of Poetry No. 8', *Paris Review* 37 (Spring 1966): 21.
[111] Ferguson, 27–8.

object in art, and serve to add elements both living and universal to his poetic. O'Hara writes about the effect these unknown things have on him, about how they are relevant to his life, to the poem he is writing, and to the experience or idea he is trying to convey. He does not try to show how much he knows, or – except in the case of the movies – advocate anything. Meaning in O'Hara's work lies in his own words and sentiments, as well as his implied delivery, because everything he writes seems to be, as Ashbery noted, 'emerging out of his life' (*CP*, x). To Wimsatt and Beardsley, who, in 1946, dismissed the intentions of the author as an 'intentional fallacy',[112] this was anathema. O'Hara's poetry does not depend on the reader knowing what Prokofieff sounds like, or what a de Kooning looks like, or what the Stagamore's 'terrific' coffee (*CP*, 265) tastes like: what matters is what these things sound or look or taste like to O'Hara, who will delineate them, in his own unique way, for the reader. Equally, he will say what he needs the reader to hear about Janice or Kenneth or Allen, or Sergei O or Pasternak or Helmut Dantine – in this way, as I noted in my introduction, with regard to the creation of collage, choice is 'the decisive creative act'.[113] Not recognising a reference in O'Hara is not, therefore, an impediment to understanding his poetry. By contrast, New Critical readings of Eliot, for instance, rendered *The Waste Land* all but off limits to those with no knowledge of the journey to Emmaus, a multiplicity of languages ancient and modern, or who Tiresias might be. Likewise Lowell's 'Mr Edwards and the Spider': without knowing anything about the eponymous Mr Edwards (an eighteenth-century New England theologian and one of the founders of what became Princeton University) the reader is kept at arm's length from the poem itself.

This expectation of prior knowledge required by the New Critics was deeply alienating to O'Hara, the implication being that poetry was for some people and not for others. In promoting literature as a discipline akin to science or philosophy, New Critics such as I.A. Richards, William Empson, and John Crowe Ransom also promulgated an unavoidably elitist agenda of separation, which was not necessarily that of the poets to whom they subjected their specialized reading techniques. Eliot, for example, had his own reservations about 'the respectable mob'[114] who read his poetry, professing 'that the poet naturally prefers to write for as large and miscellaneous an audience as possible, and that it is the half-educated and ill-educated, rather than the uneducated, who stand in his way'.[115] The New Criticism was influenced by Cleanth Brooks and Robert Penn Warren's *Understanding Poetry* (1938), a highly successful poetry textbook designed to help first-generation college students (many on the GI Bill) with literary studies. Although Brooks and Warren saw the New Criticism as helping to democratize the

[112] Wimsatt/Beardsley, 'The Intentional Fallacy', *Sewanee Review* 54 (1946): 468–88.

[113] Thomas, 81.

[114] Eliot, 'London Letter', *The Dial*, May 1922, 510–13.

[115] Eliot, *The Use of Poetry and the Use of Criticism* (Cambridge: Harvard University Press, 1933), 146.

study of poetry, their view of the poem as an autonomous structure sustained the New Critical tendency to situate the text out of reach, forcing would-be readers to attempt a perilous ascent of the crags around their ivory tower, to claw their way from myth to ancient language to obscure spiritual reference until they had learned to appreciate all the technical inner workings and academic allusions of the poem in question. This is not necessarily a bad thing, or indeed the direction that Eliot or Pound envisaged their poetry taking, but it is what O'Hara objected to: such a process lacked *joie de vivre*, and, furthermore, underpinning it all was a stultifying autonomy which was incompatible with both his democracy of vision and his notion of his 'life held precariously in the seeing / hands of others' (*CP*, 245).

O'Hara's response to the New Criticism, however, as well as to the dominant parameters associated with contemporary poetics (allusiveness, ambiguity, symbolism), was not to deliberately set out to carve his own identity as particularly particular. It was, rather, as Lytle Shaw explains,

> to destabilize and displace the markers of literary universality that would allow poetry to operate in an established, understood public sphere – a sphere characterized by norms of tone, canons of reference, and what O'Hara, referring specifically to the New Critics, calls "certain rather stupid ideas about ... the comportment in diction that you adopt".[116]

For O'Hara, poetry was about communication and conversation: it was not an academic delicacy designed to please the palate of an artificial public. The differences between his work and that of the more academic poets working (and having more success) at the time, were not so much a matter of mass culture versus high art (in these respects they actually share several characteristics), but the ways in which he intended it to be, and in which it was, received and discussed. O'Hara wrote that he wanted to 'keep the surface of the poem high and dry, not wet, reflective and self-conscious' ('Notes on "Second Avenue"', *CP*, 497), revealing that the technical intricacies of his poems must ultimately be subordinated to an overall evaluation of their effects, to the experience rather than the interpretation of them, and to prioritizing his creative processes over his finished creations. Jackson Pollock once remarked that appreciating his painting ought to be 'like looking at a bed of flowers – you don't tear your hair out over what it means'.[117] This applies equally to O'Hara's poems. Readers are not required to probe beneath their collaged but deliberately flat surfaces: just as Pollock wanted 'to do away with [the image], to let the painting come through',[118] so O'Hara seems to be asking that the reader involve themselves in his work by trying to experience the fragments of his life which he is showing (rather than explaining) to them. Whilst O'Hara

[116] Shaw, *Frank O'Hara: the Poetics of Coterie* (Iowa City: University of Iowa Press, 2006), 5.

[117] Quoted in Steven Naifeh and Gregory Smith, *Jackson Pollock: An American Saga* (New York: Clarkson N Potter, 1989), 592.

[118] Naifeh and Smith, 591.

is not a confessional poet, his epithets – such as 'Happiness / the least and best of human attainments' ('Poem Read at Joan Mitchell's', *CP*, 265) or the wonderful 'Grace / to be born and live as variously as possible' ('In Memory of My Feelings', *CP*, 252) – have a certain Wildean universality in their marriage of highbrow social aestheticism and camp wit, forming an integral part of a narrative that is directly addressed to the reader, whoever he or she may be. His 'I do this, I do that' poems give the reader an almost documentary perspective on both his quotidian and poetic activities. The evenly presented pageant of images in O'Hara's work permits the listener or reader the same liberty of contemplation that one has in an art gallery, with the result that we are able to fulfil the plea of another poet, Denise Levertov, who implores, simply: 'O taste and see'.[119]

Part of the reason, then, for O'Hara's strong associations with the Abstract painters in New York, and with artists in general, which he had cultivated since he began making weekend trips to the city whilst still a student at Harvard, was, as he discusses in another part of Richard Moore's film, their disavowal of what he describes mockingly as the prevailing '*partis pris* about academic standards'. He explains:

> John [Ashbery], and Kenneth, and I, and a number of other people, later found that the only people who were interested in our poetry were painters, or sculptors. You know, they were enthusiastic about the different ideas, and were more inquisitive ... Being non-literary they had no *partis pris* about academic standards, attitudes and so on. So that you could say, 'I don't like Yeats', and they would say 'I know just how you feel, I hate Picasso too'. You know, that sort of thing, which was a much pleasanter atmosphere than the literary community was providing at the time.[120]

His relationship with the intellectual and philosophical hangover left in American poetry by the work of Eliot and Pound was more complicated. He found it overly grand, lacking in humour, and felt that it caused subsequent poets, such as Charles Olson (whom he nevertheless admired), to be too focussed on 'saying the important utterance', a trait which he described to Edward Lucie-Smith as being 'not particularly desirable most of the time' (*SS*, 13), rather than writing from the heart. This seems to be more directly related to the ways in which Eliot and Pound's poetry was received in academic circles, than to their poetry itself – there are certainly connections to be made particularly between Eliot's fusion of high modernism with his own lowbrow interests (melodrama, boxing, comic strips) and O'Hara's own combinations of high art and popular culture. O'Hara and the other New York poets also acknowledged that the elder poets' provocative uses of collage, juxtaposition, and layering effects inspired them, if only once they were detached from their more serious agenda. Talking about Pound's poetic techniques, particularly his employment of collage, Koch speaks generously about

119 Levertov, *O Taste and See* (New York: New Directions Books, 1964), 53.

120 *USA Poetry: Frank O'Hara*, dir. Moore.

his 'quirky way of talking ... a very flat, spoken style mixed in with unexpected quotes and other languages', but goes on to clarify the extent of the influence this had on himself, John Ashbery, and O'Hara: 'Pound did it to make some kind of point, whereas I think we did it because we just liked the splash of it, having everything in'.[121] In this sense, the texture and variety of many of O'Hara's poems illustrates an outward debt to Eliot and Pound, whilst remaining at a remove from the latter's more Manichean bent and his lofty and expansive poetic philosophy. As Will Montgomery notes, O'Hara's rejection of 'an all-encompassing poetics' is directly related to his 'invocation of unpredictability [which] implies an openness to all the things that language can do while the poet isn't looking ... a liberty that realizes the limits of the self in directing language'.[122]

O'Hara rarely concerns himself with a quest for overarching meaning or poetic universality (or a universal poetics). His poetry uses the sounds and appearances of things to explore localised, individualised meanings, which, largely on account of their tone, are able to resonate widely nonetheless, in a manner similar to Joe Brainard's unconventional memoir *I Remember* (1970), which despite being an uninterrupted verbal collage of highly personal recollections nonetheless reverberates remarkably with the reader. Collage for O'Hara, and this is particularly evident in his own collage collaborations with Brainard, represented an opportunity to question conventional norms of representation and poetic discourse. Nick Selby dexterously explores the 'poetics of intimacy' in the overlapping work of O'Hara, Brainard, and Jasper Johns, using the example of the 1964 Brainard and O'Hara collage collaboration *I Grew this Mustache* to illustrate how collage may be used to focus attention upon, in this instance, 'the cultural frames through which maleness is both obscured and made apparent, and upon men's masks and masques'.[123] The collage is simultaneously explicated and complicated by O'Hara's comic text, which reads: 'I grew this mustache because my girl has one and I think mustaches are pretty sexy'. In addition, a semi-obscured Spanish text reads 'Charro boricua' (the Puerto Rican cowboy). The collage also contains a red-tinted picture of a man who looks like a movie star, wearing a suit and tie, a black and white shot of a naked or semi-naked fencer holding a foil, a Japanese style painting of a flower, and a border of Ghanaian stamps. Selby elegantly posits this as a roguish challenge to 'the ways in which masculinity and the figure of the male body are placed at the heart of American ideology'.[124] This playful aesthetic negotiation, facilitated throughout his body of work by the collage practice, allows O'Hara to engage provocatively and dynamically, without taking either himself or his art too seriously, with the issues which confronted him in everyday life, be they questions

[121] Koch, in Daniel Kane, *What is Poetry*, 96.

[122] Will Montgomery, '"In Fatal Winds": Frank O'Hara and Morton Feldman', in *Frank O'Hara Now*, 201–2.

[123] Nick Selby, 'Memory Pieces: Collage, Memorial and the Poetics of Intimacy in Joe Brainard, Jasper Johns and Frank O'Hara', in *Frank O'Hara Now*, 234.

[124] Selby, 234.

of sexual freedom within the context of the Cold War, Marino Marini's failure 'to pick the rider as carefully as the horse' (*CP*, 360), or the simple pleasures of 'neon in daylight' (*CP*, 258). It also allowed him to exhibit – or, at least, to always seem to be exhibiting – the processes of his creativity.

His openness and receptivity to what he was thinking or seeing or experiencing – his ability, as it were, to listen to himself – enabled him to direct into his writing what Merle Brown qualifies as 'those unforeseeable, unplanned, unintended forces of his inner and surrounding life as no deliberate, crafty, intentional writer could do'.[125] But of course O'Hara was, in his own unique way, a 'deliberate, crafty, intentional writer', engaged in a lifelong endeavour to constantly renew the cherished subterfuge of spontaneity, immediacy, and improvisation within his work. It is possible to conclude from this innate, creative, self-reciprocity, that the spontaneity and impulsiveness of O'Hara's work is both a poetic tactic and a natural impulse, on many occasions both manifested in and facilitated by his use of collage, which operates in his work as more than just a method or a technique: it is a state of mind, a mental modus operandi, which, to return to Lévi-Strauss, 'lies half-way between scientific knowledge and mythical or magical thought'.[126]

[125] Brown, 'Poetic Listening', 137.

[126] Lévi-Strauss, 22.

Fig. 3.1 Mario Schifano. *Frank O'Hara*, 1965. © DACS 2013.

Chapter 4
Bob Dylan and Collage:
'A deliberate cultural jumble'[1]

'Great art can be done on a jukebox'[2]

Bob Dylan launched his career in the hallucinatory, multifarious, patchworked metropolis of 1960s New York City. It was in Greenwich Village that he wrote many of his best and most successful songs, drawing inspiration from the 'cultural junk'[3] and juxtaposed discourses, voices, and traditions, which exist predominantly in cities. Dylan found the processes involved with collage compelling, and whilst he discovered that it was not always possible, nor indeed relevant, to use the technique directly within the context of his songs, his songwriting on *Bringing It All Back Home* (1965), *Highway 61 Revisited* (1965), *Blonde on Blonde* (1966), and *Blood on the Tracks* (1975) (as well as certain songs on *The Freewheelin' Bob Dylan* [1963] and *The Basement Tapes* [1975]) regularly employs what might more accurately be termed the collage-esque. The liner notes to two of his albums feature a version of Burroughs's cut-up technique, as does his collage-novella, *Tarantula* (1965).[4] So too, to a certain extent, does the 'Subterranean Homesick Blues' video, in which, in an alley behind the Savoy in London, Dylan slings to the ground laconic cue cards featuring fragments of the song's lyrics, on occasion deliberately misspelled or misquoted. These, in addition to numerous songs on the albums listed above, as well as many of his interviews and performances between 1962 and 1975, are clearly indicative of his larger desire (and ability) both to be 'hip to communication' and to create what he referred to as a 'collage of experience' for his listeners and for himself.[5]

[1] Frank Kermode and Stephen Spender, 'The Metaphor at the End of the Funnel', in *The Dylan Companion*, ed. Elizabeth Thomson and David Gutman (London: Macmillan, 1990), 158.

[2] Ginsberg, quoted in an interview with Ralph J. Gleason for *Ramparts*, March 1966; see Artur, *Every Mind Polluting Word: Assorted Bob Dylan Utterances*. Don't Ya Tell Henry Publications, 306, http://content.yudu.com/Library/A1plqd/BobDylanEveryMindPol/resources/914.htm [Accessed August–December 2013].

[3] Jameson, 80.

[4] Written between 1965 and 1966, *Tarantula* was due to be published in 1966, but Dylan was involved in a motorbike crash in July 1966, and as a result the publication stalled. Unofficial copies were produced by the San Francisco publisher Albion, and the book was officially published, to general critical derision, in 1971.

[5] Dylan, in an interview with Paul J. Robbins, California, 1965. Originally printed in two parts in the *Los Angeles Free Press*, 17 and 24 September 1965 (see Artur, 114).

This final chapter will assess the role that collage techniques play in a selection of Dylan's work from the early 1960s to the mid-1970s, considering songs including 'A Hard Rain's A-Gonna Fall' (1962), 'Desolation Row' (1965), 'Visions of Johanna' (1966), and 'Tangled Up In Blue' (1975). It will emphasise the assertion, made in my introduction, that collage articulates an intellectual and emotional relationship with any given aesthetic environment, and that its most significant principle is the linking of, and free experimentation with, disparate phenomena. As with William Burroughs, it would be incorrect to assert that Dylan was deliberately using collage in any specific tradition; rather, his methodology was more that of the magpie, as he eclectically (even accidentally) wove into his lyrics the practices and techniques of a range of previous artists and writers (many of whom had used collage themselves). This chapter will show how, as it had also done for Burroughs in particular, collage enabled Dylan to set himself up as an original, abounding in influences whilst rarely seeming derivative. Like that of both Burroughs and O'Hara, Dylan's collage work manifests a typically iconoclastic impulse, symptomatic of a desire to re-view the world, to take it apart and rebuild it. Whether through free-standing elements that are dynamically tied together as the work unfolds, or through narrative, scenic intercutting, Dylan used collage to facilitate his style of social commentary, his methods of self-portrayal, and his ambition to make songwriting new.

The 1960s produced several notable examples of musical collage – including compositions by John Cage and Morton Feldman, several songs on The Beatles' *Sgt. Pepper's Lonely Hearts Club Band* (1967) and their self-titled 1968 LP (also known as *The White Album*), as well as The Who's 'A Quick One While He's Away' (1966), The Rolling Stones' 'Midnight Rambler' (1969), and The Doors' 'When the Music's Over' (1967). Dylan's use of collage during roughly the same period, however, is primarily confined to his lyrics, which are constructed out of a collaged set of juxtaposed words, character snapshots, images, vignettes, and visual ideas, and often feature the kind of fragmentation, ellipsis, deliberate opacity, and discontinuous composition used not just by modernist writers but in Futurism, Surrealism, and Dada as well. By contrast, his music, on the whole, is stylistically and formally continuous, although if we accept Michael Gray's analysis of it as an amalgamation of 'Yankee, Southern Poor White, Cowboy, and Black' folk music, it too is also arguably an extended, sustained form of collage.[6] Notwithstanding, the larger continuity of Dylan's music creates a productive tension between the radical, experimental nature of his lyrics and the more reassuring repetitiveness of his blues and folk-inflected music. Indeed, this tension between his lyrics and his music is an essential part of Dylan's success; together they are like dynamite, but when separated they lose their power.[7] The profound cultural impact of most

[6] Michael Gray, *Song and Dance Man: The Art of Bob Dylan* (London: Abacus, 1973), 32.

[7] A crucial shortcoming of Christopher Ricks's otherwise expansive book, *Dylan's Visions of Sin* (London: Penguin, 2004 [2001]), is that broadly it fails to accept that Dylan

of Dylan's records from *Freewheelin'* to *Blood on the Tracks* owes much to his use of, and interest in collage, and his ability to make it work flexibly, resonantly, and effectively within the context of blues-style lyrics. Because his use of collage occurs primarily in the context of his lyrics, it is to his lyrics rather than his music that I will devote my attention throughout this chapter. Dylan used collage to dramatically centralize himself as hipper-than-hip, cutting and pasting himself into the counterculture in the form of a sort of a Rimbaud figure, and co-opting everyone and everything from the Madonna and the Mayflower to Ezra Pound and Chuck Berry into playing a role in his exultant lyrical collage of wit, drama, and eloquent disaffection. His application (consciously or otherwise, as I will explain) of collage techniques to the writing of his lyrics and album copy, and even to the performing of his songs and his conduct in interviews ('chock full of aphoristic non-sequiturs that already seemed fragmented'[8]), enabled him to elevate his brand of rock and roll to a level of heightened aestheticism, with the result that the experience of listening to his music required (and still requires) a different quality of attention than, for instance, listening to an Elvis Presley record.

As a creative vehicle, collage complemented the folk idiom in which Dylan initially developed, facilitated his penchant for witty linguistic games and inventive combinations of words and images, and enabled him to use micro-narratives and short character sketches as a means of building his songs. The highly visual imagery which can be found in even his earliest, most folk-inflected or political narrative songs, and his tendency to fuse folk ballads with the blues and literary references with popular culture, indicates a desire to use assembled fragments of past musical and lyrical traditions to create his unique contemporary brand of rock and roll, in which multiple perspectives are incorporated non-hierarchically within a single plane of view. Collage-esque techniques are evident in many of the folk songs that Dylan cut his teeth on, and he showed a sustained awareness of the potential effectiveness of collage and the collage-esque; when complaining, for instance, that news magazines such as *Time* lacked 'ideas' and systematically failed to 'print ... the truth', he suggested that truth and ideas might be easier located were the magazine to use 'some sort of collage of pictures'.[9] Taken on its own, this suggestion can come across as tersely indistinct, but it seems to relate to the approach he had taken to songwriting. 'A Hard Rain's A-Gonna Fall', for example,

was predominantly a musician, preferring to locate him as a poet within a highly literary tradition, and thereby disconnecting him from the politics and social protest of the folk movement with which he was initially associated.

[8] David Yaffe, 'Bob Dylan and the Anglo-American Tradition', in *The Cambridge Companion to Bob Dylan*, ed. Kevin J.H. Dettmar (Cambridge: Cambridge University Press: 2009), 15.

[9] Interview with Horace Judson (correspondent for *Time*), 9 May 1965, London, Royal Albert Hall (Artur, 152). Dylan's ideas on this subject clearly correspond to those of William Burroughs, whose cut-ups were, at least in part, a calculated – almost ritualistic – act of revenge on Henry Luce's media empire (*Time*, *Life*, and *Fortune*), against whose imperialist and capitalist attitudes he continually railed.

was an attempt to convey the truth as he saw it and to reinvigorate the protest song genre by using just such a 'collage of pictures'. This song, which developed alongside the Cuban Missile Crisis of 1962, figures the singer as a steadfast purveyor of the truth as he sees it, a raggedy but resolute oracle who promises to embody and broadcast it as widely as possible. The song's effectiveness lies in Dylan's discovery in composing it of the lyrical – and, consequently, the political – possibilities yielded by an arrangement of collaged vignettes. It is made up, broadly, of a collage of self-contained images, whose order, as in many of Dylan's songs, could be altered without much affecting the sense or indeed the relevance of the song. The effect of this, to borrow from Stephen Scobie, is to 'de-emphasize the linear progression of the song and to see its structure in more spatial terms, as if all the images were laid out alongside each other in a continuous present tense'.[10] Dylan asserted that the problem with straightforward protest songs was that they tended to preach to the already converted, alienating those that they were trying to reach by enforcing a sense of guilt. He suggested that a better approach would be to attempt to change someone's point of view without inducing this sense of guilt:

> The people that do hear them are going to be agreeing with you anyway. You aren't gonna get somebody to hear it who doesn't dig it. People don't listen to things they don't dig. If you can find a cat that can actually say 'Okay, I'm a changed man because I heard this one thing – or I just saw this one thing ...' Hey, it don't necessarily happen that way all the time. It happens with a collage of experience which somebody can actually know by instinct what's right and wrong for him to do. Where he doesn't actually have to feel guilty about anything.[11]

'A Hard Rain's A-Gonna Fall' uses collage to illustrate a particular point of view whilst simultaneously allowing for – and even encouraging – natural human contradictions and particularized complications. Made up as it is of a series of complex but compressed narratives or encounters, which are placed in apposition to one another whilst remaining loosely affiliated, 'A Hard Rain's A-Gonna Fall' is possibly Dylan's earliest attempt to transform a song into a 'collage of experience'.

For the principal purposes of this chapter, Dylan's interest in the collage practice is evidenced by the dynamic, metamorphic, highly visual image-sequences in his lyrics written predominantly during the mid-sixties, but also on certain songs recorded with The Hawks (later The Band) during *The Basement Tapes* sessions, and on *Blood on the Tracks*. We can also find it, however, in the liner notes to two of his albums, in *Tarantula*, in his fascination with Harry Smith's

[10] Scobie, *Alias Bob Dylan Revisited* (Calgary: Red Deer Press, 2004), 97. Aidan Day also draws attention to this effect, in relation to 'Desolation Row' and 'Gates of Eden', in *Jokerman: Reading the Lyrics of Bob Dylan* (Oxford: Blackwell, 1989), 61.

[11] Interview with Robbins, 114.

collaged *Anthology of American Folk Music*,[12] in the recurrence of the thief motif throughout his oeuvre, and in his dynamic shape-shifting public selfhood in which he seems, as John Hughes suggests, to be 'always in motion between two incarnations of the self, past and future'.[13] It is even present, arguably, in his decision as a teenager to dissever his own surname and replace it with another, as well as in *The Basement Tapes* sessions, themselves a collaborative experiment in cutting up an archive, in which, as Scobie observes, 'we can legitimately read, in the traces of the choices he makes, a map of his own sensibility'.[14] Some of the recordings, fittingly, took place at the Woodstock home of the renowned outsider artist Clarence Schmidt, who had built an enormous environmental sculpture made entirely of found objects on the slope of the Ohayo Mountain. Furthermore, Dylan's life in New York City – as well as his more itinerant pre-New York period spent in and around Minneapolis, St Louis, and Kansas City – immersed him in a culture and an environment that had long embraced collage as a key art form. Gray suggests that the kind of collage evident in Dylan's lyrics – notably in his subversion of linear time and narrative chronology – is in fact characteristic of folk music, and also that the compositional and performative techniques which are often held up as literary are instead reflections of the folk music traditions in which Dylan developed.[15] However, Gray's definition of folk music – that it is 'created by the people and for the people' and that it 'gives form to the democratic ideal'[16] – actually chimes directly with the definitions of collage explored throughout this book. Moreover, Dylan's association with artists, writers and 'scholarly types', who were not necessarily a part of the folk-music scene, added the crucial cross-disciplinary aesthetic dimension to his songs, typical of collagists since Picasso's era. As Gray himself acknowledges, 'for Dylan, Highway 61 leads to the dust-bowled '30s, Kerouac and Kant, Chuck Berry's neon-California and Eliot's wasteland simultaneously'.[17] Dylan recalls coming across 'art books ... books of Motherwell and early Jasper Johns',[18] encountering 'a lot of poets and painters', being 'turned ... on to all the French poets', and reading 'Kerouac, Ginsberg, Corso, and Ferlinghetti ... Pound, Camus, T.S. Eliot, e.e. cummings ... Burroughs,

[12] Smith himself confirmed that 'the whole *Anthology* was a collage. I thought of it as an art object'. Quoted in *Think of the Self Speaking: Harry Smith – Selected Interviews*, ed. Rani Singh (Seattle: Elbow/Cityful Press, 1999), 81.

[13] Hughes, *Invisible Now: Bob Dylan in the 1960s* (Burlington, VT: Ashgate, 2013), 4. Hughes's book is an extended, and very interesting, exploration of Dylan's selfhood during the 1960s. His emphasis on the essentially transitory nature of subjectivity in Dylan's work chimes with the effects of collage on the viewer/reader, and the artist's refusal to assert a controlling subjectivity.

[14] Stephen Scobie, *Alias Bob Dylan Revisited* (Calgary: Red Deer Press, 2004), 215.

[15] Gray, *Song and Dance Man III: The Art of Bob Dylan* (London: Cassell, 2000), 75.

[16] Gray, *Song and Dance Man*, 30.

[17] Gray, *Song and Dance Man*, 78.

[18] Bob Dylan, *Chronicles: Volume One* (London: Simon & Schuster, 2004), 40.

Nova Express, John Rechy, Gary Snyder …'.[19] These recollections are key in their inclusion of a number of writers and artists, several of whom I have already discussed, who made significant use of the collage practice (notably Motherwell, Pound, Eliot, Ginsberg, Corso, and, of course, Burroughs), and who signal Dylan's formative awareness of both the technique and the ideas and history behind it.

It may seem surprising, therefore, given his interest in and use of it, that Dylan's work is rarely considered directly within the context of collage. Whilst plenty of critics, including Michael Gray, Aidan Day, Sean Wilentz, Mike Marqusee, Robert Christgau, Clinton Heylin, and Howard Sounes, all mention Surrealism or Dada or modernist traditions or jumbled influences in relation to Dylan's lyrics or persona, the collage practice is only ever passingly cited and rarely explored or discussed explicitly. There seem to be several reasons for this. The first is the most general, and has already been addressed in my introduction to this book – namely the paucity of critical attention thus far paid to collage outside the sphere of art history. The second is that Dylan's most prominently collaged work – *Tarantula* – is also his least successful. Seemingly written in a methamphetamine-fuelled frenzy, Dylan himself was ultimately embarrassed by it. Its poetic qualities are largely subordinated to its manic and garbled effects, and its eventual publication was on account of Dylan's success and worldwide fame as a musician – and fans' persistent bootlegging of the material – rather than because the book was deemed to have any particular literary merit. Robert Christgau wrote that when reading *Tarantula* 'the only literary precedent that comes to mind is *The Naked Lunch*',[20] and in a sense this is true, though it ignores the cut-up novels. However, it is also misleading. Both *Naked Lunch* and *Tarantula* are examples of prose collage (and certainly Dylan had read *Naked Lunch*),[21] but *Naked Lunch* was ultimately the successful product of a sustained and psychologically tortured period of construction, through which Burroughs came to realise the potential of collage as a literary tool. The chaos in *Tarantula*, on the other hand, is conspicuously contrived, reading like the excited ramblings of, as Christgau continues, 'a word-drunk undergraduate'.[22] Parts of it are witty, occasionally the imagery is arresting, and whilst it is in some ways akin to his songs from the 1960s, without the accompanying music the Surrealistic language falls flat. Without the music, and, perhaps more importantly, without Dylan's rambunctiously mordant delivery, *Tarantula* loses its comic context; so whilst lines like 'the sun's not yellow, it's chicken' ('Tombstone Blues', *Highway 61 Revisited*) sound sharp and funny and

[19] Interview with Cameron Crowe, August/September 1985 (for liner notes for *Biograph* [1985]) (Artur, 851–69).

[20] Robert Christgau, 'Tarantula', *New York Times Book Review*, 27 June 1971; reprinted in *The Dylan Companion*, 141.

[21] Tony Glover attested that he ordered a copy of *Naked Lunch* from France in 1959, and lent it to Dylan, who returned it after a couple of weeks. See Sean Wilentz, *Bob Dylan in America* (London: Vintage, 2011), 50.

[22] Christgau, 142.

defiant when sardonically drawled over the sound of drums and electric guitar, similar lines in *Tarantula* are rendered less quotable for lying inert on the printed page. A further problem with *Tarantula* – and a key reason for its failure – is that, as a standalone experimental text, it lacks the courage of its convictions. Unlike Burroughs's cut-up texts, which were written as part of an extended and serious literary and quasi-political experiment, *Tarantula* was largely the product of a drug-fuelled and ultimately derivative moment of abstract spontaneity. As its author, Dylan is demonstrably uninterested by *Tarantula*, making it plain that it really has very little part to play in his oeuvre. It gives the reader no impression of potential artistic progression or even purpose, and in this sense particularly it bears almost no relation to Dylan's vast and continually evolving catalogue of songs. The linguistic games in *Tarantula*, as Paul Williams notes,

> are not liberating or stimulating but transparent and banal; the rhythms of the writing are fun for a sentence or two at a time but quickly become stodgy, stagnant, sleep-inducing … *Tarantula* is show-off stuff, and it is very interesting to discover that Dylan, for all his genius with language, is not impressive when he's just showing off.[23]

However, because it is a sustained, standalone instance of verbal collage, *Tarantula* nevertheless draws attention away from the more successful, but more fragmented occurrences of collage in Dylan's lyrics. It remains broadly uninteresting from a critical point of view, except in the sense that the freedom of experimentation he enjoyed whilst writing it may actually have enabled or led him to the kind of writing we see on *Highway 61 Revisited* and *Blonde on Blonde*. In relation to this, Dylan's recent penchant for making artworks in the form of paintings and iron sculptures, rather than collages, further submerges his earlier use of the practice. It seems plausible, however, that it is precisely because Dylan has already used collage (and at such an important juncture in his career) that he no longer feels the need to use it in his artistic ventures. Like Burroughs, Dylan progressed through and out of the collage practice, ultimately leaving it behind whilst still allowing it to inform much of his later work.

The final reason for the lack of attention thus far paid to collage in Dylan's work seems to be simply that it has slipped between the cracks of the myriad and divergent views of Dylan's fans, critics, and scholars regarding his influences, style, and methodology. As noted above, numerous writers on Dylan have come relatively closely to discussing collage in the context of their own analytical angles, but have nevertheless not yet done so, primarily because they are already focussing on something else. The result of decades of fertile critical speculation, fuelled by Dylan's own deliberate fostering of his listeners' enthralment with his variable public persona and the mystery inherent in his songs, is that a rich and complex tapestry of ideas has grown up around his work (a collage in its own

[23] Paul Williams, *Bob Dylan: Performing Artist: the Early Years (1960–1973)* (London: Omnibus Press, 1990 [2004]), 171.

right), in which it is difficult – and generally irrelevant – to assert the plausibility of one idea over another, particularly given that Dylan himself rarely endorses any of them.[24] As Thomas Jones observed:

> there are so many Dylans, or so many sides to Dylan, there isn't one right way to look at his work; rather, there are many right ways (and many wrong ways, too, foremost among which is the one founded on the idea that the songs are riddles with fixed answers, which will be revealed if only you can find the proper exegetical key).[25]

It is important to note at this juncture, therefore, that collage in the context of Dylan's work and methods is chiefly an additional useful framework through which to approach and understand them, rather than one with which to displace other arguments. It is a major and recurrent – even indispensable – element in his work, and one that opens up new vantage points on it. Dylan's fragmented selfhood – described variously as his masks, his sides, his chameleonic personality, and so on – has been thoroughly well-explored from a critical perspective (most effectively in John Hughes's recent book, *Invisible Now: Bob Dylan in the 1960s*). It therefore does not require further delving into here; suffice it to say that in addition to the lyrics of his songs of the mid-sixties, it seems to be one of the most obvious manifestations of his use of collage. As far as this book is concerned, collage and the critical concept of Dylan's dynamic or divided selfhood self-evidently relates to Burroughs's desire to conceal himself in the gaps between the fragments of his cut-up texts, to O'Hara's notion of a splintered selfhood, and to Cornell's lifelong autobiographical impulses, explored in the three previous chapters.

Collage was one of many influences on the first decade or so of Dylan's work, along with Anglo-American folk traditions, Beat writing, and the European avant-garde. In fact, it was largely because of collage that all these influences were able

24 'There's no great message', Dylan informed Horace Judson, the London correspondent for *Time*, in May 1966 (Artur, 151). To Fred Billany (London, April 1965, for the *Newcastle Evening Chronicle*; Artur, 120–21) he claimed 'I have no message for anyone. My songs are only me talking to myself'. Kermode and Spender note that with many of Dylan's songs 'the listener provides the response, brings his own meanings; he is offered no message, only mystery' ('The Metaphor at the End of the Funnel', 158). The following excerpt from an interview with Nat Hentoff, published in Playboy magazine in 1966, is indicative of Dylan's refusal to assign specific meanings to his songs:

> Dylan: I *do* know what my songs are about.
> Playboy: And what's that?
> Dylan: Oh, some are about four minutes. Some are about five. And some, believe it or not, are about eleven or twelve.
> Playboy: Can't you be a bit more informative?
> Dylan: Nope.

25 Thomas Jones, 'Forget the Dylai Lama' (review of *Dylan's Visions of Sin* by Christopher Ricks), *London Review of Books* 25, no. 21, (6 November 2003), 12.

to leave their amalgamated traces in his work to such unique and compelling effect. Dylan wrote in 'My Life in a Stolen Moment' (1962):

> I can't tell you the influences 'cause there's
> too many to mention an' I might leave one out
> An' that wouldn't be fair

In using collage, Dylan was able to be fair, and to ensure that his songs, for the most part, embodied his influences without submitting them to an aesthetic hierarchy. By its nature, as I have shown throughout this book, collage functions democratically, resisting exclusivity and insisting upon multiple perspectives which exist simultaneously. A collage framework, therefore, not only allows us to accept numerous interpretations of Dylan's approach to songwriting, but also to better understand and appreciate his magpie methodology. In the context of this book, my discussion of collage in Dylan is a sort of coda; whilst it is certainly intended to be illuminating with respect to Dylan studies, it is also included here in order to demonstrate the far-reaching nature of the collage practice itself, and to show both how much and how little collage had changed since Picasso first started experimenting with it in 1912.

Banishing the Scholar: Literary Influences and 'Desolation Row'

Dylan's use of collage is clearly related to the eclecticism of his approach to, and appreciation of, literature. His literary influences, which often make disjunctive or unlikely bedfellows, are manifested throughout his lyrics, and have been well-documented. He admitted, in an interview with Paul Robbins in 1965, vacillating between, among others, Robert Frost, Allen Ginsberg, and François Villon, before coming to the conclusion that 'poetry isn't really confined to the printed page' (he immediately rescues this statement by joking 'Hey, then again, I don't believe in saying "Look at that girl walking! Isn't that poetry?" I'm not gonna get insane about it').[26] Nicholas Roe points out, and Christopher Ricks demonstrates throughout *Dylan's Visions of Sin*, that Dylan has been critically linked with dozens of highly divergent writers and literary movements, as diverse as John Skelton, Yevgeny Yevtushenko, John Keats, Hermann Hesse, and Charles Dickens.[27] Mike Marqusee observes that 'Dylan's reading was sporadic and undisciplined, but he was a magpie, and even a casual acquaintance with Eliot, cummings, the French Symbolists, and the Surrealists left traces in his work'.[28] It is equally possible to

[26] Dylan, interview with Robbins, 113.

[27] Nicholas Roe, 'Playing Time', in *Do You, Mr Jones? Bob Dylan with the Poets and Professors*, ed. Neil Corcoran (London: Chatto & Windus, 2002), 85; Christopher Ricks, *Dylan's Visions of Sin*.

[28] Mike Marqusee, *Wicked Messenger: Bob Dylan and the 1960s (Chimes of Freedom, Revised and Expanded)* (New York: Seven Stories Press, 2005), 159.

situate him as a poet working in the Symbolist tradition, influenced by Verlaine and Rimbaud,[29] as a Beat writer in the vein of Ginsberg or Jack Kerouac (he described *On the Road* as being 'like a Bible to me',[30] and the influence of *Howl* on his mid-sixties songs is unmistakeable), or even as a collaged amalgamation of Herman Melville, Walt Whitman, Victor Hugo, Lewis Carroll, and F. Scott Fitzgerald. 'A Hard Rain's A-Gonna Fall' famously riffs on an old Scottish ballad, whilst 'Subterranean Homesick Blues' (*Bringing It All Back Home*, 1965) features a rhyme scheme first used by Browning in his 1855 poem 'Up at a Villa – Down in the City' ('sandals, candles, handles, scandals').[31] Dylan's particular interest in 'the French guys' (chiefly Symbolist writers such as Arthur Rimbaud, Stéphane Mallarmé, and Paul Verlaine, but also François Villon and Victor Hugo) began when he was in his late teens and early twenties and was the logical continuation of his discovery of contemporary American poetry: 'Ginsberg, Gary Snyder, Philip Whalen, Frank O'Hara and those guys'.[32] Dylan closely identified with the 'breathless, dynamic bop poetry'[33] of the Beats, absorbing much of his literariness from Ginsberg, as well as deliberately trying to emulate the theory behind Burroughs's cut-up technique. In addition, Kerouac scholar Dave Moore has noted that two songs in particular from *Highway 61 Revisited* ('Desolation Row' and 'Just Like Tom Thumb's Blues'), as well as the liner notes, feature several phrases which have been cut directly out of Jack Kerouac's *Desolation Angels* (published May 1965 – three months before *Highway 61 Revisited* was recorded) and collaged into the songs.[34]

Dylan's lyrics embrace a range of publicly accessible literary influences and ideas, seemingly without much critical evaluation or sense of hierarchy, which he collages into his more private, day-to-day experiences. His work shares with that of both Burroughs and Frank O'Hara the vitality and dynamism of the coterie, a key component of the collage practice. Like O'Hara in particular, he was a gregarious artist writing at the centre of a large creative group, and his most chimerical, dynamic work emerged during the mid-to-late 1960s and early 1970s, when, as Mark Ford notes, 'Dylan was king of the cats in New York, and then

[29] 'I came across one of [Rimbaud's] letters called "Je est un autre", which translates into "I is someone else". When I read those words the bells went off. It made perfect sense'. Dylan, *Chronicles*, 288.

[30] Dylan, *Chronicles*, 57.

[31] See Gray, *Song and Dance Man III*, 64.

[32] Dylan, quoted in Clinton Heylin, *Behind the Shades – Take Two* (London: Penguin, 2001 [2000]), 138.

[33] Dylan, *Chronicles*, 57.

[34] Dave Moore, 'Was Bob Dylan Influenced by Jack Kerouac?', http://www. dharmabeat.com/kerouaccorner.html#Bob Dylan influenced by Jack Kerouac [Accessed 30 July 2013]. The borrowed lyrics include 'the perfect image of a priest', 'her sin is her lifelessness', and 'Housing Project Hill'.

hanging out with the Band in Big Pink'.[35] Dylan was less comfortable within his coterie than O'Hara, however, particularly as his fame grew and he found himself increasingly commodified, mythologized, and surrounded by people who were not always what they seemed. By the mid-1960s it must have seemed, in some ways, that his coterie had somehow expanded to include the whole world. Although never as specific as Burroughs's fear that he would be 'cut in half by fiends', many of Dylan's songs betray a sense of impending dissolution, possibly indicative of a feeling that there were increasing demands to divide him up, or the notion that some of his fans would willingly tear him into fragments if they could. He appears to explore this sense of unease, and even distaste, in the carnivalesque 'Desolation Row', a macabre, satirical, acid-tinged collage of fairy tale and folklore which in many ways invokes and subverts both Hans Christian Andersen's stories and collaged screens, and Joseph Cornell's visual fantasy scenarios. Desolation Row, as a place, is an imagined reality which embodies Dylan's notion of a song as a 'composite picture of something which you can't say exists in [the artist's] mind',[36] with imagery gathered from literature, from his personal experiences, and from the flotsam and driftwood of mid-century urban American existence. At the end of the song, which features a complex network of familiar intertextual characters and role-players, from Cain and Abel and Casanova to a group of mirthful calypso singers and an agitated riot squad, the singer surveys the intricate and apocalyptic tableau and proceeds to disparage any attempt by listeners to identify these seemingly recognisable characters. They become the 'lame' sum of their component parts. Identities, with which the listener would traditionally have associated, slip irretrievably between the fissures of the extended collage scene, rearranged and renamed, by the narrator's own admission. The collaged proliferation of proper nouns within 'Desolation Row' simultaneously seduces and disorients even the most well-read listener by incorporating recognisable characters within its plane whilst holding little or no regard for their iconic status. The heightened subjectivity and acknowledgment of the quotidian as a constituent of high art made the collage practice an ideal mechanism for Dylan to convey such an expansive *galerie* of characters, both real and fictitious, with all the vitality, immediacy, and anxiety of a party. Dylan is able to give his listeners what every good party does – something they do not expect. He simultaneously strips these cultural fragments of their iconicity, whilst also elevating them to a new conceptual level. We think we know everyone at the party (as he no doubt felt he knew the members of his coterie), until we realise that the familiar figures have been distorted, so that while they still resemble their former selves they can no longer quite be identified with them. The adventurer and libertine Casanova is being spoon-fed, the Phantom of the Opera, formerly a deformed and psychologically disturbed abductor with the voice of an

[35] Mark Ford, 'Bob Dylan and the Vignette' (unpublished lecture given at 'The Seven Ages of Dylan' conference, University of Bristol, 2011).

[36] Dylan quoted in Miles, *Bob Dylan in his Own Words* (London: Omnibus Press, 1978), 65.

angel, is now 'a perfect image of a priest', whilst Cinderella is being likened to the actress Bette Davis doing something she allegedly never did (putting her hands in her back pockets – back pockets the dress-wearing Cinderella never had).

Desolation Row is, as Neil Corcoran observes, a 'place of transformation and instability where identities are misplaced, replaced, or forever lost'.[37] It is, however, this mystifying collation of rearranged faces, absurd elements melded together, and ellipses created by Dylan's judicious use of collage characteristics, that makes it such a stimulating, alluring, and disturbing locale. Here Dylan is able simultaneously to hold on to 'some integrity of personal perspective'[38] whilst also contemplating and enunciating the foolishness, complexity, savagery, and uncertainty of the world as he saw it and experienced it, articulating it, as Frank Kermode and Stephen Spender suggest, as

> a deliberate cultural jumble – history seen flat ... culture heroes of all kinds known only by their names, their attributes lost by intergenerational erosion – all of them so much unreality against the background of Desolation Row, the flat and dusty truth, the myth before the myth began.[39]

This is partly the key to Dylan's appeal: by actively employing discontinuous composition techniques, and by selecting vibrant, incongruent characters from literature, history, contemporary culture, and his own imagination and personal life experiences, he created a seductive sequence of strange, dislocated, or fragmented realities. By abolishing the differences between high and low culture, he ensured an emancipating, levelling effect. He then peopled these hallucinatory locales with collaged 'character-grotesques' through which his songs might operate, in order to perpetuate what Richard Brown identifies as the 'irresolvable enigma which is both the incitement to and perpetual frustration of readerly desire'.[40] Mark Ford suggests that Dylan's use of vignettes in this way also allowed him to blend traditional blues and rock lyrics

> with more elite art forms, in particular the collage techniques of Modernism, that is Ezra Pound and T.S. Eliot, fighting in the Captain's tower ... 'Desolation Row' can't help but summon up the ghosts of *The Waste Land*, which also operates so much through the vignette.[41]

The Waste Land (as well as several other poems by Eliot), also operates, of course, through collage, employing, as does 'Desolation Row', sustained narrative

[37] Neil Corcoran, 'Death's Honesty', in *Do You, Mr Jones?*, 163.

[38] Michael Gray, *The Bob Dylan Encyclopedia* (London: Continuum, 2006), 368.

[39] Kermode/Spender, 'The Metaphor at the End of the Funnel', in *The Dylan Companion*, 158.

[40] Richard Brown, 'Highway 61 and Other American States of Mind', in *Do You, Mr Jones?*, 206.

[41] Ford, 'Bob Dylan and the Vignette'.

discontinuity and repeated metaphoric shifts to achieve its sense of universal mockery, wonder, and dismay at the chaotic state of affairs it both embodies and depicts. Dylan's witty, dynamic, self-assured lyrics differ from Eliot's, however, in the sense that they largely resist syntactic analysis or interpretation as autonomous written texts. On account of this, the Barthesian notion of 'author-cide' seems more applicable to Dylan than to Eliot; Dylan's tangled and seemingly disordered lyrics rely more heavily for their effect upon the imaginative interpretation of the listener. The song leaves us on our own, as it were, whilst also featuring the singer as now looking into, now trapped within Desolation Row. Collage is linked to this duality, as well as to the severing of the author from the text. Whereas much of Eliot's work can actually be unlocked or better understood by greater historical, linguistic or cultural knowledge, songs such as 'Desolation Row', 'Highway 61 Revisited' or 'Visions of Johanna' better fit Barthes's definition of 'texts of bliss'. Like O'Hara's poetry, they too

> impose a state of loss ... that discomforts (perhaps to the point of a certain boredom), unsettles [our] historical, cultural, psychological assumptions, the consistency of [our] tastes, values, memories, brings to a crisis [our] relation with language.[42]

Whereas the majority of Eliot's more abstruse lines tend, ultimately, to have some kind of definable literary meaning, however well-obscured initially, Dylan's lyrics are fundamentally more mercurial, perhaps because they are set in a distinct cultural moment about which we as listeners feel we simultaneously know very little and a great deal. Eliot's work demands exegesis, whereas it would seem beside the point or wrong-headed with Dylan. Whilst characters from *The Waste Land* such as Philomel and Tiresias, for instance, have a time-honoured and fairly well-defined place in literary history (as does Eliot himself, of course), characters such as Johanna or Miss Lonely or even Cinderella in the context of Dylan's lyric – and, indeed, Dylan himself – do not. Our awareness of who they might be depends very much on a cultural or personal knowledge of the era from which they originate, and, more importantly, on our imagination. No matter how well we think we know Dylan or Dylan's coterie or the New York of 1965 or 1966, it does not ultimately matter if Edie Sedgwick was Miss Lonely or if Joan Baez was Queen Jane or if Dylan himself was Mr Jones, just as when reading O'Hara there is no need for us to know who Jap or Ashes or Janice were. Catalogues of names are, after all, 'an American abundance'.[43] As listeners to Dylan's lyric we are able – indeed required – to make our own decisions as to its nature and content. We become, in other words, a collaborative 'producer of the text'.[44] We take it on its terms and on our own, rather than, as is more often the case with Eliot's work, finding ourselves restricted to the position of academic 'consumer' of the 'well wrought

[42] Barthes, *The Pleasure of the Text*, 14.

[43] Daniel Karlin, 'Bob Dylan's Names', in *Do You, Mr Jones?*, 30.

[44] Barthes, *S/Z*, trans. Richard Miller (London: Jonathan Cape, 1975), 4.

urn', burdened by the expectation of pre-existent knowledge or the willingness to conduct research. Ambiguous turns of phrase or volatile characterisations in Dylan are given to the listener as loaded, anarchic, anti-elitist gifts, rather than as clues leading to intellectual enlightenment. Rock and roll, after all, 'romanticizes the outlaw and banishes the scholar'.[45] Dylan seems to be implying this in the rather iconoclastic fight scene in 'Desolation Row', for instance, in which the editor of *The Waste Land* fights its author in front of an amused calypso choir. As with O'Hara's poems, Burroughs's cut-ups, and Cornell's boxes, obscure references rarely detract from the overall effect of Dylan's lyrics. Instead, operating like found objects or collaged fragments whose fascination lies in both their displaced and newly-acquired meanings, they serve to enrich and enliven the song in question, even as they obscure it. Or, to paraphrase (and re-state) Jackson Pollock, too much tearing of one's hair over precise meanings ultimately serves only to detract from the experience of listening to Dylan's songs.

Artistic Influences and 'Tangled Up In Blue'

Dylan's identification of plastic art as a parallel medium to his own is also key to understanding why and how he used collage. Like Joseph Cornell, he seems to have seen connections and associations where others might have seen only boundaries. That he felt his songs and songwriting methods to be directly related to plastic art meant that using collage in his work was less a great leap of creativity than a natural, or logical, occurrence. Although plastic art does not appear to have formed a conscious part of his approach to songwriting until the mid-1970s, its influence on him and on his methods of writing is in evidence throughout much of his earlier work. We see it, for instance, in his claims during a number of performances in the 1960s that 'Love Minus Zero / No Limit' (*Bringing It All Back Home*) was a painting in silver or purple, and in his belief in the inspirational powers of Picasso ('Just think how many people would really feel great if they could see a Picasso in their daily diner'[46]). Looking back at the 1960s in *Chronicles*, Dylan writes less obliquely of his early admiration for Picasso, an artist whom he viewed as 'revolutionary' and worthy of emulation ('I wanted to be like that'), who 'had fractured the art world and cracked it wide open'.[47] Leonard Cohen called Dylan 'the Picasso of song',[48] and Paul Williams has also repeatedly linked the two. Williams asserts that Dylan 'is an artist who breaks new

[45] Yaffe, 26. To be fair to Eliot, as I explained in my previous chapter, this is not necessarily a direction that he himself had envisioned his poetry taking, and is more a comment on the New Critical approach to his work.

[46] Dylan, in an interview with Nora Ephron and Susan Edmiston, Forest Hills, New York, late summer 1965; intended for an article for *The New York Post* (Artur, 177).

[47] Dylan, *Chronicles*, 55.

[48] Quoted in *Wanted Man: In Search of Bob Dylan*, ed. James Bauldie (London: Black Spring Press, 1990), 142.

ground, over and over in his career – like Picasso, this is sometimes a function of his inventiveness, sometimes of his primitivism, and always of his integrity'.[49] Of course the resemblance between the two does not stop here. Scobie flags up 'Dylan's fondness for images of the self at one remove, the self which is itself but not quite itself'.[50] This observation recalls Picasso's notion of the shock produced at the juncture of departure and arrival, discussed in my introduction, in which 'the displaced object [enters] a universe for which it was not made and where it retains, in a measure, its strangeness'.[51] 'Tangled Up In Blue' (*Blood on the Tracks*), in particular, with its temporal shifts and disjunctive sense of looking at both the past and the present simultaneously, recalls Picasso's own 'passion for switching identities, for clever bluff and counterfeit'.[52] We find this manifested in *Still Life With Chair Caning*, for example, which compels the onlooker to view it vertically and horizontally at the same time. Arguably, 'Tangled Up In Blue' is also a subtle nod toward Picasso's Blue Period.

Dylan's desire and ability to break away from the folk idiom and write songs in a whole new way mirrors Picasso's earlier disillusionment with traditional modes of artistic representation. Just as figurative painting seemed to have lost its potency for Picasso, so the more traditional folk music, in which Dylan was initially immersed, seemed to lose its power for him. Both sought to see and to show things differently, and both gave the viewer or listener an essential and unique role as interpreter of the artwork or song, liberating them from the didacticism of figurative painting and 'finger-pointin' songs' respectively. As Mike Marqusee observes, 'Dylan's Picasso-in-the-diner Dadaism re-states Picasso's own concern to rescue the life-enhancing, perception-changing power of art from conventional representation and the polite condescension of institutions'.[53] Frank O'Hara, similarly, had attempted, in his capacity as curator at MoMA, to reconcile the vanguardism of the artists whose work he curated with its attendant commodification.

Dylan explicitly likened his compositional methods to those of a painter creating a 'composite picture of something which you can't say exists in his mind',[54] implying that he was attempting to build his songs less from the imagination than from collated snapshots of real life, which he transformed into lyrical collages. Having lost the spontaneity and ease of his first sustained period of creativity, he credited the painter and art teacher Norman Raeben, whom he first encountered in 1974, with teaching him 'how to see'; in other words, how to do deliberately what he had done so precociously almost a decade earlier. Dylan recalled: 'he put my mind and my hand and my eye together, in a way that allowed me to

[49] Williams, *Bob Dylan: Performing Artist*, 204.
[50] Scobie, 35.
[51] Gilot and Lake, 70.
[52] Taylor, *Collage*, 19.
[53] Marqusee, *Wicked Messenger*, 159.
[54] Quoted in Miles, *Bob Dylan in His Own Words*, 69.

do consciously what I unconsciously felt'.[55] He later referred to his experiences with Raeben, and the writing of *Blood on the Tracks* in particular, as his 'painting period', or his 'excursion into the world of art, you know, learning how to paint on canvas'.[56] As Carrie Brownstein notes, painting 'allowed him to play with temporality and meaning, to create shades and layers that could be understood both individually and as part of a whole'.[57] This technique is at its best in 'Tangled Up In Blue', a song that Dylan said 'took him ten years to live and two years to write'.[58] Regarding its composition, Dylan recalled:

> I wanted to defy time, so that the story took place in the present and the past at the same time. When you look at a painting, you can see any part of it, or see all of it together. I wanted that song to be like a painting.[59]

When performing it he tends to rearrange or even change the lyrics and the narrative point-of-view, indicating that collage was an essential part of its composition, as well as helping to sustain it performatively. 'Tangled Up in Blue' may not seem immediately painterly, or even particularly collage-esque, but although its autobiographic fragments do not march past the listener the way they do in 'Desolation Row', they accumulate nevertheless, and in such a way that we hear one chronological, relatively straightforward love story intersect with several other, more abstract tales, which defy chronology. Dylan, once again, creates a 'collage of experience', albeit in a different vein to the precocious juxtapositions of the mid-1960s: here he is using the collage practice to illustrate how little lived time has to do with the time of emotion and memory that continually interrupts it. Simon Armitage suggests that, from a poet's point of view, this song is 'something of a mess',[60] but the multiple layers which make it up (and which can certainly make it seem messy, from an analytical perspective) are essential components of the song's investigation into atemporality and the effects of having, as Dylan desired, 'yesterday, today and tomorrow all in the same room'.[61] The chaos which Armitage diagnoses in the writing of the song is also an important part of the singer's exploration of the implications of narrative, in which, as collagists from Ernst to Cornell had done before him, he works to deny fixed notions of time and space. The result of this is, as Aidan Day observes, 'a splitting of perspectives on the self'.[62] Significantly, Day draws attention to the song's inherent creative

[55] Bert Cartwright, 'The Mysterious Norman Raeben', in *Wanted Man*, ed. Bauldie, 87.

[56] Interview with Eliot Mintz, Los Angeles, California, March 1991 (Artur, 1096).

[57] Carrie Brownstein, '*Blood on the Tracks* (1975)', in *The Cambridge Companion to Bob Dylan*, 156.

[58] Heylin, 370.

[59] Heylin, 370.

[60] Armitage, 'Rock of Ages', in *Do You, Mr Jones?*, 123.

[61] Dylan, quoted in Cartwright, 'The Mysterious Norman Raeben', 82.

[62] Day, 57.

democracy – a key feature of the collage process, highlighted throughout this book – noting that 'the indeterminacy generated by [the song's] fragmentation about whether we are in the presence of one or more stories, encourages specific awareness of the creative role of the audience in reading or hearing narrative'.[63] Once again, we are the producers rather than merely the consumers of the text.

As a whole, 'Tangled Up In Blue' resembles a jigsaw puzzle which has been put together incorrectly, but, as with many collages, with an effective incongruity. Day has written in some depth about the 'disturbance of sequential structure' in this song, but it is necessary to briefly do so again here in order to draw attention to the importance of collage for achieving this effect.[64] The song begins with the singer wondering about his past lover, a red-haired woman who is never introduced and who remains nameless. After four lines, the lyrics cut to a memory of her parents and his, a memory that is the first in a long sequence of interrelated but logically unconnected flashbacks which stand outside chronological time. The narrator is suddenly standing in the rain, heading east, at an unspecified temporal juncture. The following verse begins with another, older memory of the couple's first meeting, before switching without warning to the end of the relationship, in a new location 'out West', where the girl prophesies that the two will one day meet again. This is followed by a narrative interlude, in which the girl becomes a memory within a memory, as the narrator moves from the chilly, north-eastern states of the U.S. to New Orleans and Delacroix. By this point in the song he has effectively covered the length and breadth of America as a consequence of his relationship with this red-haired woman. At the start of the fourth verse, temporal – and to a certain extent locational – disorder truly sets in, operating on two key levels. In one sense, the prophecy made at the end of the second verse is fulfilled: as the woman predicted, the couple meet again. And yet, at the same time, they seem very much like two people who have never met before. The question 'Don't I know your name?' operates simultaneously as a genuine question and as a flirtatious response to the persistently voluptuous gaze of a male admirer. The tension and unease at this point in the song is marked, and works to support both perspectives equally. Furthermore, it is unclear, within the context of the song, when this event took place. It could simply be sequential, taking place near Delacroix, the singer's last known whereabouts, or it could have taken place much earlier, and in fact be the very first meeting between the singer and the red-haired girl. She remarks in the following verse that the singer 'looks like the silent type' – an observation that refutes the realisation of the prophecy in its strong implication that she has never seen him before. She then hands him a book of thirteenth-century Italian poetry, which strikes such a chord with the singer that it causes him to switch pronouns, suddenly communing directly with an unannounced 'you', who might be his lost love, or his listeners, or someone else entirely. This precedes the introduction of a 'them', and a 'he', also unannounced but with whom the singer lives for a time on

[63] Day, 60.

[64] Day, 52.

a street in either New Orleans or Brooklyn, before he finally packs up his bags and starts his search all over again, simultaneously taking a new road and an old. The final verse is suffused with a sense of self-reflexive dissolution, as memories fade, friendships wane, and the singer delivers a final nod to the shifting of perspectives that has underpinned the song in its entirety: 'we just saw it from a different point of view'.

The reason why Armitage finds this song messy is that he – deliberately – approaches it from a poet's point of view, partly in order to prove the point that Dylan's lyrics are not strictly poetry. Whilst his point is a valid one, the problem with this approach is that it detracts greatly from the effects of the song, which, like O'Hara's poem 'The Day Lady Died', for instance, reveals far more when it is experienced as a whole, rather than intricately dismembered from a critical stance. Like Pollock's bed of flowers, Dylan's work is often best experienced unquestioningly rather than interpreted too closely. Dylan referred to this particular song as a painting because it is evocative of a mood and does not rely on a chronological narrative. Like *Naked Lunch*, 'Tangled Up In Blue' wastes no 'paper getting The People from one place to another'.[65] Furthermore, in its incorporation of multiple perspectives within a single plane, it is quasi-Cubist in its structure. The hypnotic regularity of the musical arrangement, carried insistently by the repetition of the song's riff, the understated but steady drumbeat, and the absence of a middle eight, is placed in apposition to the disorienting, improvisatory qualities of the lyrics, which are composed in a manner clearly characteristic of the collage practice. Dylan's use of collage in this song has evolved from that of his mid-1960s work, however, in that he is no longer using it as a means by which to cut his listeners adrift from their own expectations: although collage continues to complicate notions of authorship, it is also impossible to separate it from Dylan's own experience, made clear by his statement that the song took 'ten years to live'. As such, the listener's expectations continue to be toyed with, facilitating the ambiguity and atemporality through which we are able to appreciate the tiers of mood and meaning evoked by the song. As it had done for Burroughs in particular, the collage practice enabled Dylan to avoid, and even subvert, the requirements and limitations of straight narrative. His songs, like Cornell's boxes, are able to capture a moment in time, maintaining nonetheless a sense of timelessness, through which experiential reflection can occur.

Experiments, Experience, and 'Visions of Johanna'

In his 1991 interview with Eliot Mintz, Dylan ascribes to his work the same term that Joan Didion used to describe Burroughs's cut-ups: namely, Marshall McLuhan's notion that 'the medium is the message'.[66] Significantly, in 1965 (a

[65] Burroughs, *Naked Lunch*, 'Atrophied Preface: Wouldn't You?', 182.
[66] Interview with Mintz, 1096.

year in which he seemed to be particularly inspired by Burroughs's work, referring to it in interviews on a number of occasions), Dylan concurred when it was put to him that some of the 'accidental sentences ... imagery and anecdotes' on the liner notes to *Bringing It All Back Home* and *Highway 61 Revisited* were very similar to the writing of William Burroughs. The liner notes feature a kind of linguistically playful, disjunctive poetry, and include notably Burroughsian phrases such as 'When I speak this word *eye*, it is as if I am speaking of somebody's eye that I faintly remember ... there is no eye – there is only a series of mouths – long live the mouths' (*Highway 61 Revisited*), and 'an so I answer my recording engineer "yes, well I could use some help getting this wall in the plane"' (*Bringing It All Back Home*). Dylan affirmed that they were indeed 'cut-ups'.[67] An interesting counterpoint to this is Marianne Faithfull's recollection that when asked by a journalist to demonstrate the cut-up technique Dylan gave the impression that 'he'd never actually done it'.[68] What this suggests is that Dylan found Burroughs's cut-up method, which had caused such a stir in the literary and cultural world, to be more significant as an idea or theory than as an actual physical practice (and, indeed, this was something that Burroughs himself later came to appreciate). Earlier in 1965 Dylan had enunciated his attempts to write lyrics in the manner of Burroughs's cut-up texts:

> I put all the words down in their correct order on the paper then I tore it in four. Then I rearranged the quarters to see if I got a better song out of the jumble. I guess the rhyming didn't work out right. But it was pretty wild wondering if I was going to get a song out of it.[69]

Ultimately, as this quotation shows, Dylan accepted the logical impossibility of performing completely collaged work, and the related futility, therefore, of trying to write it: 'it gets too long or it goes too far out', he told Paul Robbins, acknowledging that, as Burroughs himself found out, faced with 'something like the cut-ups' 'the majority of the audience – I don't care where they're from, how hip they are – ... would just get totally lost'.[70] Interestingly, some of the songs recorded during *The Basement Tapes* sessions, including 'Tiny Montgomery', 'Million Dollar Bash', and 'Please, Mrs Henry' – songs which were never really intended for public consumption, or at least not initially – come closest to Burroughs's writing in terms of compelling a reassessment of the rules of reading. These songs are, as Scobie notes, 'fundamentally indecipherable within the normal rules of linguistic communication'.[71] But although, in the main, 'the rhyming didn't work out right', the theory behind the collage practice took root,

67 Interview with Ephron and Edmiston, 174.
68 Quoted in Heylin, 196.
69 London, May 1965. Quoted in Miles, *Bob Dylan in His Own Words*, 65.
70 Interview with Robbins, 118.
71 Scobie, 219.

and became, in a sense, the 'absent origin'[72] of much of Dylan's work from 1965 onwards, a significant proportion of which relies for its impact upon collage-esque methods and visual techniques.

From 'Bob Dylan's 115th Dream' and 'Desolation Row' to 'When I Paint My Masterpiece' and 'Idiot Wind', Dylan's lyrics are imbued with a sense of visual spectacle, the effect of which is that we as listeners do not just hear the songs, we also *see* them. Some of his lyrics use imagery that operates in the vein of an absurd Surrealist collage or photomontage, conjuring up a skewed version of reality in which the prosaic meets the impossible. We see this in the image of Botticelli's niece waiting in a hotel room in Rome for a date with a man from the land of Coca-Cola, in the psychedelic 'When I Paint My Masterpiece' (*Greatest Hits Vol. II*, 1971), for instance, and throughout the contemptuously slapstick 'Bob Dylan's 115th Dream' (*Bringing It All Back Home*), in which a foot appears to burst out of a telephone, a parking ticket is affixed to the mast of the Mayflower, and the protagonist of the mini-yarn is given directions to the Bowery by a stray Guernsey cow. Some songs, 'Subterranean Homesick Blues' being the most obvious example, use a fragmentary technique, which enables Dylan to evoke the entire counterculture within a few lines. This technique also recalls Apollinaire's advocacy of the use of the random elements of everyday life in art and poetry, on the basis that whilst they may be 'new in art, they are already soaked in humanity'.[73] Other songs function more abstractly, either using fragmentation in a rather cursory fashion – for instance, Dylan once referred to 'Love Minus Zero/No Limit' as 'a sort of fraction' ('Love Minus Zero *over* No Limit'[74]) – or employing images such as 'the ragman' who 'draws circles up and down the block' but who refuses to speak ('Stuck Inside of Mobile with the Memphis Blues Again', *Blonde on Blonde*). This song in particular evokes, as O'Hara's poetry also did, photographs of Jackson Pollock at work in his studio, creating looping, repetitious paintings, which documented their own conception. In a manner that further recalls O'Hara's self-scrutinising 'scene of my selves', Dylan's collage style, in songs such as 'Like a Rolling Stone' and 'Ballad of a Thin Man' (both *Highway 61 Revisited*), also enables him to explore the spectacle of self-hood and audaciously stage 'the drama of his own self-divisions'.[75] In 'Visions of Johanna' (*Blonde on Blonde*), Dylan inserts the *Mona Lisa* into the lyrics, recalling Marcel Duchamp's *L.H.O.O.Q.*[76] In this song Da Vinci's masterpiece is similarly transformed into an everyday object, or *objet trouvé*, dissevered from another context and incorporated into the tapestry

[72] Krauss, 20.

[73] Apollinaire, quoted in Rosand, 126.

[74] Newcastle, 9 May 1965, released as one of the bonus tracks on the DVD of *Don't Look Back* (1999). See Ricks, 289.

[75] Mark Ford, 'Trust Yourself: Emerson and Dylan', in *Do You, Mr Jones?*, 133.

[76] Duchamp painted a moustache on a postcard of the *Mona Lisa* and titled it *L.H.O.O.Q.*, a series of letters which when read out loud in French sound like 'elle a chaud au cul', or, in English, 'she has a hot ass'.

of popular culture. Indeed, as Aidan Day suggests, the *Mona Lisa* here seems to represent Dylan's desire to rework the established order of things from within: the 'colloquialism which defines the *Mona Lisa*'s unease – her boredom with her own status – itself constitutes an affront to and an erosion of the laws of approved respect that conventionally hem her in'.[77] This observation, and Dylan's wider usage of collage methods inherited from previous generations of iconoclasts, also clearly chimes with accounts of his behaviour during press conferences and interviews. Marqusee highlights a key factor behind Dylan's apparent flippancy when probed about a variety of issues, suggesting that when

> bombarded by obtuse, unhip, cliché questions, or often, questions that were perfectly fair but for which he simply had no answers … at times, he turned the press conference into a form of performance art … an act of protest, a Dadaist challenge to a reductive social order.[78]

Dylan's understanding of collage and its history, not just within the context of art and literature, but also social protest and individualist expression, manifests itself throughout his idiom. He used collage as part of his mission to subvert social, political, and creative expectations, and to produce what he felt to be a fitting and also challenging response both to scenarios unique to him as an increasingly commodified individual and to the wider, relatively turbulent times in which he was writing his songs. *Blonde on Blonde*, released in 1966, embodies this approach. Unsettling, exhilarating, and provocative, the album uses a subtly Surrealist language – bolstered by Dada-esque recording methods[79] – to explore, above all, the lonely dynamics of a crowd, and the difficult juncture between private emotion and public expression. Although Dylan claims that he writes songs purely for himself,[80] he is necessarily driven, as a performer, by the notion that 'without an audience, there is no message, no art'.[81] The album as a whole feels conspiratorial but also double-edged. The singer artfully reaches out to and yet simultaneously rejects the listener, evoking fear in a 'handful of rain', or suddenly, bewilderingly addressing us directly (recalling Burroughs's similarly direct address to the reader in the cut-up trilogy), or dislocating words from their common contexts and forcing the imagination to defy its own assumptions. Michael Gray argues that Dylan's language on *Blonde on Blonde*, whilst being 'Surrealistic' in the loosest sense of the word, is 'distinctly unlike that of Dalí or Magritte' because 'there is

[77] Day, 115.

[78] Marqusee, *Wicked Messenger*, 168–9.

[79] When recording *Rainy Day Women*, Dylan wanted the song to sound like a Salvation Army Band, so the musicians swapped instruments, and even took some apart altogether, disassembling the trombone or using chairs as drums. See Bob Spitz, *Dylan: A Biography* (New York: Norton, 1991 [1989]), 339.

[80] Miles, *Bob Dylan in His Own Words*, 56.

[81] Armitage, 'Rock of Ages' in *Do You, Mr Jones?*, 115.

no suggestion that the narrators in these 1966 songs stand, like Magritte, on the threshold of madness'. He continues:

> On the contrary, they are sane men surrounded by the madness and chaos of other people and other things. The Surrealistic pile-ups of imagery do not reflect the state of a narrator's (or Dylan's) psyche: they reflect the confusion which a calm and ordered mind observes around it.[82]

In fact, I would suggest, the act of calm observation and the desire to document chaos by embodying it is distinctly, even self-consciously Surrealist, as well as having roots in Synthetic Cubism. In *Blonde on Blonde* we see Dylan using collage techniques in order to embody the encounter between the rational, observant mind, attuned to its own emotions, however inexpressible they may be, and to the chaos of urban American life, as well as life as a celebrity, as he saw and was experiencing it. His songs function around him. He rarely, on this album, attempts to simply represent reality; rather, he embodies within his songs his own approach to and position regarding his version of reality. Having discarded what John Hughes describes as his 'politically viable persona, or a self circumscribed by its responsibility to others',[83] Dylan seems to use this album in particular to explore the liminal space between self-love and alienation, 'insisting on his own alienation rather than sardonically identifying it in others',[84] as he does on *Highway 61 Revisited* and *Bringing It All Back Home*. The abundant, collaged cast of characters featured in the lyrics on this record is consciously arranged in order to evoke, ironically, a sense of separateness, exposing the singer and, indeed, the individuals arranged around him, in their isolation or 'strandedness'.[85]

Character snapshots within much of Dylan's work, if treated as fragments of a collage, enable the audience to perceive how they function within the constructed reality of the song or poem, rather than as 'real' individuals or iconic characters. We have already seen this technique in operation in 'Desolation Row', on *Highway 61 Revisited*, in which the apocalyptic locale is not so much the setting as the subject of the song. To a certain extent, it is also the song's 'absent origin', in the sense that rather than actually being there, characters are more often seen going to it, peeking into it, passing through it, not thinking too much about it, stopping people from escaping to it, and being told to mail letters from it. The technique is repeated, and indeed refined, in 'Visions of Johanna', *Blonde on Blonde*'s most Surrealistic song and the one that seems to best represent the ideas explored above. In this song, the main premise is that the fragment we are continually expecting to be inserted into the disjointed narrative – the elusive Johanna – never appears. The fragments that collect around the idea of her, in her absence, ensure her power. By leaving her

[82] Gray, *Song and Dance Man III*, 144.

[83] Hughes, *Invisible Now*, 114.

[84] Hughes, *Invisible Now*, 134.

[85] Mike Marqusee, *Chimes of Freedom: The Politics of Bob Dylan's Art* (New York: The New Press, 2003), 196.

out of the song, and at the same time heavily populating it with other names and other characters, Dylan enables a sense of loneliness and isolation to underpin its ostensibly prevailing freneticism. The notion of this present absence, as I explored in my introduction, sustains the practice of collage in two important ways. Firstly, it signifies that the absence of the original fragment or idea is essential to the finished work, in order to facilitate that from which it is absent. Secondly, it highlights the concept that although the artist is avoiding directly depicting an object or idea, this object or idea exists nevertheless and, moreover, is important because of its unrepresentability. Other, subordinate fragments cluster around the suggestion of Johanna, in a lyrical manipulation of the collage technique that enables Dylan to move beyond the limitations of a straightforward paean and imbue his subject with a mercurial quality that transcends the binds of chronology.

The opening line is a rhetorical question which, coupled with the first person pronoun which follows it, draws the listener into a marginal space in which 'lights flicker', 'pipes cough', and Johanna's absence is strongly felt. Dylan also juxtaposes the quotidian (Louise, 'the all-night girls') with the iconic (the Madonna, the *Mona Lisa*) in order to evoke the eponymous, kaleidoscopic, absent heroine. The song is permeated with uncertainty, frustration, and Surrealist duplicity, in which vision is obstructed and nothing is quite as it seems: the group is trying to deny that they are stranded, ladies are playing blindman's bluff, the night watchman is driven to questioning his sanity by the girls' whisperings, the 'little boy lost' is loitering tentatively in the hallway, one of the 'jelly-faced women' has somehow lost her knees, and unbeknownst to the hapless pedlar, the countess is only 'pretending to care for him'. The fragments that, collectively, make up the song, are held at a remove from one another by the haunting half-refrain ('these visions of Johanna'), which accentuates the undeniable solitude of the singer, in contrast to the seeming proliferation of individuals around him. Looking closer, however, it becomes clear that the song is actually a collage of ghosts and illusions – akin, as Jonny Thakkar suggests, to the opening scene of *Hamlet*.[86] The 'we' in line two is ambiguous, perhaps referring to the singer and Louise, or perhaps reaching out rhetorically to the listener, or both; the 'empty lot' (recalling the 'vacant lots' of Eliot's *Preludes*) is *where* the ladies play and the girls whisper, but they do not seem to be corporeally present; 'voices echo', and even the 'electricity' is ghostly. Unnamed figures such as the 'night watchman', 'little boy lost', 'the peddler', and 'the fiddler' function metonymically as the singer himself, whilst 'the countess' might be Louise, and 'Madonna' the absent Johanna. The tenacity of the quasi-refrain – the repeated half-line at the end of each verse – further reinforces the ephemerality of the verses, embodying a variant of Clearfield's observation that in a collage 'the seams are always more interesting than whatever is on either side of them'.[87] Although the verses in this song are not necessarily less interesting than the refrain, the insistence of the repeated phrase serves to prioritise or even exalt

[86] Thakkar, 'Visions of Infinity', in *The Owl Journal* 4, no. 7 (March 2004), 20.
[87] Clearfield, 10.

it in the context of the song, continually drawing the listener's focus back to it. In this sense it operates as the collage seam holding together each transient verse or vision, and ensuring that Johanna (and the tormented singer), remained isolated from the chaotic crowdedness of the rest of the song.

'What in hell is really going on here?'

Paul Williams, writing shortly after the release of *Blonde on Blonde*, spoke for first-time Dylan-listeners everywhere when he asked 'what in hell is really going on here?'[88] The creation of this sense of bewilderment, achieved partly through the use of collage, is, of course, deliberate on Dylan's part. Collage enabled the effects that Dylan was seeking to use – illusion, misrepresentation, disguise, temporal shift and fragmented narrative. Furthermore, using collage allowed him to play on its attendant symbolism involving ellipses, fissures, intersections, and borderlines. It is not always easy to establish whether Dylan used collage deliberately; in fact it is arguable that by the mid-1960s collage had become so much a part of the zeitgeist, particularly in the context of New York City, that it would have been difficult for him *not* to use it in some form or another. However, the fragmentation of the status quo and the dismantling of the establishment were also part of the zeitgeist by the mid-1960s. As Dylan himself was playing an important role in this, it is understandable that he would have explored and addressed social, political, and personal chaos via songs written using a technique born out of political and aesthetic insurgency. It was Dylan's ambition to create a 'collage of experience', both for his listeners and for himself. This would allow him to engage intellectually and emotionally with his physical, political, and psychological environment, and to articulate his experiences in doing so. It would also facilitate his free and democratic experimentation with bringing a range of disparate phenomena into contact within the context of his songs. The fundamental appeal of the collage practice is its power to subvert expectations, and with his expansive collage of assorted characters, real and imaginary, alive and dead, making up the myriad scenes embodied in his songs, Dylan succeeds in doing so to an extraordinary degree. He is a sort of embodiment of Ezra Pound's projected 'bag of tricks', full of 'quirks and tweeks', and evidence indeed that 'the modern world needs such a rag-bag to stuff all its thoughts in'.[89]

[88] Paul Williams, 'Understanding Dylan' in *Bob Dylan – Watching the River Flow* (London: Omnibus Press, 1996), 17. Originally published in *Crawdaddy!*, in August 1966.

[89] Ezra Pound, 'Three Cantos: I', in *Poetry: A Magazine of Verse* 10, no. 3 (June 1917), 13.

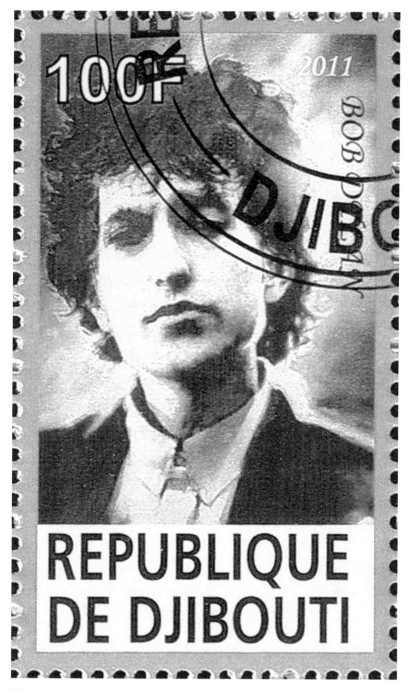

Fig. 4.1 A postage stamp printed in the Republic of Djibouti showing Bob Dylan, c. 2011.

Conclusion:
'Yield us a new thought'[1]

and who therefore ran through the icy streets obsessed with a sudden flash
of the alchemy of the use of the ellipsis the catalog the meter & the
vibrating plane,

who dreamt and made incarnate gaps in Time & Space through images
juxtaposed, and trapped the archangel of the soul between 2 visual
images

—Allen Ginsberg[2]

This book has been a study of the creative uses of fragmentation in art and
literature, and an examination of the workings of collage across different media,
showing how diverse practitioners of collage could be whilst sharing many of the
same influences. As such, I was keen that the main subjects of my study embody
this practice, and be themselves relatively divergent, using different techniques,
and moving in largely unrelated social and creative circles. This priority, as well
as more practical concerns about the length of this book, led me to occlude several
figures who also worked in collage or the collage-esque during this period and
who had close links with New York City, two of whom – Allen Ginsberg and John
Ashbery – I will discuss in more detail below. Of course, as Pierre Joris asserts,
'there isn't a 20th century art that was not touched, rethought or merely revamped
by the use of [collage]',[3] and so a degree of arbitrariness in my choice of subjects
was inevitable. Brandon Taylor's observation that 'collage looms large enough in
the annals of the New York scene to underscore virtually every achievement of
note',[4] further confirms this.

Robert Rauschenberg ('the trashcan laureate'[5]), Jasper Johns, Franz Kline,
Willem de Kooning, Lee Krasner, Ann Ryan, and Larry Rivers were among the
New York-based artists who carried collage forward through the 1950s and on into
the 1960s, helping to buoy it up in the engulfing waters of Abstract Expressionism
and Pop Art, and, as had happened previously in Europe, to enable it to extend
productively into other disciplines. Whilst Gregory Ulmer is correct to suggest that
collage had lost some of its revolutionary sheen by the 1960s,[6] this did not prevent

[1] Emerson, 'The Poet', 463.

[2] Ginsberg, *Howl*, in *Collected Poems 1947–1997* (New York: HarperCollins, 2006),
138.

[3] Joris, 86.

[4] Taylor, 106.

[5] Jonathan Jones, 'The Trashcan Laureate', *Guardian*, 15 May 2008, 23.

[6] Ulmer, 409.

it from continuing to flourish, and many artists, most notably Joe Brainard, Jess, and Romare Bearden, worked successfully in collage until late in the twentieth century. The idiosyncratic Brainard, 'painter among poets',[7] distanced himself from the seriousness and machismo of the New York art scene, and popularised the comic-strip cartoon as a collaborative medium. His delicate, intelligent, labour-intensive collages require engagement from and exchange with the viewer, and significantly, as Jenni Quilter notes, in Brainard's work 'error is seen as a trace of development rather than an imperfection'.[8] Jeff Koons, John Ashbery, Rosemary Karuga, Star Black, and Wangechi Mutu continue to work in collage. John Cage and Morton Feldman developed collage musically, Cage relishing particularly the validation of everyday minutiae: 'beauty is now underfoot wherever we take the trouble to look'.[9] In addition to Bob Dylan's trans-location of the blues and employment of collage techniques in his songwriting, George Martin and the Beatles spliced up tape, and David Bowie used the cut-up method to write lyrics, a practice which later influenced Thom Yorke and Kurt Cobain. Julio Cortázar used collage and cut-ups to write his 'counter-novel', *Hopscotch* (1963), whilst Allen Ginsberg also realised, as the quotation above indicates, the potency of 'images juxtaposed' and the facility, offered by collage, for processing and presenting real information.

Collage represented, for Ginsberg, a means of getting close to and of recreating the human consciousness. It also enabled him to find an appropriate tone in which to articulate his prophetic politics: asked about *The Fall of America: Poems of These States* (1973), he commented that the collection's purpose was 'to cover like a collage a lone consciousness travelling through these states during the Vietnam War'.[10] Indebted to Pound and to William Carlos Williams, Ginsberg felt that a poem could be

> a collage of the simultaneous data of the actual sensory situation [which] the very nature of the composition ties … together. You don't really have to have a beginning, middle, and end – all they have to do is register the contents of one consciousness during the time period.[11]

[7] Richard Deming, 'Everyday Devotions: The Art of Joe Brainard', *Yale University Art Gallery Bulletin* (2008): 82.

[8] Quilter, 'The Love of Looking: Collaborations between Artists and Writers', in *Painters and Poets: Tibor de Nagy Gallery* (New York: Tibor de Nagy, 2011), 78.

[9] Cage, 'On Robert Rauschenberg, Artist and His Work', from *Silence: Lectures and Writings*, 98.

[10] Quoted in Michael Andre, 'Levertov, Creeley, Wright, Auden, Ginsberg, Corso, Dickey: Essays and Interviews with Contemporary American Poets', unpublished doctoral dissertation (Columbia University, 1974), 146. (Source: Fred Moramarco, 'Moloch's Poet: A Retrospective Look At Allen Ginsberg's Poetry', in *American Poetry Review* 11, no. 5 (September/October 1982): 10–14, 16–18.

[11] Ginsberg, 'Improvised Poetics', in *Composed on the Tongue*, ed. Donald Allen (Bolinas: Grey Fox, 1980), 26–7.

This approach is evident in poems such as 'Wichita Vortex Sutra', in which auditory phenomena, such as snippets from the radio (*'you certainly smell good'*) and visual images ('Turn Right Next Corner / *The Biggest Little Town in Kansas'*), recorded as Ginsberg saw them, are juxtaposed with imaginary scenes ('When a woman's heart bursts in Waterville / a woman screams equal in Hanoi').[12] It is also manifest in *Howl*'s sequence of surreally juxtaposed collage-esque vignettes, whose dizzying visual, temporal, and syntactical shifts, which make up the fabric of much of the poem, give it a dynamic collage texture. This is fundamental to *Howl*'s strikingly performative nature: it extends beyond the poet and demands that the reader bear witness to the metamorphic collage actions of the 'angelheaded hipsters' and listen to the poet's attempts 'to recreate the syntax and measure of poor human prose', thus coercing a quasi-political engagement with the poem, not just as a reader of the catalogue of insanity, but also as a viewer of the succession of apocalyptic scenes, and an active listener to the poet's howl.[13]

John Ashbery: 'calculated incoherence' and a New Avant-garde

When John Ashbery made his debut as a professional artist at the age of eighty-one, exhibiting a collection of collages at the Tibor de Nagy Gallery in New York in September 2008, he confessed that he 'did the collages for amusement, without thinking anyone else would see them or be interested'.[14] In one sense, this remark is a testament to Ashbery's modesty and understatedness as an artist, but there is also more to it than that. As a poet, Ashbery has always seemed more interested in the process of writing poetry than in the poetry itself – his own work, as he said of Frank O'Hara's, is also the 'chronicle of the creative act that produced it'.[15] Furthermore, Ashbery's collages make clear his artistic debt to Joe Brainard, in whose work, as noted above, 'error is [always] seen as a trace of development rather than an imperfection'.[16] Far from being artworks which would never be seen or in which no one would be interested, Ashbery's collages, like his poems, are simultaneously an aesthetic end in themselves, and also a creative process laid bare.

Collage is something that Ashbery does, regularly, and has always done, in a sense, in his poetry. To borrow from John Yau, 'if ... you didn't suspect that [Ashbery] might be a man with a pair of scissors (along with Max Ernst, Andre Breton, Joseph Cornell, and his friend Joe Brainard), then you probably haven't

12 Ginsberg, 'Wichita Vortex Sutra', *Collected Poems*, 402–19.

13 Quotations are from *Howl*, in *Collected Poems*, 134 and 138.

14 Ashbery, quoted in Holland Cotter, 'The Poetry of Scissors and Glue', *New York Times*, 8 September 2008, http://www.nytimes.com/2008/09/14/arts/design/14cott.html [Accessed 20 June 2012].

15 Ashbery, Introduction to *The Collected Poems of Frank O'Hara*, viii-ix.

16 Quilter, 78.

read a single thing he has written'.[17] For Ashbery, collage is more than just a crucial part of his creative process: it is almost a way of life. He is an 'enthusiast who gets excited by all manner of things, from the loftiest realms of high culture to the weirdest currents of popular culture'.[18] Collage enables him to present ideas or concepts whilst resisting grandeur – he values its accessibility and democracy, its ability to keep secrets, drop hints, and provoke discussions, to play with time, and to be simultaneously the simple souvenirs of a life and also compelling works of art. Physically, his visual collages enable him to embody the pluralism he has manifested throughout his oeuvre, as well as 'the fated nature of encounter',[19] to quote Geoff Ward, with which Ashbery has always been fascinated.

Although the 2008 exhibition was Ashbery's first solo show, two of the collages shown dated back to the late 1940s, having been made when he was still a student at Harvard. As well as several pieces created with the event in mind, the exhibition also featured work dating from the 1970s, which had only been recently rediscovered. The bulk of this was made at Joe Brainard's house in Vermont, where, Ashbery recalls, 'after dinner we got in the habit of sitting around and cutting up old magazines and making collages'. Not only are several collages dedicated to Brainard, but they are, in fact, made up of old postcards and cut-out things which he had sent to Ashbery over the years.

Given the wide temporal scope of Ashbery's first exhibition, the collages displayed differed widely in terms of their content, but their style – and indeed that of the collages he has made since – possessed the same inventiveness, eclecticism, and lightness of touch which characterises his poetry. His influences as an artist and writer emerge almost as a collage in their own right: images of birds and children, superheroes and cities, Renaissance figures and cartoons encounter each other in media ranging from postcards to board games to simple scraps of paper, with the legacies of Picasso, Ernst, Schwitters, Cornell, Anne Ryan, and Brainard all in evidence. In particular, as Dan Chiasson observed in the *New York Review of Books* in 2009, 'Ashbery is spiritual cousin to Joseph Cornell, the great collector of clay pipes, pill boxes, and girls' dolls, and to the outsider artist Henry Darger, whose homemade cosmology, brilliantly embellished in watercolor and collage, influenced Ashbery's 1999 book *Girls on the Run*'.[20] Many of the collages are compellingly seamless in their composition, forcing the viewer to peer closely in order to establish the nature of the almost invisible fissures. In his juxtaposition of figures, often children, with disquieting grounds, Ashbery succeeds in evoking a

[17] John Yau, 'John Ashbery: Collages: They Knew What They Wanted', *The Brooklyn Rail*, 10 October 2008.

[18] Ibid.

[19] Geoff Ward, *Statutes of Liberty: The New York School of Poetry* (New York: St Martin's Press, 1993), 160.

[20] Dan Chiasson, 'John Ashbery: "Look, Gesture, Hearsay"', *New York Review of Books*, 9 April 2009.

kind of time-limited innocence, in which lurks the devastation and excitement of incipient knowledge.

Ashbery exhibited further collages with Tibor de Nagy in 2011. In 2013, the Loretta Howard Gallery put on an exhibition entitled *John Ashbery Collects: Poet Among Things*, which invited viewers to experience the 'living collage'[21] which is Ashbery's house in Hudson, New York. Embellishing the gallery walls with trompe-l'oeil paintings of doorframes and windowsills, and even a grand piano, curators Adam Fitzgerald and Emily Skillings made public a version of Ashbery's art-filled home, displaying pieces of vintage bric-a-brac, ceramic pots, sheet music, a flier of Sylvester the Cat speaking French, various well-loved books by Ronald Firbank, Henry James and Gertrude Stein, among others, and, of course, selected pieces from Ashbery's art collection, including work by Joe Brainard, Jane Freilicher, Alex Katz, Joseph Cornell, Willem and Elaine de Kooning, Joan Mitchell, Fairfield Porter, and Henry Darger. To call this an 'art collection', however, is to mislabel it as something far more cold and pecuniary than it is – many of these artists were or are Ashbery's friends, and as Holland Cotter observed, in his review of the show for the *New York Times*, 'it's a comfort, really, to know that, once the show's over, they'll be returning home, to resume their roles in an art-filled life that has been so much, and so movingly, of a piece'.[22] These items are less a collection, then, than a public presentation of a private life, in keeping with Ashbery's poetry, which succeeds in being simultaneously secret and well-known, incomprehensible and democratic.

Ashbery has written articulately and persuasively about numerous collagists, including Anne Ryan, E.V. Lucas and George Morrow, Max Ernst, and Kurt Schwitters, and his sustained interest in the collage process is evident in much of his poetry. His most notable and successful use of poetic collage is in his highly experimental, oppositional collection *The Tennis Court Oath*, published in 1962. *The Tennis Court Oath* was met with disapproval even by Ashbery's admirers, including Helen Vendler, who views it as an unsuccessful 'mixture of wilful flashiness and sentimentality', Marjorie Perloff, who finds the poems to be 'excessively discrete', and Harold Bloom, who argues that Ashbery 'attempted too massive a swerve away from the ruminative continuities of Stevens and Whitman'.[23] Certainly, the collection can be troubling, difficult, and obscure, but the poems are powerful in their raw experimentalism, and their embrace of

[21] Adam Fitzgerald, 'Right at Home: On John Ashbery's Hudson House and Its Collections', in *John Ashbery Collects: Poet Among Things* (online exhibition catalogue), 10–18, http://issuu.com/lorettahoward/docs/ashbery_pages_pages_issufinal [Accessed 15 April 2014].

[22] Holland Cotter, 'John Ashbery Collects': 'Poet Among Things', *New York Times*, 25 October 2013.

[23] Helen Vendler, 'Understanding Ashbery', *The New Yorker* (16 March 1981), 114–36; Marjorie Perloff, 'Fragments of a Buried Life', in Lehman, *Beyond Amazement: New Essays on John Ashbery* (Ithaca and London: Cornell University Press, 1980), 78; Harold Bloom, *John Ashbery* (New York: Chelsea House, 1985), 50.

an Emersonian state of flux and an alternative interpretation of what it means to be avant-garde. As Frank O'Hara announced, having apparently found himself brought almost to hysteria by it, it is 'a work of desperate genius'.[24] The poems in *The Tennis Court Oath* subvert readerly expectations of poetry, demanding, in their ellipses, missing words, swift transitions, disjunctive syntax, partial erasure and illogical constructions, that the reader find ways of understanding his work other than straightforward or traditional critical analysis, eschewing New Critical-style 'symbol-hunting'.[25] In a 1983 interview with *Paris Review*, Ashbery recalled the process of publishing *The Tennis Court Oath*:

> I didn't expect to have a second book published, ever. The opportunity came about very suddenly, and when it did I simply sent what I had been doing. But I never expected these poems to see the light of day. I felt at that time that I needed a change in the way I was writing, so I was kind of fooling around and trying to do something I hadn't done before.[26]

Many of the poems in the collection, then, are chronicles of their own creative acts, and Ashbery seems to ask that the reader of his work give precedence to the same principle to which he adheres as a writer – namely, to value the *processes* of reading and attempting to understand over any definitive answers that the poetry may or may not yield. The collection also, despite manifest associations with avant-garde art techniques, succeeds in situating itself at a remove from the movements – including Dada, Surrealism and Abstract Expressionism – which generated them. Harold Bloom lamented that the collection was an exercise in 'calculated incoherence',[27] but imaginatively the poetry is relatively straightforward, if one is prepared to accept 'that the imagination is not an inward quality in search of expression, but, rather, an event that occurs when perception contacts the world with the force of desire in the form of words or paint or sounds'.[28]

The collection, whose unique meditative qualities are merged with noticeable affinities with Duchamp's readymades and found objects, and with the deliberate erasure practised by Jasper Johns, Robert Rauschenberg, and Willem de Kooning, requires that the reader actively contribute to the poetry in a non-traditional way. Given the absence of any internal explanation on Ashbery's part, and the use, throughout the text, of the word 'I' as a verbal found object rather than as an expression of character or direct opinion, the reader must provide their own

[24] Frank O'Hara (9 March 1962), quoted in Epstein, *Beautiful Enemies*, 241.

[25] Lehman, 157.

[26] John Ashbery, 'The Art of Poetry No. 33', interviewed by Peter A. Stitt, *Paris Review* 90 (Winter 1983), 30–60.

[27] Harold Bloom, 'The Charity of the Hard Moments', in *John Ashbery*, ed. Harold Bloom (New York: Chelsea House, 1985), 53.

[28] Donald Revell, 'Purists Will Object: Some Meditations on Influence', in *The Tribe of John: Ashbery and Contemporary Poetry*, ed. Susan Schultz (Tuscaloosa: University of Alabama Press, 1995), 91–100.

flexible interpretations of the work, taking into account the significance of ellipses, the poetry's auditory qualities, and the possibilities engendered by the fissures which run throughout the text. As in his visual collages, the collection's success is in its 'distribution of the elements of discontinuity so that they are just held in balance, or framed, by the fewest necessary cohesive elements'.[29]

Ashbery's view on Surrealism fell in line with that of Henri Michaux, the painter and poet whom he interviewed in 1961, who observed that the movement gave to writers and artists 'la grande permission'. In other words, as Ashbery wrote, its significance lay in 'the permission [the Surrealists] gave everybody to write whatever comes into their heads'.[30] Notwithstanding, he maintained a certain distance from the European avant-garde, downplaying its influence on his work, primarily because, as David Sweet suggests, 'to be avant-garde in the wake of the radical Avant-Garde is to have a kind of perverse recourse to tradition, illusionism, and obsolete form'.[31] Ashbery also pointed out that

> What has in fact happened is that Surrealism has become a part of our daily lives: its effects can be seen everywhere, in the work of artists and writers who have no connection with the movement, in movies, interior decoration, and popular speech. A degradation? Perhaps. But it is difficult to impose limitations on the unconscious, which has a habit of turning up in unlikely places.[32]

Sweet suggests that Ashbery, in the 1960s, sought a new 'true Avant-Garde' which 'only properly exists in a condition of cultural tenuousness: unconsolidated and largely unrecognized'.[33] His observation chimes with Ashbery's own disparaging remarks about Grove Press's exhortations on subway posters to 'join the "Underground generation" as though this were as simple a matter as joining the Pepsi generation'.[34] *The Tennis Court Oath* embodies Ashbery's refusal to ascribe fixed meanings to his poems, and thereby place limitations on the unconscious, either his own or that of his readers; and as such the collection is a model of an uncircumscribed avant-garde poetic.

The second poem in the collection, 'They Dream Only of America', exemplifies Ashbery's use of collage in *The Tennis Court Oath*, and also, in direct relation to this, the sense that Andrew Epstein has of Ashbery as 'a pragmatist, tolerant of infinitely multiple perspectives, who sees life as an often baffling struggle with randomness and contingency, where human experience consists of limited and

[29] David Shapiro, *John Ashbery: An Introduction to the Poetry* (New York: Columbia University Press, 1979), 61.

[30] Ashbery, *Reported Sightings*, 398.

[31] David Sweet, '"And Ut Pictura Poesis Is Her Name": John Ashbery, the Plastic Arts, and the Avant-Garde', *Comparative Literature* 50, no. 4 (Autumn 1998): 319.

[32] Ashbery, 'In the Surrealist Tradition', *Reported Sightings*, 4.

[33] Sweet, 230.

[34] Ashbery, 'Writers and Issues: Frank O'Hara's Question', 81.

always provisional attempts to cope with and adjust to changing circumstances'.[35] Like Bob Dylan's 'Tangled Up in Blue', and Ginsberg's *Howl* and 'Wichita Vortex Sutra', this poem is both a multi-layered assemblage of stories and a quasi-nomadic collage of America. Its illusions, misrepresentations, disguises, temporal shifts, and unstable roles invite a multiplicity of interpretations. Some read it as a tale of two gay fugitives waiting 'for our liberation',[36] others as a Twain-esque murderer and child 'hiding from darkness in barns';[37] it could even be read as a more conventional Beat-style trip taken by a pair of lovers. Of course, even if one accepts the possibility of these multiple narratives, one is still circumscribing oneself within the limitations of chronological story-telling, which this poem, in its unstable, mercurial lyricism seems to be striving to undermine. As Ashbery remarked in the *Paris Review* interview:

> Things are in a continual state of motion and evolution, and if we come to a point where we say, with certitude, right here, this is the end of the universe, then of course we must deal with everything that goes on after that, whereas ambiguity seems to take further developments into account.[38]

'They Dream Only of America' begins with an unidentified personal pronoun ('They dream only of America'), which is repeated in the second stanza ('They can be grownups now'), before transitioning into an also unidentified 'he', which then segues into 'we', then 'I', and, finally, 'you'. The collaging of multiple identities in this way prevents the reader from interpretively using the numerous poetic symbols which, self-reflexively, punctuate the poem ('Was the cigar a sign? / And what about the key?'). The poem advocates a suspicion of symbols, highlighting the worthlessness of symbolism for symbolism's sake, and illustrating the futility of a symbol if we cannot tell to whom or to what it refers. David Herd points out that Ashbery goes so far as to suggest that an uninhibited fondness for symbols may even be dangerous, noting that the 'delicious' honey 'burns the throat', that the carefree drive 'at night through dandelions' causes a headache, and that the final seduction by 'cigar' and 'key' results in a broken leg:

> Whenever the speaker seems to be growing too fond of signs and symbols – at each point at which they seem in danger of preoccupying him – he receives a painful reminder that such fondness is inappropriate, dangerous even, insofar as it causes one to neglect the reality of the situation.[39]

[35] Epstein, *Beautiful Enemies*, 133.

[36] John Shoptaw, *On the Outside Looking Out* (Cambridge: Harvard University Press, 1994), 65–6.

[37] Alan Williamson, *Introspection and Contemporary Poetry* (Cambridge: Harvard University Press, 1984), 121–2.

[38] Ashbery, 'The Art of Poetry' (No. 33), *Paris Review* 90 (Winter 1983), 46.

[39] David Herd, *John Ashbery and American Poetry* (Manchester: Manchester University Press, 2000), 85.

However, the fact that the poem is full of discontinuously employed poetic symbols, that rear incongruously up out of the collage syntax, indicates that Ashbery both acknowledges and understands our love of and need for them, as well as his own, both in poetry and in life. He knows what it is to 'care only about signs', and seems to suggest, in the lines – 'There is nothing to do /For our liberation, except wait in the horror of it' – an awareness that the writing and reading of this new, oppositional kind of poetry is difficult and painful, but that it requires patience and a willingness to absorb rather than methodically collect meanings. The uncertainty and discontinuity in the poem, expedited by the collage form and manifested in broken syntax, rejection of metaphor, demarcated fragments of speech, and incongruous adverbs, prevents rhythm from building, or acceleration from taking place Although the words in the poem unilaterally indicate flight either to or from something undefined, ultimately the poem itself, detached from verbal meanings, embodies an impulse to pause and wait. This is typical of Ashbery's larger preoccupation with the relationship between stasis and motion: after all, he ends his poem 'The Bungalows', from *The Double Dream of Spring*, with the lines:

> For standing still means death, and life is moving on,
> Moving on towards death. But sometimes standing still is also life.[40]

Ashbery seems, in 'They Dream Only of America', in *The Tennis Court Oath*, and in his visual collages, to be attempting to combine together the 'self-abnegating'[41] creative methods of Surrealism with the ruminative styles of Baudelaire, Eliot, or even Joseph Cornell, in which fleeting intersections create constellations of imagery which can, but are not necessarily required to represent anything beyond themselves. In spite of the affiliations of his poetry to Dada and Surrealism, Ashbery rejects his role as the successor of an avant-garde which had been undone by its own success, and which had, as a result, become mainstream; instead he creates his own avant-garde, which may be 'unconsolidated and largely unrecognized',[42] which may run the gamut of being labelled calculatedly incoherent, but whose main achievement is to resist solitary posturing, didacticism, and the urge to provide a definitive poetic or aesthetic statement. As Ashbery remarked in 'The Invisible Avant-Garde', published in ARTnews in 1968, 'artists are no fun once they have been discovered'.[43]

[40] John Ashbery, 'The Bungalows', from *The Double Dream of Spring* (New York: Dutton, 1970).

[41] Sweet, 325.

[42] Sweet, 320.

[43] John Ashbery, 'The Invisible Avant-Garde', *ARTnews Annual*, October 1968.

Fig. C.1 John Ashbery. *The Mail in Norway*, 2009. Collage, digitized print,
16 ¼ x 16 ¼ inches. Courtesy Tibor de Nagy, New York.

Encompassing the Aesthetic Universe

Alfred Leslie asserted that his 1964 film, *The Last Clean Shirt*, should provoke
the question: '"What the fuck is going on?"' because, 'to most people, reality
is nothing more than a confirmation of their expectations'.[44] Expectations of
collage are that it is strictly flat, one-dimensional, and limited to the realm of
plastic art, but the reality is quite different, often provoking, on the part of the
viewer, reader or listener, precisely Leslie's question. This is its fundamental
appeal: in and of itself, it subverts expectations and alters our perception of

[44] Quoted in Daniel Kane, *We Saw the Light: Conversations between the New
American Cinema and Poetry* (Iowa City: Iowa University Press, 2009), 96.

reality. I began this book by showing that the tendency to circumscribe the art of collage within the limited sphere of cut-and-paste is misleading. Collage is a practice which demands a multiplicity of approaches: to delineate it stringently as either one thing or another is to severely limit our understanding of the work of the artists, writers, and musicians who came to use it in a non-traditional way. In part, this is the reason for the lack of attention thus far devoted to collage in the work of Joseph Cornell, William Burroughs, Frank O'Hara, and Bob Dylan. It is also why, in spite of the considerable amount of existing scholarship on collage as a plastic art form, relatively little work has been carried out relating to the interdisciplinary aspects of the practice. However, as I hope I have illustrated, a view of collage that is as open and adaptable as the collage practice itself, enables the critic not only to appreciate the multiple ways in which it operates as an art form, but to also insert into its history individuals who might not otherwise have taken up their place there.

For Cornell, Burroughs, O'Hara, and Dylan, as for many other twentieth-century artists, writers, and musicians from Picasso to Ashbery to Bowie, in spite of their very different personalities and creative output, encountering collage had a catalytic effect, enabling each to overcome a crisis in representation that threatened to destabilize their work. Cornell, who felt convinced that he was an artist and yet was hampered by his inability to draw or paint, used collage to gain access to the art world and to show what he was capable of creating given the right medium. For Burroughs, his formal, organisational problems with linear composition were turned to his advantage by his use of collage, which enabled him to move beyond requirements for narrative and chronology; collage is also a key tool for readers approaching his cut-up novels. For O'Hara, collage provided a means of writing poetry that navigated an effective path between plastic art and literature, enabling him to choose the facets of each which best suited his compositional style and what he wanted to say. Dylan was able to use collage to uniquely enunciate his brand of social commentary whilst also succeeding in discovering new possibilities within a genre that apparently had no more to give.

Part of the problem with existing work on collage in Cornell, Burroughs, O'Hara, and Dylan is that it fails to situate them within the wider context of the evolution of twentieth-century collage, tending to treat their uses of collage in isolation, which limits its impact and has the effect of blinkering the reader's understanding of what they were doing and why it was important. Collage changed not just the ways in which art is made, but also the ways in which viewers approach art, giving them a newly subjective and interactive role to play, and simultaneously abolishing the notion of a single approach or solution to any given piece of art, writing, or music. It had a similar effect on literature, changing the reading experience by allowing the author to abdicate his or her role as absolute arbiter of meaning, making the process of reading and interpreting more fluid, more subjective, more experiential, and bringing it closer to art. Collage can be seen as both an assault on the reader or viewer,

and as an invitation to participate in the artwork or text's plastic or conceptual processes. Either way, it is an invitation to engage, rather than to look or to read in passivity. Whilst historically the pasting to paper of miscellaneous items is, of course, a key part of the collage practice, it evolved, from 1912, to encompass the artist or writer or musician's emotional and intellectual relationship with their aesthetic universe, which includes not just whatever it is that constitutes their work, but also the individuals who will, collectively, come to interpret it, and to whom, as a result, a 'new thought' is yielded.[45]

[45] Emerson, 'The Poet', 463.

Bibliography

Altieri, Charles. *Enlarging the Temple: New Directions in American Poetry During the Sixties*. Lewisburg: Bucknell University Press, 1979.

Andre, Michael. 'Levertov, Creeley, Wright, Auden, Ginsberg, Corso, Dickey: Essays and Interviews with Contemporary American Poets'. Unpublished doctoral dissertation (Columbia University), 1974.

Ansen, Alan. 'Whoever Can Pick Up A Frying Pan Owns Death'. In *The Burroughs File*, by William Burroughs, 17–23. San Francisco: City Lights Books, 1991 (1984).

Antin, David. 'Modernism and Post-Modernism: Approaching the Present in American Poetry'. *boundary 2* 1, no. 1 (1972): 98–133.

Aragon, Louis. *Les Collages*. Paris: Hermann, 1980 (1965).

Armitage, Simon. 'Rock of Ages'. In *Do You, Mr Jones? Bob Dylan Among the Poets and Professors*, edited by Neil Corcoran, 105–26. London: Chatto & Windus, 2002.

Artur, *Every Mind Polluting Word: Assorted Bob Dylan Utterances*. Don't Ya Tell Henry Publications. http://content.yudu.com/Library/A1plqd/Bob DylanEveryMindPol/resources/914.htm [Accessed August–December 2013].

Ashbery, John. 'The Art of Poetry No. 33'. *Paris Review* 90 (Winter 1983): 30–60.

———. *The Double Dream of Spring*. New York: Dutton, 1970.

———. 'The Invisible Avant-Garde', *ARTnews Annual*, October 1968.

———. *Houseboat Days*. New York: Penguin, 1979.

———. *Reported Sightings*, edited by David Bergman. New York: Knopf, 1989.

———. *Selected Prose*. Manchester: Carcanet, 2004.

———. 'Writers and Issues: Frank O'Hara's Question'. *Bookweek*, 25 September 1966.

'Authors Disappointed with Edinburgh Conference'. *Times*, 24 August 1962.

Ballard, J.G. 'Terminal Documents'. *Ambit* 27 (1966): 46.

Banash, David. 'From Advertising to the Avant-Garde: Rethinking the Invention of Collage'. *Postmodern Culture* 14, no. 2 (2004): 5.

Barr Jr, Alfred H., *Fantastic Art Dada Surrealism*. New York: The Museum of Modern Art, 1936.

Barthes, Roland. *Image, Music, Text*, edited by Stephen Heath. London: Fontana, 1977.

———. *The Pleasure of the Text*, translated by Richard Miller. London: Jonathan Cape, 1976.

———. *S/Z*, translated by Richard Miller. London: Jonathan Cape, 1975.

Bauldie, John, ed. *Wanted Man: In Search of Bob Dylan*. London: Black Spring Press, 1990.

Beiles, Sinclair, William Burroughs, Gregory Corso and Brion Gysin. *Minutes to Go*. Paris: Two Cities, 1960.

Belgrad, Daniel. *The Culture of Spontaneity: Improvisation and the Arts in Postwar America*. Chicago: University of Chicago Press, 1998.

Bellow, Saul. *Seize the Day*. London: Penguin, 2006 (1956).

Berkson, Bill and Joe LeSueur. *Homage to Frank O'Hara*. Bolinas: Big Sky, 1978.

Bigsby, Christopher, ed. *The Cambridge Companion to Modern American Culture*. Cambridge: Cambridge University Press, 2006.

Blair, Lindsay. *Joseph Cornell's Vision of Spiritual Order*. London: Reaktion Books, 1998.

Blasing, Multu Konuk. *Politics and Form in Postmodern Poetry: O'Hara, Bishop, Ashbery, and Merrill*. Cambridge: Cambridge University Press, 1995.

Blesh, Rudi and Harriet Janis. *Collage: Personalities, Concepts, Techniques*. New York: Chilton, 1962.

Bloom, Harold. *The Anxiety of Influence: A Theory of Poetry*. 2nd Edition. Oxford: Oxford University Press, 1997.

———. *John Ashbery*. New York: Chelsea House, 1985.

Bois, Yve-Alain and Rosemary Krauss. *Formless*. New York: Zone Books, 1997.

Bourdon, David. 'Enigmatic Bachelor of Utopia Parkway'. *Life*, 15 December 1967, 63–66a.

Brady, Andrea. 'Distraction and Absorption on Second Avenue'. In *Frank O'Hara Now: New Essays on the New York Poet*, edited by Robert Hampson and Will Montgomery, 59–69. Liverpool: Liverpool University Press, 2010.

Brainard, Joe. *I Remember*. New York: Granary Books, 2001 (1975).

Breslin, James E.B. *From Modern to Contemporary: American Poetry, 1945–1965*. Chicago: University of Chicago Press, 1984.

Breton, André. *Entretiens 1913–1952*. Paris: Gallimard, 1952.

———. 'First Manifesto of Surrealism'. In *Art in Theory 1900–2000: An Anthology of Changing Ideas*, edited by James Gaiger, Charles Harrison and Paul Wood, 452. Oxford: Blackwell, 2002.

———. *Mad Love (L'Amour fou)*, translated by Mary Ann Caws. Lincoln: University of Nebraska Press, 1987.

———. 'Second Surrealist Manifesto'. *La Révolution surréaliste* 12, Paris, 15 December 1929, 1–17.

Brockelman, Thomas. *The Frame and the Mirror: On Collage and the Post Modern*. Evanston, IL: Northwestern University Press, 2001.

Brooks, Cleanth and Robert Penn Warren. *Understanding Poetry: An Anthology for College Students*. New York: H. Holt and Company, 1938.

Brown, Merle. 'Poetic Listening'. *New Literary History* 10, no. 1 (1978): 125–39.

Brown, Richard. 'Highway 61 and Other American States of Mind'. In *Do You, Mr Jones? Bob Dylan with the Poets and Professors*, edited by Neil Corcoran, 193–220. London: Chatto & Windus, 2002.

Brownstein, Carrie. '*Blood on the Tracks* (1975)'. In *The Cambridge Companion to Bob Dylan*, edited by Kevin J.H. Dettmar, 155–9. Cambridge: Cambridge University Press, 2009.

Bürger, Peter. *Theory of the Avant-Garde*, translated by Michael Shaw. Manchester: Manchester University Press, 1984.

Burgess, Anthony. *The Novel Now: A Student's Guide to Contemporary Fiction.* London: Faber, 1967.

———. '"On the End of Every Fork" – review of The Naked Lunch'. *Guardian*, 20 November 1964.

Burroughs, William S. 'The Art of Fiction No. 36'. *Paris Review* 35 (Fall 1965): 30.

———. *The Burroughs File*. San Francisco: City Lights, 1991 (1984).

———. 'The Cut Up Method'. In *The Moderns: An Anthology of New Writing in America*, edited by LeRoi Jones, 345–8. London: MacGibbon & Kee, 1965.

———. 'The Cut-Up Method of Brion Gysin'. In *A Casebook on the Beat*, edited by Thomas Parkinson, 105–6. New York: Crowell, 1961.

———. *Dead Fingers Talk*. London: Tandem, 1970 (1963).

———. *The Electronic Revolution*. Bonn: Expanded Media Editions, 1970.

———. *The Job: Interviews with William Burroughs by Daniel Odier*. London: Jonathan Cape, 1970.

———. *Junky*. London: Penguin, 2002 (1953).

———. *Junky: The Definitive Text of Junk*, edited by Oliver Harris. London: Penguin, 2003 (1953).

———. 'Letter from a Master Addict on Dangerous Drugs'. *British Journal of Addiction to Alcohol and Other Drugs* 53, no. 2 (1957): 119–32.

———. *Naked Lunch: The Restored Text*, edited by James Grauerholz and Barry Miles. London: Harper Perennial, 2005 (1959).

———. *Nova Express*. London: Granada, 1978 (1964).

———. *Queer*, edited by Oliver Harris. London: Penguin, 2011 (1985).

———. *The Soft Machine*. London: Paladin, 1986 (1961).

———. *The Ticket That Exploded*. London: Paladin, 1987 (1962).

Burroughs, William S. and Allen Ginsberg. *The Yage Letters: Redux*, edited by Oliver Harris. San Francisco: City Lights Books, 2006 (1963).

Burroughs, William S. and Brion Gysin. *The Third Mind*. London: John Calder, 1979.

Burroughs, William S. and Eric Mottram. 'Interview with Eric Mottram, London 1964'. In *Burroughs Live: The Collected Interviews of William S. Burroughs 1960–1997*, edited by Sylvère Lotringer, 54–9. Los Angeles: Semiotext(e), 2001.

Burroughs, William S. and Felix Scorpio. 'Tactics of Deconditioning'. Interview with Felix Scorpio, London 1969. In *Burroughs Live: The Collected Interviews of William S. Burroughs 1960–1997*, edited by Sylvère Lotringer, 116–25. Los Angeles: Semiotext(e), 2001.

Burroughs: The Movie. Directed by Howard Brooker. Giorno Poetry Systems, 1983.

Cage, John. *Silence: Lectures and Writings.* Middletown: Wesleyan University Press, 1961.

Calder, John. 'Looking Ahead' (2005). *Textualities.* http://textualities.net/john-calder/looking-ahead [Accessed 21 March 2012].

Campbell, James. 'Review of Rub Out the Words: the Letters of William Burroughs 1959–1974'. *Guardian*, 23 March 2012.

———. 'Scenes from the Early Life of William Burroughs'. *The Threepenny Review* 75 (1998): 10–12.

Carroll, Paul. *The Poem In Its Skin.* Chicago: Follet Publishing Co., 1968.

Cartwright, Bert. 'The Mysterious Norman Raeben'. In *Wanted Man: In Search of Bob Dylan*, edited by John Bauldie, 85–90. London: Black Spring Press, 1990.

Caws, Mary Ann, ed. *Joseph Cornell's Theatre of the Mind: Selected Diaries, Letters and Files.* London and New York: Thames & Hudson, 1993.

Chalk, Martyn. *Missing, Presumed Destroyed: Seven Reconstructions of Lost Works by V.E. Tatlin.* Kingston-upon-Hull: Ferens Art Gallery, 1981.

The Chambers Dictionary. Edinburgh: Chambers, 1999.

Chiasson, Dan. 'John Ashbery: "Look, Gesture, Hearsay"', *New York Review of Books*, 9 April 2009.

Christgau, Robert. 'Tarantula'. *The New York Times Book Review*, 27 June 1971. Reprinted in *The Dylan Companion*, edited by Elizabeth Thomson and David Gutman, 139–43. London: Macmillan, 1990.

Clearfield, Andrew. *These Fragments I Have Shored: Collage and Montage in Early Modernist Poetry.* Ann Arbor: UMI Research Press, 1984.

Conley, Tom. 'Vigo Van Gogh'. In *Collage*, edited by Jeanine Parisier Plottel, 153–66. New York: New York Literary Forum, 1983.

Corcoran, Neil. 'Death's Honesty'. In *Do You, Mr Jones? Bob Dylan with the Poets and Professors*, edited by Neil Corcoran, 143–74. London: Chatto & Windus, 2002.

———, ed. *Do You, Mr Jones? Bob Dylan with the Poets and Professors.* London: Chatto & Windus, 2002.

Cotter, Holland. 'John Ashbery Collects': 'Poet Among Things', *New York Times*, 25 October 2013.

———. 'The Poetry of Scissors and Glue'. *New York Times*, 8 September 2008.

Crase, Douglas and Jenni Quilter. *Painters and Poets: Tibor de Nagy Gallery.* New York: Tibor de Nagy, 2011.

Crotty, Patrick. 'Bob Dylan's Last Words'. In *Do You, Mr Jones? Bob Dylan with the Poets and Professors*, edited by Neil Corcoran, 307–33. London: Chatto & Windus, 2002.

Dalí, Salvador. 'L'Âne pourri'. *Le Surréalisme au service de la Révolution* 1 (1930): 9–12.

Day, Aidan. *Jokerman: Reading the Lyrics of Bob Dylan.* Oxford: Blackwell, 1989.

Deming, Richard. 'Everyday Devotions: The Art of Joe Brainard'. *Yale University Art Gallery Bulletin* (2008): 75–87.

———. 'Naming the Seam: On Frank O'Hara's "Hatred"'. In *Frank O'Hara Now: New Essays on the New York Poet*, edited by Robert Hampson and Will Montgomery, 131–43. Liverpool: Liverpool University Press, 2010.

d'Harnoncourt, Anne. 'The Cubist Cockatoo: A Preliminary Exploration of Joseph Cornell's Homages to Juan Gris'. *Philadelphia Museum of Art Bulletin* 74, no. 321 (1978): 2–17.

Didion, Joan. 'Wired for Shock Treatments: Review of The Soft Machine'. *Bookweek*, 27 March 1966, 2–3.

Digby, John and Joan Digby. *The Collage Handbook*. London and New York: Thames & Hudson, 1985.

Diggory, Terence. 'Community "Intimate" or "Inoperative": New York School Poets and Politics from Paul Goodman to Jean-Luc Nancy'. In *The Scene of My Selves: New Work on the New York School Poets*, edited by Terence Diggory and Stephen Miller, 13–32. Orono, ME: National Poetry Foundation, 2001.

Diggory, Terence and Stephen Miller. *The Scene of My Selves: New Work on the New York School Poets*. Orono, ME: National Poetry Foundation, 2001.

Dimakopolou, Stamatina. 'Nostalgia, Reconciliation and Critique in the Work of Joseph Cornell'. In *Joseph Cornell: Opening the Box*, edited by Jason Edwards and Stephanie L. Taylor, 205–18. Oxford: Peter Lang, 2007.

Dos Passos, John. *Manhattan Transfer*. London: Penguin Classics, 2000 (1925).

Drudi Gambillo, Maria and Teresa Fiori. *Archivi del Futurismo*, translated by Marjorie Perloff. Vol. 1. Rome: de Luca, 1958.

Dylan, Bob. *Blonde on Blonde*. 1966.

———. *Blood on the Tracks*. 1975.

———. *Bringing It All Back Home*. 1965.

———. *Chronicles: Volume One*. London: Simon & Schuster, 2004.

———. *Highway 61 Revisited*. 1965.

———. *Lyrics 1962–2001*. London: Simon & Schuster, 2006.

'Edinburgh Writers Conference'. Edinburgh: Unpublished transcript/tape recordings held by The British Library (1962). (Series Identifier: NP550WR-NP561W (audio); 11881.g.1 (transcript).

Edwards, Jason. 'Coming out as a Cornellian'. In *Joseph Cornell: Opening the Box*, edited by Jason Edwards and Stephanie L. Taylor, 25–44. Oxford: Peter Lang, 2007.

Edwards, Jason and Stephanie L. Taylor, eds. *Joseph Cornell: Opening the Box*. Oxford: Peter Lang, 2007.

Elderfield, John. *Kurt Schwitters*. London and New York: Thames & Hudson, 1985.

Eliot, T.S. *Four Quartets*. London: Faber & Faber, 1944.

———. 'London Letter'. *The Dial*, May 1922, 510–13.

———. *The Sacred Wood*. London: Faber, 1997 (1920).

————. *The Use of Poetry and the Use of Criticism*. Cambridge: Harvard University Press, 1933.

Elledge, Jim, ed. *Frank O'Hara: To Be True to a City*. Ann Arbor: University of Michigan Press, 1990.

Emerson, Ralph Waldo. *The Collected Works of Ralph Waldo Emerson (Vol IV), Representative Men: Seven Lectures*, edited by Wallace E. Williams. Cambridge: Harvard University Press, 1987.

————. *Essays and Lectures*. New York: Library of America, 1983.

Epstein, Andrew. *Beautiful Enemies: Friendship and Postwar American Poetry*. Oxford: Oxford University Press, 2006.

Ernst, Max. 'Au-delà de la peinture'. In *Écritures*, 256. Paris: Gallimard, 1970 (1936).

————. *Beyond Painting*. New York: Wittenborn, Schultz, 1948.

————. *La femme 100 têtes; Une semaine de bonté*. Zweitausendeins: Frankfurt am Main, 1963.

Feigen, Ronald, Howard Hussey and Donald Windham. *Joseph Cornell: Collages 1931–1972*. New York: Castelli Feigen Corcoran, 1978.

Ferguson, Russell. *In Memory of My Feelings: Frank O'Hara and American Art*. Berkeley: University of California Press, 1999.

Fiedler, Leslie. *Love and Death in the American Novel*. New York: Criterion Books, 1960.

Fitzgerald, Adam. 'Right at Home: On John Ashbery's Hudson House and Its Collections', in *John Ashbery Collects: Poet Among Things* (online exhibition catalogue), 10–18. http://issuu.com/lorettahoward/docs/ashbery_pages_pages_ issufinal [Accessed 15 April 2014].

Ford, Mark. 'Bob Dylan and the Vignette' (unpublished lecture given at 'The Seven Ages of Dylan' conference, University of Bristol, 2011).

————. 'Trust Yourself: Emerson and Dylan'. In *Do You, Mr Jones? Bob Dylan with the Poets and Professors*, edited by Neil Corcoran, 127–42. London: Chatto & Windus, 2002.

Foucault, Michel. *Surveiller et Punir: Naissance de la Prison*. Paris: Gallimard, 1975.

Gaiger, James, Charles Harrison and Paul Wood. *Art in Theory 1900–2000: An Anthology of Changing Ideas*. Oxford: Blackwell, 2002.

Gascoyne, David. *Collected Verse Translations*, edited by Robin Skelton and Alan Clodd. Oxford: Oxford University Press, 1970.

Geertz, Clifford. *The Interpretation of Cultures*. London: Fontana, 1993.

Gilot, Françoise and Carlton Lake. *Life With Picasso*. London: Nelson, 1964.

Ginsberg, Allen. *Allen Verbatim: Lectures on Poetry, Politics, Consciousness*, edited by Gordon Ball. New York: McGraw-Hill, 1974.

————. 'The Art of Poetry No. 8', *Paris Review* 37 (Spring 1966): 13–55.

————. *Collected Poems 1947–1997*. New York: HarperCollins, 2006.

————. *Composed on the Tongue*, edited by Donald Allen. Bolinas: Grey Fox, 1980.

————. *Howl*. City Lights Books: 1956, San Francisco.

Gold, Herbert. 'Instead of Love, the Fix'. *Sunday New York Times Book Review*, 25 November 1962, 4.

Gooch, Brad. *City Poet: The Life and Times of Frank O'Hara*. New York: Knopf, 1993.

Goodman, Paul. 'Advance-Guard Writing, 1900–1950'. *Kenyon Review* 8, no. 3 (1951): 359–80.

Gray, Michael. *The Bob Dylan Encyclopedia*. London: Continuum, 2006.

———. *Song and Dance Man: The Art of Bob Dylan*. London: Abacus, 1973.

———. *Song and Dance Man III: The Art of Bob Dylan*. London: Cassell, 2000.

Greenberg, Clement. *Art and Culture: Critical Essays*. Boston: Beacon Press, 1961.

———. *The Collected Essays and Criticism, Volume 2: Arrogant Purpose, 1945–1949*, edited by John O'Brian. Chicago: University of Chicago Press, 1986.

———. *The Collected Essays and Criticism, Volume 4: Modernism with a Vengeance, 1957–1969*, edited by John O'Brian. Chicago: University of Chicago Press, 1995.

———. *Joan Miró*. New York: Arno, 1969 (1948).

Guest, Barbara. *Forces of Imagination: Writing on Writing*. Berkeley: Kelsey Street Press, 2003.

Guilbaut, Serge. *How New York Stole the Idea of Modern Art: Abstract Expressionism, Freedom, and the Cold War*, translated by Arthur Goldhammer. Chicago: University of Chicago Press, 1983.

Gutman, David and Elizabeth Thomson, eds. *The Dylan Companion*. London: Macmillan, 1990.

Gysin, Brion and Terry Wilson. *Here To Go: Planet R-101*. San Francisco: RE/Search Publications, 1982.

Hampson, Robert and Will Montgomery, eds. *Frank O'Hara Now: New Essays on the New York Poet*. Liverpool: Liverpool University Press, 2010.

Harris, Oliver. '"Burroughs Is a Poet Too, Really": The Poetics of Minutes to Go'. *Edinburgh Review* 114 (2005): 24–36.

———. 'Confusion's Masterpiece: Re-Editing William S. Burroughs' First Trilogy'. 16 September 2010. *Reality Studio*. http://realitystudio.org/scholarship/confusions-masterpiece [Accessed November 2010].

———. 'Cut-Up Closure: The Return to Narrative'. In *William S. Burroughs at the Front: Critical Reception, 1959–1989*, edited by Robin Lydenberg and Jennie Skerl, 251–62. Carbondale: Southern Illinois University Press, 1991.

———, ed. *The Letters of William S. Burroughs, 1945–1959*. New York: Viking, 1993.

———. *William Burroughs and the Secret of Fascination*. Carbondale: Southern Illinois University Press, 2003.

Harris, Oliver and Ian Macfadyen, eds. *Naked Lunch@50: Anniversary Essays*. Carbondale: Southern Illinois University Press, 2009.

Hartigan, Lynda Roscoe. *Joseph Cornell: Navigating the Imagination*. Salem: Peabody Essex Museum, 2007.

Hartigan, Lynda Roscoe, Walter Hopps, Robert Lehrman and Richard Vine, eds. *Shadowplay – Eterniday*. London and New York: Thames & Hudson, 2003.

Hartman, Anne. 'Confessional Counterpublics in Frank O'Hara and Allen Ginsberg'. *Journal of Modern Literature* 28, no. 4 (2005): 40–56.

Hassan, Ihab. 'The Subtracting Machine: The Work of William Burroughs'. *Critique* 6 (1963): 4–23.

Hauptman, Jodi. *Joseph Cornell: Stargazing in the Cinema*. New Haven: Yale University Press, 1999.

Hausmann, Raoul. 'Synthetische Cino der Malerei (Synthetic Cinema of Painting) (1918)'. In Raoul Hausmann, *Am Anfang war Dada*, 27–30. Steinbach/ Giessen: Anabas-Verlag Gunter Kampf, 1972.

Hemmer, Kurt. '"the natives are getting uppity": Tangier and Naked Lunch'. In *Naked Lunch@50: Anniversary Essays*, edited by Oliver Harris and Ian Macfadyen, 65–72. Carbondale: Southern Illinois University Press, 2009.

Herd, David. *Enthusiast! Essays on Modern American Literature*. Manchester: Manchester University Press, 2007.

———. *John Ashbery and American Poetry*. Manchester: Manchester University Press, 2000.

Hesse, Hermann. *Steppenwolf*. London: Penguin, 1973.

Heylin, Clinton. *Behind the Shades – Take Two*. London: Penguin, 2001 (2000).

Hibbard, Allen, ed. *Conversations with William Burroughs*. Jackson: University Press of Mississippi, 1999.

Hoffman, Katherine, ed. *Collage: Critical Views*. Ann Arbor: UMI Research Press, 1989.

Homberger, Eric. 'New York City and the Struggle of the Modern'. In *The Cambridge Companion to Modern American Culture*, edited by Christopher Bigsby, 314–31. Cambridge: Cambridge University Press, 2006.

Hopps, Walter. 'Gimme Strength: Joseph Cornell and Marcel Duchamp Remembered'. In *Joseph Cornell/Marcel Duchamp ... In Resonance*, edited by Polly Koch, 67–78. Houston and Ostfildern-Ruit, Germany: The Menil Collection/Philadelphia Museum of Art/Cantz, 1998.

Houng, Cynthia. 'Art Review – Joseph Cornell: Navigating the Imagination'. *KQED Arts*. 5 November 2007. http://www.kqed.org/arts/visualarts/article. jsp?essid=20183 [Accessed September 2009].

Hubert, Renée Riese. 'Patch and Paradox in Joseph Cornell's Art'. In *Collage*, edited by Jeanine Parisier Plottel, 167–79. New York: New York Literary Forum, 1983.

Huelsenbeck, Richard. '"En Avant Dada: a History of Dadaism" (1920)'. In *Dada Painters and Poets: An Anthology*, edited by Robert Motherwell, 21–48. Cambridge: Harvard University Press, 1951.

———. 'First Dada Lecture in Germany (January 1918)'. In Richard Huelsenbeck, *The Dada Almanac*, edited by Alastair Brotchie and Malcom Green, 110–13. London: Atlas Press, 1998.

Hughes, John. *Invisible Now: Bob Dylan in the 1960s*. Aldershot: Ashgate, 2013.

Hughes, Linda K. and Michael Lund, eds. *The Victorian Serial*. Charlottesville and London: University Press of Virginia, 1991.

Hughes, Robert. *The Shock of the New: Art and the Century of Change*. London and New York: Thames & Hudson, 2005.

Hugnet, Georges. 'In the Light of Surrealism'. In *Fantastic Art Dada Surrealism*, edited by Alfred H. Barr Jr, 35–52. New York: The Museum of Modern Art, 1936.

Huret, Jules. *Enquête sur l'évolution littéraire*. Paris: Corti, 1999 (1891).

Hussey, Andrew. '"Paris is about the last place …": William Burroughs In and Out of Paris and Tangier'. In *Naked Lunch@50*, edited by Oliver Harris and Ian Macfadyen, 73–83. Carbondale: Southern Illinois University Press, 2009.

Hussey, Howard. 'Collaging the Moment'. In *Joseph Cornell: Collages 1931–1972*, edited by Ronald Feigen, Howard Hussey and Donald Windham, 15–24. New York: Castelli Feigen Corcoran, 1978.

Jameson, Fredric. *Fables of Aggression: Wyndham Lewis, the Modernist as Fascist*. Berkeley and Los Angeles: University of California Press, 1979.

Jones, LeRoi, ed. *The Moderns: An Anthology of New Writing in America*. London: MacGibbon & Kee, 1965.

Jones, Thomas. 'Forget the Dylai Lama'. *London Review of Books* 25, no. 21, 6 November 2003, 10–12.

Joris, Pierre. *A Nomad Poetics*. Middletown: Wesleyan University Press, 2003.

Kahnweiler, Daniel-Henry. *The Rise of Cubism (Der Weg zum Kubismus)*, translated by Henry Aronson. New York: Wittenborn, Schulz, 1949 (1920).

Kane, Daniel. *We Saw the Light: Conversations between the New American Cinema and Poetry*. Iowa City: Iowa University Press, 2009.

———. *What is Poetry: Conversations with the American Avant-Garde*. New York: Teachers and Writers Books, 2003.

Karlin, Daniel. 'Bob Dylan's Names'. In *Do You, Mr Jones? Bob Dylan with the Poets and Professors*, edited by Neil Corcoran, 27–49. London: Chatto & Windus, 2002.

Kelly, Julia. 'Sights Unseen: Raymond Roussel, Michel Leiris, Joseph Cornell and the Art of Travel'. In *Joseph Cornell: Opening the Box*, edited by Jason Edwards and Stephanie L. Taylor, 69–86. Oxford: Peter Lang, 2007.

Kermode, Frank and Stephen Spender. 'The Metaphor at the End of the Funnel'. In *The Dylan Companion*, edited by David Gutman and Elizabeth Thomson, 155–62. London: Macmillan, 1990.

'King of the YADS (review of Naked Lunch)'. *Time*, 30 November 1962, 96–8.

Klaver, Elizabeth. *Sites of Autopsy in Contemporary Culture*. Albany: State University of New York Press, 2005.

Koch, Kenneth. 'All the Imagination Can Hold'. *The New Republic*, 1 and 8 January 1972, 23–5.

Koch, Polly, ed. *Joseph Cornell/Marcel Duchamp … In Resonance*. Houston: Menil Foundation, 1998.

Koestenbaum, Wayne. 'Review of Joseph Cornell's Theater of the Mind, by Mary Ann Caws'. *Artforum/Bookforum* 32 (Summer 1994): 1–2.

Kramer, Hilton. 'The Enigmatic Collages of Joseph Cornell: Review of Joseph Cornell's Robert Cornell: Memorial Exhibition'. *The New York Times*, 23 January 1966.

Krauss, Rosalind. 'In the Name of Picasso'. *October* 16 (1981): 5–22.

Lautréamont, Comte de. *Les Chants de Maldoror*, translated by Paul Knight. London: Penguin, 1988 (1868).

Leefmans, Bert M. 'Das Unbild: A Metaphysics of Collage'. In *Collage*, edited by Jeanine Parisier Plottel, 183–227. New York: New York Literary Forum, 1983.

Lehman, David. *The Last Avant-Garde: The Making of the New York School of Poets*. New York: Doubleday, 1998.

Leibowitz, Herbert A. 'A Pan Piping on the City Streets'. Review of *The Collected Poems of Frank O'Hara*. *New York Times Book Review*, 28 November 1971, 7, 28.

Leighten, Patricia. 'Picasso's Collages and the Threat of War, 1912–13'. In *Collage: Critical Views*, edited by Katherine Hoffman, 21–170. Ann Arbor: UMI Research Press, 1989.

Leiris, Michel. 'Le Voyageur et son Ombre'. *La Bête noir* (1935).

LeSueur, Joe. *Digressions on Some Poems by Frank O'Hara*. New York: Farrar, Strauss & Giroux, 2004.

Levertov, Denise. *O Taste and See*. New York: New Directions Books, 1954.

Lévi-Strauss, Claude. *The Savage Mind*. London: Weidenfeld and Nicolson, 1966.

Levy, Julien. *Memoir of an Art Gallery*. New York: G. Putnam's Sons, 1977.

Libby, Anthony. 'O'Hara On The Silver Range'. *Contemporary Literature* 17, no. 2 (1976): 240–62.

Lodge, David. 'Objections to William Burroughs'. *Critical Quarterly* 8 (1966): 203–12.

Lotringer, Sylvère, ed. *Burroughs Live: The Collected Interviews of William S. Burroughs, 1960–1997*. Los Angeles: Semiotext(e), 2001.

Lott, Eric. *Love and Theft: Blackface Minstrelsy and the American Working Class*. Oxford: Oxford University Press, 1993.

Lowell, Robert. *For the Union Dead*. New York: Farrar, Straus & Giroux, 1964.

———. *William Burroughs' Naked Lunch*. New York: Grove Press, 1962, 16.

Lydenberg, Robin. 'Engendering Collage: Collaboration and Desire in Dada and Surrealism'. In *Collage: Critical Views*, edited by Katherine Hoffman, 271–85. Ann Arbor: UMI Research Press, 1989.

———. 'Notes from the Orifice: Language and the Body in William Burroughs'. *Contemporary Literature* 26, no. 1 (1985): 55–73.

———. *Word Cultures: Radical Theory and Practice in William S. Burroughs' Fiction*. Urbana: University of Illinois Press, 1987.

Lydenberg, Robin and Jennie Skerl. *William S. Burroughs at the Front: Critical Reception, 1959–1989*. Carbondale: Southern Illinois University Press, 1991.

Macfadyen, Ian. 'The Writing of Perilous Passage: Terry Wilson in Conversation with Ian MacFadyen'. 20 February 2012. *Reality Studio*. http://realitystudio. org/interviews/terry-wilson-cutting-up-for-real [Accessed June 2012].

Mailer, Norman. *Advertisements for Myself*. London: HarperCollins, 1994 (1961).

———. 'Evaluations – Quick and Expensive Comments on the Talent in the Room'. *Big Table* 3 (1959): 88–100.

Malevich, Kazimir. *Essays on Art 1915–1933*, edited by Troels Andersen and translated by Xenia Glowacki-Prus and Arnold McMillin. Vol. 2. London: Rapp and Whiting, 1969.

Marin, Louis. *Études Sémiologiques: Écritures, peintures*. Paris: Klincksieck, 1972.

Marinetti, F.T. 'The Founding and Manifesto of Futurism, 1909'. In *Futurist Manifestos*, edited by Apollonio Umbro, 19–24. London and New York: Thames & Hudson, 1973.

———. *Selected Writings*, edited by R.W. Flint and translated by R.W. Flint and A.A. Coppotelli. New York: Farrar, Straus & Giroux, 1971.

Marqusee, Mike. *Chimes of Freedom: The Politics of Bob Dylan's Art*. New York: The New Press, 2003.

———. *Wicked Messenger: Bob Dylan and the 1960s, Chimes of Freedom, Revised and Expanded*. New York: Seven Stories Press, 2005.

Mayakovsky, Vladimir. *Pro Eto – That's What*, translated by Larisa Gureyeva and George Hyde. Todmorden: Arc Publications, 2009 (1923).

McCarthy, Mary. 'Burroughs' Naked Lunch'. *Encounter*, no. 115 (1963): 92–7.

McNair, David and Jayson Whitehead. 'Interview with Eric Lott for Gadfly Online'. *Gadfly Online*. December 10, 2001. http://www.gadflyonline.com/12-10-01/book-ericlott.html [Accessed January 2009].

Mengham, Rod. 'French Frank'. In *Frank O'Hara Now: New Essays on the New York Poet*, edited by Robert Hampson and Will Montgomery, 49–58. Liverpool: Liverpool University Press, 2010.

Miles, Barry. *The Beat Hotel: Ginsberg, Burroughs and Corso in Paris, 1957–1963*. London: Atlantic, 2003.

———. *Bob Dylan in His Own Words*. London: Omnibus Press, 1978.

———. 'The Naked Lunch in My Life'. In *Naked Lunch@50: Anniversary Essays*, edited by Oliver Harris and Ian Macfadyen, 114–22. Carbondale: Southern Illinois University Press, 2009.

———. *William Burroughs: El Hombre Invisible*. London: Virgin, 1993.

Miller, Henry. *Tropic of Cancer*. London: Calder, 1963 (1934).

Molesworth, Charles. '"The Clear Architecture of the Nerves": The Poetry of Frank O'Hara'. *Iowa Review* 6, nos 3–4 (1975): 61–74.

Montgomery, Will. '"In Fatal Winds": Frank O'Hara and Morton Feldman'. In *Frank O'Hara Now: New Essays on the New York Poet*, edited by Robert Hampson and Will Montgomery, 195–210. Liverpool: Liverpool University Press, 2010.

Moore, Dave. 'Was Bob Dylan Influenced by Jack Kerouac?' *Dharma Beat.*
 http://www.dharmabeat.com/kerouaccorner.html#BobDylaninfluencedbyJack
 Kerouac [Accessed 30 July 2013].

Moramarco, Fred. 'John Ashbery and Frank O'Hara: The Painterly Poets'. *Journal
 of Modern Literature* 5, no. 3 (1976): 436–62.

———. 'Moloch's Poet: A Retrospective Look at Allen Ginsberg's Poetry'.
 American Poetry Review 11, no. 5 (1982): 10–14, 16–18.

Morgan, Bill, ed. *Rub Out The Words: The Letters of William S. Burroughs
 1959–1974.* London: Penguin, 2012.

Morgan, Ted. *Literary Outlaw: A Life and Times of William S. Burroughs.* New
 York: Henry Holt, 1988.

Motherwell, Robert. 'Beyond the Aesthetic'. *Design* 47, no. 8 (1946): 38–9.

———. ed. *Dada Painters and Poets: An Anthology.* Cambridge: Harvard
 University Press, 1951.

Mottram, Eric. *William Burroughs: The Algebra of Need.* New York: Intrepid,
 1971.

Naifeh, Steven and Gregory Smith. *Jackson Pollock: An American Saga.* New
 York: Clarkson N Potter, 1989.

National Gallery of Art. 'Introduction to Dada'. http://www.nga.gov/
 exhibitions/2006/dada/cities/index.shtm [Accessed February 2009].

Nelson, Cary. 'The End of the Body: Radical Space in Burroughs'. In *William
 S. Burroughs at the Front: Critical Reception 1959–1989*, edited by Robin
 Lydenberg and Jennie Skerl, 119–32. Carbondale: Southern Illinois University
 Press, 1991.

O'Doherty, Brian. *The Voice and the Myth: American Masters.* London and New
 York: Thames & Hudson, 1988.

O'Hara, Frank. *Amorous Nightmares of Delay: Selected Plays.* Baltimore: The
 John Hopkins University Press, 1997.

———. *The Collected Poems of Frank O'Hara*, edited by Donald Allen. Berkeley:
 University of California Press, 1995 (1971).

———. 'Reviews and Previews: Joseph Cornell and Landes Lewitin'. *Artnews*
 54, no. 5 (1955): 50.

———. *Robert Motherwell.* New York: The Museum of Modern Art, 1965.

———. *Standing Still and Walking in New York*, edited by Donald Allen. Bolinas,
 CA: Grey Fox Press, 1975.

Oxenhandler, Neal. 'Listening to Burroughs' Voice'. In *Surfiction: Fiction Now ...
 And Tomorrow*, edited by Raymond Federman, 181–201. Chicago: Swallow
 Press, 1975.

Parisier Plottel, Janine, ed. *Collage.* New York: New York Literary Forum,
 1983.

Parkinson, Thomas, ed. *A Casebook on the Beat.* New York: Crowell, 1961.

Pasternak, Boris. *Doctor Zhivago.* Translated by Max Hayward and Manya Harari.
 London: HarperCollins, 1995 (1957).

Perl, Jed. *New Art City.* New York: Knopf, 2005.

Perloff, Marjorie. '"Fragments of a Buried Life": John Ashbery's dream songs', in *Beyond Amazement: New Essays on John Ashbery*, edited by David Lehman (Ithaca and London: Cornell University Press, 1980), 66–86.

———. *Frank O'Hara: Poet Among Painters*. Chicago: University of Chicago Press, 1998 (1977).

———. 'The Invention of Collage'. In *Collage*, edited by Jeanine Parisier Plottel, 5–47. New York: New York Literary Forum, 1983.

Poggi, Christine. *In Defiance of Painting: Cubism, Futurism and the Invention of Collage*. New Haven: Yale University Press, 1992.

Polito, Robert. '*Highway 61 Revisited* (1965)'. In *The Cambridge Companion to Bob Dylan*, edited by Kevin J.H. Dettmar, 137–42. Cambridge: Cambridge University Press, 2009.

Poore, Charles. '*Naked Lunch*: Review'. *New York Times*, 20 November 1962.

Pound, Ezra. 'Three Cantos: I'. In *Poetry: A Magazine of Verse* 10, no. 3 (June 1917): 113–21.

Prose, Francine. 'Magic Moments: Hans Christian Andersen and William Seward Burroughs'. In *Cut-Outs and Cut-Ups: Hans Christian Andersen and William Seward Burroughs*, edited by Hendel Teicher, 57–62. Dublin: Irish Museum of Modern Art, 2008.

Ragon, Michel. *Dubuffet*. Translated by Haakon Chevalier. New York: Grove Press, 1959.

Revell, Donald. 'Purists Will Object: Some Meditations on Influence'. In *The Tribe of John: Ashbery and Contemporary Poetry*, edited by Susan M. Schultz, 91–100. Tuscaloosa: University of Alabama Press, 1995.

Ricks, Christopher. *Dylan's Visions of Sin*. London: Penguin, 2004 (2001).

Rimbaud, Arthur. *Rimbaud: Complete Works, Selected Letters*, edited by Wallace Fowlie. Chicago: University of Chicago Press, 2005 (1966).

Rodari, Florian. *Collage: Painted. Cut and Torn Paper*. New York: Skira Rizzoli, 1988.

Roe, Nicholas. 'Playing Time'. In *Do You, Mr Jones? Bob Dylan with the Poets and Professors*, edited by Neil Corcoran, 81–104. London: Chatto & Windus, 2002.

Rosand, David. 'Paint, Paste and Plane'. In *Collage*, edited by Jeanine Parisier Plottel, 121–38. New York: New York Literary Forum, 1983.

Rosenbaum, Susan. *Professing Sincerity: Modern Lyric Poetry, Commercial Culture, and the Crisis in Reading*. Charlottesville and London: University of Virginia Press, 2007.

Rosenberg, Harold. *Artworks and Packages*. Chicago: University of Chicago Press, 1969.

———. *The Tradition of the New*. New York: McGraw-Hill, 1965.

Sawday, Jonathan. *Emblazoned on the Body: Dissection and the Human Body in Renaissance Culture*. London and New York: Routledge, 1996.

Sawin, Martica. *Surrealism in Exile and the Beginning of the New York School*. Cambridge: The MIT Press, 1997.

Schapiro, Meyer. 'Nature of Abstract Art'. *Marxist Quarterly* 1 (1937): 77–98.

Schwitters, Kurt. 'Die Merzmalerei'. *Der Sturm* (4 July 1919), 61.

Scobie, Stephen. *Alias Bob Dylan Revisited.* Calgary: Red Deer Press, 2004.

Seitz, William C. *The Art of Assemblage.* New York: Museum of Modern Art, 1961.

Selby, Nick. 'Memory Pieces: Collage, Memorial and the Poetics of Intimacy in Joe Brainard, Jasper Johns and Frank O'Hara'. In *Frank O'Hara Now: New Essays on the New York Poet*, edited by Robert Hampson and Will Montgomery, 229–46. Liverpool: Liverpool University Press, 2010.

Shapiro, David. *John Ashbery: An Introduction to the Poetry* (New York: Columbia University Press, 1979).

Shaw, Lytle. *Frank O'Hara: The Poetics of Coterie.* Iowa City: University of Iowa Press, 2006.

———. 'Gesture in 1960: Toward Literal Situations'. In *Frank O'Hara Now: New Essays on the New York Poet*, edited by Robert Hampson and Will Montgomery, 29–48. Liverpool: Liverpool University Press, 2010.

Shoptaw, John. *On the Outside Looking Out: John Ashbery's Poetry.* Cambridge: Harvard University Press, 1994.

Simic, Charles. *Dime-Store Alchemy: The Art of Joseph Cornell.* New York: New York Review Books, 1992.

Simmel, Georg. 'The Metropolis and Mental Life'. In *Classic Essays on the Culture of Cities*, edited by Richard Sennett, 47–60. Englewood Cliffs, New Jersey: Prentice-Hall, 1969.

Skerl, Jennie. Interview with William Burroughs, 4 April 1980, New York City. *Modern Language Studies* 12, no. 3 (Summer 1982): 3–17.

———. *William S. Burroughs.* Boston: Twayne, 1985.

Smith, Hazel. *Hyperscapes in the Poetry of Frank O'Hara: Difference/ Homosexuality/Topography.* Liverpool: Liverpool University Press, 2000.

Solataroff, Theodore. 'The Algebra of Need'. *The New Republic*, 5 August 1967, 29–34.

Solomon, Deborah. *Utopia Parkway: The Life and Work of Joseph Cornell.* London: Pimlico, 1998.

Sontag, Susan. *Styles of Radical Will.* London: Secker and Warburg, 1969.

Sounes, Howard. *Down the Highway: The Life of Bob Dylan.* London: Black Swan, 2002.

Spies, Werner. *Max Ernst Collages: The Invention of the Surrealist Universe*, translated by John William Gabriel. New York: Harry N. Abrams, 1991.

Spitz, Bob. *Dylan: A Biography.* New York: Norton, 1991 (1989).

Stevens, Hugh. 'Joseph Cornell's Dance to the Music of Time: History and Giving in the Ballet Constructions'. In *Joseph Cornell: Opening the Box*, edited by Jason Edwards and Stephanie L. Taylor, 87–109. Oxford: Peter Lang, 2007.

'Strange Taste'. *Newsweek*, 26 November 1962, 94.

Sweet, David. '"And Ut Pictura Poesis Is Her Name": John Ashbery, the Plastic Arts, and the Avant-Garde'. *Comparative Literature* 50, no. 4 (1998): 316–32.

Tanner, Tony. 'Rub Out the Word'. In *William S. Burroughs at the Front: Critical Reception, 1959–1989*, edited by Robin Lydenberg and Jennie Skerl, 105–13. Carbondale: Southern Illinois University Press, 1991.

Tashijan, Dickran. *Joseph Cornell: Gifts of Desire*. Miami Beach: Grassfield Press, 1992.

Taylor, Brandon. *Collage: The Making of Modern Art*. London and New York: Thames & Hudson, 2004.

Thakker, Jonny. 'Visions of Infinity'. *The Owl Journal* 4, no. 7 (2004): 20.

Thomas, Jean-Jacques. 'Collage/Space/Montage'. In *Collage*, edited by Jeanine Parisier Plottel, 79–102. New York: New York Literary Forum, 1983.

Times Literary Supplement, 21 November 1963–23 January 1964 (Issues 3221–30).

Trotter, David. *Cooking with Mud: The Idea of Mess in Nineteenth Century Art and Fiction*. Oxford: Oxford University Press, 2000.

Tytell, John. *Naked Angels: Kerouac, Ginsberg, Burroughs*. Chicago: Ivan R. Dee, 1976.

Tzara, Tristan. 'Zurich Chronicle 1915–1919'. In *The Dada Painters and Poets: An Anthology*, edited by Robert Motherwell, 235–42. Cambridge: Harvard University Press, 1951.

Ulmer, Gregory. 'The Object of Post-Criticism'. In *Collage: Critical Views*, edited by Katherine Hoffman, 383–412. Ann Arbor: UMI Research Press, 1989.

Umbro, Apollonio, ed. *Futurist Manifestos*, translated by Robert Brain. London and New York: Thames & Hudson, 1973.

USA Poetry: Frank O'Hara. Directed by Richard O. Moore. WNET, 1966.

Vendler, Helen. 'Understanding Ashbery', *The New Yorker* (16 March 1981), 114–36.

Walters Jr, Raymond. 'In and Out of Books'. *New York Times Book Review*, 16 September 1962, 8.

Ward, Geoff. '"Housing the Deliberations": New York, War and Frank O'Hara'. In *Frank O'Hara Now: New Essays on the New York Poet*, edited by Robert Hampson and Will Montgomery, 13–28. Liverpool: Liverpool University Press, 2010.

———. *Statutes of Liberty: The New York School of Poetry* (New York: St Martin's Press, 1993).

Warne, Frederick. *Warne's Picture Puzzle Album*. London: Frederick Warne and Co., 1870.

Weatherby, W.J. 'Report on the Edinburgh Writers' Conference'. *Guardian*, 21 August 1962, 5.

Welch, Denton. *In Youth Is Pleasure*. Oxford: Oxford University Press, 1982 (1944).

Wescher, Herta. *Collage*, translated by Robert E. Wolf. New York: Harry N. Abrams, 1978.

White, E.B. *Here is New York*. New York: The Little Bookroom, 1999 (1949).

Wilentz, Sean. *Bob Dylan in America*. London: Vintage, 2011.

'William Burroughs Naked Lunch'. Grove Press publicity pamphlet. New York: Grove Press, 1962.

Williams, Paul. *Bob Dylan: Performing Artist: The Early Years (1960–1973)*. London: Omnibus Press, 1990 (2004).

———. *Bob Dylan – Watching the River Flow*. London: Omnibus Press, 1996.

Williams, William Carlos. *Selected Essays*. New York: Random House, 1954.

Williamson, Alan. *Introspection and Contemporary Poetry*. Cambridge: Harvard University Press, 1984.

Wimsatt, William K. and Monroe C. Beardsley. 'The Intentional Fallacy'. *Sewanee Review* 54 (1946): 468–88.

Wolfram, Eddie. *The History of Collage*. London: Studio Vista, 1975.

Wordsworth, William. *Lyrical Ballads with Pastoral and Other Poems (2 volumes)*. London: Longman, 1805.

'Writers' Conference Draws an Audience of 2,000'. *Times*, 21 August 1962, 4.

Yaffe, David. 'Bob Dylan and the Anglo-American Tradition'. In *The Cambridge Companion to Bob Dylan*, edited by Kevin J.H. Dettmar, 15–27. Cambridge: Cambridge University Press: 2009.

Yau, John. 'John Ashbery: Collages: They Knew What They Wanted', *The Brooklyn Rail*, 10 October 2008.

Archives

Allen Ginsberg Papers, Rare Book and Manuscript Library, Columbia University in the City of New York, 1943–1991 (bulk 1945–1976).

Archives, Brooklyn Museum. Press Releases: International Exhibition of Modern Art, assembled by Société Anonyme. 19 November 1926–10 January 1927.

Jack Kerouac Papers, Rare Book and Manuscript Library, Columbia University in the City of New York, 1945–1971.

Joseph Cornell Papers, Archives of American Art, Smithsonian Institution, 1804–1986 (bulk 1939–1972).

William S. Burroughs Papers, The Henry W. and Albert A. Berg Collection of English and American Literature, The New York Public Library, 1951–1972 (bulk 1958–1972).

William Seward Burroughs Papers, Rare Book and Manuscript Library, Columbia University in the City of New York, 1957–1976.

Index

CPSIA information can be obtained
at www.ICGtesting.com
Printed in the USA
BVHW01s2042160118
505445BV00002B/73/P

9 781138 743335